MONET AND HIS MUSE

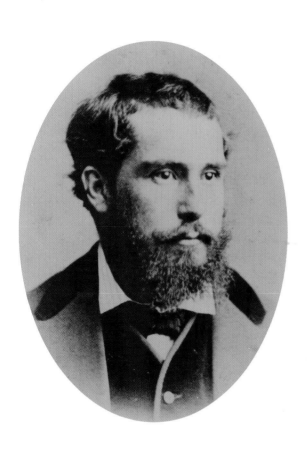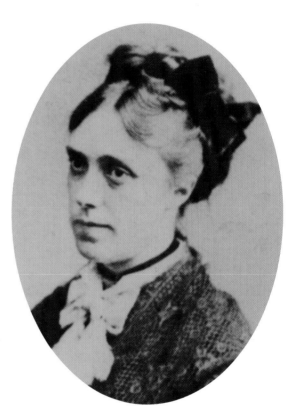

MONET

AND HIS MUSE

Camille Monet in the Artist's Life

MARY MATHEWS GEDO

The University of Chicago Press Chicago and London

Originally trained as a child psychologist, Mary Mathews
Gedo turned to art history in what she describes as a
midlife reincarnation; she received her PhD from North-
western University in 1973. She is the author of *Picasso:
Art as Autobiography* (University of Chicago Press,
1980) and *Looking at Art from the Inside Out* (1994) and
the editor of *Psychoanalytic Perspectives on Art* (3 vols.,
1985–88), as well as numerous articles in art-historical
and psychoanalytic publications.

The University of Chicago Press, Chicago 60637
The University of Chicago Press, Ltd., London
© 2010 by The University of Chicago
All rights reserved. Published 2010
Printed in China

19 18 17 16 15 14 13 12 11 10 1 2 3 4 5

ISBN-13: 978-0-226-28480-4 (cloth)
ISBN-10: 0-226-28480-8 (cloth)

Library of Congress Cataloging-in-Publication Data

Gedo, Mary Mathews.
 Monet and his muse : Camille Monet in the artist's life
/ Mary Mathews Gedo.
 p. cm.
 Includes bibliographical references and index.
 ISBN-13: 978-0-226-28480-4 (cloth : alk. paper)
 ISBN-10: 0-226-28480-8 (cloth : alk. paper)
 1. Monet, Claude, 1840–1926—Psychology.
 2. Monet, Claude, 1840–1926—Relations with women.
 3. Painters—France—Biography. 4. Monet, Camille,
 1847–1879. 5. Painters' spouses—France—Biography.
 I. Monet, Claude, 1840–1926. II. Title. III. Title:
 Camille Monet in the artist's life.
 ND553.M7G33 2010
 759.4—dc22
 [B]
 2009048499

♻ The paper used in this publication meets the mini-
mum requirements of the American National Standard
for Information Sciences—Permanence of Paper for
Printed Library Materials, ANSI z39.48–1992.

Page ii: (*left*) A. Greiner, *Claude Monet*, Amsterdam,
1871, Wildenstein Institute Archives, Paris;
(*right*) A. Greiner, *Camille Monet*, Amsterdam,
1871, Wildenstein Institute Archives, Paris

CONTENTS

The mourning never ends,
it just changes.

EDWARD ALBEE,
INTERVIEW IN *NEW YORK TIMES*, 2007

This book began life as "Monet and the Human Figure." I soon realized, however, that for me the essence of this topic lies in the artist's depictions of Camille Doncieux, which at the same time record the history of their relationship. Camille possessed unusual talent as a model—a talent recognized not only by Monet but also by Auguste Renoir and Edouard Manet, who also created some of their greatest paintings featuring her. Just as important for Monet was Camille's role as a source of inspiration.

His various representations of her provide hints about Monet's evolving attitudes toward Camille as model, mistress, wife, and mother of his two sons. Because all documents pertaining to Camille's personal history have been destroyed, my understanding of the meanings of Monet's portrayals of her has had to depend on the artist's surviving correspondence of the period, the testimonies of various contemporaries, and Monet's later recollections, recorded by various friends and interviewers. These materials often provide considerable insight into the artist's attitudes and behavior toward his muse—both as mistress and as wife and mother.

As in the case of my previous works, I have combined the data and skills of the two disciplines in which I have been trained, clinical psychology and art history.[1] Consequently, I have paid particular attention to Monet's background, especially his childhood and adolescent dependence on his mother and a paternal aunt. Both women showed unusual attachment to young Claude and also encouraged his talent through their own interest in art and the example of their artistic training.

The death of Monet's mother, shortly after his sixteenth birthday, was a tragedy from which he never recovered. "Mourning never ends, it just changes." So it was with Monet. The availability of his aunt Lecadre, who became a guardian and foster mother, did enable the young Monet to continue his artistic development. When he moved to Paris to pursue his formal career, however, he required the presence of a muse to replace these maternal figures. His encounter with Camille Doncieux, who posed for his first major success at the Salon of 1866, fulfilled this need. Their marriage in 1870 consolidated their relationship, which lasted until her death in 1879.

In that emergency, Monet was succored by the availability of Alice Hoschedé, who soon became his mistress and later his second wife. He was able to continue painting, eventually to achieve his great success. When Alice died in 1911, he stopped working until his stepdaughter (and daughter-in-law) Blanche Hoschedé Monet joined him in 1914 to become his final muse.

Because this book is focused on the work Monet created during the relationship to Camille Doncieux, I have dealt with his life preceding their meeting and his character development in a prologue. An epilogue briefly covers his relationships with Alice and Blanche Hoschedé and the artistic production of the final decades of his career. The heart of the book is focused, chapter by chapter, on the work he created between the

unfinished *Luncheon* of 1865–66, the first painting for which Camille posed, and the ones that reflect Monet's response to her death. Her continuing influence, long after her demise, on the creation of the memorial gardens at Giverny and their representations in Monet's art concludes the book.

The picture of Monet's character presented here often differs from that offered by other authors, especially by the late Daniel Wildenstein, whose mammoth work forms the basis for all subsequent studies of the artist. Although I am by no means a feminist (my cleaning lady describes me, despite my lack of religion, as a "biblical wife"), I found it impossible not to identify with Camille Monet, whose suffering was truly tragic. I note several situations in which Wildenstein identified with Monet and I with Camille.

ACKNOWLEDGMENTS

I wish to begin by thanking William Conger, professor emeritus in the Department of the Theory and Practice of Art at Northwestern University. Well known for his technical skill as a painter, Professor Conger not only coauthored with me chapter 5 (where we discuss *On the Bank of the Seine at Bennecourt*) but also enriched my knowledge about many other aspects of Monet's art and provided several sketches used as illustrations in this book. Our understanding of *On the Bank of the Seine* was enhanced by the work of Timothy Lennon, conservator emeritus at the Art Institute of Chicago, and Frank Zuccari, executive director of the Conservation Department, who repeatedly discussed the x-rays of the work with us.

I wish to express my gratitude to Dr. John Lurain, director of gynecological oncology at Northwestern Memorial Hospital (Chicago), who proposed (and repeatedly clarified) the most likely diagnosis of Camille Monet's final illness.

Without the help of Sachiko Levin, it would have remained impossible to find all the information relevant to comprehension of the imagery of *La Japonaise*.

Eva Sandberg, my secretarial assistant, not only read what she entered on the computer but asked pertinent questions and pointed out oversights. My "other Eva," Eva Masur Bornstein, fulfilled the role of volunteer research assistant, for which her superb command of French proved to be invaluable.

Without the expertise and organizational skill of Barbara Mirecki, the onerous task of collecting photographic materials for the illustrations in this book would have defeated me.

I also owe thanks to Gloria Groom, David and Mary Winton Green Curator of Nineteenth-Century Art at the Art Institute of Chicago, and to Porter Aichele, professor of art at the University of North Carolina at Greensboro.

I am particularly grateful for their help to two eminent Monet scholars, Charles F. Stuckey and Paul Hayes Tucker, both of whom located difficult-to-find paintings for me. Charles Stuckey also provided me with copies of rare but relevant nineteenth-century publications.

Special gratitude goes to Mary Winton Green, a close friend for almost fifty years: her generous subsidy has permitted the University of Chicago Press to produce a volume richly endowed with color.

Susan Bielstein and her staff at the University of Chicago Press have been very helpful with the onerous task of editing and producing this book.

Most important of all, I owe unending gratitude to my husband, John Gedo, who read and reread these chapters endlessly and even cajoled me into finishing the project by telling me I was afraid I would die if I completed it. Thanks to John, I did finish and—so far—have not passed away.

Monet's Character

I am a Parisian from Paris. I was born there in 1840 under good king Louis-Philippe, in a circle entirely given to commerce, and where all professed a contentious disdain for the artist. But my youth was passed at Hâvre, where my father had settled in 1845, to follow his interests more closely, and this youth was essentially that of a vagabond. I was undisciplined by birth; never would I bend, even in my most tender youth, to a rule. It was at home that I learned the little I know. School always appeared to me like a prison, and I never could make up my mind to stay there, not even for four hours a day, when the sunshine was inviting, the sea smooth, and when it was such a joy to run about on the cliffs, in the free air, or paddle around in the water.

Until I was fourteen or fifteen years old, I led this irregular but thoroughly wholesome life, to the despair of my poor father. Between times, I had picked up in a haphazard way the rudiments of arithmetic and a smattering of orthography. This was the limit of my studies. They were not over tiresome for they were intermingled for me with distractions. I made wreaths on the margins of my books, I decorated the blue paper of my copy-books with ultra-fantastical ornaments, and I represented thereon, in the most irreverent fashion, deforming them as much as I could, the face or profile of my masters.

I soon acquired much skill at this game. At fifteen I was known all over Hâvre as a caricaturist. My reputation was so well established that I was sought after from all sides and asked for caricature-portraits. The abundance of orders and the insufficiency of the subsidies derived from maternal generosity inspired me with a bold resolve which naturally scandalized my family. I took money for my portraits. According to the appearance of my clients, I charged ten or twenty francs for each portrait, and the scheme worked beautifully. In a month my patrons had doubled in number. I was now able to charge twenty francs in all cases without lessening the number of orders. If I had kept on, I would today be a millionaire.[1]

Legend and fact blend in this reminiscence, which demonstrates that Monet's creativity expressed itself as much in his ability to construct an elaborate personal mythology as in his art. He may have been unusually strong willed, even in infancy, but this account exaggerates both the extent and the precocious onset of his rebelliousness. As a child, little Oscar-Claude, as his parents called him, certainly conformed enough to parental standards to internalize the typical middle-class values his family espoused. Despite his unconventional domestic arrangements as an adult, Monet was in many respects quintessentially bourgeois, a fact verified by numerous sources.[2] In the romanticized version of his past that the artist related to Thiébault-Sisson, emphasis on conventional bour-

geois values intermingled with claims to nonconformity. Monet began his recitation to Thiébault-Sisson with a prideful allusion to his Parisian heritage and birth, followed by a string of references to his family's dedication to commerce (and upward mobility), as exemplified by Monet senior's willingness to move his family to Normandy to pursue financial (and social) gain.[3]

The artist's lifelong commitment to the work ethic and profit motive mirrored parental values, reflecting his father's efficacy as a role model—at least in this aspect of his son's character formation. Paul Tucker described Monet as "a niggler about money. It almost made no difference how much he had, he would insist he needed more, demanding it out of spite, revenge, or defense."[4] This judgment seems a bit harsh; although where money was involved Monet could behave in ways ranging from whining and begging to the most hard-nosed bargaining, he was by no means consistently miserly. He enjoyed living and eating well (and had the figure to show for it!) and was a gracious and hospitable host; he was also capable of generous behavior when he thought the situation warranted it.[5] Much that Tucker criticized might be interpreted alternatively as an indication of that "peasant cunning" on which members of the French bourgeoisie habitually pride themselves. However, Monet certainly displayed a cavalier and irresponsible attitude about settling his outstanding debts. Even in an era when middle-class people were generally remiss about paying tradesmen and service people promptly, he distinguished himself by negligence. He was, in fact, something of a deadbeat and evidently never completely repaid certain debts incurred during the 1860s and 1870s even after he could well afford to do so. Most likely his delinquency in such matters reflected his father's attitudes about them.

Monet's adult character suggests that no matter how his parents attempted to deal with him during childhood, their educational methods were only partially successful. He possessed such a powerful personality that it is conceivable that he had the ability—even as a toddler—to overwhelm anyone. We do not know any of the details of his childhood character formation—only its outcome. His parents evidently tried to impose their ways on him but succeeded only partially. His capacities to persevere, to remain goal directed, and to keep his working materials and studios (as well as his person) meticulously clean and neat demonstrate that he accepted and internalized certain parental standards. But he rejected other modes of behavior and ideals that would ordinarily be congruent with these virtues. As a result, he grew to adulthood as a highly inconsistent but apparently untroubled personality. He showed little of the conflict or guilt one might expect from a person who had engaged in a titanic struggle with his parents throughout childhood. In contrast to the way most individuals would react to such an upbringing, during the first forty years of his life Monet exhibited none of the tendencies to procrastinate or dither indecisively that typically characterize ambivalent people. This was so at least until middle age, when he apparently underwent a character change that disturbed the harmonious balance of opposites he had successfully maintained throughout his twenties and thirties. This transformation occurred beyond the

terminus of the period to be considered in detail in this book, but it will be discussed briefly in a final chapter.[6]

Recently, pertinent new information about Monet's background and early career has become available, thanks to the discovery of the so-called Grand Journal, a detailed memoir based on a diary (no longer extant) that Comte Théophile Beguin Billecocq kept between 1854 and 1884.[7] He became acquainted with the Monets in 1853, when he stayed at Ingouville (a quarter of Le Havre) with his Aunt Ardonne and cousin (and future wife) Amélie and her brother, Théodore. Lodged in the Monet home in Ingouville, which is described as "seeming to have functioned as a 'bed and breakfast' for Parisian tourists," Théodore Billecocq, only three years Monet's senior, became Oscar-Claude's close friend, and the pair spent long summer days together around Le Havre, sketching along the coast, as well as in locations nearer Paris where in subsequent years the count rented summer quarters.[8]

Théophile describes the young Monet as "a fair-haired child, with a mischievous smile, cheerful, roguish, and greedy. Intelligent, lively, curious, a good boy, of course." In contrast to the latter statement, he also reports that Monet possessed "an undisciplined spirit that exasperated his father [who] dubbed him 'an American savage.' A good-for-nothing child, who disrupted his classes by drawing grotesque caricatures in his school books." Théophile characterizes *père* Monet as "an honorable business man, whose own interests lay in foreign politics and geography, but who appreciated his wife's talents in bringing together the notables of Le Havre and its environs."[9]

The "Grand Journal" is particularly rich in details about the future artist's mother, described as a woman of culture, well read in literature and romantic poetry, who also wrote poetry herself. She kept drawings and watercolors in sketchbooks, which she shared only with her family. She had a beautiful trained voice and in her well-appointed grand salon entertained "upper Havre society" with informal concerts and one-act comedies.[10] Théophile calls Monet's aunt, Mme. Marie Jeanne Lecadre (1795–1870), "a talented amateur" who "had trained with a recognized teacher and produced watercolor and oil paintings." She "doted on her nephew, Oscar, who shared her love of drawing."[11]

The information revealed in the "Grand Journal" demonstrates how much Monet's various later depictions of his background and upbringing distort and ignore the comfortable, culturally rich environment his parents and aunt provided for him. Whether conscious or unconscious, these distortions work to make him even more of a wunderkind, having to create his own career out of whole cloth, than was really the case.

Despite the testimony of Beguin Billecocq, a paucity of biographical information makes it impossible to sort out the individual roles played by Monet's parents during his formative years. Art historians have nonetheless sometimes condemned Adolphe Monet as insensitive at best and downright ornery at worst. John Rewald, for example, characterized Monet *père* as "not only overbearing, but actually petty and cruel."[12] I cannot concur in this assessment, which fails to account for the difficulties of dealing with a

child as headstrong as Oscar-Claude seems to have been. In Adolphe Monet's defense, it must be noted that, unlike many another nineteenth-century bourgeois father, he eventually yielded to his son's wish to become a professional artist and did support his vocational choice, at least at first. Witness Monet *père*'s two petitions for a special municipal art subsidy that would permit the boy to study in Paris. When these petitions failed, Adolphe Monet evidently agreed to finance a sojourn in the capital for the budding artist, only insisting, not unreasonably, that the youth apply himself seriously to his studies.[13]

Monet's adult behavior and relationships do not suggest that he had been the childhood victim of a brutal and tyrannical father. Hardly an inhibited character of the type such fathers often produce, the young Monet was audacious and self-confident—even downright cocky.[14] (Of course, he exaggerated and glorified these traits in his mythic recasting of his personal history.) Throughout his long lifetime Monet maintained close ties with other men, to whom he was able to turn for needed help and support as well as comradeship. Monet's friendship with Eugène Boudin (1824–98), his first important teacher, began around 1857 and lasted until the older artist's death. During the last years of his life, Monet enjoyed an unusually close relationship with Georges Clemenceau (France's prime minister during the First World War), who had been his friend since the 1860s.[15] Clemenceau not only proposed that the artist undertake the creation of the water lily murals (now in the Orangerie, Paris) as a gift to the state but also sustained him through the many difficulties he encountered during the project.[16] His capacity for enduring relationships with other men suggest that Monet's childhood interactions with his father cannot have been so negative or threatening as some critics imagine.

Most scholars concur in portraying the mother-son relationship in a positive light, citing Mme. Monet's reported singing talent and interest in music as evidence that she probably supported the lad's artistic development. In an interview with the dealer René Gimpel conducted shortly before the artist's death, he mentioned that during his childhood Monet's mother had encouraged him in his drawing and had rented plaster casts for him to copy.[17] A photograph of Monet taken around 1864 (fig. 0.1) reveals him to have been a handsome, sturdy fellow with a self-confident air. No doubt as a small boy he had been equally attractive, easily able to arouse and sustain his mother's interest.

Renoir recalled that the adult Monet once rejected the advances of a pretty but rather common young woman with the remark "You must pardon me, but I only sleep with duchesses—or servant girls. Those in between nauseate me. My ideal would be a duchess' servant."[18] Monet's ability to command the love and loyalty of four women who would—like his mother—play critical roles in his career began with his father's half-sister, Aunt Lecadre, the unofficial guardian and protector of his adolescence. He later wooed and won the beautiful Camille Doncieux, who served as the model for his most important figurative paintings of the 1860s and '70s. Even before Camille's death in 1879, Monet had initiated the relationship with Alice Hoschedé that culminated in their marriage in 1892. The history of the artist's liaison with Mme. Hoschedé, who

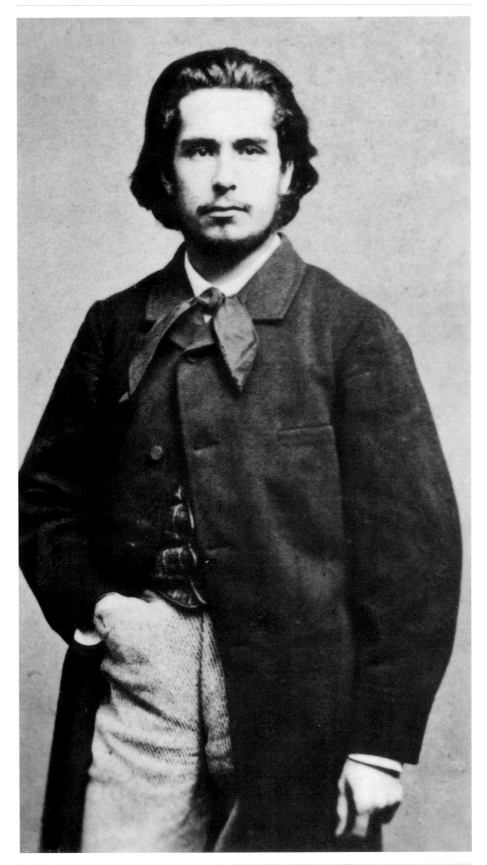

0.1. Etienne Carjat,
Claude Monet,
ca. 1864, Collection
Toulgouat

was herself still married to Ernest Hoschedé when it began, reverberates with overtones of unresolved oedipal rivalries enacted within an adult arena.[19] During Monet's final years, his stepdaughter (and daughter-in-law) Blanche Hoschedé Monet sacrificed her own artistic interests to devote herself completely to the elderly widower's welfare. The creative paralysis that had gripped the artist from the time of Alice Monet's death in 1911 ended when the death of Blanche's husband, Jean Monet, permitted her to commit herself to stay at the elderly master's side throughout the remaining years of his life.

As an adult, Monet demonstrated a singular mastery of what might best be called the "crybaby technique" for arousing sympathy, a behavioral mode that was in all likelihood learned in the course of early childhood victories over a mother all too responsive to tears and piteous tales. Scores of Monet's surviving letters to friends exemplify his tendency to present the problems of his current situation in the darkest possible light. During the 1860s and 1870s, these pathetic missives almost invariably reviewed his desperate financial state and culminated in pleas for loans. His later correspondence, especially his letters to Alice Hoschedé, more often reflected dissatisfactions and doubts about his artistic achievements or detailed the discouraging problems caused by the unfavorable weather conditions encountered on painting expeditions that took him away from Giverny, his difficult mistress, and their compound family.[20] The disheartened tone of such letters need not mean that the artist was suffering from severe depression when he penned them, as has sometimes been assumed. More likely it reflected the persistence into adulthood of behaviors that had regularly elicited a sympathetic response from his mother. (It should be noted parenthetically that Monet may not have been conscious that he was deliberately bidding for sympathy through such maneuvers; it seems even more unlikely that he would have connected them with childhood memories.)

The artist's lifelong preoccupation with his attire, his arrogant insistence on being clothed from the skin out in the finest custom-made garments, constitutes another example of his belief in his special status and sense of entitlement. Throughout his early adulthood he managed to maintain the desired level of sartorial splendor, despite a chronic shortage of funds, by failing to pay the tradesmen who outfitted him. Many years after the fact, Renoir recounted the story of his friend's youthful interactions with a leading Parisian tailor. Intimidated by Monet's imperious manner and threats to withdraw his patronage, the poor man continued to clothe the artist though the latter never paid him. "He was born a lord," sighed Renoir admiringly.[21] At least during the later years of his life, Monet affected a kind of uniform of his own design, consisting of frilly white shirts with ruffled cuffs combined with suits of rough wool tweed, cut in an idiosyncratic manner that ignored current fashion trends. This garb, with its incongruous blending of elements of outmoded dandy and country squire, was worn with pride and authority by the aging prince of Giverny. Although we have no information to substantiate such a reconstruction, it seems likely that Monet's fondness for dressing up in picturesque costumes was also the legacy of childhood experiences with a doting mother.

Whatever the exact nature of young Oscar-Claude's relationship with his mother, one thing is clear. He never completely recovered from her premature death, which occurred on January 28, 1857, just a few months after he had celebrated his sixteenth birthday. At least during the last years of his life, Monet habitually misremembered the exact year of her death and at least once claimed that this tragedy had occurred when he was only twelve.[22] Although, as already noted, Monet typically represented himself as younger than he had been at the time important events took place (a restructuring contributing to the image of the rebellious wunderkind that became a fixture of his personal mythology), his paramnesias involving the chronology of his mother's death were more extensive and inconsistent. In recounting stories about his youth, he typically described his mother as alive at the time of incidents that actually occurred several years after her demise, a version of events particularly incompatible with his claim that she had died when he was twelve.

The profusion of mutually contradictory stories of this type suggests that following his mother's death Monet suffered a confusional state that left him permanently disoriented about the chronology of that period. As Daniel Wildenstein perceptively suggests, the memories of youthful truancies and permanent departure from school at age fourteen or fifteen with which Monet later regaled Gimpel and other journalists probably tell us less about what actually happened than about the boy's feelings of desperation and loss following his mother's death. The exhilarating sorties along the waterfront and cliffs around Le Havre that he described to Thiébault-Sisson with such zest probably did not take place during school hours at all, as he claimed, but on Sundays and holidays.[23] As Wildenstein dryly observes, inconsistent with having devoted as little time and attention to school as Monet later claimed had been the case, the artist possessed a creditable writing style, a businesslike grasp of mathematics and accounting, and more than a smattering of culture.[24]

Wildenstein's suggestion that those expeditions along the seashore were connected with the mother's death seems especially intuitive in view of Monet's own explicit equation of the ocean with death: "I would like always to be before it or over it, and when I die, to be interred in a buoy," he told his friend and biographer Gustave Geffroy, who noted that the artist laughed with pleasure "at the thought of being confined forever in this float, dancing invulnerably among the waves, braving the tempests, gently responding to the harmonious movements of the calm sea, under the light of the sun. This evocation had nothing of the funereal for him, seeming to him the logical conclusion of his love for the sea."[25] Indeed, far from being funereal, Monet's associations seem closer to a description of the intrauterine life of the fetus, who floats suspended like a buoy within the mother's womb, that dark, watery world in which all needs are fulfilled. Did Monet, as a bereaved youth, turn to the sea—*la mer*—as a substitute for the lost mother, *la mère*? Perhaps as he learned to portray the sea in its many moods and phases, he also unconsciously learned to control and master his own sense of loss. He remained throughout his long lifetime the quintessential painter of watery landscapes, ranging

from views of the ocean and the Seine to the myriad interpretations of his own water gardens at Giverny that became the magnificent obsession of his old age. Did all these paintings of water refer on some deeply unconscious level to the loss of his mother and his need to be reunited with her forever? Monet's wish to be interred in a buoy suggests an underlying belief that death would bring him together with his mother in the symbiotic union that ordinarily precedes our earthly life rather than occurring at its close—as the artist delighted in the fantasy that such would be his special fate.

We know nothing about Monet's early relationship with his childless aunt, Mme. Lecadre, but the fact that she so quickly assumed a maternal role vis-à-vis the motherless adolescent suggests that their bond had long been close.[26] As already noted, during his adult life Monet twice repeated this cycle of the loss-and-replacement of the beloved woman. His capacity for stimulating sympathetic responses, already well honed in childhood, no doubt played an important role in persuading women to commit themselves to the adult artist in his times of need.

This capacity was first noted in the summer of 1857, when Beguin Billecocq, who had rented the Lecadre house at Ste.-Adresse for his vacation, noted that Monet had matured to become "an elegant young man . . . [who was] amiable, droll and knew how to laugh. . . . A bon vivant, he liked good food, and his independent character had developed, so too his sense of curiosity and fantasy. But sometimes he fell into a profound melancholy that would leave him just as suddenly as it overtook him . . ." Although the journal does not connect these episodes with the death of the boy's mother, it is legitimate to infer that this was indeed the cause.[27]

APPRENTICESHIP

The elderly Monet's insistence on portraying himself as having been a wunderkind is nowhere more evident than in his fanciful reconstruction of his juvenile career as a caricaturist. Far from being a polished, commercially successful practitioner of this genre by age fifteen, as he had boasted to Thiébault-Sisson, Monet executed his first tentative proto-caricatures during 1857. That is, his preoccupation with caricaturing, like his sketching expeditions along the seacoast, postdated his mother's death. During his lonely rambles beside the ocean, the boy literally isolated himself from human contact. Perhaps his activities as a caricaturist afforded the grieving youth a parallel psychological insulation from too much intimacy with others. After all, a competent caricaturist must possess an innate sensitivity to subtle individual idiosyncrasies of appearance and manner. Achieving and maintaining such a nuanced attitude requires not only a keen eye but also the ability to distance oneself psychologically from one's subjects. Such encounters surely involved a certain cheekiness—perhaps even a degree of covert condescension—on the part of the adolescent artist vis-à-vis his adult subjects.

Although Monet undoubtedly exaggerated the degree of acclaim and remuneration he had experienced as an adolescent caricaturist, by 1858–59 he did enjoy a certain

celebrity for his satiric portraits of fellow Havrais. However, as late as January of 1859 he continued to feel insecure enough about his mastery of this genre to engage in the covert practice of copying caricatures by Nadar and others reproduced in popular journals of the day. Monet kept these souvenirs of his "clandestine apprenticeship" hidden away at Giverny throughout his lifetime, unacknowledged and unexhibited.[28]

We do not know precisely when Monet began painting with Eugène Boudin, but they were certainly working together by the summer of 1858, when both artists exhibited paintings depicting sites in Rouelles (a village north of Le Havre) at a municipal exposition held in Honfleur that August and September. In retrospect, Monet remembered Boudin with a tenderness and respect he did not always accord to his other teachers. In the interview with Thiébault-Sisson already quoted, the artist recalled how he first encountered Boudin in the shop of the frame maker who exhibited the young artist's caricatures in the same windows with Boudin's landscapes. When the shopkeeper introduced them, Boudin complimented Monet on his caricatures but urged him to move beyond them, to study and learn to see, to draw, and to paint. He repeatedly invited the boy to join him on outdoor sketching expeditions, but Monet, who found Boudin's paintings difficult to digest, politely demurred.

> [Finally] summer came—my time was my own—I could make no valid excuse. Weary of resisting, I gave in at last, and Boudin, with untiring kindness, undertook my education. My eyes finally were opened, and I really understood nature. I learned at the same time to love it. I analyzed it in all its forms with a pencil. I studied it in its colorations. Six months later, in spite of the entreaties of my mother, who had begun to seriously worry because of the company I kept, and who thought me lost in the society of a man of such bad repute as Boudin, I announced to my father that I wished to become a painter and that I was going to settle down in Paris to learn.
>
> "You shall not have a cent."
>
> "I will get along without it."
>
> Indeed, I could get along without it. I had long since made my little pile [the two thousand francs allegedly earned from the sale of his caricatures]. After obtaining some letters of introduction . . . I set out posthaste for Paris.[29]

This romanticized account manifests the same features that characterize Monet's other myths about his past: Once again he represented himself as more precocious, more audacious, and more independent than had been the case in reality. At the same time he portrayed his mother as alive and assuming an active role in his life, although she was almost certainly dead before he began painting with Boudin. (One wonders whether some version of the words attributed to Mme. Monet were actually uttered by Aunt Lecadre, whose image he repeatedly confused—or fused—with that of the mother she had replaced.) Several aspects of this fictionalized account ring true, however. The respect that the elderly Monet expressed for Boudin was real enough: As already noted,

they had quickly struck up a deep friendship that endured until the older artist's death in 1898. When Monet and Camille Doncieux honeymooned at Trouville during the summer of 1870, Boudin and his wife joined them. As late as 1892, Monet wrote Boudin: "You know the affection that I have always had for you and also the gratitude. I have never forgotten that you were the first who taught me to see and to comprehend."[30]

In the light of his evident affection for Boudin, it is not surprising that Monet later connected his firm resolve to become a professional artist—as well as his assertion of independence from Adolphe Monet—with the initiation of his informal apprenticeship with Boudin. Sixteen years Monet's senior, Boudin evidently impressed the younger artist as a benign and helpful father figure, a man to idealize and emulate. It is fascinating, then, that at the height of his adolescent turmoil the youth managed to find kindly substitutes for both parents. Even during the intervals (which became increasingly rare as Monet matured) when harmony governed the father-son relationship, Monet *père* could not have experienced the same degree of empathy for the budding artist's interests and ambitions as did Boudin, and Monet never forgot the debt of gratitude he owed him: "During my whole stay in Paris, which lasted for four years [this estimate lumps together the period of study in Paris following his army service with the year he spent there before being conscripted], and during which time I frequently visited Hâvre, I was governed by the advice of Boudin, although inclined to see nature more broadly."[31] This recollection suggests that the older master continued to play a paternal role in Monet's art and life at least until the younger artist reached his midtwenties. While living in Paris during 1859 and '60, Monet repeatedly wrote Boudin, urging the latter to join him in the capital.[32] Although Monet always couched this suggestion in terms of the benefit of Parisian exposure for Boudin's career, it seems reasonable to suppose that the young man missed his benign mentor and craved his guidance. Before Monet set off for Paris in the spring of 1859, Boudin had provided Monet with a letter of introduction to his friend the Barbizon painter Constant Troyon (1810–65). In letters to Boudin written soon after arriving in the capital, Monet praised Troyon's paintings and expressed his intention to follow the older artist's advice about entering Couture's studio.[33] The sentiments expressed in that letter are quite at odds with the revisionist account of his attitude toward Couture Monet expressed to Thiébault-Sisson in the interview of 1900: "Did not Troyon tell me to enter the studio of Couture? It is needless to tell you how decided was my refusal to do so. I admit even that it cooled me, temporarily at least, in my esteem and admiration for Troyon. I began to see less and less of him, and, after all, connected myself only with artists who were seeking." Despite the airy rejection of Couture reflected in this reminiscence, it is possible that it was not Monet who rejected Couture as a potential mentor but Couture who rebuffed the youth as a prospective pupil.[34]

Whatever the reason, when Monet returned to Paris during the Christmas holidays in 1859, he did not enter Couture's atelier but enrolled instead in the loosely organized Académie Suisse, where students were provided with live models but no supervision.

There he met Camille Pissarro (1831–1903), "who was not thinking of posing as a revolutionist and who was tranquilly working in Corot's style. The model was excellent. I followed his example, but during my whole stay in Paris . . . I was governed by the advice of Boudin."[35]

In truth, Monet apparently spent relatively little time that year in following *anyone's* good advice. Rather, he devoted his time and energy—and funds—to pursuing the *vie de bohème* at the Brasserie des Martyrs, where he mingled with avant-garde writers and artists—and, no doubt, with the less talented wastrels and demimondaines who also frequented the establishment.[36] The pattern of self-indulgent extravagance that would become so characteristic of him during his early maturity began to assert itself during this period. To his shame, he sacrificed the little painting by Charles Daubigny that Aunt Lecadre had given him (perhaps as a Christmas or birthday present?) to finance further debaucheries.[37] It is difficult to disagree with Monet's own retrospective assessment of that first year in Paris as a wasted interval in which he did himself great harm.[38] In the light of such behavior, it is hardly surprising that no paintings have come to light that can be securely assigned to these months, when he seems to have produced little besides the handful of caricatures (w D. 510–15) that proved to be his final experiments in this genre.

Meanwhile, back at Le Havre, Adolphe Monet had entangled himself in a situation that ill became a man of his age and status: he had fathered an illegitimate daughter, born to a young servant girl on January 3, 1860. His son's subsequent misconduct suggests that the youth reacted with chagrin and humiliation to an event no doubt made doubly bitter because it occurred so close to the third anniversary of his mother's death.[39] As Wildenstein observes, this was hardly the example for a sixty-year-old father to set before a son already inclined to waywardness.[40]

Moral repercussions aside, the birth of his new half-sister had an obvious impact on Monet's immediate future: his father, burdened and distracted by his new responsibilities, showed little enthusiasm for subsidizing further prodigal behavior on his son's part. When the artist drew an unlucky number in the national conscription lottery, neither his guardian angel, Aunt Lecadre, nor his father bought him out. Fired with enthusiasm by the descriptions of a friend who had served with the Chasseurs d'Afrique and, no doubt, by fantasies of the dashing figure he would cut in their colorful uniform, Monet volunteered for the Chasseurs and landed in Algeria with his regiment on June 10, 1861.[41]

In his 1900 interview with Thiébault-Sisson, Monet presented a version of the events leading to his army induction as inconsistent as it was inaccurate:

I reached my twentieth year. The hour for conscription was about to strike. I saw its approach without fear. And so did my family. They had not forgiven me my flight; they had let me live as I chose among those four years [here the artist again fused his two Paris interludes into a single four-year stay], only because they thought they would catch me when the time came for me to do military duty. They thought

that once my wild oats were sown, I would tame down sufficiently to return home, readily enough, and bend at last to commerce. If I refused, they would stop my allowance [an interesting contradiction of his preceding statements about living totally on his own resources in Paris]. If I drew an unlucky number they would let me go.

They made a mistake. The seven years of service that appalled so many were full of attraction for me . . . and I replied to my father's ultimatum with a superb gesture of indifference. I succeeded by personal insistence, in being drafted into an African regiment and started out.

In Algeria, I spent two charming years [he actually spent one but always recalled it as two]. I incessantly saw something new; in my moments of leisure I attempted to render what I saw. The impressions of light and color that I received there were not to classify themselves until later; but they contained the germs of my mature research.

In a later conversation with Thiébault-Sisson, the artist regaled the journalist with a wild tale about taking an army mule for an unauthorized ride, only to have the animal run away and throw him, unconscious, in a wilderness where a search party later found him raging with fever. Allegedly he escaped imprisonment for this escapade only because he became so ill that he was shipped back to Le Havre to recuperate.[42] Hardly surprisingly, pertinent military records fail to provide any verification of this picaresque tale. In fact, Wildenstein uncovered very little information of any kind about Monet's army stint; even the prolonged bout with typhoid fever that he reported went unmentioned in the relevant records, though there seems no reason to doubt that he really did become so ill with some sort of infection that he was sent back to France to complete his recovery.

Monet's memories of what he accomplished professionally in Africa were no more consistent than his other recollections about this period. To André Arnyvelde, he claimed that "the officers took advantage of my talents a great deal, and that was good for some favors."[43] To Georges Clemenceau, he mentioned painting a portrait of an officer that has not survived—if it ever existed.[44] Although in his 1900 interview with Thiébault-Sisson Monet stated that while in Africa he had attempted to render what he had seen whenever he had the leisure to paint, in a later discussion with the same journalist the artist confessed—no doubt more honestly—that his experiences in Africa had been so terrible that he "had not even thought of painting for an instant" while there.[45]

Monet did paint one picture in Algeria that survived—at least until he reacquired it, presumably for the purpose of destroying it. Many years after his army stint, his dealer, Paul Durand-Ruel, purchased a small canvas signed by the artist, depicting an Algerian scene painted in the manner of Eugène Fromentin, whose works set in the Near East had been famous in the 1860s. When Durand-Ruel showed it to Monet, the artist denied having painted it but then offered to exchange it for one of his recent canvases.

The dealer realized that during his African tour Monet—no doubt in need of money, as usual—had painted a fake Fromentin, which he had later signed with his own name after failing to peddle it as a Fromentin. Naturally he wished to get rid of this embarrassing evidence of lack of scruple, and must have destroyed it as soon as he regained control of the canvas.[46]

Monet's stories about his return to Le Havre were much more consistent than his tales of army life. However, in all these accounts Monet invariably forgot that by 1862 his mother had been dead for several years; he spoke of the joy both parents showed over the return of their prodigal offspring. These paramnesias constitute additional examples of his confusion of memories of his mother with incidents involving Aunt Lecadre. Nor do any of these tales give poor Aunt Lecadre due credit for buying him out, attributing this generous action instead to his immediate family.[47] Nonetheless, a touching letter from his aunt to her friend the painter Armand Gautier about her nephew's mood of reform makes it clear that it was she who purchased his release so that he could continue his artistic training and make a place for himself, "because I won't always be there." She concluded her missive by asking, rather rhetorically, whether Gautier did not think it essential for her nephew to return to Paris to complete his studies. Her statement suggests that she was also the moving force in arranging for Monet's second Paris sojourn.[48]

Whatever the factual history of Monet's military service, there can be no doubt that he experienced his release as a true deliverance. Until he entered the army, he had enjoyed the status of a golden boy whose only devastating experience had been the premature death of his mother—and the impact of that tragedy had been softened somewhat by Aunt Lecadre's tenderness toward him. In Africa his charmed life ended, and for the first time in his rather pampered existence he came face to face with harsh reality. The experience had a salutary effect on his character. His Algerian sojourn stimulated him to develop a self-discipline that he had not previously shown. From the time he returned to Le Havre in 1862 until his death sixty-four years later, Monet dedicated himself to unstinting labor in the service of his art.

The artist's false memory that his mother had been alive to welcome him back into the bosom of his family provides yet another proof of the fact that her untimely death had marked him with a wound as unhealed and painful as that of Philoctetes. But his paramnesias about his homecoming served another purpose as well: in addition to resurrecting his mother, these inventions simultaneously denied the fact that Adolphe Monet was no longer a faithful husband but had become the aging lover of a woman thirty-six years his junior and the father of her illegitimate child. In view of *père* Monet's distractions, one wonders whether he had really greeted his son as enthusiastically as the latter claimed many years after the fact. In the 1900 interview with Thiébault-Sisson, the artist characterized his father's reaction in a manner quite at variance with his other accounts (including the version he later produced for the same journalist, who never seems to have noticed the contradictions between this story and the one he printed in an article

published in 1926): "Seeing me thus persisting [in working], worn as I was by the fever, my father became convinced that no will could curb me, that no ordeal would get the better of so determined a vocation, and *as much from lassitude as from fear of losing me*, for the Doctor had led him to expect this, should I return to Africa, he decided, towards the end of my furlough to buy me out."[49] This atypical version portrays Monet *père* not as the joyful sire of a returned prodigal but as the somewhat detached parent (no doubt because preoccupied with his new familial responsibilities) of a grown son whose activities and future no longer engaged him as they once had. This same account also credited the artist's father, rather than his aunt, with purchasing his army replacement. At the time it was indeed customary for middle-class fathers to buy their son's army replacements; Monet corrected his parent's oversight via his distorted recollection.

Whatever his degree of emotional involvement, Adolphe Monet eventually did decide to subsidize another period of study in Paris for his son (who would, of course, thus be conveniently removed from the family home), provided certain conditions were met:

> "But it is well understood," he said to me, "that this time you are going to work in dead earnest. I wish to see you in an *atelier*, under the discipline of a well-known master. If you resume your independence, I will stop your allowance without more ado. Is it a bargain?" This arrangement did not more than half suit me, but I felt it was necessary not to oppose my father when he for once entered into my plans. I accepted. It was agreed that I should have at Paris, and in the person of the painter [Auguste] Toulmouche . . . an artistic tutor, who would guide me and furnish regular reports of my labors.
>
> I landed one fine morning at Toulmouche's with a stock of studies which he declared pleased him very much. "You have a future," he said, "but you must direct your efforts in some given channel. You will enter the studio of [Charles] Gleyre. He is the staid and wise master that you need."[50]

If Monet's recollection about the conditions underlying his reentry into the Paris art world was more or less factual (and it was presented fairly consistently from one interview to another), he fictionalized the subsequent chapter of his history in his best self-aggrandizing fashion, claiming that he had almost immediately objected to Gleyre's philosophy and methods and had "preached rebellion" to his new friends Pierre-Auguste Renoir, Alfred Sisley, and Frédéric Bazille, who soon joined him in a permanent exodus from Gleyre's atelier.[51] "This new infraction set me at odds with my father once again, and I returned to the same makeshift life I had known before my military service. But I was already exhibiting paintings in the Salons in the spring. Some collectors took notice of me, and I began to sell. I managed to survive fairly well from these profits, as well as from the small sum of money that *my mother sent me in secret*" (italics mine).[52]

Monet outdid himself in constructing the myth of his career at Gleyre's and its sequelae—the story is riddled with errors through and through. Far from storming out of Gleyre's atelier after spending only a few weeks there, Monet remained under the

master's tutelage for at least one year, perhaps two. Like his friend Bazille, he probably stayed on until shortly before Gleyre permanently closed up shop at the end of the spring term of 1864.[53] Nor did Monet quarrel with his father or lose his monthly stipend at this juncture. Quite the contrary: his family was apparently quite satisfied with his conforming behavior and artistic progress during this period, as Aunt Lecadre's letter of March 20, 1863, to Gautier reveals.[54] No doubt it was Aunt Lecadre—clearly not his dead mother—who sent those little extra sums to him each month, a subsidy she would continue for several more years.

But if Monet did not actually play the role of rebel vis-à-vis Gleyre, neither does he seem to have been appreciably influenced by the older artist. Despite Wildenstein's skepticism, there is little reason to doubt the veracity of Monet's story that Gleyre criticized him for reproducing the decidedly non-Grecian proportions of a nude model exactly as nature had formed him: "I want you always to remember, young man, that when one executes a figure, one should always think of the antique. Nature, my friend, is all right as an element of study, but it offers no interest. Style, you see, style is everything."[55] One can only respond to the skepticism Wildenstein expressed about this reminiscence with the Italian proverb *Si non è vero, è ben trovato* (if it isn't true, it's well invented). This putative exchange between pupil and master certainly illustrates the gulf separating an older academic artist from an avant-garde realist dedicated to painting what he saw rather than what should have been.

If Gleyre's influence on his student was negligible, Monet's landscapes and marine paintings of 1864–65 provide ample evidence of the important role that Johann Jongkind (1819–91) played in shaping the younger artist's oeuvre between the autumn of 1862, when they met, and the latter half of 1865, when Monet's development took another turn. As he had in the case of Boudin, Monet always acknowledged his multiple debts to Jongkind with touching reverence, as this reminiscence of their first encounter reveals:

> The impromptu nature of the adventure [Monet and another young admirer had invited Jongkind to lunch] amused [Jongkind]; moreover, he was not accustomed to being thus sought after. His painting was too new and in a far too artistic strain to be then, in 1862, appreciated at its true worth. Neither was there ever anyone so modest and retiring. He was a simple, good-natured man, murdering French atrociously and very timid. That day he was very talkative. He asked to see my sketches, invited me to come and work with him, explained to me the why and the wherefore of his manner and thereby completed the teachings that I had already received from Boudin. From that time on [Jongkind] was my real master, and it was to him that I owed the final education of my eyes.
>
> I frequently saw him again in Paris. My painting, need I say it, gained by it. I made rapid progress. Three years later, I exhibited [in the annual Salon]. The two marines that I had sent were received with highest approval and hung on the line [i.e., at eye level] in a fine position.[56]

This recollection provides a fascinating contrast to the tenor of most of Monet's autobiographical reminiscences. The recurring factual and chronological distortions that one repeatedly encounters in his early life and career are nowhere evident in his description of his initial encounter with Jongkind (accurately set in 1862, although earlier in the same interview Monet had stated that he was still in Africa at this time). Nor did the aging artist fail to acknowledge how much the landscapes and marines he painted between 1862 and 1865 owed to Jongkind's tutelage. The touching quality of his comments about the Dutch painter stands in marked contrast to the character assassination Monet performed on poor Gleyre, whom Bazille characterized as a man beloved by all who came into contact with him, and who was not regarded by other former students as rigid or dictatorial.[57]

The chasm that separates Monet's assessment of these two mentors and his interactions with them tells far less about their characters than about that of Monet. Headstrong and determined as he had been from infancy, how he must have railed against the circumstances that forced him to submit to his father's will and enter Gleyre's studio! In retrospect, Monet took revenge by transforming poor old Gleyre into the bad father, blind to the importance of his artistic son's new way of perceiving and the extent of his originality. By contrast, Jongkind, whom Monet himself had selected as his mentor, was assigned the role of the good father, a part well suited to this generous and modest man, who managed—as had Boudin before him—to instruct his talented pupil without becoming involved in an unpleasant contest of wills.

From earliest childhood, Monet had resisted control. Discrepancies between the known facts of his early years and the free reinventions of his personal history he fabricated as an aging celebrity underline his rebelliousness. Monet's personal mythology eliminated or transformed all humiliating episodes of necessary submission to the dictates of his parents or parental surrogates into manifestations of his independence and infallibility. But the very toughness that must have repeatedly tried the patience of his family also provided Monet with the resilience to persevere in leading the Impressionist revolution.

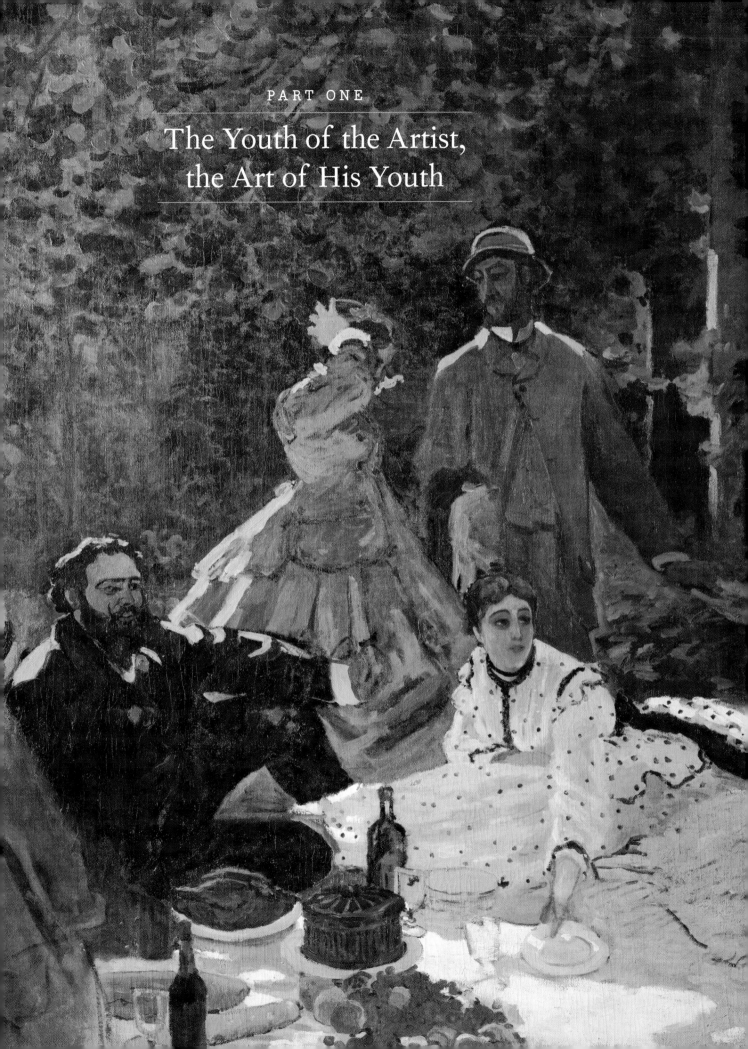

The Youth of the Artist, the Art of His Youth

CHAPTER ONE

The Perils of Young Love

MONET'S MAGNIFICENT FAILURE

THE CONTEXT

Painting together at Chailly during the Easter vacation of 1863 and around Saint-Siméon in Honfleur in June 1864 consolidated the friendship that had developed between Frédéric Bazille and Monet as fellow students of Gleyre.[1] Their decision to rent a joint atelier in Paris, where they could spend their long working days side by side, served as silent testimony to their new intimacy.[2] They found a suitable studio at 6 rue de Furstenberg and took possession in January 1865.[3]

Although the friendship between Monet and Bazille was grounded in their joint devotion to art, they brought different assets to this relationship, qualities each recognized and admired in the other. Bazille, for his part, clearly perceived Monet as his artistic superior, and in the regular letters he dutifully wrote to his parents he often referred to his companion's achievements with great admiration. He understood and respected Monet's willingness to sacrifice everything to his art, to devote all the time and effort to his craft that his unusual energy level permitted. Rather than feeling envious, Bazille treated Monet as a respected mentor whose professional counsel should be solicited, and whose paintings deserved to be copied.[4] Bazille's recognition of his friend's great talent must have been of inestimable value to Monet in confirming his own judgment of his potential. As the discussion that follows demonstrates, he counted heavily on Bazille to provide such reinforcement during the evolution of *Luncheon on the Grass* (1865–66). (Several scholars have proposed interpretations of Bazille's sexuality and relationship with Monet which differ from that presented here.)[5]

If Monet provided Bazille with an ideal example of diligence in the service of art, Bazille, for his part, possessed the good breeding, good manners, and good contacts in which Monet was relatively deficient. Bazille's family belonged to the Huguenot *haute bourgeoisie* and could trace their lineage—and prominent role in Montpellier life—back at least to the sixteenth century; Frédéric had grown to manhood in an intact, loving family that provided an atmosphere of security and freedom from material want.[6] Although often unable to emulate Bazille's gracious behavior, the more rough-hewn Monet clearly respected his friend's character and standards. He must have been appreciative, too, of the fact that Bazille included him in invitations to the home of his distant relative the collector Commandant Hippolyte Lejosne, whose Paris salon was frequented by leading literati and artists, including the poet Charles Baudelaire (1821–67), the painter Henri Fantin-Latour (1836–1904), and the photographer Nadar (Félix Tournachon, 1820–1910), all of whom Monet encountered there for the first time.

In the light of their closeness, it seems noteworthy that Bazille and Monet apparently did not address one another by the familiar *tu*. (One assumes that the formal *vous* employed in their correspondence mirrored their face-to-face form of address.) We might assume that the persistence of such polite conventions reflected Bazille's more formal upbringing; however, Auguste Renoir certainly did not hesitate to *tutoyer* Bazille when they became intimate companions in the summer of 1865.[7] Perhaps instead it was Monet who felt uncomfortable about such demonstrations of intimacy. Although by no means withdrawn, he possessed an inner reserve, a tendency to distance himself from others that deeply colored even close relationships, including his friendship with Bazille.[8]

An air of mystery surrounds Monet's activities during the late winter and early spring of 1864–65. We simply do not know how, when, or where he met Camille Léonie Doncieux (1847–79). Their initial encounter could not have occurred before mid or late November, because Monet was still in Honfleur when he wrote to Bazille on November 6 (WL 14).

Apparently only Bazille resided at the rue de Furstenberg studio, while Monet lodged elsewhere.[9] Since an obvious motivation for leasing the joint studio had been economic, it seems surprising that Monet elected not to live there too, even if the private space the studio provided was somewhat cramped. Perhaps the two young men briefly shared living as well as working space in the new atelier until Monet's growing involvement with Camille Doncieux made this arrangement awkward, whereupon he moved to separate quarters where he could enjoy private trysts with his mistress. The evidence indicates that the Doncieux-Monet romance must have been well advanced by the time the artist conceived the plan to create his magnum opus *Luncheon on the Grass*, a decision he had firmly in mind by February or March 1865.

Little information about Camille's background or personal history has come to light, thanks in large part to Monet's shameful surrender to the unreasonable demands of Alice Hoschedé (1846–1911), Camille's successor in his affections, that he destroy every memento attesting not only to Camille's role in his life but to her very existence. Every shred of his late wife's correspondence, her photographs, and any documents that might have illuminated her relationship with her family of origin—all were sacrificed to appease Mme. Hoschedé's pathological jealousy. Only one photograph of Camille escaped Alice's purge: she evidently never knew about the photo of Camille made in Holland in 1871 (figure 1.1) and sequestered in a private collection ever since. Alice's insistence in the matter seems especially cruel since it deprived Camille's children of all personal mementos of their mother. Their primary souvenirs of her would consist only of the numerous paintings of Camille that Monet retained in his private collection until his death.[10]

Thanks to the diligent efforts of Wildenstein and his assistants, we do know that Camille's family came from Lyon, where she was born on January 15, 1847. Sometime before 1864 they migrated to Paris, where they lived rather modestly. Camille had a

1.1. A. Greiner,
Camille Monet,
Amsterdam, 1871,
Wildenstein Institute
Archives, Paris

single sibling, a sister, Geneviève, ten years her junior. In 1867 this child inherited the entire estate left by a M. Antoine de Pritelly, who had previously disinherited his two adult sons in her favor. His will also provided Mme. Doncieux (whose husband was retired or unemployed) with a special legacy, while granting her free lifetime access to the capital left to her daughter. (If, as the data suggest, Geneviève was a love child, Camille, like Monet, had a transgressing parent and an illegitimate half-sister.)[11] Perhaps her uneasy circumstances made Camille more receptive to Monet's advances, more willing to leave her parents and entrust herself completely to her lover.

The roman à clef *L'Oeuvre*, by Emile Zola (1840–1902), which appeared in volume form in 1886, provides a few additional clues about Camille's personality and life with Monet. The novel recounts the tale of a doomed *plein air* painter, Claude Lantier, his mistress (later his wife) Christine, and their son, Jacques. The fact that Zola's hero is an amalgam, based primarily on aspects of the lives and careers of Monet, Manet, and Cézanne, has been widely recognized, but there has been far less agreement about how much each member of this triumvirate contributed to Zola's portrait.[12] As Rodolphe Walter has observed, several points of intersection exist between Monet's real-life experiences and those of the fictive Lantier, and works that Zola describes Lantier as executing (or destroying unfinished) resemble successful paintings Monet executed during the 1860s and '70s, when his friendship with Zola was at its zenith.[13]

Whatever Claude Lantier owes to Claude Monet, the novel's heroine, Christine—portrayed as a beautiful brunette with a gentle, passive, and slightly melancholy personality—resembles the real-life Camille in appearance and personality insofar as we know her from the portraits painted by Monet and his friends during the 1860s and '70s.[14] The climactic incident in *L'Oeuvre*, Lantier's suicide following his prolonged struggle with his failed masterpiece, may also be based on Zola's recollections of Monet's personal history and the latter's equally fruitless contest with his *Luncheon on the Grass*. (Of course, the painting described in the novel is a pastiche, related to Monet's composition only in its scale—and permanently unfinished state.)[15]

By the time Monet finally abandoned his *Luncheon* in the late winter of 1865–66, the painting had surely become a hateful symbol of frustration and failure to its young creator. Fortunately Monet, made of far tougher stuff than Zola's fictive painter-hero, neither despaired nor committed suicide in reaction to his inability to bring his composition to a successful conclusion. Instead, he immediately set to work on *Camille* (*Woman in a Green Dress*), which he submitted to the Salon jury of 1866 in lieu of the abortive *Luncheon*. He did not attempt to return to the full-scale version of the *Luncheon* after completing *Camille*. Instead, he began planning another large-scale figurative composition, *Women in the Garden* (1866–67).

But if Monet never completed his picnic scene, neither did he destroy or abandon it; the picture remained in his possession until 1878, when his straitened financial circumstances forced him to leave the rolled-up canvas with his second landlord at Argenteuil, Alexandre Flament, as security for unpaid rent.[16] Flament, unmindful of the precious character of the collateral he held, consigned the canvas to his cellar, where it suffered extensive damage from mildew. When Monet finally succeeded in reclaiming the work in 1884, he was able to salvage only two fragments: a large segment from the heart of the composition, plus a long, narrow portion immediately to the left of this central section. (Figure 1.2 represents the final study for the *Luncheon*; figure 1.3 shows the final study for the painting with these two areas outlined.) Perhaps because the vertical piece from the left margin (figure 1.4)—which had been left in a less polished state than the heart of the painting—spoke all too eloquently of the terrible struggle Monet had expe-

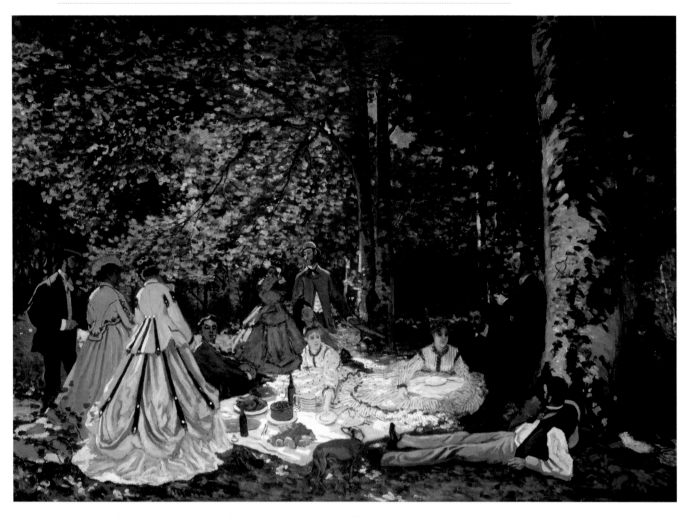

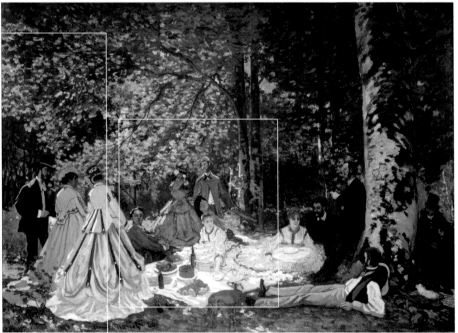

1.2. (*top*) Claude Monet, *Luncheon on the Grass*, 1865–66, Pushkin Museum of Fine Arts, Moscow. Scala/Art Resource, NY

1.3. (*bottom*) Claude Monet, *Luncheon on the Grass*, 1865–66, with areas outlined, corresponding to figures 1.4 and 1.5. Pushkin Museum of Fine Arts. Moscow, Scala/Art Resource, NY

rienced while working on it, he evidently never showed it to anyone. It lay rolled up and forgotten (perhaps even by its creator) in a dusty corner at Giverny until Georges Wildenstein rediscovered it during an inventory of the artist's studios carried out in the early 1950s. Donated to the Louvre in 1957 and transferred to the Musée d'Orsay in 1986, it now hangs side by side with its larger sister fragment (figure 1.5), which entered the museum in 1987.[17]

Although Monet never publicly exhibited the central section of the *Luncheon*, in his twilight years he enjoyed displaying this relic of his youthful hubris to the privileged few invited to make the pilgrimage to Giverny. A 1920 photograph (figure 1.6) shows the artist with the Duc de Trévise, viewing a group of his earlier figurative paintings, kept on display in a disused studio. They have paused before the large fragment of the *Luncheon*, which enjoyed pride of place in this private exhibition of Monet's Monets. "This is a *Picnic*, which I did after Manet's," the artist informed his guest. "At that time, I did what everyone else did; I proceeded bit by bit with studies done from nature, which I would then put together in my studio. I am much attached to this work, which is so incomplete and mutilated."[18]

MONET'S *LUNCHEON*: CONCEPTION AND EVOLUTION

The brief summary Monet provided for Trévise of the method he had followed half a century earlier seems accurate enough—as far as it goes. However, aside from hinting at his desire to compete with—and outdo—Manet, the statement provides little detailed information about either the painting's history or its personal significance for its creator, questions of primary interest for this study. What actually prompted Monet, then a brash youth of twenty-five, to attempt the quantum leap from painting easel-size pictures to covering a canvas as vast as many of the greatest "machines" exhibited in the Louvre? First and foremost, one must credit an increase in Monet's self-confidence, an audacity that led him to believe he could successfully undertake such a monumental figurative composition despite his lack of experience either in working on the scale he now envisioned or in portraying the human figure.[19] His oeuvre prior to that time had consisted primarily of small landscapes and seascapes. The largest paintings he had executed to date, two marines specifically designed for submission to the Salon of 1865 (w 51 and 52), measured only three by five feet. Both were studio productions, based on smaller, more rapidly executed studies created before the motif. But these minor exercises in enlarging *plein air* sketches into studio productions scarcely prepared him for the task he now set himself: transferring a painted study (figure 1.2), whose own dimensions (4 × 6 ft) exceeded the size of any canvas he had previously painted, to a monumental support measuring approximately fifteen by twenty feet. Viewed from our vantage point, Monet's grandiose scheme seems like a recipe for disaster. But fears of failure were far from his mind as he finalized plans for what he perceived as an ambitious but perfectly feasible project.

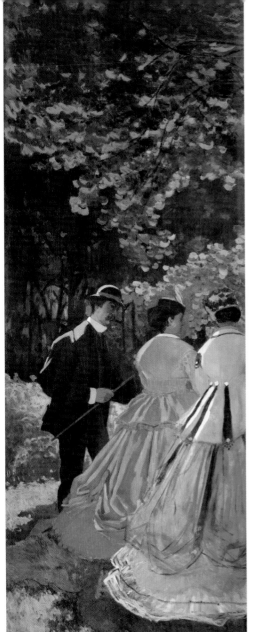

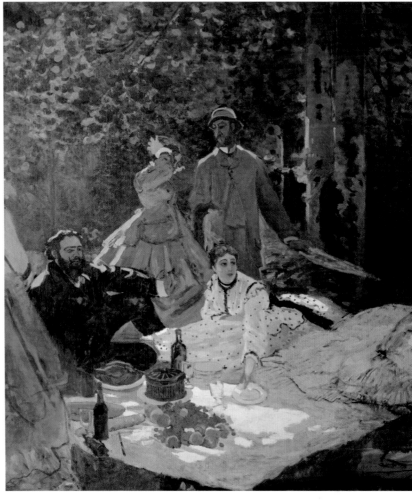

1.4. (*top left*) Claude Monet, *Luncheon on the Grass*, 1865–66, left fragment, Musée d'Orsay, Paris. Erich Lessing / Art Resource, NY

1.5. (*top right*) Claude Monet, *Luncheon on the Grass*, 1865–66, central panel, Musée d'Orsay, Paris. Erich Lessing / Art Resource, NY

1.6. (*bottom*) *Monet in His Studio with the Duc de Trévise before the Central Panel of "Luncheon on the Grass,"* 1920. Réunion des Musées Nationaux / Art Resource, NY

In order to prevent problems, Monet attempted to organize all his procedures in advance. The enormous atelier he had rented with Bazille not only would accommodate his machine-size canvas but would permit him to study the work in progress from a sufficient distance to give him an accurate idea of how the composition was shaping up—not to mention imagining how it might look when installed in the vast spaces of the Salon of 1866, the destination for which he had intended his magnum opus from its inception.

Monet had also preselected the spot he would use as a base for carrying out his preparatory studies: the small village of Chailly, located just outside the forest of Fontainebleau, easily accessible from Paris by rail. He knew the area well: he had painted there with Bazille in the spring of 1863 and had returned to the spot alone in April 1864. On both occasions he had lodged at the Cheval Blanc Inn, which he intended to make his headquarters for what he correctly anticipated would be a lengthy stay in the area during the spring and summer of 1865.

Leading scholars have carefully considered the roles the achievements of Gustave Courbet and Edouard Manet (especially the latter's 1863 picnic scene) played in shaping Monet's ambitious plan. Obviously, his desire to compete with and triumph over these leaders of the artistic avant-garde was critical to Monet's decision to create a mural-size work. As these same critics have observed, Charles Baudelaire's influential essay "The Painter of Modern Life," first published in *Le Figaro* in 1863, also helped to shape Monet's ambition to create an absolutely contemporary picture, featuring representations of eleven members of his circle clad in the latest fashions and represented on a scale hitherto primarily reserved for crowned royalty, historical heroes, and mythic figures.[20]

The central role another person played in the genesis of Monet's ambitious undertaking has been largely overlooked—that of Camille Doncieux. The artist's burgeoning love affair with this beautiful young woman lent wings to his ambition, inspiring him to new levels of daring. (Such competitiveness is often stimulated by a youth's initial success in winning a desirable woman.) By the time he finalized his plans to relocate to Chailly, the lovers must already have been living together, for Camille had obviously accompanied him "on location." Her continual presence in his life provided him not only with self-confidence, companionship, and sexual satisfaction but also—more central to his great project—with the constant availability of a lovely model to pose for the five female figures he wished to feature in the composition. Monet had found his muse; the era of heroic figurative paintings could begin.[21]

Camille's talents as a model soon proved greater than Monet could have anticipated. She demonstrated a real flair for assuming postures and attitudes, an aptitude that may have been honed by a knowledge of current theatrical styles.[22] Whether or not she introduced her lover to the latest fashion plates, as Joel Isaacson has suggested, she was surely familiar with these popular prints, from which Monet drew inspiration both for determining poses assumed by Camille and, later in the evolution of the composition,

for suggesting how certain of the costumes in which she is shown might have been modified to keep up with the latest fashion trends.[23]

No eyewitness accounts have come down to us concerning the interactions between artist and model as Camille posed for the *Luncheon*. However, we do have reliable information about Monet's inconsiderate treatment of his stepdaughter, Suzanne Hoschedé, when she posed for the twin compositions of 1886 (w 1076–77) that show her standing outdoors in summer weather. Ignoring Suzanne's fatigue, Monet insisted that she hold the same pose during working sessions that sometimes lasted for hours.[24] There seems little reason to doubt that he would have behaved in a similar manner twenty years earlier. Unlike Suzanne, Camille evidently possessed the stamina (or stoicism) and patience to meet Monet's demands; after all, she was in love with the artist. Again in contrast to Suzanne—the passive, reluctant victim of Monet's professional attentions—Camille quickly assumed the active role that transformed her from mere model into participatory muse.

Secure in the love of his beautiful mistress-model, elated by the success he enjoyed in the 1865 Salon, where his two marines had attracted favorable attention from critics and fellow artists, Monet must have begun his initial preparations for the *Luncheon* in a state close to euphoria.[25] To add to his sense of triumph, the paintings Manet showed at the 1865 Salon, *Olympia* (1863, Musée d'Orsay) and *Jesus Mocked by the Soldiers* (1864–65, The Art Institute of Chicago), had been greeted with public derision and critical disdain. To his chagrin, Manet found himself being congratulated not for his own work but for two seascapes painted by a young upstart with an all-too-similar name.[26]

Unfortunately, Monet's grandiose plans for his luncheon project began to unravel almost immediately, as if the gods, angered by this show of hubris, were determined to crush him. He had planned from the beginning to use the tall, distinguished-looking Bazille as the model for several male figures to be featured in the *Luncheon*. Monet based his entire schedule on the unrealistic assumption that Bazille would be at his beck and call, willing to make the jaunt from Paris to Chailly whenever his services were required. But Bazille proved less responsive to such imperious demands than Monet had anticipated. As early as April 9 Monet was already writing the first of a series of letters requesting his friend's cooperation. Initially he put this as an invitation: "We expect you for dinner tomorrow."[27] A few weeks later Monet repeated the invitation (wL 18), apparently again to no avail. In his next letter, written about May 4, he played his trump card: "The young Gabrielle arrives Monday during the day, and it won't be funny if you're not here" (wL 19). In a postscript, the normally cocky Monet made an uncharacteristic admission of uncertainty: "I should like your opinion about the choice of landscape for my figures; I am sometimes afraid to commit myself about this." The prospect of a reunion with Gabrielle (about whom nothing is known but who evidently interested Bazille) clearly jarred Bazille loose from Paris, and he arrived at Chailly with the fresh supply of paper and crayons that Monet had requested in the same letter.

1.7. Frédéric Bazille,
*The Improvised Field
Hospital: Monet Injured
at the Hôtel du Lion
d'Or in Chailly-en-
Bière*, 1865, Musée
d'Orsay, Paris

We do not know how long Bazille remained at Chailly, or how much—if any-thing—artist and model were able to accomplish during this visit, because it was prob-ably at this time that Monet suffered a leg injury that forced him to spend several days in bed. Bazille memorialized this incident—as well as the Rube Goldberg–like device he had invented to keep water dripping on the impatient patient's swollen limb—in *The Improvised Field Hospital* (figure 1.7). It seems unlikely that the restless and energetic Monet could have refrained from offering tips and guidance to Bazille as he painted, or that the latter, so respectful of his friend's talents, would have ignored such counsel.

As Monet's confession of reliance on Bazille's opinion concerning the site for the picnic project reveals, the role Bazille played in the evolution of the *Luncheon* was by no means limited to that of model. Whether he helped Monet to resolve questions about the site during his first visit to Chailly remains unclear. Unfortunately, any attempt to reconstruct the evolution of the *Luncheon* in detail is hampered not only because so few preliminary studies have survived but also because some of Monet's correspondence from these months, including critical letters to Bazille, has evidently been lost. By the time he sent his next extant missive to him, Monet's tone had turned

decidedly reproachful. He accused Bazille of having put him completely out of mind (*de côté*) and repeatedly urged his friend to fulfill his promise to pose: "All my studies go marvelously, lacking only the male figures. . . . I no longer think of anything but my painting, and if I knew that I should fail [to finish] it, I believe I would go mad over it. Everyone knows that I am doing it and encourages me very much about it. . . . I am counting on your past good friendship [to cause] you to come very quickly to my aid."[28]

At length, responding to another desperate plea from Monet, dated August 16 (WL 21), Bazille finally returned to Chailly (where, he informed his parents, Monet awaited him "like the messiah"), only to have constant rain force painter and model to cool their heels for five days, until the sun shone again.[29]

By October 14, when he penned his next surviving letter to Bazille (then in Montpellier), Monet was back in their Paris studio but again having financial difficulties and not yet ready to commence work on the full-scale *Luncheon*. In this rather ill-tempered missive, he upbraided Bazille for failing to send his share of the rent in timely fashion. He also revealed that he had experienced problems in leaving Chailly and still did not have all his belongings, but he hoped to recover them shortly so that he could devote himself with full heart to his enterprise. He instructed Bazille not to forget to bring along "the trappings you used this summer" (presumably clothing and accessories worn in the various painted studies). As Monet's letter (WL 22) reveals, he was already running behind schedule and apparently had been forced to leave behind essential preliminary studies, perhaps including the final study (now in Moscow), no doubt as collateral for unpaid accounts. He had allowed himself precious little time to effect the enlargement of his study, itself not yet finished, to a canvas more than twelve times that size. In order to have his magnum opus ready for submission to the Salon jury by the prescribed March deadline, he had to accomplish this herculean task in less than five months. As Bazille's undated November letter to his mother reveals, Monet's mood remained optimistic at that time: "Monet has been hard at work for some time now. His painting has much advanced, and I am sure it will attract a lot of attention. He has sold a thousand francs worth of paintings in the last few days, and he has one or two other commissions. He is on his way" (BL 73).

The parade of curious artists who had made the pilgrimage to Chailly the previous summer to check on the status of the *Luncheon* project (which Monet had obviously touted to one and all) swelled to a flood in Paris, distracting him and increasing his sense of urgency as he labored throughout the autumn and winter to realize his grandiose scheme. In a letter to his brother written in December, Bazille remarked that more than twenty artists had dropped by to admire Monet's canvas, which, he added, was far from finished (BL 74). Boudin, who visited Paris that autumn, was initially among the admirers, but as the winter progressed he realized that his former pupil had overreached himself; he soberly noted in a letter to his brother that the task of finishing his enormous painting was costing Monet "the eyes in his head."[30]

DETHRONING KINGS: THE *LUNCHEON* AS "OEDIPAL WEAPON"

Courbet, whom Monet knew well by that time, also called frequently at the rue de Furstenberg studio, where he probably posed for the central seated male figure in the definitive painting (figure 1.8, detail), whose resemblance to the Master of Ornans has frequently been noted. If this personage was indeed modeled on the older artist, Monet depicted Courbet as an idealized, slimmed-down, youthful figure, sporting a splendid mustache and beard. According to Bazille, Courbet proclaimed himself "delighted" with Monet's progress on the *Luncheon*, a verdict seemingly at variance with Monet's own retrospective accounts, which attempted to shift at least part of the blame for the failure of the project onto Courbet. As Monet later recalled their interactions, the older artist repeatedly intervened, persuading him to modify the composition in ways that so dissatisfied its creator—even though he had accepted them at the time—that he ultimately abandoned the work unfinished.[31]

This account, delivered many years after the fact, suggests that Monet's youthful competitiveness with—and ambivalence toward—Courbet continued to rankle decades after the latter's death. As already noted, the fact that Monet had planned his picnic scene as a challenge to Courbet, as well as to Manet, has been universally recognized. The size of Monet's *Luncheon* would have rivaled the dimensions of Courbet's two great machines (both now in the Musée du Louvre, Paris), *Burial at Ornans*, 1848 (123 × 262 in), and *The Painter's Studio*,

1.8. Claude Monet, *Luncheon on the Grass*, 1865–66, central panel, detail, Musée d'Orsay, Paris. ©Photo R.M.N.- SPADEM

1855 (141 × 234 in). In this instance, Monet, like many another youth of great talent, perceived himself as an artistic Oedipus who would "slay," then succeed, the reigning kings of modernism, Courbet and Manet. Courbet, never reluctant to dispense paternalistic advice, unwittingly played his assigned role in promoting Monet's "father transference," an enduring attitude reflected in the aged artist's reminiscence attributing his failure to complete the *Luncheon* to Courbet's repeated interventions—which Monet may have perceived in retrospect as efforts to safeguard Courbet's preeminence.[32]

Wildenstein, rightly skeptical about the role Courbet's counsels played in determining the fate of the *Luncheon*, suggests that the abandonment of the beautiful joint rue de Furstenberg atelier exacerbated the technical and financial difficulties Monet was already experiencing prior to his enforced move to a smaller studio.[33] But Wildenstein does not allude to what must have been the most deleterious effect of the move for Monet: the dilution in the intensity of his relationship with Bazille that inevitably followed the latter's decision to relocate to a separate studio. Bazille's fervent belief in his friend's unusual talents and prospects, and his continual presence in the rue de Furstenberg atelier, had surely helped to sustain Monet while he worked on the painting with which Bazille had been so intimately involved as model, adviser, and witness. Like Joseph Conrad's "secret sharer," Bazille may have functioned as an active, sub-rosa

participant in Monet's ambitious undertaking.[34] We simply do not have the evidence to reconstruct precisely Bazille's role in reinforcing his friend's critical judgment or in countering Monet's tendency to suffer spells of discouragement and uncertainty—a characteristic that would become more marked in his later career but first became evident during the evolution of the *Luncheon*, as his contemporary correspondence with Bazille reveals.

Since neither Monet nor Bazille could afford an individual atelier as grand as their quarters on the rue de Furstenberg, one wonders why they did not look for another joint studio. A letter Bazille sent his brother sometime in December 1865 expressing relief over the prospect of being "away from all my acquaintances, so I can work in greater tranquillity," suggests that his had been an unilateral decision to separate from Monet.[35]

Whatever Bazille's reasons for striking out alone, Monet's forced relocation sounded the death knell to his project. Following his move to cramped new quarters—a process that in itself obviously involved a considerable loss of time—he painted with increasing desperation as the Salon deadline drew closer.[36] No longer the child of luck, he had become a victim of calamity. Fortunately, at this moment Courbet reappeared, enacting the role of the genie with the magical solution. Recognizing that Monet had literally painted himself into a corner, Courbet counseled: "Don't give those people the excuse of imperfections that they will be able to use as a pretext for excluding you. And never let anything leave your studio that isn't completely satisfying. You don't have the time to perfect [the *Luncheon*]. Save it for next year and send them at the Palace of Industry [the site of the annual Salon] a canvas of more modest dimensions that you will be able to paint quickly and well, in a single stroke."[37]

This account seemingly contradicts Monet's claim that following Courbet's wrongheaded advice had led to the ruin of the *Luncheon*. His divergent stories present Courbet as a kind of artistic Shiva, simultaneously destructive and constructive—instigator of ill-advised changes in the picnic scene but also father of the plan that inspired Monet to create *Camille*, his great Salon success of 1866. Courbet's prescription presented a negative diagnosis in positive terms, cloaking the older artist's conclusion that the ills affecting the *Luncheon* were probably irremediable and its successful completion unlikely while simultaneously insulating Monet's self-esteem by expressing confidence that he could quickly and successfully produce a work of more modest size that would dazzle the Salon jury. Not even the most skilled psychotherapist could have provided a more appropriate intervention, coupled with a practical plan of action that, if carried out effectively, would enhance Monet's reputation. At the time, Courbet must have appeared to Monet like one of those angels about whose existence the Master of Ornans expressed so much skepticism.

Since Monet did not yet know Manet personally, he carried out his dialogue—and duel—with *this* rival without developing the same type of father transference that colored his relationship with Courbet. Monet's recollection that Manet's *Luncheon on the Grass* (figure 1.9) had directly inspired his own picnic scene seems entirely convincing.

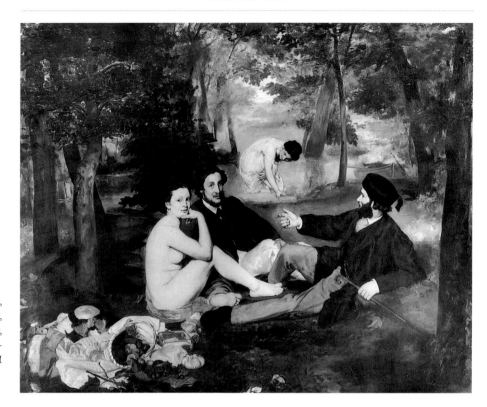

(Parenthetically, it should be noted that this competition was by no means unilateral: after hearing about Monet's project, Manet rechristened his painting, previously known as *Le Bain* (*The Bath*), as *Le déjeuner sur l'herbe*, or *Luncheon on the Grass*.)[38]

But Monet conceived his reinterpretation not as an unambivalent homage to the older artist but as a painted demonstration of the superiority of *his* vision over that of Manet. Determined to create a work as ultrarealistic and ultracontemporary as possible, he emphatically rejected virtually every aspect of Manet's approach—his sources, methods, and iconography all seemed equally unacceptable to the young upstart who sought to wrest the title of king of avant-garde painters from his senior colleague. While praising Manet as an important precursor of the modern vision, Monet subtly deplored the older artist's inability to grasp the importance of (direct) vision for the new "school of *plein air*" painting until Monet showed him the way. Manet's failure to grasp this principle (Monet later emphasized to Geffroy) led him to create a *Luncheon* that was (merely) a modernization of a composition by Raphael, "[which is] illuminated by the light of the atelier, although the scene occurs in a summer landscape."[39]

In view of their very different personalities and backgrounds (for Manet came from a distinguished *haut-bourgeois* family), it is scarcely surprising that his playful reuse of the past as part of the vocabulary of the new would have seemed unacceptable, even incomprehensible, to Monet. As the quintessential representative of the artist-*flâneur*,[40] a type then much admired, Manet consciously prided himself on maintaining a certain distance from his oeuvre—as from his emotions (or at least from public displays of feelings)—and the sardonic references to earlier masterpieces embedded in his *Lun-*

cheon constituted but one of his methods for maintaining this desired distance. More direct, concrete, and unashamedly ambitious than Manet (whose position as *flâneur* also mitigated naked displays of competitiveness), Monet resolved to make his mark by demonstrating his complete independence not only from the art of the past but from that of his contemporaries.[41]

Although innocent of the specific historicizing allusions found in Manet's version, Monet's *Luncheon* was by no means a child without ancestors; its relationship to the French eighteenth-century pictorial tradition, especially motifs of the hunt breakfast and the *fête galante*, has frequently been discussed.[42] By the time he painted the definitive study for the full-scale picture, he had modified those compositional features most obviously revelatory of affiliations with earlier French art. However, Monet's earliest surviving preliminary drawing for the *Luncheon* (figure 1.10) features a deep, open, orderly recession into space strikingly similar to that depicted by Antoine Watteau (1684–1721), allegedly Monet's favorite artist, in paintings such as *The Perspective* (ca. 1715, Boston Museum of Fine Arts). As his conception evolved, Monet eliminated this feature, substituting the more enclosed bower represented in the Moscow study, a change that not only provided a cozier setting for his picnickers but also deemphasized the connections between Monet's "pastoral" composition and those of Watteau.[43]

It is surely no coincidence that Monet's friend and adviser Courbet had also painted an enormous hunt breakfast scene just seven years before Monet began his representation of an al fresco repast. The early history of Courbet's *The Hunt Meal* (1858) remains obscure, and it is possible that Monet never saw the actual painting and knew about it only from Courbet's description or sketches. The large size of Courbet's composition (81 ½ × 128 in) no doubt played its role in stimulating Monet to create his *Luncheon* on an even grander scale.[44]

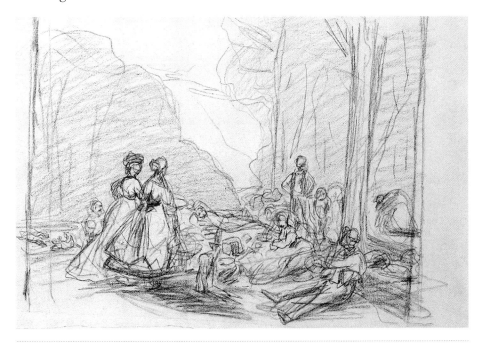

1.10. Claude Monet, *The Luncheon on the Grass*, ca. 1865, Collection of Mr. and Mrs. Paul Mellon. Image courtesy of the Board of Trustees, National Gallery of Art, Washington

As Isaacson notes, the heroic scale of Monet's *Luncheon* had few parallels in nine-teenth-century art: "Picnic scenes were not unheard of, but rarely did they remove themselves so effectively from the realm of the anecdotal or the picturesque. It was only in the 1860s that scenes of everyday life came to be treated on a scale previously associated with grand themes. Picnic scenes, specifically, tended to remain small, geared to the purse of their prospective middle-class audience."[45] The popular lithographs produced so plentifully in France during the latter half of the nineteenth century include sterling examples of such "anecdotal" picnics. The freewheeling groups of working-class picnickers depicted in many of these prints display a far looser standard of conduct than the proper bourgeois personae who inhabit Monet's painted world.[46] The growing popularity of such images helped to determine Monet's plan to undertake a version that, by virtue of its size and conception, would elevate the humble theme of the woodland picnic to the level of high art, while simultaneously establishing his protagonists as the modern bourgeois counterparts of the protagonists who people the canvases of artists like Watteau and Carle van Loo.[47]

MONET'S PROCEDURES

So few of Monet's preparatory studies for the *Luncheon* survive that one can only make educated guesses about its evolution. Several paintings (w 55a–60a) depicting aspects of the forest of Fontainebleau date from Monet's lengthy sojourn at Chailly in 1865. Some of these compositions, like *Le Pavé de Chailly in the Forest of Fontainebleau* (w 57), may have originated in the course of the artist's efforts to determine the ideal setting for his picnic project. But others, such as *The Bodmer Oak, Forest of Fontainebleau* (figure 1.11) seem only indirectly related to the *Luncheon*. Redolent of the light and atmosphere of the woodland, these works function admirably as independent compositions, although painting them probably aided Monet in rendering accurately the effects of dappled light playing through foliage, so beautifully represented in the final study in Moscow.[48]

Monet no doubt worked up his *Luncheon* by the composite process he later described to the Duc de Trévise—recording details in drawings and small canvases, using models posing in the forest, for later transfer to the composite study and definitive canvas. The sole survivor among such preparatory oils depicts Camille and Bazille in a broadly rendered bosky setting (figure 1.12). A comparison of this sketch with the relevant segment of the Moscow painting reveals their close correspondence. Aside from rendering both figures and setting in a less cursory fashion and adding a few brightening touches to his palette, the most substantive changes between this painting and the corresponding detail in the Moscow picture consist of altering Bazille's position slightly, to render his image less stiff and awkward than in the preliminary study, and in integrating both figures more adequately into their woodland setting.

As previously noted, in developing the repertory of figures for the *Luncheon* Monet relied principally on Bazille and Camille; his mistress probably posed for all five young

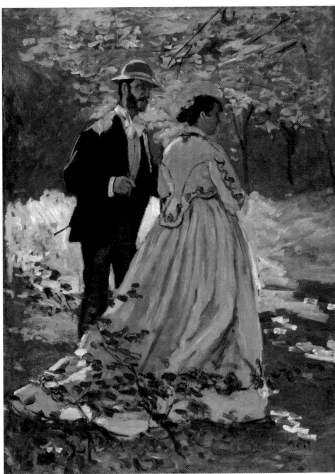

1.11. (*top*) Claude
Monet, *The Bodmer
Oak, Fontainebleau
Forest*, 1865, The Met-
ropolitan Museum of
Art, New York, gift of
Sam Salz and bequest
of Julia W. Emmons, by
exchange. 1964 © The
Metropolitan Museum
of Art

1.12. (*bottom*) Claude
Monet, *Bazille and
Camille* (study for
Déjeuner sur l'herbe),
1865, Alisa Mellon
Bruce Collection.
Image courtesy of the
Board of Trustees,
National Gallery of Art,
Washington

women shown in the Moscow study, while Bazille appears four times: in the left margin, the center middle ground, leaning against the tree at the right margin, and stretching lankily across the foreground. The two remaining male figures in the Moscow picture have never been securely identified, but Monet no doubt found models for them among the numerous artists who visited him at Chailly that summer.[49]

Did Monet work on the Moscow painting at Chailly, adding elements to the composition as soon as he had resolved them in smaller sketches, or did he defer beginning the composite study until he had returned to Paris and assembled his entire repertory of preparatory sketches in the studio? The surviving evidence provides no clear-cut answer, but Isaacson's conviction that Monet did begin the Moscow painting while still at Chailly and that he worked on it, at least in part, outdoors seems persuasive. Perhaps he delayed his return to Paris until mid-October in order to bring the composite study to a state that could be completed in the studio.[50]

The slender vertical fragment (figure 1.4) salvaged from the left margin of the full-scale painting bears mute testimony to the intensity—and futility—of Monet's struggle to complete his epic task. Growing ever more desperate as the deadline for the Salon submission approached, he frantically reworked the costumes of the two standing female figures depicted in this fragment. As a comparison of this fragment with the relevant detail from the Moscow canvas reveals, Monet shortened their skirts to show a greater expanse of petticoats and provided the model originally depicted in an off-white costume with a new gray outfit featuring brilliant scarlet trimming, cummerbund, and petticoat, as well as a new hat, repainted to conform to chapeaux shown in the latest fashion publications. Although these changes may have been introduced to enhance spatial effects, as Isaacson has suggested, such Band-Aid solutions could not counteract the core problems affecting the composition. The dark, tortured, leathery surface of the vertical fragment reveals all too clearly the difficulties its creator had experienced in attempting to make the composition work. Small wonder Monet never showed it to visitors.[51]

The central remnant of the *Luncheon* benefits from the more relaxed poses of the principal figures, the tender glimpses of flesh afforded by the quasi-transparent dotted muslin frock worn by the woman proffering the plate, and the convivial expression and open gesture of the Courbet-like personage seated to her right. But the feast laid out on the wedge-shaped cloth (now brought right up to the edge of the canvas, a change facilitated by the removal of the whippet hound shown in the Moscow study) fails to tempt. Monet's foodstuffs resemble stage props rather than actual viands; how unfavorably they compare with the exquisitely rendered brioche and fruit featured in Manet's *Luncheon*!

In studying both fragments of Monet's unfinished painting, one confronts the "violence" of the light (to borrow the felicitous term used by Robert Gordon and Andrew Forge), light transformed from tinted vapor into concrete slabs of brightness that weigh upon the shoulders of the back-lit figures, pinion the picnic cloth to the grass, and divide the composition into discrete blocks of color, interfering with one's perception of it as a gestalt. These bright, impasto patches emphasize the contest between realism

and abstraction evident in both fragments. Once Monet realized that he could not force those wayward slabs of light to submit and assume their proper role in the composition, he finally abandoned the effort to transform the work into a unified whole. In a contest between painterliness and realism destined to remain forever unresolved, the light, rather than the picnickers, assumes primacy of place.[52]

By contrast, the Moscow picture presents a far more harmonious vision; the sketchier treatment of visages and costumes, the shimmering light playing on the gently swaying leaves, the sheltering character of the grove in which the picnickers have gathered—all these elements seem congruent and integrated. Unfortunately, much of this was lost in the twelvefold enlargement in size.

THE ICONOGRAPHY OF THE *LUNCHEON*

As previously noted, in his attempt to create the most realistic, modern—and enormous—picnic scene possible, Monet featured members of his inner circle as his protagonists. In contrast to Courbet, who openly and unashamedly utilized his creativity as a vehicle for self-glorification, Manet, always careful to maintain the public persona of the sophisticated *flâneur*, typically introduced more subtle, indirect self-references into his paintings, assigning the role of alter ego to one of his brothers, or to his son (or stepson), Léon Leenhoff.[53] Since he did not enjoy the kind of intimate relationship with relatives that would permit him to utilize male family members as doppelgängers, Monet selected his best friend, Frédéric Bazille, for this role. In so doing, Monet created an idealized self-image of an individual whose social status, moral character, and family relationships were all superior to those of the artist himself. In the Moscow *Luncheon*, Bazille appears twice as the special companion of Camille: they stand together at the left margin of the painting and again in the center background. In this pairing Monet paid tribute to his mistress by representing the young woman from a modest background as an appropriate partner for the scion of a fine old family, elevating her social status via the fiction of paint into that of a personage who would have been more than acceptable to the artist's own family.

In contrast to Manet, who used his picnic scene not only as a vehicle for modernizing the masters but also for gently ridiculing the values of his own class, Monet's Moscow version silently reaffirms his endorsement of conventional bourgeois standards of conduct and consumption. Elegantly costumed, decorously behaved, attended by a liveried servant (who discreetly peeps from behind the tree at the far right), Monet's protagonists conduct themselves with rather self-conscious dignity as they wait for the picnic feast to commence. The contrast between Manet's and Monet's central female personae seems especially telling. Unlike Manet's sassy heroine, Monet's proper (and fully clothed) young lady enacts the role of gracious hostess; extending a plate toward the spectator, she invites us to join the party and partake of the repast spread before us. Her welcoming gesture mirrors the behavior of her creator, who would become celebrated as an unusually generous and hospitable host.

When Monet turned to the full-scale *Luncheon*, he augmented the programmatic significance of the composition by replacing the figure of the clean-shaven young man seated at the left with that of Courbet, a decision that not only paid homage to the older artist but also, by portraying him making a gesture virtually replicating that of the reclining man on the right in Manet's picnic scene, created a witty visual pun.

Although Monet's *Luncheon* paid ambivalent homage to Manet and Courbet, on its most intimate level it constituted a painted paean of praise to Camille's beauty and a lover's pride of possession. By featuring multiple, large-scale images of his mistress in varying costumes and poses, Monet directed the attention of his friends to her central importance in his professional and personal life. The carved heart pierced by an arrow shown on the tree trunk near the right margin of the Moscow picture, underscores this covert message.[54]

Monet no doubt consciously intended the image of the liveried servant to symbolize the fact that the bourgeoisie now had access to amenities and services formerly available only to the nobility.[55] But the concealed position and alert pose of this fellow, who turns toward the picnickers as if eavesdropping, suggests that he also plays a second role (which the artist may not have consciously intended), of disguised representation of Monet *père*, symbolizing the artist's apprehension that his father might spy out information about his liaison with Camille. The fact that neither in the Moscow study nor in the surviving fragments of the definitive canvas does Monet represent Camille's features in clearly recognizable fashion reflects his concern about concealing her identity and role in his life and art. In the three figures in the Moscow study portraying her standing, Monet hid Camille's face by depicting her, respectively, from the back, in *profil perdu*, and, finally, in the center background, with her face concealed by her raised arms as she adjusts her hat. Disguising her role as the model for the two seated women facing the viewer posed greater difficulties. Monet solved the problem by giving these women Camille's body (and clothing) but using other models for their faces. The vivid but sketchily rendered features of these personae in the study seem quite lifelike, suggesting that they were based on rapid sketches of real models, perhaps posed by two of the more attractive companions of artists visiting Chailly that summer.

Presumably these models were no longer available by the time Monet began work on the full-scale canvas, forcing him to rely on preliminary sketches he had executed, perhaps supplemented by photographs. These indirect procedures resulted in the striking loss of vivacity apparent when one compares the features of the young woman proffering the plate in the central fragment (figure 1.3) with her "twin" in the Moscow study (figure 1.2). In the final version her face, opaque and expressionless, seems as impenetrable as a porcelain mask.[56] The contrast between this figure's impassive, "false" face (which appears to have been heavily reworked) and the tender glimpses of her "real" flesh, visible through the semitransparent bodice and sleeves of her dress, bears mute testimony to the forceful impact of Camille's continuous presence on the quality of her lover's artistic production. Both his instructions to Bazille (then sojourning with

his family in Montpellier) to bring the accessories he had previously used at Chailly with him when he returned to Paris that fall (WL 22) and the fact that Monet replaced the image of the clean-shaven young man in the Moscow picture with that of Courbet in the definitive canvas suggests that even in late stages of the *Luncheon* campaign he continued to rely on live models whenever possible.

UNANSWERED QUESTIONS ABOUT THE UNFINISHED *LUNCHEON*

In view of the obvious problems Monet encountered in attempting his grandiose project, one cannot help but wonder why he did not abandon the final canvas earlier, to concentrate instead on bringing the Moscow picture—itself a work of impressive dimensions—to the state of completion he deemed appropriate for submission to the Salon jury.

Another, perhaps more fundamental question about the project might be raised: Why did Monet insist on undertaking this vast campaign "on location" at Chailly, rather than using the Paris studio as his headquarters? (Was it easier to carry on a secret liaison *en campagne*?) Had he situated his picnic on the banks of the Seine—a site favored by numerous contemporary lithographers who depicted such al fresco repasts—he would have obviated a whole train of problems resulting from the decision to transfer his operation to the Fontainebleau area. By remaining in Paris, he would have reduced his financial burdens (since his obligation to contribute his share of the rental for the rue de Furstenberg studio continued throughout his stay at Chailly), while simultaneously eliminating the problem of transporting models and material from capital to suburb. More important, by operating out of the rue de Furstenberg atelier he could have enjoyed much easier access to the services (and counsel) of his principal male model, Bazille, who worked there until August. The spaciousness of the studio would also have permitted Monet to transfer details derived from sketches painted *en plein air* to the Moscow picture and the full-scale canvas in quick succession, rather than being forced to postpone work on the definitive painting until his return from Chailly in late autumn. Georges Seurat, who may have profited from familiarity with the history of Monet's *Luncheon*, sited his great Post-Impressionist vision of Parisians at leisure, *Sunday on the Island of La Grande Jatte* (1884–86; The Art Institute of Chicago), at a locale within easy commuting distance from his Paris studio.

Whatever Monet's motives, there can be no doubt that he unwittingly engineered his own defeat by such rash decisions. Was such self-defeat motivated? There is nothing in Monet's subsequent history to support such a conjecture; it seems more likely that his success in love had convinced him that, whatever he undertook, he was bound to succeed. He learned his lesson.

With the passage of the years, the *Luncheon*, the most mutilated of the children of his fancy, became a proud symbol of Monet's youthful daring, a treasured souvenir of days of wine and roses long past and of a beautiful young woman forever vanished.

Success and Scandal

THE CONTEXT

However reluctantly Monet had abandoned his unfinished *Luncheon*, the rapidity with which he recovered his equanimity and organized the campaign resulting in *Camille* (figure 2.1) testifies to his resilience as well as to his high energy level.[1] It might be an exaggeration to claim that the frustration he had experienced in his fruitless struggle to complete his grand project had permanently curbed Monet's hubris, but he did learn from the mistakes that had predestined the *Luncheon* to failure. Never again did he attempt a figurative composition on such a grand scale, nor one involving so many personae. With no time to lose if he hoped to meet the March 20 deadline for Salon submission, the artist decided to limit the protagonist of his new painting to his faithful companion, Camille, whom he planned to depict in a full-length, life-size representation. The amorphous indoor setting he selected as the background obviated the problems of attempting a *plein air* composition during the uncertain weather of the late Parisian winter.

In executing *Camille*, Monet followed to the letter Courbet's advice to create a work the Salon jury could not reject.[2] Carefully composed and painted, the picture embraces a conservatism in tone and technique that Monet had emphatically rejected in his daring *Luncheon*. In contrast to the *Luncheon*, neither the facture nor the lighting of *Camille* challenges the impression that one perceives a realistically represented figure inhabiting a believable space. The fastidiousness with which he rendered the model's striped green silk gown and fur-trimmed jacket demonstrates that, when motivated to do so, Monet could successfully emulate time-honored techniques for rendering fabric and fur illusionistically. As numerous critics have pointed out, Camille's attire and posture indicate that the artist and model continued to rely on fashion prints and other popular images for information about the latest trends in costumes and poses.[3]

As Courbet had predicted, the Salon jury, recognizing Monet's talent, accepted *Camille*, as well as his other submission, *The Road to Chailly*, a beautiful autumnal landscape from 1864 (w 19).[4] Although both pictures were badly hung, *Camille* immediately became a major attraction of the exhibition. Lampooned by prominent caricaturists, reviewed (generally favorably) by leading critics (including Emile Zola, Jules-Antoine Castagnary, and W. Bürger [Théophile Thoré]), and praised in verse by E. d'Hervilly (who hailed the protagonist as "Parisian Queen" and "Triumphant Woman"), *Camille* enjoyed a great success, exceeding even Monet's most ambitious fantasies.[5] He must have been especially gratified by Zola's enthusiastic characterization of him as "a man among a crowd of eunuchs," suggesting, as Cézanne might have phrased it, that Monet "painted with his balls."[6]

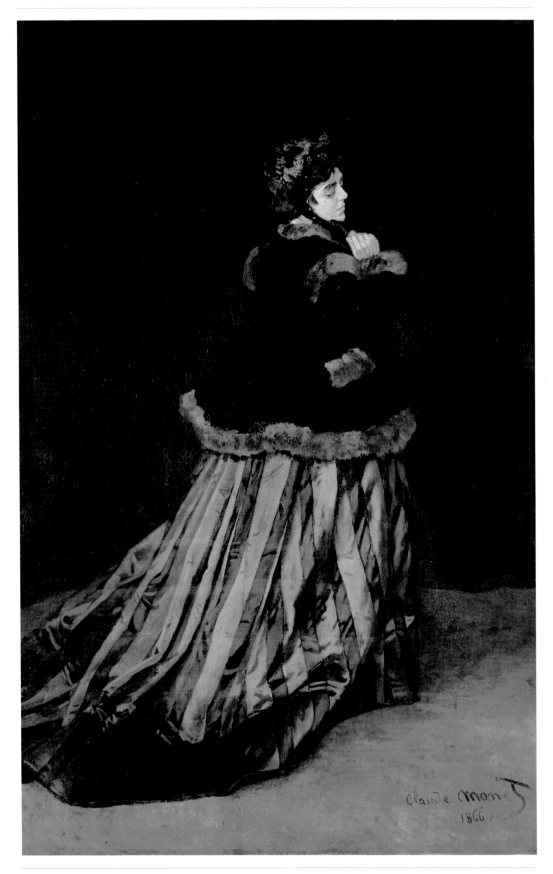

2.1. Claude Monet,
Camille (*Woman
in a Green Dress*),
1866, Kunsthalle
Bremen. Erich
Lessing/Art
Resource, NY

To add to his delight, Aunt Lecadre, who had been threatening to terminate his monthly stipend, was so "enchanted" by Monet's success and the congratulations she received from everyone that she abandoned such threats.[6]

MYTH AND REALITY IN THE EXECUTION OF *CAMILLE*

From a psychological viewpoint, the review by W. Bürger [Théophile Thoré] is the most interesting, revealing that even at this early stage of his career Monet (who was surely the source for the fictive history of the picture's creation reported by Bürger) was already actively shaping the mythic self-image he wished to bequeath to posterity:

> But wait! Here is another very young man, M. Claude Monet, more fortunate than his near homonym Manet . . . who's had the good luck to get his *Camille* accepted— a large portrait of a standing woman seen from behind, trailing a magnificent green silk dress, fully as dazzling as the fabrics painted by Veronese. I'd like to reveal to the jury that this opulent painting was done in four days. When you're young you don't stay cooped up in a studio, you go out gathering rosebuds. The deadline to submit to the Salon was approaching. Camille was there, fresh from gathering violets, in her lawn-green train and velvet jacket. Henceforth Camille is immortal and is known as the *Woman in the Green Dress* [sic].[7]

In Bürger's fanciful account, the artist appears not in the desperate situation in which he actually found himself when he initiated the composition, but as the playboy of the Parisian art world, briefly interrupting (glamorous?) extracurricular activities to immortalize his mistress as the "woman in green."

The extensive conservation project carried out by Bremen museum staff reveals that the artist did indeed work rapidly, applying successive layers of paint over earlier layers not yet completely dried, causing marked cracking of the picture surface in certain areas. However, their findings also reveal that Monet revised the composition extensively during its execution, making both major and minor alterations.[8] They concluded that he most likely began by painting the dress (presumably with Camille wearing it, a point the report does not clarify). He then laid in the carpet on which she stands, which originally featured a pattern of reds, blues, and yellows, later covered with a thin, ochre-gray paint, creating a neutral effect. He also toned down the floor-length drapery that forms the background of the composition; initially painted in shades of red, it was subsequently repainted a quiet reddish brown. X-rays reveal that while toning down the background Monet also altered the outline of Camille's dress in many places, covering excised areas with the background color to produce a slimmer silhouette. He also effected other changes to the shape of the dress, the fur-trimmed jacket, and— most importantly—to Camille's own face, body, and pose. Her face shape, which was originally more rounded, was made thinner "and presented with a more pronounced turn toward the rear." Perhaps during this same operation, he reduced the size of her

right arm and hand and made additional small alterations to her neck and collar. As the conservators point out, these changes "make the figure of Camille look slimmer and more dynamic in her movement."[9] Monet's earlier decisions to darken the background and to substitute a neutral gray floor for the patterned carpet obviously also contribute to the dramatic impact of Camille's figure. His final step before submitting the picture to the Salon consisted in applying a layer of the colorless, transparent varnish he then preferred to use.

The size of the painting (89 ¾ × 58 ⅛ in) and the numerous changes the artist effected during its evolution argue against Bürger-Thoré's tale of the process as a four-day wonder.[10] In an interview with Thiébault-Sisson conducted decades later, the elderly Monet recalled that *Camille* had required "a week or two to complete," an estimate that seems more credible; it seems highly unlikely that the composition could have been completed in less than ten days to two weeks.[11]

If—as proposed here—Monet himself had been the source for Bürger-Thoré's account, in this instance, as in later mythic reconstructions of his youthful history, Monet cast himself as the bold hero-painter. At least in the story he presumably invented for Bürger-Thoré, however, he had the decency to acknowledge the key role his mistress had played in *Camille*'s creation. Perhaps, just as Bürger reports, Monet actually had been inspired by the sight of his mistress entering the studio aglow from an expedition in the brisk outdoor air. As a model, Camille clearly offered her artist partner more than beauty, although she possessed that quality too. Patient, pliant, and empathic, she proved to be an ideal model, capable not only of responding to but also of anticipating the artist's demands. As they labored together, she assumed the status of a full-fledged artistic partner in producing a work that owes its enduring effectiveness almost as much to its model's unique ability to assume and sustain a static pose suggestive of motion as to Monet's inspired decision to preserve forever in the fiction of paint an incident from real life.

Despite *Camille*'s emphasis on costume, Monet managed to imbue the young woman's image with a subtle psychological quality that is at once distinctive and ambiguous. His inspired decision (or Camille's?) to portray his model in half-arrested motion—as though undecided whether to remain or to flee—provides an enigmatic character that piques our interest. Decades after the painting's completion, Gustave Geffroy, presumably echoing Monet's own reminiscence, indicates that the artist had deliberately infused the protagonist's persona with this elusive quality: "The beautiful creature passes through, appears and is about to disappear, with an allure full of power and grace. She turns back in half profile, holding in one of her little gloved hands the ribbon of her hat. Her expression is untranslatable, a kind of disdainful coquetry notable in the lowered eyelids and the corners of the mouth of her beautiful, harmonious visage. . . . It is an individual portrait, one of the fortunate chances in painting that has arrested the model in a moment of perfection."[12] It is precisely the enigma the picture presents that has enabled the work—despite its formal conservatism—to retain its interest for

modern viewers. Interestingly enough, most contemporary critics who discussed the painting seemed impervious to the psychological ambiguity inherent in Camille's pose and expression, a question that challenges Monet scholars today, as contrasting inter-pretations of her countenance attest: does her visage (figure 2.2) reflect "melancholy," as Joel Isaacson perceives it, or "hardness," as Virginia Spate has suggested?[13]

To appreciate the magnitude of Monet's achievement, one has only to contrast *Camille* with a composition representing a similar motif, created by one of his more conservative (and highly successful) peers, Alfred Stevens (1826–1906). Although much smaller in scale than *Camille*, Stevens's *Hesitation* (figure 2.3), circa 1867, also features a full-length rendition of a fashionably garbed woman posed in an interior. Like Monet, Stevens focuses on a critical moment of indecision in the woman's life: with the sudden appearance of a billet-doux being slipped beneath her door, she has abruptly risen and rushed to the doorway, where she stands paralyzed by indecision about whether to retrieve the note. Stevens invites the viewer to participate in his hero-ine's amorous dilemma, but his failure to convey effectively any convincing evidence of her psychological state in either her posture or her expression (she appears rather vapid) reduces the composition to an example of the coy eroticism favored by many academic painters of the Victorian era.[14]

2.2. (*left*) Claude Monet, *Camille* (*Woman in a Green Dress*), 1866, detail, Kunsthalle Bremen. Erich Lessing/Art Resource, NY

2.3. (*right*) Alfred Stevens, *Hesitation* (*Madame Morteaux?*) ca. 1867, The Art Institute of Chicago, Mr. and Mrs. Martin A. Ryerson Collection

Long after Zola had praised the picture in his 1866 review, memories of Monet's effective presentation of emotional dilemma in *Camille* continued to haunt him, inspiring a scene in *L'Oeuvre* (1886) that focuses on a critical moment of decision in the life of the novel's heroine, Christine Hallegraine. She makes a surprise visit to Claude Lantier's studio to thank him for having rescued her when the terrified young woman—then a complete stranger to Paris—was crouching in a doorway during a midnight thunderstorm. The passage begins as Claude, engrossed in his painting and assuming that the visitor he has just bid enter is his concierge, continues working for several minutes before becoming aware of his error.

Suddenly he realized who it was, "It's you, mademoiselle" . . .

"Yes, it's me, monsieur," she said. "I thought it was not nice of me not to have thanked you."

She blushed, and her speech was hesitant, as if she could not find her words. Maybe the long climb up the stairs from the street had made her out of breath, for her heart was beating very fast. Had she done the wrong thing, she wondered, to pay this call which she had discussed with herself so often until at last it had appeared to her quite a natural thing to do. What made things worse was her having bought those roses as she came along the embankment, to give the young man as a kind of thank-offering. Now she found them simply embarrassing. How should she give them to him? What was he going to think of her? The indecorousness of all these things had only dawned on her once she had opened the door.[15]

CAMILLE'S IDENTITY AND ROLE PUBLICLY REVEALED

As previously noted, in executing the multiple representations of his mistress featured in the *Luncheon* Monet had employed various devices to disguise her true identity. In painting *Camille* he abandoned such stratagems, introducing his beloved as her own persona, a decision he underscored by titling the picture *Camille*. But by using the first name to title the picture rather than dubbing it "Portrait of Mlle. Doncieux" or, more anonymously, "Portrait of a Young Woman in Green," Monet, whether inadvertently or purposefully, cast aspersions on the moral and social status of his companion.[16] Until the painting made its Salon debut, only members of the artist's inner circle had been aware of his relationship with Camille; now it became public knowledge. Bürger's review, while paying tribute to Camille's role as Monet's muse, made explicit the fact that she was the artist's mistress. Outsiders had no way of knowing that unlike many models of the period, who routinely engaged in transient sexual relationships with artist employers, Camille was committed to a monogamous relationship with Monet.[17] The young woman, who came from a conventional, albeit modest, background, obviously understood the implication of this public proclamation of her identity and questionable status—a revelation she must have found extremely discomforting.

The public reaction when Monet next exhibited *Camille*, as one of five paintings he selected for the Exposition maritime internationale, held in Le Havre in October 1868, would prove even more embarrassing for its protagonist. In a generally favorable review of Monet's work, published in the *Journal du Havre*, Léon Billot inserted a poison pill. After praising the skill with which the artist had rendered *Camille*'s costume, he continued:

> On the other hand, critics could find a lot to say about this lady's head. A head which is obviously only a sketch. Had the lady only consented to the exhibition of the painting in the Salon on the condition that she not be recognized? And M. Monet, who is not a man who would alter a head created by the good Lord, could he not have found another stratagem than that of creating no head at all? Mystery! The fact remains that from Camille's gait and the provoking way in which she treads upon the sidewalks, one has no trouble guessing that Camille is not a woman of the world but [just] a Camille.[18]

Billot's appetite for these insinuations may have been stimulated by the news that Arsène Houssaye, director of the respected periodical *L'Artiste*, had purchased *Camille* from the exhibition, not only paying the (then) handsome sum of eight hundred francs but publicly announcing his plan to donate it to the Palais de Luxembourg. The reviewer's snide comments (in addition to being quite accurate about the degree of finish of the model's head) suggest that by the time his review appeared, Monet's liaison with Camille had become common knowledge throughout the Le Havre area, where the Monet-Lecadre clan played a prominent role in commercial and social life. Still more damaging was his thinly veiled implication that Mlle. Doncieux was a prostitute. The resulting scandal aggravated the artist's already strained relations with his family, reinforcing their rejection of Camille (never to be revoked during the lifetimes of Monet *père* and Aunt Lecadre). One only hopes the artist was as embarrassed for his beloved's sake as for his own!

If *Camille* provided Mlle. Doncieux with a definitive—if questionable—identity, the painting also functioned as a metaphor for the uncertainty characterizing the relationship between the lovers. The elusiveness and indecisiveness with which Monet endowed Camille's persona mirrored the ambiguity—and potential instability—of their real-life partnership. Despite his attachment to Camille—and his growing dependence on her as his artistic partner—Monet remained far from willing to commit himself to her definitively. With his decision to reveal the nature of their relationship to the general public, he tacitly proclaimed his assessment of his mistress as his social inferior. Her lover's ambivalence—combined with his willingness always to put his own needs before hers—made Camille's situation very precarious, even before a pregnancy threatened his commitment to her. To this observer, as to Isaacson, Mlle. Doncieux's expression in *Camille* appears more melancholy than hard. She had reason to be sad!

Monet's description of the painting many years later (reflected through the prism of Geffroy's account) as the embodiment of "a vision . . . that passes, appears, and is about

to disappear" suggests that in retrospect the artist had come to regard it as a painted prediction of Camille's early death, an unintentional memento mori. Did he take comfort in the knowledge that he had indeed immortalized his lost love (just as Bürger had predicted), not only in *Camille* but in the numerous depictions of her he would create during the decade that followed?

<div style="text-align:center">

CAMILLE WITH A SMALL DOG:
THE PRIVATE COUNTERPART TO A PUBLIC PICTURE

</div>

Unlike the three large canvases of 1865–67 that would feature Camille, this small-scale, intimate picture (ca. 28 × 39½") was intended from its inception as a purely personal memento, and Monet retained it in his private collection, unexhibited, throughout his lifetime. (Michel Monet sold the work after his father's death, as he would numerous other portraits of his mother.)

The canvas, signed and dated 1866, reveals close stylistic affinities with *Camille*, suggesting that it was painted during the same weeks. During periods of enforced pauses between working campaigns on his intended Salon submission, did Monet occupy himself with this easel-size painting, which shares *Camille*'s dark background and realistic treatment?[19]

Whereas the costumes that Monet selected for his mistress to wear in the *Luncheon* were later recycled for her multiple appearances in *Women in the Garden*, he never again portrayed her in the outfit she wears in *Camille with a Small Dog* (figure 2.4). The costume seems overly busy, lending a note of frivolity that contrasts oddly with Camille's serious expression. Over a simple black-and-white striped dress with white cuffs she wears a weskit of bright red, edged with ball-fringe and featuring an enormous black velvet bow at the neck, surmounted by a high collar like a frivolous counterpart to a seventeenth-century ruff.

While *Camille* represents the model in a flattering, softly lit interior, *Camille with a Small Dog* illuminates Mlle. Doncieux's features with a bright, sharp light that emphasizes the angular profile of her

2.4. Claude Monet, *Camille with a Small Dog*, 1866, Foundation E. G. Bührle Collection, Zürich / Bridgeman Art Library

nose and the prominence of her chin. The latter was not Camille's best feature, and in subsequent representations of her Monet typically avoided such stark profile views. (The only other portrait that emphasizes Camille's chin in an equally unflattering manner is *On the Bank of the Seine, Bennecourt*, discussed in chapter 5.)

In *Camille with a Small Dog* she appears somber, weary from the seemingly unending hours of posing not only for the large canvas, which required her to simulate motion while remaining static, but also for *Camille with a Small Dog*, not to mention struggling to keep her canine companion as motionless as herself while the artist portrayed them.

The soft contours of the little white dog, captured by Monet in a mélange of quick, broken brushstrokes vividly suggesting, rather than defining, its body, provide a striking contrast to the more deliberate facture Monet employed in rendering Camille's features. Despite the freedom with which he depicted the canine's form, he delineated its face with sufficient detail for this dog lover to read its expression as one of patient forbearance.

It was the flickering brushstrokes with which Monet portrayed the little dog, rather than the realistic rendition of his mistress's face and form (in both the large- and-small-scale pictures), that predicted the future of his art. Arguably, *Camille with a Small Dog* can be called the first proto-Impressionist canine portrait in the history of art.

Camille as Flora

The acclaim Monet enjoyed as the painter of *Camille* brought immediate financial rewards. He sold several pictures to patrons impressed by his talents—and favorable reviews. He was also commissioned, and paid in advance, to execute a smaller replica of *Camille* for the dealers Alfred Cadart and Jules Lucquet, who planned to offer it for sale in America.[1]

Monet's creditors had been hounding him even before the Salon opened; in an effort to elude their grasp, he and Camille abandoned Paris in mid-April, fleeing to Sèvres, where they rented a little house. Their new home featured two important amenities: an attractive garden and easy access to the nearby Ville d'Avray railroad station, from which Monet could quickly reach Paris to visit the Salon, bask in glory, and—he hoped—drum up more business. His flight did not long deter Monet's creditors, who began threatening legal action as soon as word of his critical and financial success at the Salon became general knowledge.

Confident that Armand Gautier would share the news of Monet's good resolutions with Aunt Lecadre, the artist wrote Gautier the first of several grateful letters from Sèvres, describing his happiness, his dedication to work, and his intention to defer big projects, for which he didn't have the money, in favor of concentrating on small pictures he could produce more cheaply. Bold as ever, Monet ended his missive by urging Gautier to use his contacts to help the artist sell several small canvases he had on hand (WL 25, written in the latter half of April).

Far from renouncing big projects, as he piously claimed to Gautier, Monet, his confidence fully restored by the popular and critical success that had greeted *Camille*, was actually planning another large experimental work, designed with the next Salon in mind and featuring four nearly life-size, fashionably garbed women in a landscape. Made painfully aware by difficulties encountered with the *Luncheon* that the play of natural light on figures could not be simulated in a painting created in an atelier, he resolved to abandon tradition and execute *Women in the Garden* (figure 3.1) *en plein air* from start to finish, using the garden of his rental home as its setting. By working in his own backyard he would avoid the expenditure of time, trouble, and money that had resulted from his decision to carry out studies for the *Luncheon* "on location." Although conceived on a suitably grand scale to dazzle the Salon jury, *Women in the Garden*, which measures roughly eight feet by almost seven, would be neither as large nor as complex as the *Luncheon* with its mural-size dimensions and twelve full-scale male and female protagonists. Still stinging from the memory of problems in securing the services of

models for the duration of the latter project, Monet resolved to rely exclusively on Camille, who posed for all the figures, wearing the same outfits in which she is portrayed in the Moscow study for the *Luncheon*. (Several Monet specialists have argued that a second model posed for the redheaded woman shown in the act of plucking a flower. In the absence of *any* documentary evidence substantiating this hypothesis, it seems more reasonable to assume that Monet simply had Camille don a red wig—and assume a *profil perdu* pose that obscured her features. A decade later, she would don a blond wig when she modeled for *La Japonaise*.)[2]

Executing a composition as large as *Women in the Garden* outdoors presented practical problems. In retrospect, Monet claimed that he had simply dug a trench or ditch in the garden, into which he lowered his canvas by means of pulleys when he wanted to work on the upper portion. This deliberately simplistic explanation probably constitutes another chapter in Monet's mythic reconstructions of his past. Unfortunately, none of his interviewers (who apparently accepted all his stories as factual) thought to question the artist about the precise nature of such an apparatus, which would have required a much more laborious and expensive arrangement than the simple trench and pulleys he mentions.[3]

Most likely he devised a much simpler arrangement, similar to the one he used in painting the *Nympheas* outdoors. As figure 15.5, in the epilogue, shows, Monet worked on these large canvases while seated on a high stool, which enabled him to reach the upper level of the canvas, supported on a huge easel. A similar arrangement would have permitted Camille and the artist to carry the picture in and out of doors with relative ease, since even a canvas as large as that of *Women in the Garden* is not terribly heavy.

The creation myth the artist wove around *Women in the Garden* again included a featured role for Courbet. According to Monet's recollections, Courbet (who would have had to travel from Paris to Sèvres to "drop in" on his younger colleague) occasionally stopped by to check his friend's progress and dispense advice. One day he allegedly found Monet idle and asked:

> "How is it, my child, that you're not working?" I responded, "Can't you see there isn't any sun!" "That doesn't matter, all you have to do is touch up the landscape."

In relating this story nearly sixty years later, Monet wryly commented, "That was a bit much, but perhaps he said it ironically."[4] Whether real or apocryphal, this tale fits the classic formula Monet had followed in the anecdote describing Courbet's interventions in the *Luncheon*: once again the Master of Ornans appeared in the role of fatherly adviser, once again he dispensed bad advice. But this time around Monet ignored the older artist's suggestions, because he now comprehended, *as Courbet failed to do*, that the future of realistic landscape painting demanded that the work be executed outdoors from start to finish, in the same spot, under similar weather conditions. Courbet, by contrast, belonged to the past; without realizing it he had already been dethroned, and the new king of naturalism had inaugurated his reign.

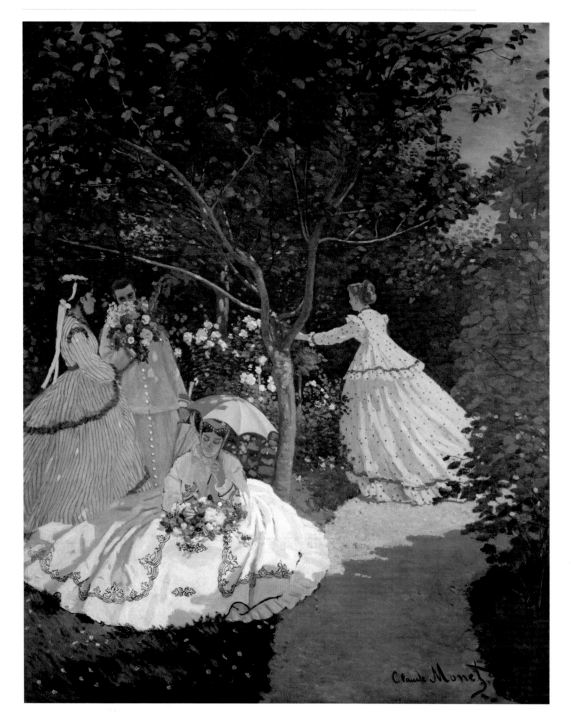

3.1. Claude Monet, *Women in the Garden*, 1866, Musée d'Orsay, Paris. Erich Lessing / Art Resource, NY

In another interview conducted thirty-four years after the fact, Monet still more boldly staked his claim to having pioneered the practice of *plein air* painting with *Women in the Garden*: "I threw myself body and soul into the *plein air*. It was a dangerous innovation. Up to that time no one had indulged in any, not even Manet, who only attempted it later, after me."[5] This boast was not entirely accurate, for the practice was not completely unknown at the time. It is true that prior to Monet only Charles-François Daubigny (1817–78) had attempted to work outdoors on a landscape (which

did not, however, include any figures) approaching the scale of *Women in the Garden*; he evidently considered the experiment a failure, because he repainted the picture in his studio several years later.[6]

Truth be told, *Women in the Garden* did not evolve as the complete child of nature, as Monet would later pretend had been the case. Far from adopting the rather spartan lifestyle he advertised in letters to Gautier, the artist boasted, in retrospect, that at the time he had "floated in opulence, temporarily at least . . . [while] I threw myself body and soul into the *plein air*."[7] The bubble soon burst, forcing the lovers to flee in order to elude bailiffs that creditors had set on them. During an interview with René Gimpel, conducted in 1918, Monet claimed that he had been forced to abandon two hundred paintings at Ville d'Avray and had slashed them to render them valueless—a greatly inflated estimate, as his letter to Bazille (WL 29) dated December 1, 1866, reveals: "I don't have very many things at Ville d'Avray, [but] it would be terrible if they sold them on me."[8] Whatever the exact number of paintings left at Ville d'Avray, the sole canvas from that sojourn which has come to light is *Women in the Garden*. The couple's movements during this period remain so shrouded in secrecy that we do not know precisely when Monet and Doncieux decamped and fled to Normandy. Wildenstein states that they left Ville d'Avray in early summer, basing the assessment on his belief that Monet had executed two paintings (W 68 and 69) depicting the garden of the Lecadre family's home at Sainte-Adresse during the summer of 1866. Not only is there no documentary evidence indicating that Monet visited Sainte-Adresse that summer, but as several critics have argued (and the present author concurs), these two works surely date from the summer of 1867, not that of 1866.[9] Apart from these two pictures of questionable date, none of the other compositions Monet executed during his Norman sojourn of 1866 clearly features a summer setting. None of the eight marines he painted during this period (W 71–77a) depict the shoreline or provide other clear-cut seasonal clues. (The largest of this group, *The Port of Honfleur* [W 77] was executed in Monet's studio during the late winter, as we know from an eyewitness account cited below.) The remaining four pictures executed in Normandy (W 79–82) all depict snow scenes and were painted during the winter of 1866–67.

The earliest documentary evidence attesting to the couple's presence in Normandy comes from an undated letter that Courbet (then vacationing in the area) sent Eugène Boudin around September 1866, in which he mentioned encountering Monet and his mistress at Deauville.[10] The next firm evidence for Monet's whereabouts derives from the letter he sent Bazille on December 1, 1866, asking him to forward several canvases, including a "Woman in White," in care of the Cheval Blanc Inn in St. Siméon, where he had established his studio. Monet explained that he planned to reuse the "Woman in White" for "an important marine"—which, he noted, he would barely have time to complete by the deadline for Salon entries. He concluded the epistle by pleading with Bazille to intercede with "Mme. Rolina," an unsatisfied creditor who had just sent him a dunning letter threatening to seize "things" (presumably pictures) abandoned at Ville d'Avray.[11]

THE EVOLUTION OF *WOMEN IN THE GARDEN*

The fact that Monet did not list *Women in the Garden* among the canvases to be shipped to him suggests that he had the picture in his possession the entire time. He had certainly been forced to abandon whatever apparatus he had constructed to work on the painting in situ and made no attempt to reconstruct the device, nor to continue working on the painting outdoors. He was working on *Women in the Garden* in his studio when the now-obscure artist A. Dubourg visited Monet's atelier around the beginning of February 1867. In a subsequent letter to Boudin, Dubourg told of finding Monet hard at work on "two enormous canvases," *Women in the Garden* and an unidentified marine (no doubt *The Port of Honfleur*, W 77). Dubourg did not comment on the marine, which he deemed not far enough advanced for one to assess its quality. However, in a judgment that would soon be echoed by the Salon jury, he rated *Women in the Garden* (which, he noted, had been initiated "after nature and in the open air") inferior to *Camille*: "It has good qualities, but the effect seems somewhat weak, no doubt because of the lack of contrast, for the color is strong."

Unfortunately, Dubourg provides no clues concerning the precise nature of the work Monet was then doing on *Women in the Garden*.[12] In point of fact, we possess little detailed information about how *Women in the Garden* evolved or about its exact state at the time work on the canvas was forcibly interrupted by Monet's flight from Ville d'Avray. The extant evidence about his movements, considered in conjunction with the authentically outdoor freshness that characterizes the painting, suggests that he worked on it outdoors until late summer and that by the time he was forced to abandon the garden that had served as its setting (along with the alleged Rube Goldberg apparatus) the picture was well advanced. No parallels for the few surviving studies partially documenting the evolution of the *Luncheon* have surfaced in the case of *Women in the Garden*, no doubt because Monet bypassed such intermediate steps in favor of drawing directly on the definitive canvas.

The Research Laboratory of the French Museums, reporting on an examination of *Women in the Garden* by radiographic and other techniques, cited Monet's treatment of the heads of the seated woman and the figure shown in profile standing just behind her as characteristic of his approach throughout the work. In lyrical passages, the report calls attention to Monet's "aerial touches," inundated with light and "supple contours." It praises his distinctive facture, which accentuates "the fragile, poetic character of the composition. . . . The great 'father' of Impressionism easily manipulates flat or round brushes, surrounding his figures with glistening nimbi of sun and shadow; he paints 'like the bird sings,' happy and impatient to translate his thoughts into action." Monet's "impatience" resulted in considerable reworking of the canvas, especially in the area around the head of the seated woman; altered while the work was in progress, this area is heavily painted and badly cracked.[13] As Isaacson points out: "In the process of establishing its final position [Monet] developed the face [of the seated woman] into

a flattened mask, a highly artificial entity. And yet the face is the product of the most careful scrutiny: observing it in the half-light of the parasol's shade, Monet paints the face tan, pink, violet, and pale blue; the upper lip and bottom of her nose are highlighted, receiving the strong light reflected from the surface of the white dress."[14] The x-rays demonstrate that Monet boldly set to work without resolving every detail of the composition in advance and that he was sometimes too impatient to revise his previous work to wait for underlying paint levels to dry completely—an impatience evidenced in the craquelure of the face of the seated woman. (One wonders whether he carried out some of these changes to the seated figure during the frantic period immediately preceding the flight to Normandy.)

Contrary to the notion that he painted as effortlessly as birds sing—a mythic reinterpretation of his early career constructed by the artist himself and reverently quoted in the report cited above—Monet was an astute self-critic and an indefatigable toiler. Not only is *Women in the Garden* a masterpiece in its own right, but it also reflects the happy resolution of problems the artist had set himself in the earlier *Luncheon* but failed to resolve at the time. The depiction of light playing on figures and objects, which shatters the unity of the surviving *Luncheon* fragments, is gloriously resolved in *Women in the Garden*. Abandoning the traditional dark priming and carefully modulated chiaroscuro practiced by his more conservative peers (including, of course, the members of the 1867 Salon jury), Monet accurately represented the flattening effect of bright summer light on his personae, but he countered this effect by simultaneous emphasis on the volumetric, bell-like silhouettes of his crinoline-skirted beauties.

The bold facture and strident color contrasts evident in the *Luncheon* fragments (effects that may be in part artifacts of their unfinished state) appear in a more refined, less jarring state in *Women in the Garden*. However, Monet's depiction of shadows as softly colored forms playing on the faces and costumes of his figures proclaimed his rejection of time-honored methods of working from light to dark and representing shadows in tones of black and brown. By contrast, he rendered the shadows playing on the skirt of the seated woman as freely brushed violet-toned areas that assume abstract shapes of their own, while the sunlight, flickering over the costume of the woman in the beribboned hat standing in the shade of the tree, takes the form of lively touches of rosy white, rapidly set down with a loaded brush tip. Although *Women in the Garden* creates an overall impression of harmony, Monet achieved this effect by triumphing over disruptive forces that he himself had introduced (whether deliberately or as a result of plunging into the complex composition impulsively, without utilizing advance studies) and that threatened to shatter its gestalt.[15] For example, the prominent path meandering through the garden divides the composition into two uneven grassy areas, a divisive effect the artist underscores by grouping three of his four protagonists in the larger area, in such close proximity that their silhouettes overlap, a feature often seen in popular fashion illustrations of the time depicting young women in gardens.[16] Monet successfully tamed these disruptive forces by transforming the entire composition into

a slow-moving carousel or Maypole dance, with the central tree acting as the fulcrum around which the figures seemingly revolve. He accomplished this tour de force by representing the redheaded woman in the process of moving forward to pluck a blossom from the rose bush (shown in such close proximity to the tree that several flowers seem to touch the trunk). So convincingly does Monet render the model's movement that one can almost feel the rush of air and hear the rustle of her skirt as she moves toward the rosebush, with her left arm raised in an expansive gesture that leads the eye directly to the tree branch above the two women standing in its shade.

Not even a model as talented as Mlle. Doncieux could have sustained the pose (more unstable than the simulated movement she had assumed for *Camille*) the new composition required. No doubt she briefly demonstrated the action—perhaps repeatedly—and then simply stood with her left arm outstretched, leaving to her partner the task of perpetuating the illusion of instability, an effect he achieved by representing the peplum and skirt of the model's lightweight muslin frock swaying in movement as she steps forward. This sensation is echoed in the playful, looping treatment Monet gave the black trim on the skirt of the seated woman, a detail that also endows her figure with a certain liveliness countering her quiet pose. Her ruffled petticoat trails across the path to her right, as does the train of the dotted dress worn by the redheaded personage, represented as though stepping from the path to the grassy area. Variations of the rosy mauves that tint the shadows playing across the skirts of these two figures recur in the meandering gravel path and patches of sky visible through the rich green foliage. The skirt of the seated woman overlaps the base of the tree as well as the skirts of the two standing figures on the left. These interconnecting silhouettes link Monet's personae to their setting while simultaneously asserting their formal connections with one another.

The seeming psychological disconnect of the personae of *Women in the Garden* constitutes a striking contrast to the conviviality displayed by the protagonists of the *Luncheon*, represented as a group of chums who have joined forces to enjoy a pastoral excursion and al fresco feast. The apparent isolation of the personages of *Women in the Garden* no doubt derives from the influence of popular fashion illustrations on the mindset of artist and model. But if Monet utilized such banal sources as throwaway fashion sheets, he transformed this dross into high art; his personae, isolated from one another though they may be, possess an awareness and a sense of self unparalleled in the work of even the most skilled designers of fashion plates. Each of her four representations presents a different aspect of Camille's physical charms and character traits. The seated figure portrays her more demure, meditative side. The profile view of the young woman nearest the seated personage provides some indication of her underlying determination and resolve, recalling in more flattering form her earlier profile portrait, *Camille with a Small Dog*. The next figure, in which she coyly trains her luminous brown eyes on the spectator over her bouquet, reflects her seductive powers. (Is there even a hint of mischief in her glance?) The "Maypole" figure not only emphasizes her

physical grace but acts as a metaphor for her quickness in grasping her artist-lover's ideas and, via her physical translation of his instructions, her ability to expand and refine them, assuming the true role of the muse, an active collaborator in creating what is now regarded as a masterpiece.

MONET'S REJECTION BY THE SALON AND ITS AFTERMATH

Shortly before the submission deadline for the Salon, Monet returned to Paris. Bazille, already housing Renoir, generously took in Monet as well, as he informed his mother in March 1867: "Monet has fallen on me from the sky with a magnificent collection of paintings that will be highly successful at the Exposition. He will stay with me until the end of the month. Along with Renoir, I am giving shelter to two needy painters. It's a veritable infirmary. This delights me. I have plenty of room, and they are both very gay."[17] Monet's gaiety—if real—reflected a capacity for denial or compartmentalization; if his Salon prospects seemed bright, another pending event spelled serious trouble: Camille was five months pregnant. (This event and its repercussions will be dealt with in the following chapter.)

Convinced that he would score an even greater coup with *Women in the Garden* than he had with *Camille*, Monet confidently submitted the composition to the Salon jury, along with *The Port of Honfleur* (W 77), a large but hastily painted harbor scene.[18] To Monet's shocked surprise, both his paintings were rejected. The fact that Paris would be playing host to the Universal Exposition of 1867, scheduled to open simultaneously with the Salon, no doubt prompted Comte Alfred-Emilien Nieuwerkerke, superintendent of Fine Art, and his administration to appoint an especially conservative group of artists to the Salon jury, including Jules Breton, Thomas Couture, Jean Léon Gérôme, and Ernest Meissonier. Their high-handed policies in rejecting two thousand of the three thousand applicants provided Monet with plenty of company among the *refusés*: the submissions of Bazille, Cézanne, Pissarro, Renoir, and Sisley were also rejected by the jury, whose members favored genre scenes above all else; about two-thirds of the works exhibited that year fell into this category.[19]

Activists in the artistic community responded to this disdainful treatment by flooding Nieuwerkerke's office with letters and petitions, but he demonstrated little sensitivity to such signs of growing militancy, denying, among others, Bazille's politely worded petition (signed by 125 artists) requesting the establishment of a *Salon des refusés*. Bazille and his friends then attempted to organize an independent exhibition but were forced to abandon the idea for lack of funds.[20]

Today *Women in the Garden* is regarded as an icon of modern art, but to the Salon jury of 1867 it must have seemed as alien as if it had descended from Mars. A comparison of Monet's composition with works of their own that two prominent jurors, Gérôme and Breton, selected for that venue demonstrates why Monet's painting was foredoomed to rejection. Gérôme's *Slave Market* (figure 3.2), purportedly set in Cairo,

depicts a swarthy group of men in caftans and turbans surrounding a female captive; although she has been stripped naked for their inspection, her potential purchasers show more interest in her dentition than her luscious body. This Orientalist fantasy would have permitted contemporary Salon visitors to enjoy viewing a shapely nude while reassuring them of the superiority of European "civilization" over that of the "barbaric" Near East. Breton's friezelike composition *Blessing of the Wheat in Artois* (1857) represents a religious procession with priests and deacons parading the consecrated host through the fields, while a crowd of those idealized, pious peasants who populate so many of Breton's canvases kneel in worship. This painting, with its vision of a utopian rural existence presided over by benign religious figures, no doubt evoked sentimental associations to the pastoral past and religious devotion among the sophisticated—and increasingly irreligious—urbanites visiting the Salon.

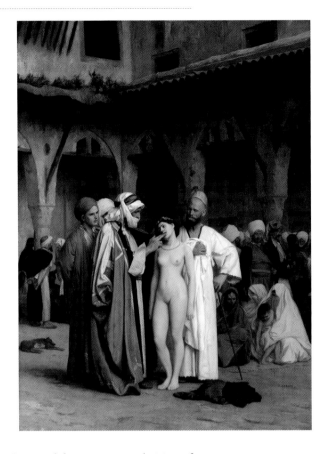

3.2. Jean-Léon Gérôme, *The Slave Market*, ca. 1867, Sterling and Francine Clark Art Institute, Williamstown, MA.

In view of the traditional approach to picture making and the romanticized vision of reality characteristic of such paintings, one can readily imagine the bewilderment with which Gérôme, Breton, and their ilk greeted *Women in the Garden*. Not only did Monet flout traditional rules of pictorial construction by executing his brightly colored composition over light priming and substituting broadly painted, tinted shadows without respecting traditional light-dark gradations, but he also eliminated every hint of narrative thread or emotional context, presenting viewers with a quartet of protagonists who seem unaware that they simultaneously inhabit the same garden in close proximity.

Monet may have accepted the rejection of the *Port of Honfleur* with some equanimity (after all, it had been a studio work, hastily produced), but he surely experienced the refusal of *Women in the Garden* as a deep narcissistic wound. Characteristically, his later mythic reconstruction of his reaction at the time emphasized his defiance and resilience rather than the distress he actually felt. For example, he claimed that Breton, when asked why he had refused the young artist's submission, had pompously explained: "It is precisely because he's making progress that I have refused him. Too many young people think only of pursuing this abominable direction. It is high time to protect them and to save art."[21] Monet also claimed that after it became evident that the alternative of organizing an independent group exhibition was not feasible, he decided to appeal directly to the public and arranged with two Parisian art shops to display the canvases originally intended for the Salon.[22]

Allegedly, while dining in a restaurant as his paintings were shown in these unorthodox venues, Monet overheard Manet (who had not yet met his younger colleague) ridiculing *Women in the Garden*. "I've just seen a picture by Monet called 'Women Out-of-Doors.' Can you imagine? Whoever heard of painting out of doors?" In another version of this incident related to yet another interviewer, Monet attributed Manet's shocked response to his first glimpse of *Port of Honfleur*.[24] The accuracy of such details, or even the veracity of the entire incident, is of minor importance. What fascinates is the unending nature of Monet's efforts, from his youth to old age, to establish the primacy of *his* artistic vision over those of Courbet and Manet. In a letter to Bazille dated June 15, 1867, Monet offered sharply critical reviews of the independent exhibitions Courbet and Manet had mounted that spring (in special pavilions constructed on the Place de l'Alma, strategically located between the sites of the Salon and the Universal Exposition):

> God, how Courbet has brought bad things out for us. He has brought a lot of blame on himself, because he had enough beautiful things not to put in everything. When I left, Manet's receipts were beginning to become more serious. This would have done a great deal of good for him, and then there are things, although I did not know them, the "Femme rose" [*Woman with a Parrot*, 1866, Metropolitan Museum of Art]—that's bad. He has done better than he's doing at this moment. God, how unfortunate it is to let oneself be praised as he has, because he ought to be making very good things.[25]

One wonders to what extent Monet's critical judgment was colored by his envy of the financial status that had enabled Courbet and Manet to undertake their costly ventures.

THE PSYCHOLOGICAL SIGNIFICANCE OF *WOMEN IN THE GARDEN*

In his old age, Monet loved to show *Women in the Garden* to visitors to Giverny. The passage of time had served only to confirm its importance as the inspiration for a new way of perceiving and painting figures in landscapes. As Gary Tinterow notes (and Monet himself must have realized), the composition "set the immediate agenda for Bazille and Renoir, and even Cézanne."[26] Nearly two decades later, the picture would exert influence on the young Georges Seurat, who surely carefully studied *Women in the Garden* (which remained on deposit with Durand-Ruel's gallery from 1882 to 1887) before undertaking *Sunday on the Island of La Grande Jatte* (1884–86; The Art Institute of Chicago).

Far more important for Monet's own artistic future, *Women in the Garden* also served as the prototype for a theme that he would develop during the 1870s: Camille as nature's ornament, the fairest flower displayed in the gardens the artist would cultivate at Argenteuil. *Women in the Garden* initiates this metaphor by representing Camille

touching, smelling, and plucking blossoms, while assuming varied poses demonstrating that, like a perfect flower, she appears beautiful from every angle—full face, in profile, or in motion, as she rushes forward with the grace of a rose touched by a breeze. By demonstrating Camille's perfection, Monet also implicitly proclaimed his love for her, his good fortune in attracting the love and loyalty of a young woman who although beautiful as a blossom, also possessed the talent to assume an active role in her lover's creative life. On a psychological level, the effectiveness of *Women in the Garden*, the most advanced of Monet's three heroic figure compositions of 1865–67, symbolizes the deepening commitment of the lovers to one another, as well as Camille's growing importance to Monet as his artistic partner.

In view of the significance *Women in the Garden* assumed in the inner world of the elderly artist, it is hardly surprising that when representatives of the French government approached him in 1921 to finalize details of Monet's proposed donation of the great *Water Lilies* murals (now installed in the Orangerie) to the state, the artist made it contingent on the government's purchase of *Women in the Garden*. He demanded—and received—the astounding sum of 200,000 francs for this wonderful child of his fancy, which had been so cruelly rejected by the art officials of an earlier era. Today it is one of the proud possessions of the Musée d'Orsay. As the ensemble sings in the concluding fugue of Verdi's *Falstaff*, "He laughs best who has the last laugh."[27]

Painted Metaphors for the Absent Woman

THE CONTEXT

Until Camille's pregnancy forced his hand, Monet had managed to keep his family in the dark about their liaison. His rejection by the 1867 Salon ended any hopes that favorable publicity resulting from his acceptance would lead to new sales and commissions. On April 8, he finally wrote to his father, informing him of his relationship with Mlle. Doncieux and the fact that she was due to deliver their child in July.[1] Two days later, Bazille—undoubtedly acting at Monet's request—also wrote *père* Monet to plead his friend's cause. Adolphe Monet immediately fired back a stern—and lengthy—response. His son's rejection at the Salon (which Bazille had evidently cited to invoke paternal sympathy), "albeit it affects me markedly on his behalf [for he] is so needful of advancement, cannot in any way influence our arrangements about him." If "Oscar" would agree to renounce the wicked ways he had followed for so long, Adolphe Monet would persuade his aged sister to receive him at Sainte-Adresse, where he could work in peace and tranquillity. As to the question of the mistress: "First of all, I'll confess that I was greatly surprised by that confidential [information]; these things usually remain silent [*dans le silence*]. . . . In the situation Oscar finds himself, he is neither obliged to hide nor to extricate himself."[2]

His father's recommendation that "Oscar" abandon Camille and their unborn child seems hypocritical, to say the least, in view of the fact that he was probably cohabiting with his mistress and their illegitimate daughter, or at least supporting them, when he penned these words.[3] Once again Monet's father provided a model of duplicity and mendacity, which his son skillfully mimicked in responding to the paternal ultimatum. Even more desperate for money than usual now that he faced the expenses for Camille's approaching confinement, Monet concluded that prudence dictated feigning submission to his father's demands and returning to Normandy, after providing as best he could for his mistress and their unborn child.

His friend's plight moved the kind and sensitive Bazille, who proposed a solution of sorts: *Women in the Garden* had failed to attract a buyer, so he offered to purchase the canvas himself for the sizable sum of twenty-five hundred francs (far more than any of Monet's other paintings had brought to date), payable in monthly installments of fifty francs. Monet quickly accepted. He also prevailed upon another friend, Ernest Cabadé, a medical student, to attend Camille's delivery. In lieu of a fee, Monet painted the young man's portrait, depicting him as a sympathetic, attractive person (w 100).

Cabadé must have considered this reimbursement quite satisfactory, for he retained the portrait in his personal collection (which eventually included three other canvases by Monet) throughout his lifetime. Another friend, Alfred Hatté, sublet a room in his spacious apartment as a space for Camille to live while awaiting the birth of the baby. The poor young woman accepted these conditions; after all, what choice did she have? Returning to her family of origin in her plight was not an option.[4]

Monet remained in the capital for several weeks after these tenuous arrangements were in place, presumably continuing to occupy Bazille's quarters after the latter had left for Montpellier taking *Women in the Garden* with him. That spring Monet and Renoir had begun working in concert on a series of views of Paris executed from various spots in the colonnade of the Louvre, and Monet completed three stunning compositions during this period (w 83–85); the last of the trio, *The Garden of the Princess* (w 85, Allen Memorial Art Museum, Oberlin College, Ohio), with its daring viewpoint, seems especially prophetic of the future course of his art. As regularly pointed out, it also reflects the influence of Japanese prints on the young artist. Their joint campaign that spring marked the beginning of an association between Monet and Renoir that would become still more intense two years later, when they would labor together to produce the epoch-making views of La Grenouillère, generally regarded as the beginning of Impressionism.[5]

Before leaving Paris, Monet visited Camille one last time and found her ill in bed and virtually without funds. He was able to ease her anxiety about the future a little by providing her with the proceeds from the recent sale of two oils, as well as by acceding to her fervent wish that he acknowledge paternity when the child's birth was registered.

Back in Sainte-Adresse, the artist deluged Bazille with letters that frequently went unanswered. In his first missive, dated June 25 (WL 33), Monet noted:

> I have been in the bosom of the family for a fortnight , as happy and as well as possible. People are being charming to me and now admire every brushstroke.
>
> I cut out a lot of work for myself. I have some 20 paintings underway, stunning marines and some figures and gardens, and in short, everything. Among my marines, I am doing the regattas of Le Havre, with many people on the beach and the harbor covered with little sails.

As his letter reveals, Monet had resumed the role of the precious wunderkind vis-à-vis his family. Well aware of his son's weakness for creature comforts, Adolphe Monet (no doubt aided by Aunt Lecadre, once again enacting her role as doting mother-substitute) deliberately exercised a corrupting influence on Claude, encouraging him to regress to the status of coddled child. Attempting to counter the regressive pull to which this environment was so conducive, Monet plunged into a frantic campaign of painting, pitting his formidable capacity for self-discipline against his parallel susceptibility to self-indulgence.

To his credit, Monet was discomfited by the contrast between his own luxurious living conditions and the difficult situation in which he had left Camille. Later in this same letter, he coupled these expressions of sympathy for her plight with the first of the pleas for financial help that would form a constant leitmotif of his correspondence with Bazille that summer. This time round he adopted a moderate tone; it would soon turn more strident:

> Ah my dear, after all what a painful situation, she's very nice, a very sweet child and has become reasonable, and precisely because of this she saddens me more. In this regard, I'm asking you to send me what you can, the more the better, send it to me for the first [of the month] because here, however well I [get along] with my parents, they have forewarned me that I could stay as long as I want, but if I need money, I'd better seek to earn some. So don't fail me, right? But I have a plea for you. Camille will deliver the 25th of July. I'll go to Paris, I will stay there 10 to 15 days, I need money for so many things. Try to send me a little more, even if it is only 100 or 150 francs. Think about it, for without this I'll be in a very awkward position. . . .
>
> Cabadé is supposed to take care of Camille and deliver her. [Hence] this already leaves me reassured, because the poor woman is quite alone. I don't know, Bazille, but it seems to me that it is rather evil [*mal*] to take away a child from his mother in this way. The idea bothers me. (WL 33)

This somewhat enigmatic passage suggests that Monet may have pressured his mistress into agreeing to surrender her baby (to a foundling home?) following its birth. A recognition that this scheme was as immoral as it was inconsiderate to Camille's feelings and the child's welfare evidently plagued Monet's conscience, as the dramatic developments recounted in his next letter to Bazille, written on July 3, reveal: "I am very disconsolate. I am losing my sight, can you believe after half an hour of work I can hardly see: the doctor says I must give up painting outdoors. What would become of me if this were not to go away?" (WL 34). Conflict and guilt had taken their toll. Monet had dealt himself the most telling blow his unconscious could devise: he was threatened by blindness if he continued working outdoors. This symptom threatened to nip his artistic career in the bud, forever ending the experiments *en plein air* that he recognized as central to the continuing evolution of his revolutionary new painting style. Although scholars have accepted the notion that Monet's ailment was organic in nature, resulting from the strain of overwork, this theory does not convince; later during his long lifetime Monet would spend countless hours working outdoors in all sorts of weather conditions, without complaining of visual problems until cataracts interfered with his superb vision during his last years.

Rather, Monet's visual symptoms of 1867 originated in his psyche, not his physiology, a classic example of conversion hysteria, that pervasive symptom of nineteenth-century civilization. In this syndrome, an *idea* is symbolically expressed by means of a functional alteration of the body: "I deserve severe punishment for my mistreatment of that sweet child—even blindness!" The lightninglike onset and equally abrupt disap-

pearance of Monet's visual problems fit the classic course of conversion symptoms to textbook perfection.[6]

In his next missive to Bazille, dated July 9, the artist *did not even allude to these visual troubles*, concentrating instead on an eloquent plea for the financial assistance that would enable him to help Camille in her hour of need. He concluded, "This is a very serious case, I would not like to have anything to reproach myself with in this affair." This sentiment represented the more mature, unselfish aspect of Monet's character, but he ended his letter with a confession that revealed his underlying desire to wish away the problem Camille had become: "Apart from that [i.e., Camille's pregnancy and tenuous situation] everything is coming along fine, work and family, and without this *accouchement*, I would be the happiest person" (WL 35). Monet's transitory visual symptoms should be examined in the light of this admission. As a blind man he could not assume the responsibility for his own welfare, let alone those of mistress and child. But the very blindness that would permit him to remain a pampered dependent would also deprive him of his prime motivation and pleasure in life, the creation of art. With marvelous psychic economy, Monet's transient conversion symptoms provided simultaneous relief and expiation.

The good Bazille soon responded to Monet, including not only a bit of money but also the advice about correct conduct in his difficult situation which Monet could not obtain from his hypocritical father. In the second of two letters he sent Bazille the day after receiving this reply, Monet pledged: "I expect to do for Camille and the child *as you advised me*. I feel very much bound to be in Paris to see for myself, because according to the behavior and appearance of the mother, I will see what I should do" (WL 36a, italics added).

Bazille, sensitive to his friend's conflict over the half-formulated plan to force Camille to surrender her baby, had evidently provided the humane counsel that Monet needed to hear. Obviously relieved that he had resolved his dilemma in an honorable manner, Monet ended this matter on the following note: "I work unceasingly. My eyes are better, thanks to the sun which has hidden itself for several days." His subsequent correspondence contains no further references either to forcing Camille to surrender the baby or to the visual problems that constituted his psychological response to the guilt engendered by that heartless scheme. As Bazille had perhaps anticipated, after the birth the sight of his "beautiful big boy" melted Monet's heart, and he not only acknowledged paternity but arranged to have Jean registered as the legitimate offspring of Claude Monet and his *spouse*, Camille Doncieux.[7]

Monet's joy over fatherhood didn't deter him from pressuring Bazille about money; in the very letter informing him of Jean's birth, Monet made a heartrending plea for funds, tailored to play on Bazille's sympathies:

> In spite of everything, I don't know how, I feel I am beginning to love [the boy], and I suffer at the thought that his mother does not have enough to eat. I was able to borrow the strictly necessary for the delivery and to come back here [to Sainte-Adresse], but neither she nor I have a healthy sou.

Oh, I am angry with you, my poor friend, repair your fault quickly and send me some money to Sainte-Adresse as soon as you receive my letter, answer me by telegraph, as I am too worried. (WL 37, dated August 12, 1867)

Bazille evidently failed to respond instantly, and in his next letter Monet pulled out all the stops, adopting a tone at once abused and abusive. Declaring that he could no longer "dare to believe" in Bazille's friendship, he ended his letter on the following note: "More than ever, I am in need, you know why, I am sick with it, and if you don't answer me, everything will be over between us; I will never write to you again, you can be sure of that. As to the payment in question, when it will please you to pay it, I will receive it gladly. For the last time, I tell you that I am in enormous need (WL 38)."[8]

MONET'S "WOMAN IN WHITE"

Among the "gardens and figures" Monet executed during the weeks immediately preceding Jean's birth, several paintings featuring a young woman in white seem especially noteworthy, both for their high artistic quality and for their psychological implications.

Clad entirely in white, the young woman stands alone in a sun-drenched suburban garden (figure 4.1). Facing away from the spectator (and from Claude Monet, the artist who portrayed her), her features remain forever unrevealed. One can discern only that she is a brunette with a slim, elegant figure. Shielding herself from the sun with a cream-colored parasol that complements her costume, she stands near a lush—yet carefully manicured—flowerbed filled with red geraniums and crowned by a blossoming tree, whose cascading white blooms provide an additional visual echo to her clothing. In this garden no breeze stirs, no leaf rustles; the quiet, almost palpable, adds to the mysterious quality of the scene, stirring one's curiosity. Who is this individual who conceals her face from us? Why does she remain alone in that hot, airless garden? Does she await the arrival of a lover, or has she fled to the garden out of ennui, preferring sun and solitude to the companionship available to her indoors?

Both the woman's white costume and her enigmatic character recall the equally mysterious protagonist of William Wilkie Collins's (1824–89) contemporary novel *The Woman in White*.[9] Collins's evocative descriptions of this uncanny personage (who, invariably clad in white, materializes, apparitionlike, at critical points throughout the novel) may have played a key role in inspiring Claude Monet to create *his* vision of a woman in white, *Jeanne-Marguerite Lecadre in the Garden*, during the early summer of 1867; it was almost certainly one of the twenty paintings, including several "with figures and gardens," on which Monet was working when he wrote Bazille on June 25 (WL 33). Although, as previously noted, Wildenstein (W 68) dates this picture to 1866, it belongs with the garden paintings of 1867, as Gary Tinterow has pointed out.[10] Monet himself assigned an 1867 date to the painting when he showed it in the Fourth Impressionist

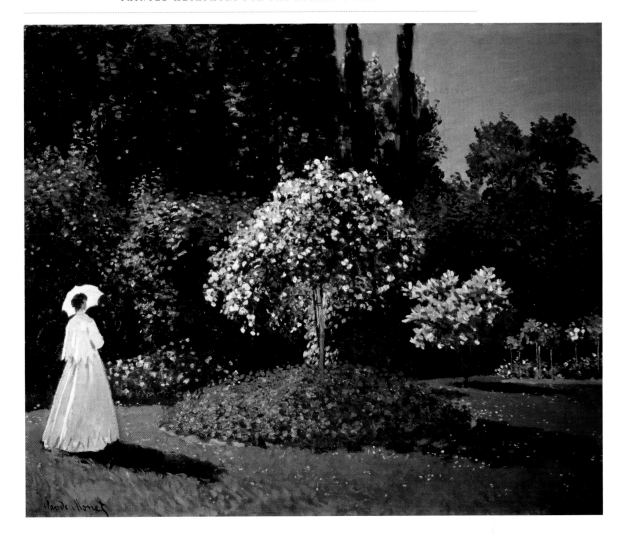

Exhibition, held in 1879. Like most artists, he was not always reliable in these matters, but there is no reason to presume that he misdated this picture, which had remained in the collection of Mme. Lecadre and her husband from the time Monet painted it until he borrowed it twelve years later.

In reality Jeanne-Marguerite Lecadre (1842–1917), far from being a woman of mystery, was simply Aunt Lecadre's great-niece and Monet's distant cousin, who posed for him several times that summer. Monet, however, repeatedly portrayed Jeanne-Marguerite not as herself but as the visual equivalent of Collins's enigmatic "woman in white."

By the time Monet painted *Jeanne-Marguerite Lecadre in the Garden*, Collins's novel—translated as *La femme en blanc*—was in the fifth of what would prove to be eight printings in France between 1861 and 1877. By contrast, the typical French novel of the period was published in one small print run and rarely reprinted.[11] The success Collins's story enjoyed in France was repeated throughout Europe and America. An early example of that popular detective-novel genre, *The Woman in White* became an international best seller as soon as it appeared in volume form on August 15, 1860.[12]

4.1. Claude Monet, *Jeanne-Marguerite Lecadre in the Garden*, 1867, State Hermitage Museum, St. Petersburg, Russia. Scala / Art Resource, NY

We have no definitive proof that Monet read Collins's novel, but it seems likely that he would have learned about the book from many sources, especially his acquaintances among avant-garde literati, in whose circles *La Femme en blanc* must have excited heated discussions. An avid reader throughout his lifetime, Monet surely would not have ignored a work that had attained the celebrity of Collins's novel, particularly since it featured an artist as the principal male protagonist.

Not only Collins's talent for vivid verbal description but also numerous details of the plot and characters of his story might have led Monet to think of *La femme en blanc* as he executed *Jeanne-Marguerite Lecadre in the Garden*, painted while he was facing a personal crisis that paralleled pivotal situations and events recounted in the novel. The plot of *The Woman in White* revolves around illegitimacy and substitute identities—multiple mysteries eventually resolved by the efforts of the artist-hero, Walter Hartwright.[13] Unbeknownst to the heroine, Laura, she has an illegitimate half-sister, Anne (the mysterious white-clad woman of Collins's title)—and the two villains of the novel (Laura's husband and a coconspirator) turn the sisters' physical similarities to their advantage. Anne's death, of natural causes, permits them to misidentify (and bury) her as Laura. In the end, the villains reap their just rewards: Collins invents horrifying deaths for both, freeing the widowed Laura to marry Hartwright and produce a legitimate heir to her property and fortune.[14]

The entwined themes of illegitimacy, secrecy, and duplicity which play such major roles in the Collins novel loomed equally large in the personal crisis that beset Monet during the summer of 1867. Like his father, whose relationship with his mistress and illegitimate child remained *dans le silence*, Monet had attempted to conceal his relationship with Camille and the impending birth of their child. His father's duplicitous behavior, conduct worthy of Collins's archvillain, served as a model of delinquency for his son. Confronted with his father's unfeeling response to his difficult situation, the artist concluded that prudence dictated subterfuge, a tactic also adopted by Collins's hero in his effort to protect his beloved Laura.

The artist no doubt had the painting of *Jeanne-Marguerite Lecadre in the Garden* underway by June 25, when he informed Bazille that the twenty canvases he had in progress included scenes of "figures and gardens." The spaciousness and formality of the garden in which the artist portrayed his cousin, as well as her chic costume (designed to be worn without crinoline, as the latest 1867 fashion dictated), might lead the viewer to conclude that his interest lay not merely in depicting the effect of bright sunlight on the human figure but also in extolling the comfortable lifestyle enjoyed by the *haut bourgeois* Lecadre family, whose members played an important role in the socioeconomic life of Le Havre.[15]

However, *Jeanne-Marguerite Lecadre in the Garden* also constituted a coded reference to the artist's current personal conflicts, signifying his guilt and distress over the precarious situation of his mistress vis-à-vis the secure social and financial position enjoyed by his cousin. The anonymous characterization of his representation of

Jeanne-Marguerite speaks to her symbolic role in the painting. Just as Collins cast his woman in white as the unwitting doppelgänger of his heroine, Laura, so Monet portrayed his cousin, also clothed in white, equally unaware that she was appearing, not as herself but as Camille's alter ego. Only four years Mlle. Doncieux's senior, Jeanne-Marguerite shared Camille's youth, elegant figure, and raven hair—physical attributes that made her an ideal stand-in for the artist's absent mistress, as she might appear if seen from the rear—if she were not pregnant. (In the late stage of pregnancy, the pelvis spreads to accommodate the impending childbirth, a transformation visible even when the woman is perceived from the rear.) In contrast to the multiple visions of Camille captured in *Women in the Garden*, celebrating her grace and beauty from varied perspectives, Jeanne-Marguerite is rendered as an elegant yet generic figure whose personal identity remains as clouded as that of Collins's doomed protagonist, Anne. From a psychological perspective, the iconography of *Jeanne-Marguerite Lecadre in the Garden* symbolized Monet's unspoken (and perhaps unconscious) conviction "Camille rightly belongs here; Jeanne-Marguerite is merely a simulacrum who has displaced her" (just as Collins's woman in white was posthumously utilized by the villains to usurp her half-sister Laura's persona and identity).

Monet included a second full-length representation of Jeanne-Marguerite Lecadre in another of the garden paintings he produced during the summer of 1867, the more daring—and justly celebrated—*Garden at Sainte-Adresse* (*Terrace at Sainte-Adresse*, figure 4.2), with its tilted oriental perspective, multiple focal points, and brilliant color zones. The influence on this composition of the Japanese prints Monet admired and collected has been universally recognized.[16]

In the *Garden at Sainte-Adresse*, Monet positioned his cousin at the far edge of the terrace overlooking the sea; turned to her right, she faces an unidentified male companion.[17] Once again Jeanne-Marguerite wears white; once again her facial features remain undefined. Monet has neither indicated the line of her profile nor articulated her eyes, nose, or mouth. By contrast, her companion's features are far more readable. At the rear of the terrace the artist portrayed his father, seated beside yet another woman in white, who also faces away from us; traditionally, and surely correctly, she has been identified as the artist's aunt Lecadre, who had functioned as a surrogate parent to her adolescent nephew following the loss of his natural mother. In the *Garden at Sainte-Adresse* she symbolically reprises that role—another woman in white with a covert identity.

In the *Garden at Sainte-Adresse*, as in the contemporary composition representing Jeanne-Marguerite in her aunt's garden, the young woman's image, with its veiled facial features, might easily be mistaken for that of (the nonpregnant) Camille. Unwitting puppet, Jeanne-Marguerite has once again assumed her assigned role as the pseudo-Camille, painted signifier of the absent beloved. But other references to Camille abound in the painting. As Virginia Spate suggests, the two empty chairs shown next to Adolphe Monet and Aunt Lecadre, although presumably vacated by Jeanne-Marguerite and her companion, might symbolically be reserved instead for others "absent from this family

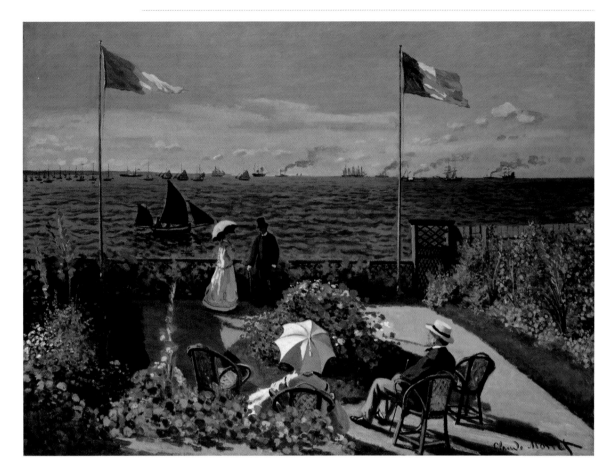

4.2. Claude Monet, *Garden at Sainte-Adresse*, 1867, The Metropolitan Museum of Art, New York, purchase, special contributions and funds given or bequeathed by friends of the Museum. 1967. ©The Metropolitan Museum of Art/Art Resource, NY

party": the artist and Camille. Spate also calls attention to the "mute and ambiguous quality of Monet's personae, who seem to demand a scrutiny quite different from the immediate, superficial recognition required of the spectator of anecdotal paintings in modern life."[18]

Joel Isaacson perceives references to Monet's conflicted personal situation in the disparity between terrace and sea: "The terrace is a protected place . . . presented as unusually calm . . . [while] the active sea and sky . . . suggest the content of Monet's thoughts, the nagging facts of life that threaten to obscure his artistic horizon. The outsize [black] boat, with its swelling sails . . . reminds one of the insistent presence of the pregnant Camille within the complex picture of his life at the time."[19]

On many levels, then, the *Garden at Sainte-Adresse* functions as another visualization of the artist's wishful fantasy that Camille might someday be accepted by his family, just as Collins's Laura finally regains her proper place.

Despite the fact that the *Garden at Sainte-Adresse* is freighted with so many covert personal references, it is a superb achievement; as Tinterow suggests, its large size ($38\frac{1}{8}$ × $51\frac{1}{8}$ in) and emphatic composition suggest that Monet intended the picture as a "demonstration piece." It certainly exemplifies the young Monet's boldness and originality; as the artist himself observed decades later in an interview with Gimpel, the painting was considered very daring when he created it.[20]

By the time Monet posted his first letter from Sainte-Adresse to Bazille on June 25 (WL 33), he had under way "regattas at Le Havre, with many people and the beach, and the harbor covered with little sails." Consonant with his report, *Regatta at Sainte-Adresse* (figure 4.3) depicts a cluster of people—locals and visitors—watching a sailboat race. Sea and sails assume primacy of place in this work, in which the beach occupies less than half the pictorial space, and Monet represents most spectators as tiny, generic images; he provides only enough detail to distinguish the working-class fishermen in their beached blue boat (waiting for the race to end so that they can return to their occupation?) from the bourgeois townsfolk or tourists grouped beyond them. The only figures presented in larger scale, the quartet depicted in the foreground, were most likely modeled on family members. We recognize the standing man gazing into the distance as *père* Monet, wearing the trademark panama hat in which he also appears in the *Garden at Sainte-Adresse* and *Adolphe Monet in a Garden* (discussed below); the remaining three personages have never been positively identified, although the features of the two men—in contrast to those of the woman—have been somewhat individualized. It seems likely that Jeanne-Marguerite, who repeatedly posed for Monet that summer, modeled for this figure as well. If so, Monet followed his characteristic pattern in depicting her as an anonymous white-clad, personage, whose face consists of little more than an amorphous blob of flesh-colored paint.

In both this scene and the most important composition of this series, the *Garden at Sainte-Adresse*, Monet underscored and embellished the role of the repentant prodigal son he played so well that summer, impressing his models with his diligence, skill, and dedication to his art. The latter qualities were real enough, but the members of

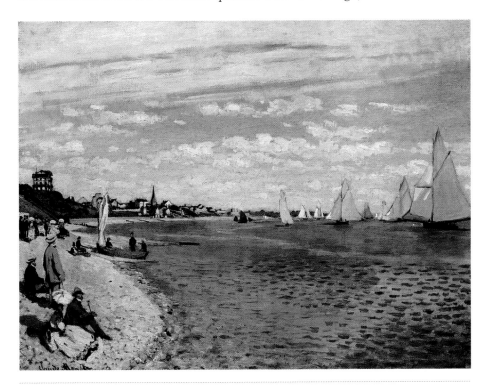

4.3. Claude Monet, *Regatta at Saint-Adresse*, 1867, The Metropolitan Museum of Art, bequest of William Church Osborn. 1951 © The Metropolitan Museum of Art

the Monet-Lecadre clan he portrayed enjoying a leisurely bourgeois existence were actually working just as hard as was the artist who portrayed them. Even in his youth Monet was a difficult taskmaster, requiring that his models replay their parts whenever weather conditions approximated those under which the composition was initiated, until he considered the painting finished or at least far enough advanced that he could dispense with their services.

Dating from these same weeks, *The Beach at Sainte-Adresse* (figure 4.4) constitutes a twin to the *Regatta at Sainte-Adresse*; virtually identical in size (approximately 29 ½ × 40 in), beach setting, and background view of Le Havre, the two compositions must have been conceived as a pair, although Monet never showed them together. In contrast to the leisurely bourgeois spectators who people the regatta scene, working-class folk are shown in *The Beach at Sainte-Adresse*, three fishermen clustered around a pair of beached boats. The weather conditions of the two pictures also contrast, the sunny conditions of the racing scene giving way to an overcast sky in *The Beach at Sainte-Adresse*.[21]

A pair of bourgeois onlookers also appear in *The Beach at Sainte-Adresse*, paralleling the cameo roles local fishermen play in the regatta scene. Depicted in minute scale in the middle distance, another woman in white and her masculine companion (who uses a telescope to get a better view) sit at the water's edge, gazing seaward. The most prominent of the boats in the harbor is a black vessel with its main sail billowing out, an image that recalls the craft pictured in *Garden at Sainte-Adresse*—whose billowing main sail reminds Isaacson of the very pregnant Camille. Do the bourgeois woman and the boat shown in *The Beach at Sainte-Adresse*, like the images in the garden scene, covertly contrast the comfortable middle-class status of yet another "woman in white" with Mlle. Doncieux's precarious situation and uncertain future?[22]

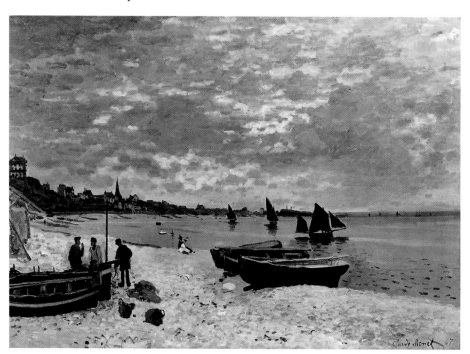

4.4. Claude Monet, *The Beach at Sainte-Adresse*, 1867, The Art Institute of Chicago, Mr. and Mrs. Lewis Larned Coburn Memorial Collection

As Wildenstein reports in the 1996 trilingual edition of his catalog (vol. 2, p. 38), radiographic studies of *Jeanne-Marguerite Lecadre in the Garden* disclosed that the protagonist had originally been shown with a companion: an elderly bearded gentleman wearing a panama hat who appeared at her right, standing directly across from the flowering tree. Both curators at the Hermitage and Wildenstein identify this sketchy image as the artist's father, wearing his trademark panama hat.[23] Although Jeanne-Marguerite seemed to be standing just a few feet from *père* Monet, he was depicted in such disproportionately small scale that he recalls those Lilliputian figures frequently illogically disposed in the middle-ground of paintings by Pontormo and other Italian Mannerists.

There can be no question of the artistic soundness of Monet's decision to eliminate his father's image, not only because it would have detracted from the visual and dramatic impact of Jeanne-Marguerite Lecadre's solitary figure but also because his strangely dwarfed proportions would have seemed unnatural. On a psychological level, the elimination of his unyielding father (dwarfed in his son's eyes by his duplicity and secretiveness) recalls *père* Monet's demand that his son eliminate Camille and their unborn child from *his* life. By burying the image of his father beneath concealing layers of paint, Monet left Camille's surrogate in sole possession of the beautiful garden. But Jeanne-Marguerite's slender figure also recalls Camille's appearance prior to her pregnancy. Did Monet magically eliminate not only the image of his infuriating father from his fantasy world but also the existence of his unborn child, whom—at that moment, as his confession to Bazille indicated—he longed to wish away as easily as he had eradicated the image of the paternal figure who had once shared the garden with Jeanne-Marguerite?

One wonders whether Monet's brief episode of hysterical blindness occurred in response to this act, in which he achieved, in the fiction of paint, the ultimate oedipal victory. (The artist-hero of *The Woman in White* enjoys a similar but "real"—and guiltless—triumph: in the closing pages of the novel, Laura's guardian, an irresponsible father-figure, dies of natural causes.) Did Monet, unwittingly following the plot of Sophocles' drama *Oedipus the King*, "blind" himself as punishment for this act of symbolic patricide?

Postscript: Monet's First Portraits of Jean

THE CONTEXT

Following Jean's birth, Monet continued to reside with his family of origin, paying surreptitious visits to his mistress and their baby (absences no doubt explained to his father and aunt as professional in nature). Camille was still living in the one-room "apartment" on the Impasse Saint-Louis where the artist had secreted her prior to Jean's birth. How frequently Monet visited his mistress and their child during the months following Jean's birth remains open to question. Wildenstein cites two paintings of baby Jean (w

101 and 108) as proof of Monet's presence on several occasions.[24] However, these pictures were obviously painted many months apart, thus providing scant evidence of the frequency of Monet's residences with his mistress and child. One hopes he came more often than the passage of time reflected in these two portraits would suggest.

Around the year-end holidays, Monet returned to Paris for a somewhat longer visit, sharing what must have been the very crowded, uncomfortable conditions of the single-room "apartment" with Camille and Jean. How long he remained in the capital, and how he explained his absence to his father and aunt, is unclear. In a letter to Bazille (WL 39), apparently written on January 1 (but devoid of any of the customary New Year's salutations), Monet gave vent to his frustration in singularly nasty language, emphasizing the pitiable conditions under which he and his little family were living, with no heat, the baby suffering from a bad cold, and he himself unable to satisfy creditors who would be demanding immediate payment the next day. Monet went on to accuse Bazille of promising to pay one hundred francs a month for *Women in the Garden* and then "reducing" the payment to fifty francs. He continued: "It is very painful for me to treat you like this, although you did not mind putting me in my place when I asked your father to have you answer me. After all, I can't remain like this without reminding you of your promise. I was always hoping that, seeing me in such a tight situation, you would, on your own, come to help me."

It is difficult to know whether Monet had actually repressed the terms of his agreement with Bazille, who had offered to pay for *Women in the Garden* in monthly sums of fifty francs, not one hundred, or whether he was simply pretending that had been their agreement. Even if Monet had convinced himself that his claim was accurate, the entire tone of his letter transcends all rules of polite discourse, let alone of a New Year's Day communication to his closest friend. *En passant*, he also revealed the shocking information that in his effort to pressure Frédéric he had dared to write Bazille *père*; one can imagine how that very proper gentleman reacted to such rudeness!

Bazille responded on January 2 with dignified restraint: "If I did not know how unhappy you are, I certainly would not take the trouble to respond to the letter that reached me this morning. You try to demonstrate to me that I do not keep my promises, but you have only succeeded in proving to me your ingratitude. As far as I know, I have never had the air of giving you charity. I know, to the contrary, better than anyone, the value of the painting that I have purchased, and I very much regret not being wealthy enough to offer you better conditions" (WPJ 15). Bazille then reviewed the details of their contract, pointing out that he had already paid Monet 980 francs, plus the cost of several frames he had requested and the fifty-four francs he had already sent for the month of January—the latter payment evidently "forgotten" by Monet. In summary, in addition to the (unspecified) expense for the frames, Bazille had paid 1,034 of the agreed purchase price of 2,500 francs for the painting.

Despite Monet's offensive letter, the kindly Bazille, whose conviction of his friend's abilities remained unshaken, soon managed to arrange the sale of one of Monet's still

life works to Commandant Lejosne. In a letter to his mother, written in the first half of January, Bazille characterized this still life as "beautiful."[25]

During that sojourn in Paris, Monet braved the freezing weather to commute to nearby Bougival, where for the first time he painted ice floes (w 105, 106), a subject that would assume singular importance in his future. He probably stayed in the capital no longer than a week before returning to Le Havre, where he remained until sometime in March, once again working outdoors in cold weather on the harbor and pier scenes he planned to submit to the Salon.

He returned to Paris just in time to have the two pictures framed and touched up before submitting them to the Salon jury on the March 20 deadline. The generous Bazille, also working on his Salon submissions, kindly invited Monet to share his studio, located conveniently near the Impasse Saint-Louis, where Camille and the baby were housed.[26]

THE EARLY PORTRAITS OF JEAN

Monet's first portrait of his son, *Jean Monet in His Cradle* (figure 4.5), depicts the infant at about four months of age, old enough to focus his eyes on an attending adult but not yet big enough to require a larger crib. He lies in his bassinet, snugly covered, wearing a charming little cap, and grasping the stem of a tambourinelike toy in his left hand. (The elegant floral covering and draperies of his cradle, as well as his attractive clothing and toys, seem inconsistent with Monet's alleged impoverishment at the time.) Little Jean, although awake, lies quite motionless, as though prematurely aware of the demands Monet made on his models (and would make on his son in a few years) to hold poses over long sessions. The baby's eyes, bright as black buttons, are focused not on the woman seated at his side but presumably on his father standing at his easel and looking down on the baby and his attendant. Immediately to the infant's right, one catches a glimpse of an adult bed, suggesting both the spatial limitations and the close watch Camille kept over her son.

The picture reveals more of the attendant personage's back than of her facial features. Nor does her clothing—her simple, dark dress and white dustcap—provide a clear clue to her identity. One would be tempted to suggest that she was a servant, had the little family the space or funds to hire help. She was formerly identified as Camille and later as Camille Pissarro's companion Julie Vellay; now, on the basis of the Beguin Billecocq journal, we can be reasonably certain that she represents a nurse hired by the count, who in all probability also provided the funds to purchase the elaborate bassinet.[27]

The identification of Jean's attendant as someone other than his mother seems entirely consistent with what would prove to be Monet's future insistence on depicting Camille as "unmother." With the exception of *The Luncheon* of 1868–69, he would *never* depict Camille and Jean interacting in any of the numerous compositions from the Argenteuil years representing them inhabiting the same physical space.[28]

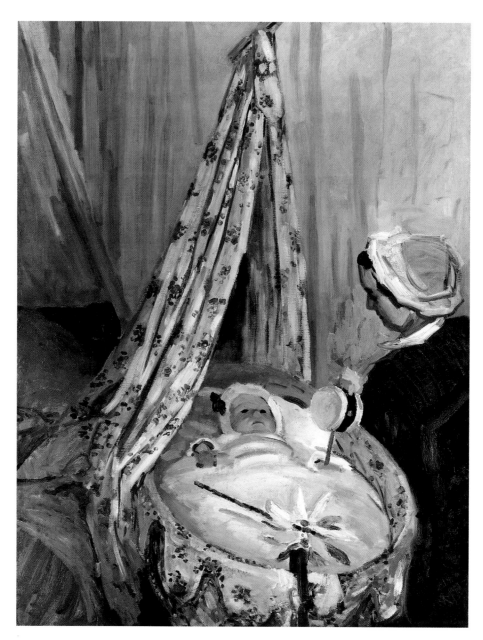

4.5. (*above*) Claude
Monet, *Jean Monet in
His Cradle*, 1867,
Collection of Mr. and
Mrs. Paul Mellon.
Image courtesy of the
Board of Trustees,
National Gallery of Art,
Washington

4.6. (*right*) Claude
Monet, *Jean Monet
Sleeping*, 1868,
Ny Carlsberg Glyp-
totek, Copenhagen.
Erich Lessing /
Art Resource, NY

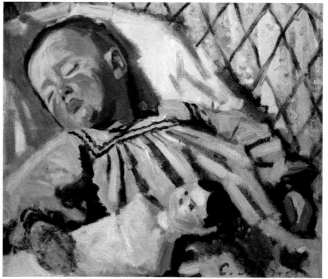

Monet's next portrait of his son (or, to be more accurate, the chronology of the picture assigned to 1867–68 by the catalogue raisonné, where it appears as w 108), *Jean Monet Sleeping* (figure 4.6), captures the somnolent child lying not in "his cradle," as Wildenstein indicates, but in a more adult-style bed with a proper pillow and linens. It does, however, have some sort of protective netting around it (visible at the rear of the picture), presumably to keep the boy from falling out of bed.

The boy's bodily proportions as depicted in *Jean Monet Sleeping* are markedly different not only from those recorded in the earlier portrait but also from those shown in another of Monet's depictions of his son, *Child with a Cup: Portrait of Jean Monet* (figure 4.7), signed and dated 1868. In the latter painting the boy is portrayed with the relatively large head and very short neck characteristic of children around a year to fifteen months of age. It seems logical to propose that the portrait *Jean Monet Sleeping* was executed later, during the family's stay at Etretat in the spring or sum-

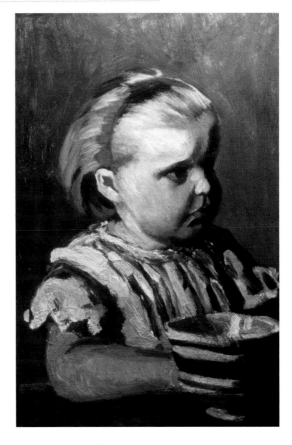

4.7. Claude Monet, *Child with a Cup, Portrait of Jean Monet*, 1868, Wildenstein Institute Archives, Paris

mer of 1869, when the boy was approximately two years of age, rather than in Paris during the late winter or early spring of 1867–68, as Wildenstein proposes.

Jean Sleeping represents him slumbering peacefully with his hand resting protectively over a mutilated, limbless doll, stripped of any clothing it might once have worn. We do not know whether the doll had been new when Jean received it or had already been damaged by a previous owner. (It is conceivable that it could have been a childhood treasure of Camille's, or, less likely, of Monet's, or even a gift from one of the Pissarro children.) If the doll had been new and intact when Jean received it, dismembering and stripping it would have required greater strength and dexterity than that possessed by an infant under a year of age (*pace* Wildenstein). However the toy met its misfortune, Jean must have been very attached to it, for the doll reappears in *The Luncheon*, 1868–69 (w 132, discussed and reproduced in chapter 6), lying beneath the chair at the lower left of the picture plane.

CHAPTER FIVE
Ariadne on the Grande Île
IN COLLABORATION WITH WILLIAM CONGER

THE CONTEXT

Scholars often point to the contrast between the seemingly serene character of Monet's painting *On the Bank of the Seine, Bennecourt* (*The River*) (1868; figure 5.1) and the turmoil that existed in his private life at the time.[1] Monet was, as usual, in desperate financial straits. His relationship with his father and Aunt Lecadre continued to be duplicitous: they still did not realize that he had not abandoned his mistress and child. Even after he left Le Havre that spring to live full time in Paris with Camille and Jean, he managed to disguise this fact from his family.

Monet eagerly awaited the decision of the 1868 Salon jury, hoping to score another major success comparable to that he had enjoyed with *Camille* in 1866. Thanks to the influence of Charles Daubigny, who headed the Salon jury that year, Monet did succeed in getting one of his entries, *Boats Leaving the Harbor of Le Havre* (w 89, now lost) accepted. However, Count Alfred-Emilien Nieuwerkerke, the imperial superintendent of fine arts, irritated by Daubigny's interventions throughout the selection process, insisted that Monet's other submission, the magnificent *Jetty at Le Havre* (w 109), be rejected.[2] *Boats Leaving the Harbor of Le Havre* failed to stimulate much critical or public interest, despite the favorable review published by Emile Zola, who discussed Monet's career at length, including works rejected by both the '67 and '68 Salons.[3]

Hounded by creditors, who stepped up their efforts after learning that Monet had a painting accepted by the Salon, Monet decided to flee Paris for the countryside, where living was cheaper and unspoiled motifs for painting readily available. Accompanied by Camille and Jean (then about nine months old), the artist left the capital in the late spring. They settled in Gloton, a hamlet near Bennecourt recommended by Zola, who had vacationed there in 1866 and 1867 and praised the region for its lovely sites as well as the generous cuisine provided by the Dumonts, proprietors of the local inn, where the Monets subsequently lodged as full pensioners.[4]

The artist executed *The River* during his brief residency in Gloton, which lasted about eight weeks. Around mid-June, Zola, his mistress Alexandrine Meley, the artist Antoine Guillemet, and the latter's wife joined the Monets at Gloton, renting rooms above the village smithy's abode, adjacent to the Dumont inn.[5] During this period Zola and Guillemet evidently observed Monet at work on *The River*, a circumstance discussed below.[6]

Monet's Gloton interlude ended with traumatic abruptness, as he informed Bazille, in a letter dashed off in Paris on June 29:

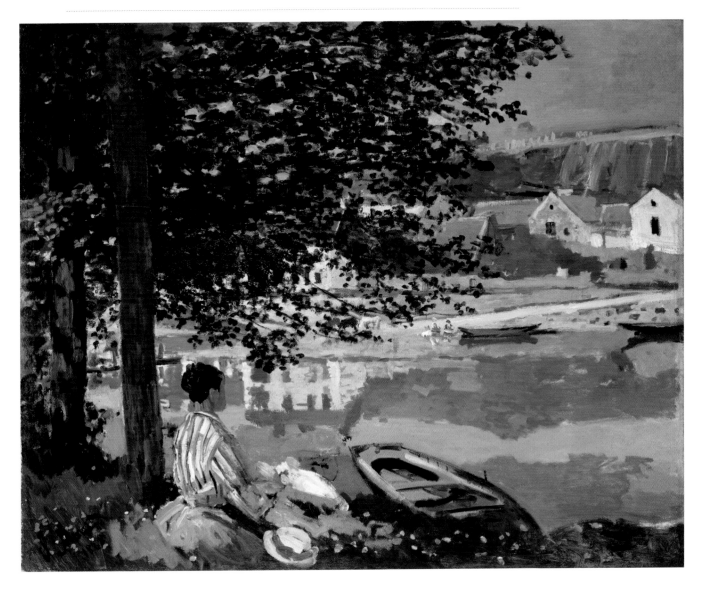

I am writing a couple of words to you in haste to ask for your prompt help, if that is possible, I was definitely born under an evil star. I have just been thrown out of the inn where I was staying, naked as a worm, I have placed Camille and my poor little Jean in [a] shelter in the country for a few days. As for me, I got here this morning and am leaving this evening for Le Havre to [call on my patron, M. Gaudibert] and try my luck.

Write to me as soon as you get this word and let me know whether you can do something for me, don't fail [to do] this; in any case, I await a word from you.

Write to me in Le Havre [in care of *poste restante*], as my family doesn't want to do anything for me anymore, and so I don't know yet where I'll sleep tomorrow.

In a dramatic postscript, Monet added: "I was so upset yesterday that I was foolish enough to throw myself into the water; luckily, nothing bad came of it."[7] (The significance of Monet's suicidal gesture will be explored later.)

5.1. Claude Monet, *On the Bank of the Seine, Bennecourt* (*The River*), 1868, The Art Institute of Chicago, Potter Palmer Collection

Whether the artist managed to take *The River* with him when he fled or did not regain possession of the canvas until late July, when the innkeeper, M. Dumont, sent the Monet family's belongings to him, is unclear. Whatever the circumstances of its preservation, Monet must have recognized even then that the painting demarcated a key moment in his artistic development, and his opinion about its importance did not change with the passage of time. Two decades later, he selected *The River* as one of only nine paintings from the 1860s to include in the Monet-Rodin exhibition of 1889.[8]

Monet scholars have confirmed the artist's judgment, hailing *The River* as "a canonical image in the history of early Impressionism" and "one of the first of Monet's works that can properly be described as 'an impression.' . . . Here, for the first time, Monet gives a structural role to reflections." Critics have also pointed out how successfully the picture conveys the sensation of recording an unique instant, "observed only for a moment or through half-closed eyes." Small wonder, then, that the work has repeatedly been likened to a painted discourse on the act of vision.[9]

Despite their consensus about the importance of the painting not only for Monet's career but also for the broader history of early Impressionism, scholars have disagreed about many aspects of the composition, ranging from such fundamental questions as whether it should be regarded as a finished work to relatively minor issues such as the identity and significance of the tiny figures portrayed on the Gloton bank.[10]

The persistence of such unresolved problems, as well as the fact that repeated evaluations of the painting conducted by the Conservation Department at The Art Institute of Chicago have never been completely published, led to a recent reexamination, which uncovered fascinating new evidence about Monet's procedures, including the complexity of the painting's evolution.[11] These findings provide new insights into the artist's inner world at the time of the picture's creation. A passage in Zola's roman-à-clef *L'Oeuvre* (1886), quoted below, not only confirms Rodolphe Walter's assertion that the novelist observed Monet working on *The River* but provides additional clues about the emotional conflicts the artist was then experiencing.

THE CREATION OF THE PAINTING

In selecting the motif for the painting, the artist simply rowed directly across from the Dumont inn and set up his equipment on the nearby Grande Île.[12] *The River* depicts Camille, clad in a simple country dress, seated on the grassy, flowering riverbank in the shade of two large trees.[13] Represented in *profil-perdu*, she seemingly directs her invisible gaze toward the buildings and shoreline of Gloton across from the island.[14] The river, its still surface unruffled by even the gentlest of currents, reflects, mirrorlike, inverted images of two structures: the blacksmith's abode, where the Zola party lodged, and the adjacent inn, where the Monets stayed.[15] Partially hidden from direct view by the fretted screen of leaves, the buildings reveal themselves more completely as inverted, watery reflections. One can also discern partial reflections of people and animals on the

opposite bank: the two women (perhaps accompanied by a little white dog), the cattle grazing nearby, and the two boats moored parallel fashion along the shore. Monet later changed the profile of the "actual" Gloton bank, which no longer matches its reflection, because he effaced the hill originally shown at the upper right, partially covering it with blue to simulate sky but leaving its brown tip readily visible, "floating" in the azure heavens.[16] Critics have observed (while offering contradictory opinions about the significance of the discrepancy) that clouds mirrored in the river also have no exact counterparts in the sky.[17]

Despite the aura of immediacy it conveys, *The River* was certainly not the product of a scene "observed only for a moment," as one critic has suggested.[18] To the contrary, the evidence reveals that several distinct working sessions took place.

As the x-ray (figure 5.2) and underpainting (reconstructed as figure 5.3) reveal, Monet originally represented Camille on a somewhat smaller scale, perhaps because he planned from the beginning to include Jean in the composition. The child's figure was certainly added early in the composition (figures 5.4 and 5.5). However, the fact that the little white dog was *also* perched on Camille's lap, with its body partially hiding her hands, creates some confusion about how she supported Jean. He is shown standing at his mother's left; she is grasping his right hand with her own right. In his free hand Jean grasped a round toy or some other circular object trimmed with ribbons. One can readily imagine that the baby shook this object vigorously, adding to his father's difficulties in portraying him.

At some point, Monet resolved this rather confused situation by retaining the dog while removing Jean's image, burying it beneath a paint layer that does not precisely match the surrounding area. The child's form has partially bled through the overpainting, rendering his ghostlike form and pink face (seemingly staring out at the viewer) visible to the unaided eye.

Thus, confronted with his own version of "The Lady or the Tiger," Monet decided to keep the dog's image in the picture while eliminating his son's. In so doing, he followed a more extreme version of the process he would adopt in later years, when he frequently portrayed Camille and Jean in the same painting but invariably emotionally isolated from one another.

Eliminating Jean required numerous modifications to the composition, including enlarging Camille's head and torso, extending her right hand, and reducing the area of the bank that had accommodated Jean's figure.[19] Monet executed several of these changes rather carelessly. For example, in enlarging his mistress's profile, he dragged paint from her dark hair onto her forehead; in retouching her chin, he violated his presketched outline of her profile, endowing her with the suggestion of a little beard (figures 5.6 and 5.7).[20] The rather vague white shape shown on Camille's lap (added to conceal some item of Jean's clothing?) may represent the same little canine Monet had shown her holding two years earlier in *Camille with a Small Dog* (figure 2.4).

The artist accomplished the necessary reduction of the island's profile by trans-

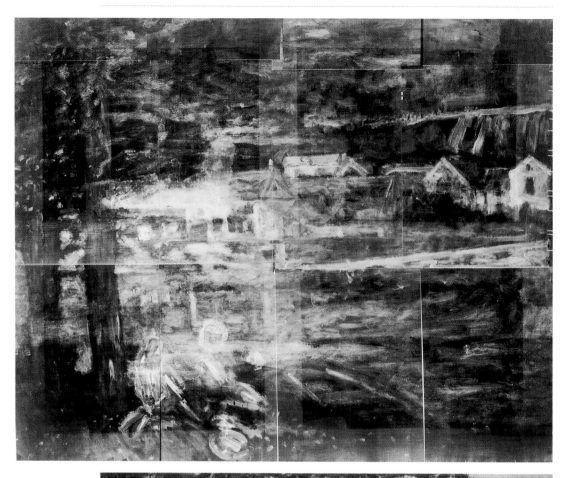

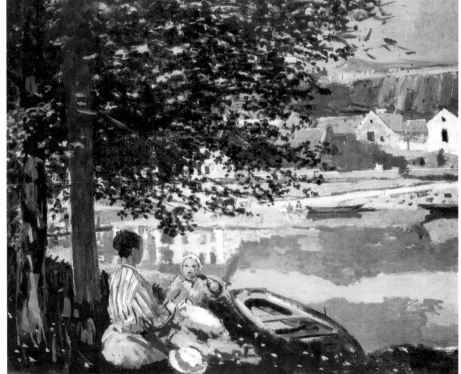

5.2. (*above*) X-ray of Monet's *On the Bank of the Seine, Bennecourt* (*The River*), 1868, The Art Institute of Chicago, Potter Palmer Collection

5.3. (*right*) William Conger (b. 1937), reconstruction of underpainted image, after x-ray of Monet's *On the Bank of the Seine, Bennecourt* (*The River*), 2006. Courtesy William Conger

5.4. (*top left*) X-ray of Monet's *On the Bank of the Seine, Bennecourt (The River)*, 1868, detail, The Art Institute of Chicago, Potter Palmer Collection

5.5. (*top right*) William Conger (b. 1937), reconstruction of Monet's *On the Bank of the Seine, Bennecourt (The River)*, 2006, detail of x-ray showing Jean Monet. Courtesy William Conger

5.6. (*bottom left*) Claude Monet, *On the Bank of the Seine, Bennecourt (The River)*, 1868, The Art Institute of Chicago, Potter Palmer Collection

5.7. (*bottom right*) William Conger (b. 1937), reconstruction of x-ray of Monet's *On the Bank of the Seine, Bennecourt (The River)*, 2006, detail of Camille's figure. Courtesy William Conger

forming land into water, submerging it beneath areas of bright cobalt blue to merge with the Seine. Changing the island's profile also altered the position of the boat; formerly nestled against the bank, its stern, now positioned diagonally, calls attention to the reflected buildings (figures 5.8 and 5.9). At some point Monet also changed the sizes and positions of the two trees on the island and added the little dots of bright yellow here and there amid the grasses, to simulate wildflowers.[21]

5.8. William Conger (b. 1937), reconstruction of underpainted image, after x-ray of Monet's *On the Bank of the Seine, Bennecourt* (*The River*), with boat against the bank, 2006. Courtesy William Conger

5.9. Claude Monet, *On the Bank of the Seine, Bennecourt* (*The River*), 1868, detail of boat pointed diagonally. The Art Institute of Chicago, Potter Palmer Collection

The more one studies these details, the more puzzling they appear. Monet seems to have deliberately left these reworked areas somewhat undefined, forcing the viewer to look elsewhere in the composition—most likely in the direction of Camille's gaze—for pictorial resolution. But the ambiguity of her form and that of the overpainted, quasi-excised child's image, plus the unprovable canine shape, prevent any certain conclusions about the artist's intent. (It is such ambiguities that have no doubt led some scholars to describe the work as unfinished.)

No concrete evidence survives to indicate precisely where or when Monet introduced all these changes. Were they executed at the site, in his quarters at the inn, or at a later date? He retained *The River* in his private collection, unexhibited and unpublished, prior to showing it in the 1889 exposition, and it is conceivable that he retouched it shortly before its belated public debut. However, the fact that Monet, typically so productive during these years even when on holiday, executed only one other work during his approximately eight-week stay at Gloton (a rough sketch painted at nearby Bonnières-sur-Seine [w 111], since lost) suggests that he introduced many—or all—of these changes while at Gloton.

Whenever and wherever Monet effected the alterations to *The River*, it almost seems as though he painted a second picture over an earlier one, a transformation accomplished with little or no effort to hide the effects of the reworking. Why did he choose to reveal the skeletal structure of these changes so nakedly, exposing earlier, as well as "final" aspects of the work? The turmoil implicit in his treatment mirrors the conflicts then governing his private life. (For contrast, one should compare the calm, carefully composed—and probably rapidly executed—painting that hangs near *The River* at The Art Institute of Chicago, *The Beach at Sainte-Adresse* (Figure 4.4), painted the previous summer while Monet sojourned at his aunt's summer home and the pregnant Camille remained behind in Paris.

MONET'S BEHAVIOR AFTER LEAVING GLOTON

Before I attempt to correlate the personal significance of *The River* for the artist with details of his procedures, it is necessary to return to events that occurred after Monet's departure for Le Havre. The arrangements he had made for Camille and little Jean were—to say the least—provisional. He left his mistress fundless, without the means to consult a physician or buy any necessary medicine for her sick child. In her desperation, Camille turned first to Zola for assistance and after his departure to Guillemet. In a letter to Zola, written on July 17, Guillemet summed up Camille's perilous situation as well as his response to her misery:

> When you departed [from Gloton] you left me with the Monet woman. I sent the husband an emotional letter dealing with the child's illness.
>
> My style had tears in its voice. Briefly, the painter's response was similarly emotional. He wrote the woman that affairs were arranging themselves and that in a short while they would be sheltered in the same alcove. The woman joyful. One waits a few days. The husband's letters become less urgent. The word "patience" appears 71 times in [a later] letter. [I] am drowned in the tears of the abandoned spouse and deafened in one ear by the cries of the child. Hence everyone's patience is exhausted.
>
> Wednesday morning, I finally get a letter from Monet. It contains [further] exhortations to be patient and gives accounts of superb excursions at sea, of bull-fights. . . . [I] share this with the abandoned woman [who collapses in a torrent of tears]. . . . [I] give advice in a weak voice to the poor abandoned one. It is to rejoin the unfaithful one at Le Havre.
>
> This advice is favorably received.
>
> I speak to Mme. Dumont about it, who doesn't refuse but requires that [M. Dumont] go with the Monet woman. They leave on Wednesday and arrive . . . at 9 p.m. Be the judge of the astonishment and *happiness* of the painter who has been chased down.

Guillemet added that, confronted by the innkeeper, Monet gave him four hundred francs, along with two promissory notes for the remaining amount owed. "Dumont *peut se fouiller* [can search his own pockets for the rest of his money], that's my opinion. He's going to send all their effects to Le Havre."[22]

THE PERSONAL SIGNIFICANCE OF THE PAINTING FOR MONET

There can be no question that Monet's decision to eliminate Jean's figure from *The River* reflected sound artistic judgment. Including the child would have distracted the viewer (all the more so because Jean would have been staring at the spectator), transforming the composition from a painted meditation on the act of vision into a genrelike scene featuring a mother and child who happen to be seated on a riverbank. One can

only wonder why the artist, who certainly cannot be described as the creator of genre compositions, seemingly initiated *The River* as a work of that type, only to eradicate the child's image so ruthlessly. Zola, who had evidently witnessed this incident, made it the basis of a fictionalized account described in *L'Oeuvre*. The scene occurs during the period when the novel's protagonist, the avant-garde artist Claude Lantier, his mistress Christine, and their baby Jacques are residing at Bennecourt. As soon as Jacques is old enough, his father attempts to paint the baby in an outdoor setting:

> They stripped him naked as a cherub and, when it was warm enough, laid him on a blanket and tried to make him keep still. But it was well-nigh impossible. Tickled and excited by the sunshine, he laughed and wiggled and waved his little pink feet in the air and rolled about and nearly turned head over heels. His father laughed, but ended by losing his temper and cursed the "damned brat who couldn't be sensible for a single minute," and wondered how anybody could think of painting as a laughing matter. Thereupon Christine would put on a severe look too, and hold the child so that his father could hastily sketch in an arm or a leg. He clung doggedly to the subject for weeks on end, captivated by the delicacy of the baby's coloring.
>
> He tried again and again, gazing at the child for hours on end, exasperated because the young rascal would not even go to sleep just when it would have been the best time to paint him.
>
> One day, when Jacques was crying and refusing to pose for his father, Christine said gently, "You tire him, poor darling. That's what's the matter with him." Then Claude was angry with himself and overcome with remorse. "Why yes, I suppose I do," he said. "I'm a fool to insist. Children aren't made for that sort of thing."[23]

In this passage, Zola—whose core plot device for *L'Oeuvre* hinges on the hero's consistent failure to produce the masterpiece he dreams of creating—transforms Monet's successful solution to a compositional problem into the tale of yet another of Lantier's botched, unfinished works. One suspects, however, that the frustration and rage the novelist attributes to his fictional artist were based on real-life observations of Monet's irritation as he attempted to represent Jean prior to deciding to eliminate him from *The River*.

The profound ambivalence toward his mistress and child that Monet was then experiencing played a key role in shaping the most unflattering image of Camille he would ever create—a depiction that unduly emphasizes her least attractive feature, her prominent chin, and makes her upper torso seem too heavy for her lower body. To appreciate fully the brutal quality of this representation, one has only to contrast Camille's appearance in *The River* with paintings featuring her that Monet created during the Argenteuil period. *Springtime* (1872; see figure 8.3), for example, also represents Mme. Monet seated on the grass amid spring blossoms but portrays her as a vision of youthful loveliness. By contrast, *The River* represents Doncieux not as an idealized figure but as an unvarnished symbol of nature; the grasses and flowers encroaching on her skirt suggest that she, like the neighboring trees, is rooted to the spot, transformed into a permanent feature of the riverbank.[24]

Like Theseus, who abandoned Ariadne on Naxos, Monet symbolically "planted" Camille on the island across from Gloton, a compositional solution that mirrored his real-life behavior when he left her unprovided for while he "sailed off" to join his family in Normandy. As Monet's letters reveal, he found the resources to indulge in carefree pleasures, oblivious to the effect such news might have on his mistress, who had been left to vegetate in Gloton with a sick child and no funds. Small wonder, then, that he appeared far from delighted when Camille, with Guillemet's assistance, "uprooted" herself and traveled to Le Havre to rejoin her lover. (Imagine Ariadne following Theseus to Athens!)

This interpretation need not imply that when Monet left Camille and Jean behind in Gloton he consciously intended to abandon them permanently, but motivations need not be fully conscious to shape one's behavior. The artist's confession to Bazille that he had tried to drown himself shortly before leaving Gloton has been regarded as a reference to a serious suicidal attempt. Walter, by contrast, expresses skepticism about the sincerity of this act: "A suicidal attempt on the part of a man reputed to be a good swimmer? [Or is it rather] a mise-en-scène intended to evoke pity from creditors, in this instance the Dumonts (landlords of the inn), or the prospective lender, Frédéric Bazille, to whom the confidence is addressed?"[25] Monet's suicidal gesture no doubt encompassed the motives Walter suggests, but it also constituted an unconscious act of symbolic expiation in advance for the sin about to be committed: abandonment of his mistress and child in a desperate situation.

His behavior in this instance recalls the episode of the previous summer when guilt over leaving Camille pregnant, ill, and impoverished in Paris while he returned to the familial comforts available to him at Sainte-Adresse precipitated transitory symptoms of imminent blindness, which then disappeared as abruptly as they had occurred. In the latter episode, as in his alleged suicidal enactment at Gloton, Monet's underlying guilt over his callous behavior vis-à-vis Camille and their baby triggered reactions that relieved his psychic distress and permitted him to enjoy the bourgeois comforts available to him in Normandy.

The disturbed behavior Monet showed in both situations reveals the same underlying process in operation: Until Camille became pregnant, he evidently treated her reasonably well. But her pregnancy tipped the scales. Immediately prior to Jean's birth, he temporarily "blinded" himself to his obligations to mother and child. In 1868 he symbolically "erased" Jean from his life by eradicating the baby's image from *The River*, while representing Camille in singularly unflattering fashion. The uncharacteristic crudity of Monet's technique in effecting these changes reveals the deep ambivalence he was then experiencing toward his little family. His willingness to leave such crudities of execution in a painting of such singular importance in his artistic development demonstrates that the formal aspects of a composition can be even more revealing of the artist's psychology than is its iconography.

The Myth of the Bourgeois Family

THE CONTEXT

Not daring to apprise his relatives of the fact that his little family had followed him to Normandy, Monet secreted Camille and Jean in a hotel room at Fécamp, where he joined them on August 1. The demanding, rather illogical letter he posted to Bazille five days later revealed that he remained far from reconciled to his new responsibilities. Unjustly blaming his friend for the fact that he found himself penniless and cooped up in a hotel room with a sick child, Monet urged Bazille to wire him immediately, sending not only his regular monthly fifty-franc payment but fifty additional francs so that he could pay the hotel and move his family into a small furnished house he had found in Fécamp, "which I could occupy if it weren't for your procrastination" (WL 41).

Monet's financial situation improved a month later, when his patron, Louis-Joachim Gaudibert, a wealthy young Le Havre resident, commissioned him to paint a portrait of his wife.[1] Since his "amateur," as Monet referred to Gaudibert in letters, refused to receive Camille and the baby, the artist left them in the rented lodging at Fécamp when he joined his patron at the latter's family home on September 7. Before departing he wrote Bazille, thanking him for (the presumably extra) forty francs just received but again begging him to send by courier any extra money he could provide, so that Monet could leave Camille with some funds and not arrive *chez* Gaudibert penniless. Despite the unreasonable tone of Monet's letter, Bazille evidently sent his irascible friend more than the fifty-franc monthly payment actually due.[2]

By the time Monet arrived at the Gaudibert family home, his patron's wife had left to visit her father at his estate, the Château des Ardennes outside Le Havre; meanwhile, Gaudibert's parents suggested that Monet should portray their son. Alas, the resulting image (W 120) did not find favor in their eyes, and they made no secret of their displeasure.[3]

Monet's "amateur" soon removed the artist to the friendlier atmosphere of the Château des Ardennes. There Monet executed the now-celebrated *Portrait of Mme. Gaudibert* (figure 6.1), together with a companion full-length painting of her husband (designed to replace the picture that had so displeased the subject's mother) and a bust-length image of the couple's son, then age three (W 212–13).[4]

During his stay at the chateau, Monet learned that Arsène Houssaye had purchased *Camille* for eight hundred francs. Unfortunately Léon Billot's review, intimating that the painting depicted a streetwalker, appeared in the *Journal du Havre* on October 9, while the jury of the *Exposition Maritime* was meeting. Did the resulting buzz of gossip about Monet's private life sway the jury? Whatever the reason, the silver medal Monet

6.1. Claude Monet, *Portrait of Mme. Gaudibert*, 1868, Musée d'Orsay, Paris. Réunion des Musées Nationaux/Art Resource, NY

had anticipated receiving was not awarded to him, and he had to content himself with one of the four (less prestigious) supplemental silver medals awarded later.[5] Moreover, the jury based its award solely on the merits of the two earliest paintings Monet had exhibited, *Camille* and *Port of Honfleur* (w 77), both completed in 1866, thus implicitly rejecting the more recent, bolder works he also showed: *Cabin at Sainte-Adresse* (1867, w 94) and *The Jetty at Le Havre* (1867–68, w 109, recently refused by the Salon jury). Despite the "royal" treatment he was enjoying at the Château des Ardennes, his separation from Camille, plus the succession of narcissistic blows, weighed heavily on Monet, inducing a mild depressive reaction he described eloquently in a letter to Bazille written in late October or early November:

> But all this is not sufficient to bring back my former ardor. Painting does not go well, and decidedly I no longer count on glory. . . . In sum, I haven't done a thing since I left you. I have become terribly lazy; everything bores me as soon as I want

to work; I see everything in black. With that, money is still lacking. Disappoint-
ments, insults, hopes, and again disappointments, that's it my dear friend. I sold
nothing at the Le Havre exhibition. I have a silver medal (value 15 francs), superb
articles in the local sheets, that is it: this provides little nourishment. Nevertheless
. . . I sold [*Camille*] to Arsène Houssaye, who came to Le Havre and was very
enthusiastic and says he wants to launch me.[6]

Monet's depressive mood seems to have been real enough. (The report by this superb
colorist that he was seeing everything in black is particularly telling.) But this incident
should not be used as evidence that he suffered recurring bouts of melancholia.[7] Pre-
cisely because his was not a true depressive personality, Monet's sadness and inertia
were short-lived and self-limiting.

MONET'S RETURN TO ETRETAT AND PRODUCTIVITY

By late October, Monet had rejoined his mistress and child and was happily installed
with them in new lodgings at Etretat, where Camille's love and support speeded the
artist's emotional recovery. The importance of her role as muse is underscored by the
contrast between his representation of her as *Camille* and his *Portrait of Mme. Gaudibert.*
The latter work, though beautifully rendered and obviously patterned on the formal
character of *Camille* (perhaps in response to a suggestion from Gaudibert himself?),
lacks the verve, animation, and enigma that make the earlier portrait so compelling.
Camille's talent as a model and his love for her sparked Monet's creativity; Mme. Gau-
dibert did not inspire. Unengaged by his subject—depicted as tall and slim, but rather
matronly looking for a young woman of twenty-two (note her sagging chin line)—
Monet rendered her as impersonally as if she constituted some new type of still life,
a "still life *vivant*"; he represented her as a symbol of contemporary haut-bourgeois
elegance rather than an individual personality. His rendition of her gown and setting,
however, is magnificent, reflecting the work's careful construction. Small wonder, then,
that the painting cost its creator great effort—a struggle little appreciated by Gaudibert
family members, except Louis-Joachim.

At Etretat Monet enjoyed a reunion not only with his little family but also with
the sea, which always nourished his creativity. In this watery environment he rapidly
recovered his élan and zest for painting. He also enjoyed a more conventional familial
life, and the profound ambivalence toward the responsibilities of fatherhood that had
previously characterized his reaction toward his son finally subsided. In an exuberant
missive to Bazille, penned at Etretat, Monet reported:

I am very happy and delighted . . . as I am surrounded by everything that I love. I
spend my time out in the open, on the shingle beach when the weather is bad or the
fishing boats go out, or I go into the countryside which is very beautiful here, that
I find perhaps still more charming in winter than in summer and, naturally I work
all the time, and I believe that this year I am going to do some serious things. And

then in the evening . . . in my little house, I find a good fire and a good little family. If you could see how [cute] your little godson is right now. My dear, it is delightful to watch this little being grow; my faith, I am really happy to have him. I am going to paint him for the Salon with other figures around him. . . . I shall make two paintings with figures this year, one an interior with the baby and two women and [another] of some sailors outdoors, and I'll do this in a splendid manner. Thanks to the Monsieur from Le Havre [Gaudibert] who comes to my assistance, I enjoy the most perfect tranquillity, since I am freed of worry, also my desire would be to remain like this always. . . .

And I believe that now it'll be a long time before I come to Paris, at most one month each year [presumably to submit to the Salon]. (WL 44, December 1868)

Monet ended this letter by asking Bazille to forward canvases left in his studio, a request he repeated more urgently—and ultimately less politely—in the four letters that followed.[8] He instructed Bazille to send them (along with any correspondence) to the Monet family home, 13 rue Fontenelle, Le Havre, where his aunt would see to their safekeeping. For the moment his relationship with his aunt remained cordial; she had not yet cut off his monthly stipend, an event that would occur several months later. The financial support he received from M. Gaudibert also contributed to Monet's improved morale (and no doubt encouraged his habitual extravagance). When, following the close of the Maritime Exposition, creditors seized his unsold paintings, his patron bought them back and restored them to the artist.[9]

THE CREATION OF *THE LUNCHEON*

Monet's productivity during the winter of 1868–69 closely matched his enthusiastic description to Bazille. He painted lively marines (W 124–27) and frosty landscapes, including *The Magpie* (W 133), one of the most magnificent snow scenes in his entire

6.2. Claude Monet, *Interior, after Dinner,* 1868–69, Collection of Mr. and Mrs. Paul Mellon. Image courtesy of the Board of Trustees, National Gallery of Art, Washington

oeuvre. And at day's end he did not always lay down his brushes, as the two nocturnal compositions *The Dinner* and *Interior, after Dinner* attest. Both pictures feature the play of light from an overhead oil lamp on individuals grouped around a dining-room table. *The Dinner* (W 120) depicts Camille and little Jean sharing their evening meal with an unidentified couple, perhaps the Sisleys. The companion *Interior after Dinner* (figure 6.2) represents the same setting later in the evening; the two women, both seated at the table, occupy themselves with handiwork, while their male companion

stands nearby, leaning against the mantel shelf. (Jean, presumably asleep by this time, does not figure in the second composition.)

The only nocturnal interiors in Monet's oeuvre, these pictures may have functioned as preliminary studies for the most ambitious composition he would create that winter, *The Luncheon* (1868–69; figure 6.3), a painting designed with the Salon of 1869 in

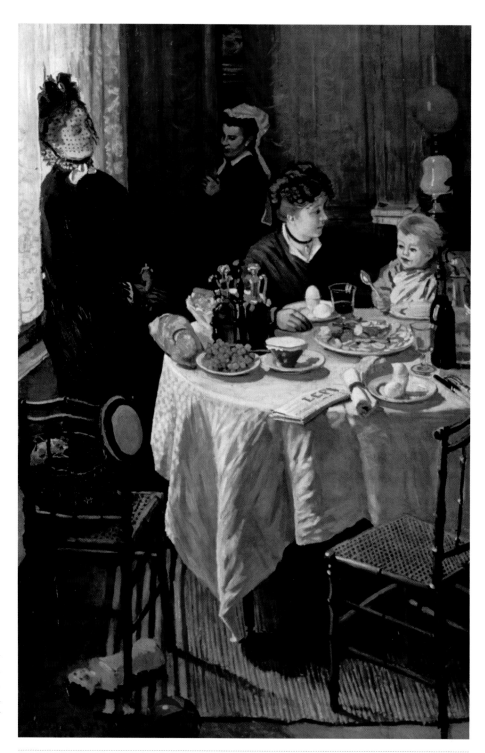

6.3. Claude Monet, *The Luncheon*, 1868–69, Städelisches Kunstinstitut, Frankfurt-am-Main, Germany / Bridgeman Art Library

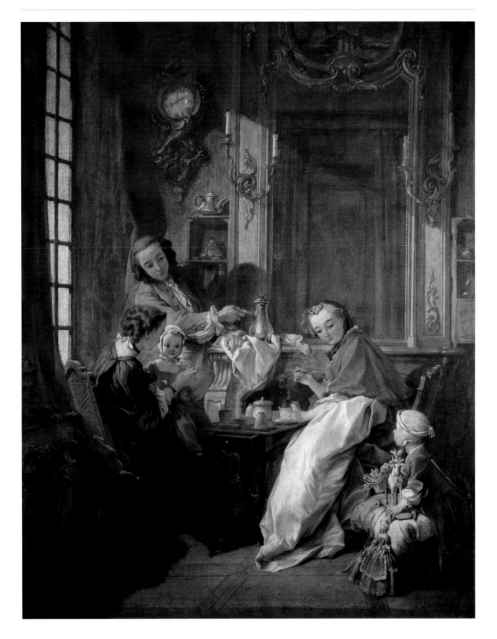

mind, as its large size (90⅛ × 39⅛ in), careful execution, and obvious relationship to earlier representations of the motif suggest.[10] But the composition, begun so enthusiastically, caused him considerable time and trouble, as its encrusted surface and craquelure reveal. Evidently still struggling with details of the painting as the deadline for the Salon submission approached, Monet requested an extension to complete his retouches, which that august body refused. The two pictures he sent instead, *The Magpie* (1869, w 133) and *Fishing Boats at Sea* (1868–69, w 126), were both rejected.[11]

Monet's luncheon scene seems so reminiscent of François Boucher's *Le déjeuner* (1739; figure 6.4) that it was surely painted with the earlier work in mind. Although Boucher's famous composition was still in a private collection in 1868, it had been engraved by Bernard Lépicié in 1744; Monet may have known the composition from this

6.4. François Boucher, *The Luncheon*, 1739, Musée du Louvre, Paris. Erich Lessing / Art Resource, NY

print, and perhaps he even owned a copy of it. Whatever the source of his knowledge of Boucher's picture, he was also clearly familiar with the assumption (which can be traced back to only the nineteenth century) that Boucher's painting depicts the artist's own wife and two young children.[12] Evidently accepting this interpretation as factual, Monet likewise represented *his* family at table, with Camille and Jean (now a vigorous toddler) assuming starring roles; the mother interacts with the child, just as she does in the Boucher. The two compositions share too many other commonalities to be attributed to coincidence. Both include a servant (a young man in the Boucher picture, an older woman in Monet's); both feature a female guest whose age and appearance closely mirror those of the mistress of the household. Monet probably modeled both figures on Camille, whereas Boucher may have used his sister to pose for the figure on the left.[13] Both works also represent the corner of a paneled room, with light streaming in from a large window at the extreme left.

If the tradition that Boucher depicted his own household is accurate, he utilized his composition to emphasize the luxurious lifestyle he provided for his family, apparent in the elegant furnishings, objets d'art, and woodwork represented. Although the interior Monet depicts is much less luxurious, both compositions celebrate the bourgeois values espoused by their creators. In reality, of course, Monet's lifestyle was neither very secure nor truly bourgeois—his financial condition, though temporarily stabilized, would soon turn precarious; moreover, Camille and he were not married, nor had their child been legitimized. In short, Monet's *Luncheon* creates a mythic version of his life situation at the time.

THE LUNCHEON AND THE RED CAPE: INTERRELATED AUTOBIOGRAPHICAL NARRATIVES

The Luncheon was not only one of the most ambitious paintings the twenty-nine-year-old Monet had essayed to date; it is also the most difficult to decipher of his early works. If one accepts, as I do, the view of scholars who date *The Red Kerchief* (*Portrait of Mme. Monet*) (figure 6.5, also known as *The Red Cape*, as it will be referred to here) to the Etretat period in 1868, the iconographic relationship between the two works becomes apparent.[14] On the most obvious level, they represent opposing views of Camille's status at the time. In *The Luncheon*, designed as a public work, she appears as the mistress of a prosperous bourgeois ménage, the successor to Mme. Boucher, whose husband was arguably the leading French artist of his epoch. *The Red Cape*, far smaller (39 × 31 ¼ in), more broadly handled, and evidently conceived from the start as a personal work, reflects a grimmer, more factual view of Camille's situation.

She stands alone in the snow, wistfully peering into French doors that separate her from the warmth of the indoors—and from the artist who paints her while comfortably ensconced in the interior to which she is denied access. Bundled in a heavy gray outfit that makes her seem bulky and shapeless, inadequately protected from the falling

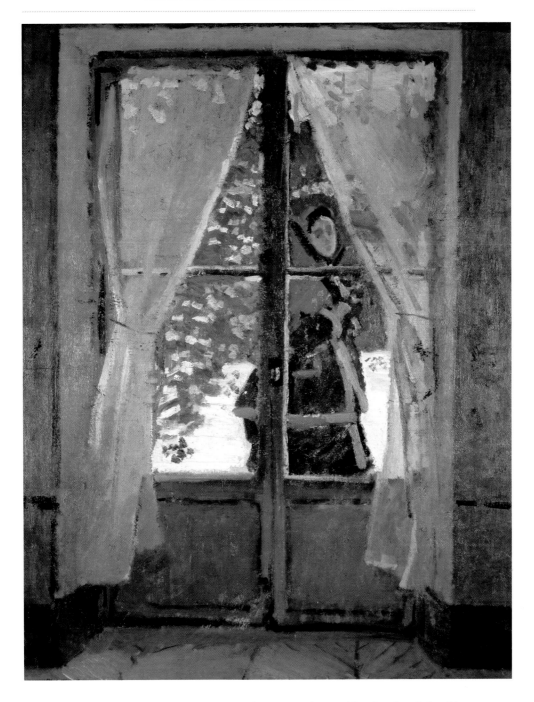

snow by an umbrella and the little red capelet wrapped round her head and shoulders, Camille is figuratively as well as literally "out in the cold"; her position as exile is underscored by the geometric grid of the window casement, which acts as a further symbolic barrier to her reentry to the interior.[15] Her poignant expression suggests not only her temporary physical discomfort but also her more enduring inner sadness. Her wistful mien recalls Guillemet's description (quoted in the previous chapter) of the endless tears Camille shed after Monet had abandoned her at Gloton, trusting to Zola and Guillemet to assume responsibility for his mistress and child. That *The Red Cape*

6.5. Claude Monet, *The Red Kerchief (Portrait of Mme. Monet)*, 1868(?), Cleveland Museum of Art. Erich Lessing / Art Resource, NY

had a special symbolic meaning for the artist is demonstrated by the fact that he neither sold nor publicly exhibited the work during his lifetime. (In his old age, he displayed the picture in his onetime second studio at Giverny, transformed into a private exhibition space.)[16]

As for *The Luncheon*, as Paul Tucker perceptively points out, "there is as much awry and disturbing in [it] as there is stable and reassuring." He suggests that the puzzling features relate to the confusions and conflicts in Monet's private life during the previous eighteen months.[17] In order to penetrate further into the layers of meaning encoded in *The Luncheon* and *The Red Cape*, one needs to approach them in the manner used to translate dream imagery into discursive language. One fruitful method is to compare that imagery to the actualities of the dreamer's life that ostensibly stimulated it.[18] With regard to *The Luncheon*, the analogous procedure would be to start with the differences between Monet's formal and iconographic solutions and those of its Boucher prototype, the alterations Monet introduced beyond showing his protagonists in modern dress and setting. The most obvious change from Boucher's composition involves the reduction of the number of visible participants from five to four: Monet has eliminated the older child, in line with the reality that Jean had no siblings at the time. By the same token, he has symbolically substituted himself as the fifth personage in the drama: the place setting at the table, complete with eggs, bread, and the folded newspaper, all signal the imminent arrival of the paterfamilias.[19] The artist's round hat, hanging on the spare chair on the left, further identifies the household as his own, as several portraits of Monet from the 1870s showing him in this headgear attest.[20] By contrast, Boucher does not intrude upon the scene he depicts, allowing the women and children to enjoy the pleasures implicit in this "chocolate break" without any painted symbols alluding to his presence (unless one subscribes to the theory that he represented himself as the waiter).

The visitor in Boucher's composition participates actively in the *déjeuner*, whereas in Monet's version she has no place at the table but is relegated to the extreme left of the scene. She is depicted in a black frock and a matching hat whose dotted veil covers her face; only the white accents around the neck and cuffs of her dress relieve the funereal gloom of her costume. Her figure gave Monet a great deal of trouble, as the tortured surface of this area and Bazille's sketch of the composition at an earlier stage (figure 6.6) attest. Initially Monet had clothed the visitor more informally in what Bazille's drawing suggests was a more form-fitting costume that emphasized her breasts. Monet also altered the more comfortable position depicted by Bazille, who showed her leaning against the windowsill supported by her arms and hands, to represent her half-perched on the sill with her hands clasped before her, a pose that appears rather awkward and unstable.[21] Isolated from the other protagonists by the chair and open door that seemingly hem her in, she intently observes the interaction between Camille and Jean, who ignore her presence, as does the uniformed maid (clad in the traditional black outfit with white headdress and collar). Who is this mysterious visitor? There has been much

scholarly controversy about whether Camille posed both for this figure and for the mother (the position I take).[22]

Despite the composition's seeming fidelity to the facts of observation, with the introduction of the enigmatic guest Monet has abandoned portraying the actualities of family life, in which the visitor appears to have no role. She is both there and not there. One might say that Monet has depicted an apparition, a being who does not coexist with the living but is capable of entering their realm without their awareness. From the "woman in white," Camille has been transformed into a woman in mourning. This is the first reference to death in Monet's surviving oeuvre. The presence, beneath the chair on which the artist's hat hangs, of the damaged, unclothed doll, which has lost not only its clothing but its arms and legs, adds to the elegiac character of the work. What a contrast separates this bedraggled toy from the elegant doll depicted by Boucher, clad in an exquisitely detailed costume whose cut and color harmonize with the blue of her little mistress's gown as well as the frock of the visitor and the coat of the manservant. If Monet's doll suggests dismemberment and death, Boucher's perfectly reflects the joie de vivre of the Rococo period.

6.6. Frédéric Bazille, *Three People around a Table (Study after Monet's "The Luncheon")*, 1869–70, Musée du Louvre, Paris. Réunion des Musée Nationaux / Art Resource, NY

The paradox of the visitor's identity in *The Luncheon* can be resolved if we assume that the past can be superimposed on the present, as is the case with dreams. Thus a young woman in mourning may symbolize a woman who died young, like Monet's mother. Such an interpretation could also explain the introduction of the maidservant. (There was no compelling reason to echo Boucher's serving man, after all, and her position in Monet's picture seems both cramped and ambiguous.)[23] Her conventional black uniform can also pass for an outfit appropriate in bereavement. Does this figure reflect memories of Aunt Lecadre's raiment following Mme. Monet's death? If so, the artist has introduced into this composition of his nuclear family memories of the support he had enjoyed in earlier years from two loving maternal beings.

In this view, *The Luncheon* represents an unconscious attempt to look for solace in the remembrance of things past. Through this work Monet assures himself that, because of these positive memories, he will not succumb again, as he did some months earlier, to the temptation to abandon Camille and their child. Two contemporaneous portraits of Jean (w 108, 131) similarly undo the artist's action in eliminating his son from the definitive version of *The River*, executed the previous spring.

On an even deeper level, the fact that Monet has symbolically substituted himself for Boucher's four-year-old daughter (who is, by the way, depicted wearing a hat similar to Monet's) suggests that *The Luncheon* also taps into early childhood memories. In this sense the toddler, receiving the sole attention of both mother and visitor, stands for Claude's childhood self. In the reconstitution of this dreamlike world Monet has eliminated a child-rival (as he did in *The River*). In *The Luncheon* it is his older brother Léon who has been exiled. Such had to be the prehistory of the lordling discerned by Renoir.[24]

The obverse of this myth of a childhood nirvana is the image of the exiled Camille in *The Red Cape*, in which Monet shows real empathy for the young woman's pathetic situation. Her face, though sketchily rendered, conveys anxiety, yearning, and grief.[25] Yet his sympathy for Camille did not prevent him from demanding that she stand in the damp and cold, perhaps for hours, even repeatedly, while he, snug and comfortable indoors, captured her pathetic image in paint. Although in fact he never again abandoned Camille, *The Red Cape* symbolizes his continual temptation to give in to Aunt Lecadre's bourgeois conventionality (and his father's duplicitous demands) by repudiating his mistress.[26] In that sense, *The Luncheon* may also represent Monet's guilt about allowing his aunt so easily to displace his real mother. In Camille's image as the visitor, his mother's spirit is about to come through the barred entrance.

If Monet had actually seen Boucher's *Le déjeuner* rather than merely the black-and-white engraving of the picture, Camille's red cape would contribute the only sad reference to her connection to such *bonheur de vie*, for it echoes the red shade of the little cape worn by Mme. Boucher in her husband's picture.[27] Monet's luncheon scene, however, omits the lively accents of color that lend such a joyous character to Boucher's painting. By contrast, *The Luncheon* seems rather somber; unlike Boucher's protagonists who all (even the doll) wear colorful costumes, Monet's maid and visitor both wear black, and the young mother is clad in brown; even the baby's outfit is a neutral gray; only the jam, grapes, and other foodstuffs, the creamy-white curtains, tablecloth, and napkins, and, of course, the magnificently depicted play of blond light relieve the prevailing sobriety of costumes, paneling, and rug. This sobriety is even more marked in the two smaller nocturnal interiors that were more or less preparatory for *The Luncheon*.

In addition to its status as the first of Monet's works to depict the themes of love and death, as well as the earliest of his "mystery paintings," *The Luncheon* is unique in two other ways: in its open reliance on a composition of the eighteenth century as its model and its almost overt admission that Camille symbolizes not only herself but also his dead mother. Only in one other work, *La Japonaise* (1875–76, discussed in chapter 11), would Monet confess in paint his propensity to equate Camille with the lost beloved of his childhood.

Honeymoon and Exile

THE CONTEXT

Following the rejection of his paintings by the Salon jury of 1869, Monet again appealed to the shopkeeper Louis Latouche, who readily agreed to exhibit one of the artist's (unidentified) studies of Sainte-Adresse; installed before the Salon even opened, the picture attracted considerable attention.[1]

Meanwhile, Monet, who had been staying with Bazille while preparing for the Salon and awaiting the jury's judgment, now moved with his little family to Saint-Michel, a hamlet near Bougival, not far from Paris, a location that would serve as their primary residence until they left for Trouville in the summer of 1870.[2] Monet's financial situation was more desperate than usual: his rejection by the Salon had eliminated sales that might have resulted from favorable publicity, and Aunt Lecadre, angry and embarrassed by the gossip about the unconventional family life her nephew was living so close to Le Havre, permanently terminated her support. Gaudibert, who helped finance the move to Saint-Michel, could provide no further assistance.[3] The income from a sale or two, plus the monthly payments from Bazille, provided the Monets with a very scanty living indeed.

Desperate for funds, the artist sent Bazille a series of hectoring, aggressive letters, upbraiding him for failing to send his payments promptly, demanding additional help, and claiming that Monet lacked the money not only for colors but even to buy food for his starving family. Wildenstein calls Monet's appeals to Bazille pathetic, adding, "There was a great gulf of incomprehension between the well-off young man on holiday at Méric and the indigent painter whose child was starving."[4] From another viewpoint, Monet's letters seem angry and melodramatic, exaggerating the severity of the situation. Bazille, his patience exhausted after being battered by several of these missives, finally ironically suggested that were he in Monet's shoes, he would walk to Le Havre and chop wood for a living. Monet responded with naked fury:

> This is to tell you that I didn't follow your inexcusable advice to walk to Le Havre. I am a little more fortunate this month, compared to the previous ones . . . [because] I sold a still life and was able to work a little. But as always I am stopped for lack of colors. Happy mortal [you], you are going to produce lots of canvases! I alone will have done nothing this year. That makes me furious against everyone, I am jealous, nasty, enraged; if I could work, everything would be all right. You tell me that neither 50 nor 100 frs. would get me out of [this] business; possibly so, but by this reckoning all I have left is to break my head against the walls, for I can't count

on any instantaneous fortune, and if all those who talk to me like you had sent me some 50 or some 40 frs., etc., I certainly wouldn't be where I am. . . . You tell me in earnest, for so you think, that in my place you would chop wood. Only people in your position believe that, and if you were in mine, you might be more disconcerted than I am. It is harder than you think, and I bet that you'd chop little wood.[5]

Amazingly, Monet ended this letter with a request that Bazille send him a shipment of wine from Montpellier: "Couldn't you arrange to have a bit sent to me and deduct the price from the amount you owe me? At the very least, we wouldn't be drinking water so often, and it would constitute a bargain. You cannot know what a [great] service that would be for us, for [wine] is a great expense. . . . Write me by the first [of the month]."

Of course the Monets, like all French families, were accustomed to having wine with their meals, but this request does cast doubt on the artist's repeated claims to Bazille of their desperate poverty. Would the head of a family actually living on the edge of starvation make such a request?

THE BIRTH OF IMPRESSIONISM

Despite his straitened financial situation, Monet enjoyed a productive period at Bougival, where artist friends were close at hand: Pissarro lived in nearby Louveciennes, and Renoir was staying with his parents at Voisins, also close to Bougival.

That summer, Monet and Renoir painted side by side at La Grenouillère, the working-class bathing station on the Seine at Bougival, where they produced a series of compositions universally hailed as the first true Impressionist paintings.[6] The partnership that developed between Monet and Renoir as they worked together emboldened both artists to engage in greater levels of experimentation. The paintings Monet completed at the bathing resort, such as *La Grenouillère* (figure 7.1), reveal how rapidly his Impressionist style had evolved since *The River*, executed only a year earlier. In contrast to the mirrorlike images reflected in the still waters of the Seine in that composition, he now depicted the stream in constant motion, its broken reflections rendered in rapid, distinct brushstrokes and vivid colors. Although Renoir worked from vantage points close to Monet's, his compositions seem (at least to this eye) less daring and more gentle, his wavelets less choppy. The two artists also represented the populace of the resort very differently. Renoir not only typically showed his personae from a closer viewpoint but preferred to depict them in street clothing rather than bathing costumes. In his version of *La Grenouillère* (figure 7.2), for example, the personae appear more decorous, more middle class, than do Monet's figures in his *La Grenouillère*, where individuals are portrayed vividly and wittily but from a more distanced physical and emotional vantage point. Monet's feminine personae in both *La Grenouillère* and *Bathers at La Grenouillère* (w 135, National Gallery, London) are represented in figure-revealing bathing suits that are anything but flattering. Note the two women standing on the left of the little artifi-

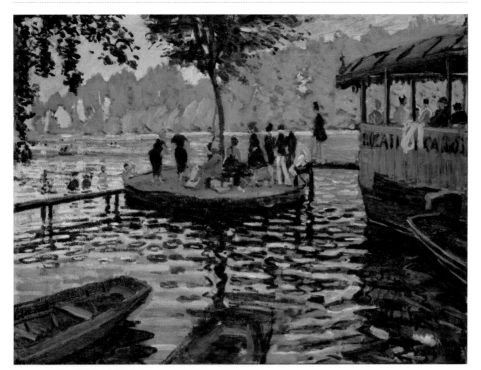

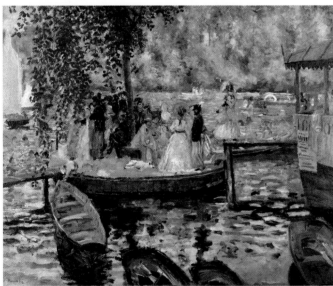

7.1. (*top*) Claude Monet, *La Grenouillère*, 1869, The Metropolitan Museum of Art, New York, H. O. Havemayer Collection, bequest of Mrs. H. O. Havemayer. 1929 © The Metropolitan Museum of Art/Art Resource, NY

7.2. (*bottom*) Pierre-Auguste Renoir, *La Grenouillère*, 1869, Kunstmuseum, Winterthur, Switzerland/Bridgeman Art Library

cial island, the so-called flowerpot, in Monet's *La Grenouillère*. Their amusing shapes, postures, and gestures recall the fact that Monet had initiated his juvenile career as a caricaturist. Perhaps when depicting people from a working-class background, as was the case with the folks who frequented La Grenouillère, Monet automatically reverted to a quasi-caricatural mode of presentation.[7]

Rather surprisingly, Monet may not have depicted Camille at all in 1869; Wildenstein assigns *The Landing Stage* (w 138, private collection) to the La Grenouillère site and period, an attribution challenged by the authors of *Monet in Holland*, who more convincingly retitle it *Garden House on the Banks of the Zaan* and date it 1871.[8]

Monet spent the late fall and winter painting sites in the nearby countryside; several canvases show the road to Louveciennes (where he often stopped to visit Pissarro) under autumnal and wintry conditions.[9] Except for occasional trips to Paris in search of customers, and an excursion to Fontainebleau, where he painted the *Boar's Head* (W 146, Museum of Modern Art, Cairo), Monet seldom strayed far from Bougival. As Wildenstein observes, Monet's brief absences from home reflect his contentment with domestic life; gone was the ambivalence so evident in his artistic and personal behavior in the spring of 1868.[10] That winter he painted the *Portrait of Jean Monet Wearing a Hat with a Pompom* (W 142; see figure 8.2); the boy appears more grown up and rather solemn—perhaps even a bit petulant—as he poses for his father. Contrary to Monet's dire claims to Bazille earlier that year, Jean appears both well nourished and well dressed.[11]

In his earlier, angry letter of September 25 to his friend, Monet had contrasted his situation with that of Bazille, who had the means "to produce a number of canvases," while Monet's dream of transforming one of his "bad sketches" (*mauvaises pochades*) of La Grenouillère into a more finished composition suitable for the Salon was destined to remain "but a dream" because he was too impoverished to buy the necessary paints. But some change of fortune must have occurred, improving Monet's financial situation as well as his mood. In any event, he did submit a version of *La Grenouillère*—probably a finished work rather than a sketch—along with *The Luncheon*, 1868–69, to the Salon jury of 1870.[12] The mean-spirited rejection of both of Monet's paintings by the jury led Charles Daubigny to resign from that body in protest.[13]

On June 28, 1870, Claude Monet and Camille Doncieux were finally married; Gustave Courbet, Gustave Monet (whose relationship to Claude is not known), and two of the artist's admirers, Paul Dubois and Antoine Lafont, served as witnesses. Although no members of Monet's immediate family attended the simple ceremony, Camille's parents, who were probably present, provided her with a dowry of twelve thousand francs, the principal to be paid on the death of her father. They included several clauses in the document specifying that her worldly goods be kept separate from those of her husband, a step evidently designed to protect her personal money from Monet's creditors. At the time of their marriage, Camille received twelve hundred in cash, which represented two years' interest on the principal.[14] Emile Zola once again borrowed from Monet's real-life experiences in describing the wedding of Claude Lantier and his mistress. Using clues from the novel, Charles Mount was able to uncover the records of the Monet-Doncieux wedding, including the terms of Camille's dowry as spelled out in the marriage contract.[15]

No doubt the threatened outbreak of the Franco-Prussian War played a causal role in shaping Monet's belated decision to marry Camille.[16] Before leaving for his honeymoon, Monet sent a packet of paintings to Pissarro at Louveciennes for safekeeping, presumably, as Wildenstein suggests, to prevent unsatisfied creditors from seizing the pictures.[17]

Did Monet also hope that legitimizing his relationship with Camille would lead to a

reconciliation with Aunt Lecadre and his father? The artist's decision to use part of the modest interest payment from Camille's dowry to finance a wedding trip to Trouville, just across the mouth of the Seine from Le Havre, may have been made with such hopes in mind. As it turned out, it was too late to mend fences with Mme. Lecadre, who had been ill for some time; she died on July 7, just nine days after Monet's wedding.[18]

On July 19, France declared war on Prussia; subsequently the French armies, ill equipped and poorly led, were defeated in one battle after another. On September 4, two days after the capitulation of the main French army at Sedan, the Second Empire was ended, and the Third Republic was established with its provisional National Defense Government.[19]

Meanwhile Monet, seemingly not too worried about being drafted (as Renoir had been), stayed on at Trouville, where Eugène Boudin and his wife had joined the newlyweds on August 12. However, the declared intent of the provisional government to continue the war until victory was achieved finally spurred Monet to alter his plans; determined to avoid being forced to fight in a hopeless struggle, he returned to Le Havre around the beginning of September, leaving Camille and Jean behind at the Hotel Tivoli (where, as usual, he owed a large bill). He obtained a passport in Le Havre on September 5 and visited his father, who was ill. He lingered on there for some time; on September 9 he wrote Boudin at Trouville, enclosing a letter for Camille, which he did not dare to send her directly, for fear that the owner of the Tivoli would set creditors on him if he learned of Monet's whereabouts (WL 55). Although his letter suggested that Monet intended to return to Trouville as soon as he had secured the necessary funds to pay the hotelier, he finally left for London without either going back to Trouville or, presumably, settling his hotel bill.[20] Whether Camille and Jean joined Monet at Le Havre or left for England later is unclear, but the latter hypothesis seems more likely. (How and where Camille obtained passports for Jean and herself is not known.) By October the family had been reunited in London, where the artist rented rather elegant quarters in a desirable neighborhood—evidence that *père* Monet had generously subsidized Claude's flight.

HONEYMOON AND MOURNING

Monet's sojourn at Trouville proved remarkably productive. During a stay of about eight weeks (roughly equivalent to the length of time he had spent two years earlier at Gloton, where he completed only one painting and a sketch), he executed eleven pictures (w 154–62, plus 157a and 158a; the present location of the latter is unknown). Monet's compositions during these weeks fall into two distinct groups: representations of the beachfront promenade and pictures of Camille at the water's edge. The beachfront compositions show fashionable vacationers strolling or seated on the beach, and the elegant hotels that catered to them (w 155–57a)—but not to the artist and his family, who stayed in the more modest Hotel Tivoli, farther from the seafront. Although

executed *con brio*, these pictures appear more highly finished than the series representing Camille. The realistic treatment of the stairs leading to the beach as well as the background buildings shown in *The Beach at Trouville* (figure 7.3), for example, suggest that this composition (as well as Monet's other views of the beachfront hotels) may not have been completed in a single session. Still, certain elements in these compositions, such as the prominent flag fluttering in the foreground of *The Hotel des Roches Noires, Trouville* (figure 7.4), with its freely painted red stripes, were obviously tossed off with rapidity and assurance.[21]

Despite the sketchlike freedom with which the four surviving canvases portraying Camille at the water's edge (w 158–61 and perhaps 162) were executed, Monet neither retouched them nor used them as the basis for more highly finished compositions. Extensive conservation studies of *The Beach at Trouville* carried out by the National Gallery, London, led the authors to label the work "the quintessential *plein air* painting," with its bold brushwork, its surface "peppered with grains of real sand," and inventive use of the unmodified ground color of the commercially prepared canvas.[22] In a letter written decades later, Boudin provided a touching description of Monet's procedures during these weeks: "I can still see you with poor Camille in the Hotel Tivoli. . . . I have even kept a drawing I made that shows you on the beach. Little Jean is playing in the sand and his papa is sitting on the ground, a sketchbook in his hand . . ."[23]

Unlike Boudin, whose beach scenes typically depict multiple figures from more distant vantage points, strung along the seashore in loose groupings, Monet represented Camille from a close viewpoint, seated (or, in one instance, standing) at the water's edge, invariably turned away from the sea. In the most freely executed of these compositions, *Camille Monet on the Beach at Trouville* (w 161, Musée Marmottan, Paris), Mme. Monet stands before a darkened sky that is apparently threatening an imminent storm (which may help to explain the haste with which the picture was executed). So generically did he depict his model in this instance that Camille is identifiable primarily on the basis of her costume and the general appearance of her figure. (The fact that Monet retained the Marmottan painting in his private collection throughout his lifetime provides further proof of the model's identity.) Her features are scarcely more individualized in *Camille Sitting on the Beach at Trouville* (figure 7.5) or in *Camille on the Beach at Trouville* (w 160). As Dorothee Hansen observes about the latter picture: "Monet did not develop the face to any appreciable extent. . . . Although the viewer may expect a portrait, the artist describes no individual characteristics, and thus the atmosphere on the beach becomes the subject of the painting."[24] Only in *The Beach at Trouville* did the artist delineate Mme. Monet's features more clearly (but not those of her companion); even here, however, Monet's emphasis continues to be on the beach and bright summer light more than on Camille.

The bold, slashing strokes of white on Mme. Monet's skirt in *The Beach at Trouville* recall the artist's similarly free brushwork in rendering Camille's costume in *The River* (1868). But his treatment also resembles the facture Boudin employed in his portrait

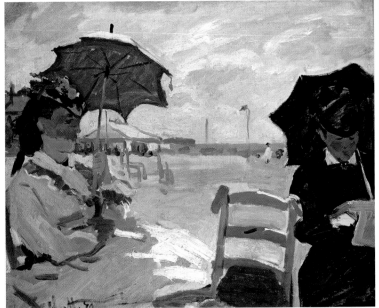

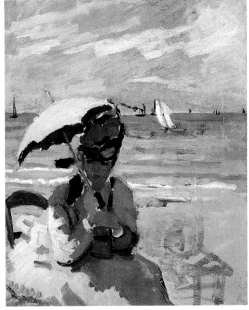

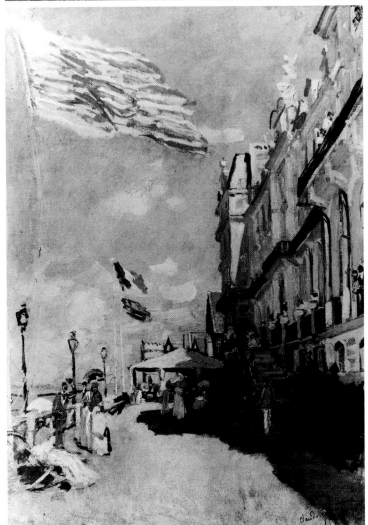

7.3. (*top left*)
Claude Monet, *The
Beach at Trouville*,
1870, National Gallery,
London / Bridgeman
Art Library

7.4. (*left*) Claude
Monet, *Hôtel des
Roches Noires, Trou-
ville*, 1870, Musée
d'Orsay, Paris. Scala /
Art Resource, NY

7.5. (*top right*) Claude
Monet, *Camille Sit-
ting on the Beach at
Trouville*, 1870, private
collection. Courtesy
Sotheby's New York

of *Princess Metternich on the Trouville Beach* (figure 7.6). Unlike his more characteristic compositions of figures on the seashore, here Boudin makes the aristocratic lady a lone figure, depicted from a close viewpoint. The free facture he employs in rendering the princess's white skirt closely parallels that which Monet employed in rendering Camille's costume in *The Beach at Trouville*. Does this similarlity reflect the continued influence of his first mentor on Monet's oeuvre, or could Boudin have been familiar with Monet's bold treatment of Camille's skirt in *The River* before he executed the portrait of the princess?

Monet's Trouville pictures reveal no hints of the catastrophe then overtaking France. (It is true that in several works the tricolor flutters in front of the smart hotels lining the beach, but the artist was no doubt accurately depicting the actual scene in

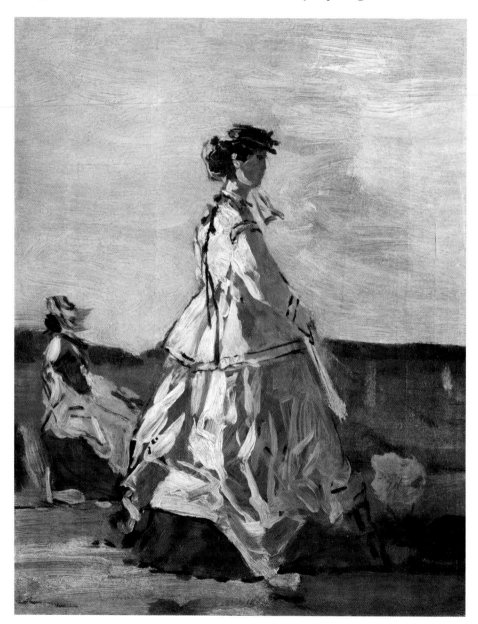

7.6. Eugène Boudin, *Princess Pauline Metternich on the Beach*, ca. 1865–67, The Metropolitan Museum of Art, New York, Walter H. and Leonore Annenberg Collection, gift of Walter H. and Leonore Annenberg, 1999, bequest of Walter H. Annenberg, 2002. ©The Metropolitan Museum of Art/Art Resource, NY

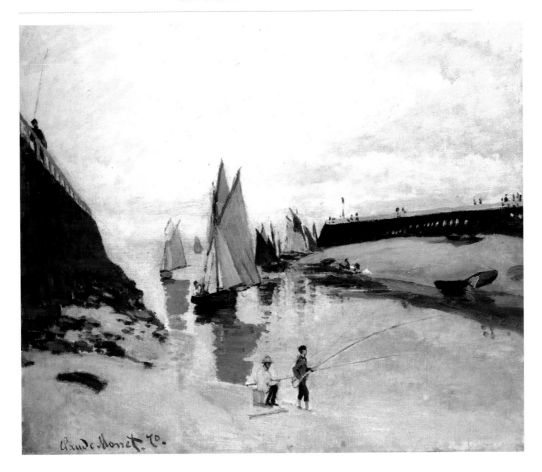

these instances.) The sole exception to the prevailing mood of gaiety is *Entrance to the Port of Trouville* (figure 7.7). Convincingly listed in the catalogue raisonné as the earliest painting Monet executed at Trouville, it seems very different in mood from the works that followed. Exquisitely rendered in a delicate color scheme featuring pearl-gray water, pinkish-beige banks (faintly echoed in the overcast sky above), and rich peach-colored sails on the boat just entering the harbor, it is, to this eye, one of the finest of Monet's compositions of any era. Both in subject matter and in emotional tone it conveys a subtly elegiac mood, despite the genre touches of the fishermen in the foreground and more distant figures in the boat and on the opposite shore. Does it represent Monet's immediate reaction to learning about the death of his surrogate mother, Aunt Lecadre? If so, it is hardly coincidental that the picture shows the entrance to the sea. Like his mother, Aunt Lecadre had now been consigned to the ocean: *la mère ensevelie dans la mer* (the mother entombed in the sea).

If the foregoing inferences are valid, during the eight or so weeks he spent at Trouville, Monet recapitulated the major events of his adolescence: bereavement, partial consolation by turning to the sea, then recovery through the support formerly of his aunt and currently of Boudin. There is a drastic change of mood between *Entrance to the Port of Trouville* and the sparkling beach scenes that followed. In their joyousness and clear, brilliant light the latter seem to defy the actualities of the painter's precari-

7.7. Claude Monet, *Entrance to the Port of Trouville*, 1870, Szépmüvészeti Múzeum, Budapest

ous situation. By contrast, *Entrance*'s harbor scene conveys stillness: the waters of the river Touques appear smooth as glass; the sails of the boat just entering the port begin to droop as a deckhand manipulates the ropes. (Blackish retaining walls on either bank of the river emphatically—almost ominously—call attention to the central craft.) The horizon line is indistinct, so that sky and water, delicately rendered in creams and light grays, imperceptibly merge, an impression reinforced by reflections of clouds mirrored in the river. Beyond tranquillity, the image represents a sense of nature's immensity, with the tiny humans in the mid- and far distance dwarfed by their surroundings. The scene conveys an atmosphere at once melancholy and poetic. Although Monet probably did not have France itself consciously in mind when he painted this picture, his country, too, was at low tide, about to be "beached" by the conquering Prussians.

Of course Aunt Lecadre was eighty years old at her death, and Monet just shy of thirty; this expectable event was no current trauma, only a reminder of those past.[25] Hence the high-spirited work that ensued did not constitute a denial of Monet's mourning for this mother surrogate but his embrace of a future with Camille. What is psychologically remarkable about the beach paintings is that, in contrast to *The Luncheon* of 1868–69, none of them show Camille with Jean. Nor did this choice to separate mother and son pictorially prove to be a temporary aberration: thenceforth Monet always either represented Camille alone or, when he showed mother and son in the same work, depicted them as oblivious of one another. From the vantage point of Monet's present, he seems to have needed to deemphasize Camille's role as mother; if we assume that, with Aunt Lecadre gone, Mme. Monet had in part become a transferential mother figure, from an unconscious perspective Monet insisted on being without a rival. Significantly, the artist did include references to an absent child in several of the beach scenes. For example, in *The Beach at Trouville* a child's beach slipper—presumably Jean's—hangs from the back of an empty chair prominently positioned between Camille and her companion. Another empty chair plays a hallucinatory role in *Camille Seated on the Beach at Trouville* (W 159; private collection). This time a child-sized chair, sketched so lightly as to be barely discernible, can be glimpsed at Camille's left, as though the artist had changed his mind about including the chair (and its small occupant?) in the composition but did not bother to erase it and tidy up the area before selling the picture several years later. In *Camille on the Beach at Trouville* (W 160; private collection) one perceives the distant figure of a woman watching over a small boy playing in the water, as Mme. Monet herself no doubt supervised Jean when he played in the sea. At the horizon line in the distance, beneath a purplish cloud hovering above the blue sky as though about to descend, the boat with peach-colored sails, so prominent in *Entrance to the Port of Trouville*, makes a second appearance. This signifier of death is now far away—in the Seine estuary, appropriately pointing toward Le Havre, where Aunt Lecadre's burial took place.

In another picture from this series, *On the Beach at Trouville* (figure 7.8), a family group appears at the water's edge: a man, two women, and a small boy, who plays in the surf. (Other less clearly defined tourists also populate the far right of the composi-

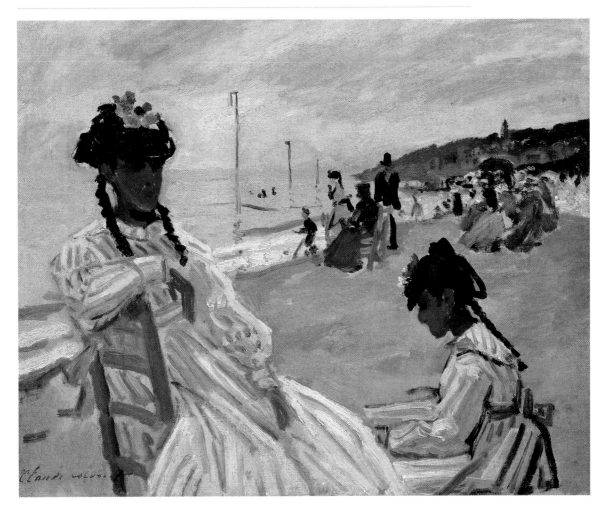

tion.) At the left, two personages seemingly unrelated to the background groups occupy pride of place at the front of the picture plane—a young woman and an adolescent girl. Although their matching costumes (blue-and-white striped dresses and black hats trimmed with white-and-yellow flowers) and hairdos (long braids) strongly suggest that they are closely related, they ignore one another, the adolescent engrossed in her book, the woman seemingly lost in her own thoughts. Previously believed to represent Camille and her younger (half?) sister, Geneviève, they are now generally presumed to be unidentified models.[26] The fact that Monet retained this painting sequestered in his private collection throughout his lifetime, unsold and unexhibited, requires explanation. If he actually did base the adult woman on Camille, he certainly altered her image, but the model's long face, prominent chin, and brunette hair suggest that if she does not actually represent Mme. Monet, she may symbolize her. The appearance of the adolescent girl also seems about right for Geneviève, who would have been fourteen at the time. The suggestion that the work possessed some deeply personal significance for Monet supports the speculation that the family group in the background may represent the artist's nuclear family of the distant past, his father, mother, and surrogate mother (Aunt Lecadre), and the future artist himself. If so, Léon is absent.

7.8. Claude Monet, *On the Beach at Trouville*, 1870, Musée Marmottan, Paris, Erich Lessing / Art Resource, NY

MOURNING AND EXILE

We do not know precisely when the Monets reached London, but the family was settled "for the duration" in Kensington by January 1, 1871.[27] One of the first, if not the earliest, of the paintings Monet executed in London, *Meditation (Mme. Monet Seated on a Sofa)* (1871; figure 7.9), shows Camille, clad entirely in black except for white collar and cuffs and a red bow at her neck; she is seated on a sofa or sofa bed covered in a red floral chintz that echoes the hue of her tie, the book she holds on her lap, and the pattern of the Japanese fan displayed on the mantelpiece in the background, next to the Oriental blue-and-white vase. The composition might well be titled "Interrupted Reading," for Camille has closed her book; marking her place with a finger, she sits wool-gathering, her expression somber and preoccupied. Monet's father, already ailing

7.9. Claude Monet, *Meditation (Madame Monet Seated on a Sofa)*, 1870–71, Musée d'Orsay, Paris, Réunion des Musées Nationaux/Art Resource, NY

when Monet visited him in September, died on January 17, a few months after marrying his long-term mistress and legitimizing their daughter. (Communications between Le Havre and England were not interrupted; Monet undoubtedly got the news of his father's passing promptly, because by January 29 he was able to appoint a proxy to represent his interests at the reading of his father's will.) It seems appropriate, then, that *Meditation* depicts Camille wearing a costume customary for mourning. Although the comparison is difficult to make with absolute assurance, her gown appears to be identical to that worn by the mysterious visitor in *The Luncheon*, except for the addition of the

red bow. Stylistically the two paintings are also close, constituting the traditional end of Monet's spectrum of styles during that period—a style he had certainly abandoned at La Grenouillère and Trouville.

A seated woman reading, or, more often, interrupted in her perusal by her own thoughts or the entrance of a "visitor" (i.e., the artist) who commands her attention, is a time-honored motif very popular among eighteenth-century French artists. François Boucher's *Madame de Pompadour* (1756; Alte Pinakothek, Munich) constitutes an example of the first type, and Jean-Baptiste-Siméon Chardin's *Les amusements de la vie privée* (1746; Nationalmuseum, Stockholm) of the second. The latter painting, which depicts the second Mme. Chardin (like Camille, a recent bride) in a domestic interior seems especially similar to *Meditation* in its subject and presentation. Although Chardin's picture has been in Stockholm since the mid-eighteenth century, Monet could have been familiar with the engraved version made before the painting was sent to Sweden in 1747. Beyond details of furnishings and costume, a major difference between the two paintings is that Mme. Chardin turns to face the viewer with an expression of quiet contentment whereas Camille is turned away from the spectator, absently gazing out the window that illuminates the room but not her inner life. The Goncourt brothers had recently suggested that Chardin's composition could have been titled "Serenity." In similar terms, Monet's might be called "Melancholy."[28]

It is, of course, beyond belief that Camille would have wasted tears on Adolphe Monet: his demise had, in fact, freed her of immediate financial cares. It is much more likely that Monet projected on the visage of his wife his *own* reaction to another death in the family, especially since his father's demise occurred so close to the fourteenth anniversary of his mother's death (January 28, 1857). The artist's lengthy and rancorous struggle against his father's misuse of his authority did not mean, of course, that Claude had no positive feelings for Monet *père*. Such projections of his internal state onto people he portrayed would recur periodically as long as Monet continued to paint the human figure.

Most likely Monet was not yet aware that he had sustained another significant loss: Frédéric Bazille, who had volunteered for service, had been killed in combat in late November.[29] Despite the harsh tone Monet had adopted in his penultimate letter to Bazille, their bond had been close, and Monet never forgot his old comrade, who had arguably been dearer to him than his blood brother, Léon.[30]

Monet's economic hardships were relieved not only through his inheritance (at the very least he must have received a letter of credit to enable him to live as well as he did in London) but through the introduction, arranged by his fellow exile Charles Daubigny, to the French dealer Paul Durand-Ruel (1831–1922), who would become Monet's principal dealer and promoter and soon began to exhibit and buy his paintings. These sales would include several beach scenes from the summer of 1870.[31] Durand-Ruel put Monet in contact with Camille Pissarro, who had also fled France and was living in Lower Norwood. Together they visited the museums, where they especially admired

the achievements of J. M. W. Turner (1775–1851) and John Constable (1776–1837); both these British artists—especially Turner—would influence Monet. The paintings the two French artists submitted to the Royal Academy for their upcoming exhibition were refused, but (thanks to the assistance of Durand-Ruel) both men participated in the International Exhibition of Fine Arts at the South Kensington Museum, which opened on May 1, 1871. Monet showed *Meditation* (exhibited as *Repose*), the reduced version of *Camille*, and, most likely, two unidentified seascapes.[32]

The Monets' London stay came to an end in late May, just as the French government was brutally suppressing the Paris Commune. As a record of his sojourn in London, Monet left only six paintings in addition to *Meditation*: two views of London parks and four of the Thames and its port (w 164–69). Fine as they are, these works do not—at least to this eye—possess the sparkle and daring of the pictures created at La Grenouillère and Trouville. Whether Monet's relatively lower output should be attributed to continued mourning, concerns about the situation in France, or simply difficulties dealing with foreign atmospheric and climatic conditions remains an unanswered question.

HOLLAND AND THE END OF EXILE

The Monets' sojourn in Holland lasted from June to October 1871. Wildenstein expresses puzzlement about Monet's decision to postpone dealing with matters that required his attention in Le Havre, Louveciennes, and Paris.[33] However, the letter he sent Pissarro shortly before leaving England expressed Monet's complete discouragement over the "Bloody Week" then occurring in Paris, in which twenty thousand citizens were massacred: "You have no doubt heard about the death of poor Courbet [erroneously reported in the press], gunned down without a trial. What ignoble conduct, that of Versailles. All that is ghastly and makes one sick. I have no heart for anything. It is all utterly distressing" (WL 56).

Fortunately, the artist's mood lifted as soon as he settled in Zaandam, a town just outside Amsterdam, a spot not unknown to French artists, including some of his friends.[34] In contrast to his lack of productivity in England, with the charms of this miniature watery universe, located on the North Sea canal, his enthusiasm for painting was rekindled, and he executed twenty-four (or twenty-six) compositions there (w 170–91a, 192).[35] With great verve Monet depicted the vistas from the canal, the picturesque windmills and brightly colored houses. These pictures convey no trace of downheartedness about the fate of either France or the Monet family.

On October 8, the painter and his family left for Amsterdam. After spending some time visiting the Dutch museums, the exiles returned to war-torn Paris, where they were installed in a hotel by November 19, as Monet's letter to Pissarro attests (WL 60). The artist painted a lively view of *The Pont Neuf in Paris* (1871, w 193; Dallas Museum of Art) with its pedestrian and vehicular traffic, a composition that reveals no hint of the

chaos and destruction that had recently visited the city; such a selective interpretation would continue to characterize many of his future compositions.

By this time, Edouard Manet and Monet were on very friendly terms, and Manet used his connections to assist Monet to find the home in Argenteuil that the family would occupy until October 1874.[36] On December 21, 1871, Monet wrote Pissarro, informing him that he was in the midst of getting settled in their new home at Argenteuil and requesting that his friend send the packet of paintings that Monet had stored with him before leaving for England. He renewed the invitation to Pissarro to visit him in his Parisian studio at 8 rue de l'Isly (which he had rented during the family's Parisian stay) and where he could find Monet every day from ten to four. As Wildenstein suggests, Monet probably planned to use the studio to work up the paintings he had begun *en plein air* at Zaandam—a practice he would follow for the rest of his life.[37] Interestingly, Monet never retouched the very free compositions showing Camille on the beach, painted at Trouville.

PART TWO

The Argenteuil Years

Argenteuil, 1872–1873

CLASSIC IMPRESSIONIST LANDSCAPES,
MYTHIC AND ENIGMATIC IMAGES

THE CONTEXT

By January of 1872, Monet had settled his family at Argenteuil, where they would live for the next six years in two different homes.[1] Although he continued to overspend, the artist's increased income from sales and funds received from both families (qua dowry or inheritance) now permitted the Monets to live in the bourgeois comfort he had previously been able to manage only in the fiction of paint. Their first years in Argenteuil would prove to be the most secure—and no doubt the happiest—Camille would experience during her relationship with Monet. The presence of a nanny and housemaid meant that Camille could lead a more leisurely existence; as paintings from this period representing her reveal, she boasted a wardrobe featuring the latest fashions in frocks and chapeaux. The Monets also frequently played host to guests Camille enjoyed, including the Sisleys and Renoir. With the assistance of a gardener, Monet renovated the landscaping, introducing favorite features such as the circular geranium bed he would also establish in their second Argenteuil home. The replenished garden provided not only aesthetic pleasure but also a secure area where Jean could play, Camille could read, and the artist could paint.

Located conveniently near the Seine (which could be glimpsed from its windows) and the railroad station, the residence provided easy access to painting sites along the river and its banks, as well as rapid hourly train service to Paris, permitting easy access to Monet's studio on the rue de l'Isly.[2]

Although Monet also sold works to other dealers and individuals, Paul Durand-Ruel was his primary "angel" during the artist's first two years at Argenteuil. The 12,100 francs Monet earned in 1872 more than doubled the following year (when Durand-Ruel purchased thirty-four works!), reaching 24,800 francs, a sum beyond the dreams of ordinary workmen and far greater than the income of a typical Parisian professional man and his family. During these "fat" years, Monet's paintings fetched high prices, especially from Durand-Ruel.[3] The dealer also purchased works from other future Impressionists and their colleagues, including Degas, Manet, Pissarro, and Sisley. He featured Monet and his friends in repeated exhibitions during 1872 and '73, as well as in a publication reproducing works by artists in his gallery, including four pictures by Monet.[4] As Stuckey points out, Durand-Ruel's efforts played a key role in shaping the group of artists "soon to be publicized as Impressionists."[5]

In addition to income from his art, Monet received his share of his father's estate in 1872. Wildenstein believes that this inheritance was modest; whatever the case, the sum added to his total earnings, as did the three hundred francs Camille received in 1872 as interest on her dowry, plus the four thousand more she inherited following the death of her father on September 22, 1873.[6]

Monet's productivity during these two years matched his prosperity; the era of "classic Impressionism" had dawned, and he worked rapidly, with supreme confidence.[7] The catalogue raisonné assigns more than fifty works to 1872, including eleven paintings depicting areas in and around Rouen, executed during a brief visit in March promoted by his brother, Léon.[8]

Monet's productivity in 1873, while still impressive, was slightly lower than the previous year's, no doubt because his leading efforts to organize an independent artists' society (which would become the vehicle for exhibitions mounted by the Impressionists and their colleagues between 1874 and 1886) consumed a good bit of his time. Nonetheless, he found time to undertake a working trip to Normandy, painting at Le Havre, where he executed the now-celebrated *Impression, Sunrise* (w 263; Musée Marmottan, Paris), as well as at Rouen and Etretat (w 258–68), plus a few pictures executed at Asnières (w 269–70).[9]

During these years, Monet initiated an exploration of landscape motifs in and around Argenteuil to which he would frequently return, above all, compositions featuring the Seine—views of the promenades along the riverbank, bridges over the stream, and boats competing in regattas under full sail or resting quietly in basins with furled sails.

A significant number of paintings executed in these two years, such as those showing Argenteuil pictured from the small branch of the Seine (such as w 230–32) as well as a number of seascapes (including *Impression, Sunrise*), were obviously painted from a boat. Early in 1872 Monet purchased a simple rowboat, which he had equipped with a rough cabin that permitted him not only to work at water level under varied weather conditions but also to take overnight "voyages" to more distant locations.

SYMBOLIC AND ENIGMATIC IMAGES

As already demonstrated, Monet was highly unreliable as an autobiographer; he created myths on canvas, as well as through his correspondence (and, in later years, in interviews with journalists, critics, and biographers). Thus, the images of his private life he produced at Argenteuil should not be taken at face value as depictions of the real world or his actual experiences. The only portraits of his wife and son the artist executed during 1872 transcend naturalistic portrayal and promote his mythic view of himself and his family. *Jean Monet on His Horse Tricycle* (figure 8.1), signed and dated 1872, constitutes a prime example of Monet's painted mythologies. The picture depicts the little boy, then around five years of age and not yet old enough to graduate to trousers, in an elegant unisex outfit comprising a beige skirt and matching vest over a white

blouse, topped by a jaunty hat in coordinated colors. Jean appears "mounted" on an elaborate tricycle, its seat and upper structure shaped in the form of a galloping horse with flowing white mane. The elegance of the boy's costume and the splendor of the unusual tricycle illustrate the scope of Monet's extravagances during these "fat years." Richard Brettell's suggestion that the picture may have been painted as a souvenir of the boy's fifth birthday (August 8, 1872), and that the tricycle had been a birthday present, seems quite plausible.[10]

There is general agreement that *Jean Monet on His Horse Tricycle* mirrors Diego Velázquez's *The Infante Baltasar Carlos on Horseback* (1635). Monet, who never visited Spain and could not have seen the original painting in the Prado, probably knew the composition from Francisco Goya's 1778 etching, which reproduces the painting fairly faithfully although its background appears more turbulent and dramatic than that of the actual picture. However, it has not been sufficiently stressed that Monet's image betrays his fantasy that *he* is royalty among artists, worthy of comparison not only with the greatest painter of Spain's Golden Age but also with the *infante*'s father, King Philip IV.

Of course, Monet's painting is grounded in the reality of the protective ambience of his Argenteuil garden and Jean's actual tricycle and clothing. By comparison, Velázquez's representation of the little prince astride a leaping steed (no doubt a stuffed animal), set against a grandiose mountainous backdrop, is highly romanticized, representing the boy (then approximately six years of age) as a skilled horseman, able to control a spirited steed. It seems inconceivable that Velázquez would have required the prince to pose for the required number of sessions; most likely a midget of the right size and general appearance, dressed in the appropriate costume, substituted for the boy, who was called upon to sit only for his actual portrait.[11] Unlike the little prince, Jean had no available stand-in, and by the time his father depicted him for his first posed portrait, *Jean Monet Wearing a Hat with a Pompom* (figure 8.2), painted circa 1870, the

8.1. (*left*) Claude Monet, *Jean Monet on His Horse Tricycle*, 1872, The Metropolitan Museum of Art, New York, gift of Sara Lee Corporation, 2000. ©The Metropolitan Museum of Art/Art Resource, NY

8.2. (*right*) Claude Monet, *Portrait of Jean Monet Wearing a Hat with a Pompom*, 1869, Fondation Bemberg, Toulouse

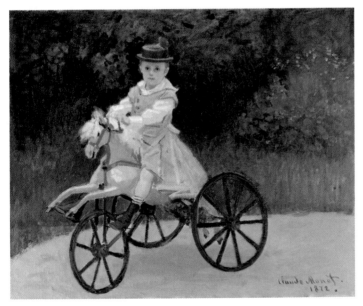 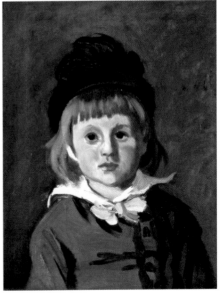

little boy was already growing accustomed to his future role as his father's frequent model, a part he played, if not always happily, at least resignedly. Like Baltasar Carlos, Jean may not have had to pose while his father depicted the tricycle and the carefully painted garden background, with its emphasis on circular forms (the tricycle wheels are echoed by the segments of the circular path and geranium bed, whose bright hues reflect the horse's red reins). Still, Jean must have spent a fair amount of time poised astride his mechanical steed, as his rather vapid facial expression suggests. Monet retained this painting, with its mythic allusions to his own identity and that of Jean, in his private collection, unexhibited throughout his lifetime. Whether before or after his death, it became the property of Blanche Hoschedé Monet, Jean's widow, who retained it until her own demise.[12]

The artist also depicted his wife in mythic terms in *Springtime* (*The Reader*) (1872; figure 8.3); nestled in a bower of flowers and foliage, Camille once again incarnated Flora, but this time Monet presented her more naturalistically than he had in *Women in the Garden* with its obviously posed multiple representations of her as *La Primavera*. Clad in a charming pale pink frock (in which strokes of lavender and white can also be discerned) and matching bonnet, Camille is seated on the grass near a bower of mature plants, whose branches shade her upper body but permit sunlight to play

8.3. Claude Monet, *Springtime* (*The Reader*), 1872, Walters Art Museum, Baltimore. Erich Lessing / Art Resource, NY

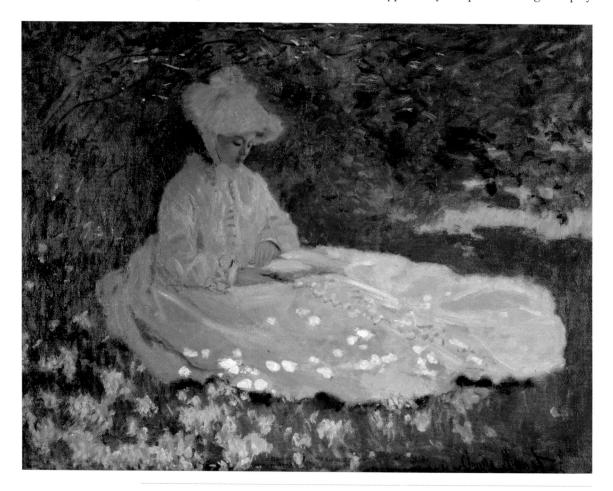

delightful games with her skirt. Engrossed in her book and captured in a moment of supreme contentment, Camille seems completely unaware of the presence of the artist who idealizes her. The appearance of youthful beauty with which Monet endows her in this picture may have been as fictive as her mythic identity, leading Wildenstein to question whether Mme. Monet could have been the model, although scholars generally agree that she did pose for the painting.[13] Without agreeing with Wildenstein, one can understand his doubts. The sole surviving photograph of Camille, the Amsterdam picture of 1871 (figure 1.1), reveals her as appearing more careworn and older than her actual age (twenty-four at the time) would suggest. In *Springtime* (*The Reader*) Monet magically restores to Camille the glow of youthful loveliness she possessed at the dawn of their relationship, before the hardships of the ensuing years took their toll. Tucker correctly notes that this picture presents Mme. Monet as "the ideal woman."[14]

Surprisingly, Monet did not retain this incarnation of Camille as Flora in his private collection, as he did with Jean's portrait as the little prince. However, the fact that he selected *Springtime* to show in the second exhibition mounted by the Impressionists in 1876, and more than a decade later in the important Monet-Rodin exhibition held at the Georges Petit gallery in June 1889, testifies to the artist's enduring pride in this exquisite painting.

Both during spring 1872 and again the following year, Monet painted several other works celebrating the advent of spring; most include human figures, who share the exquisite play of light and shade as well as the serenity of *Springtime*, without either focusing on portraiture or evoking that picture's mythic connotations. These compositions, such as *Lilacs, Grey Weather* (w 203; Musée d'Orsay, Paris) and *Lilacs in the Sun* (w 204; Pushkin Museum, Moscow), might more accurately be described as lyrical landscapes with figures rather than figures in landscapes, for the artist focuses on the play of shadow in varying weather conditions on the garden setting, as well as on the three small-scale figures (presumably Camille and Alfred and Marie Sisley, who visited that spring) nestled beneath the protective branches of the tall lilac bushes, heavy with pink blossoms.[15]

The Garden (1872; figure 8.4) represents two women seated on the grass in the garden, enjoying the lovely spring afternoon. Although we view them from a close vantage point, their features are so summarily indicated that one can only assume, rather than assert, that Mesdames Monet and Sisley served as the models. The fact that they are in a cultivated suburban garden is underscored by the small segment of the well-manicured gravel path visible at the front edge of the canvas, where three of the large blue-and-white planters Monet had acquired in Holland are ranged in an irregular sequence, the two end pots filled with flowering daisy plants, the center one with a small evergreen.

The artist, obviously interested in creating the vision of a perfect afternoon in a private garden rather than in painting dual portraits, focused on the play of light on the two women's bright costumes, the nearer figure in white, the other in pale yellow (both rapidly, loosely rendered), and the beauty of the blue sky above, dotted with small

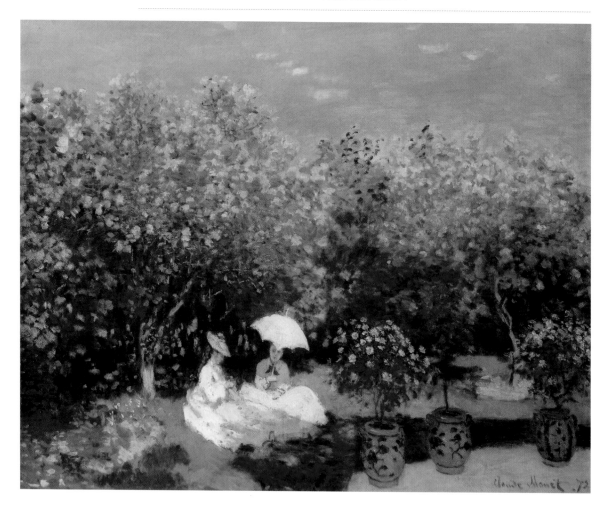

8.4. Claude Monet, *The Garden*, 1872, private collection

clouds. The pink lilac trees behind the women extend across the canvas and beyond its edges, forming a protective floral wall separating them from the outside world and emphasizing their relationship with nature.[16]

Sequestered in this serene environment, the women feel free to conduct themselves more informally than in public, where they would never sit directly on the grass. The privacy of their situation is also reflected by the hairdo of the woman in white, whose light-brown locks hang in a long braid down her back rather than in the chignon she would have worn in public. The two women do not actively interact; the one in white busies herself with needlework as her companion quietly watches. They seem as quiet and tranquil as their environment, where (presumably) the only sound comes from the gentle breezes agitating the flowering trees and precipitating the fall of spent blossoms; perhaps they also hear the songs of birds and the hum of honeybees, whose presence we infer rather than see. *The Garden* implicitly contrasts the tranquillity of this serene, protected environment with the hustle-bustle of Paris, only a short train ride away.

In 1873 Monet represented Camille and Jean more frequently, both in portraits and in landscapes with figures. One of the most delightful of the latter group, executed as part of his celebration of another beautiful spring and early summer, *Poppies at Argenteuil*

(figure 8.5), shows Camille and Jean as though gamboling down a rise where wild poppies bloom in profusion. Although the setting suggests that they enjoy an unspoiled meadow filled with native flowers and grasses, the house visible through a break in the trees arrayed along the background attests that they are, in fact, quite close to the town.

At first glance, the composition, which shows Camille and Jean twice, at both the apex and base of the hill, suggests that Monet has resurrected the device of continuous narration used by early artists to convey the passage of time within a single work. But Monet fools us! At the apex of the rise Camille wears an all-black gown with a white collar and hat, but at its base in the lower foreground she not only sports a green parasol but now wears a straw hat and what appears to be a light-colored dress with a black scarf at the neckline. Her costume is so sketchily rendered, in hues so close to those of the wild grasses in which she is half-immersed, as to suggest—once again—that she is an integral part of her surroundings, a symbol of Nature. (Camille's dress has a few strokes of black here and there. Did Monet originally intend to color it all black but leave it in its present state because it blends so beautifully with the grasses? Even so, this scenario fails to account for the changed neckline of her gown and the color of her hat.) Jean, too, seems fused with his natural environment; his lower trunk is completely concealed by grasses, as if he were springing from the earth itself, like the posy of wild poppies he clutches (which, it should be noted, match his red hatband).[17]

8.5. Claude Monet, *Poppies at Argenteuil*, 1873, Musée d'Orsay, Paris. Réunion des Musées Nationaux / Art Resource, NY

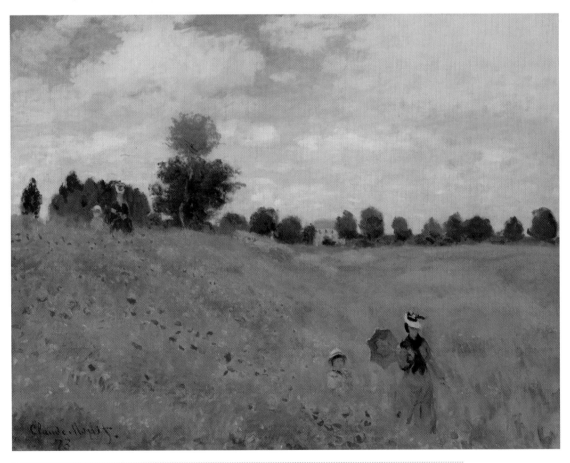

Later that summer the artist painted another portrait of Mme. Monet with mytho-
logical allusions, *Camille and Jean Monet in the Garden at Argenteuil* (figure 8.6). The
picture shows Mme. Monet emerging from a rather disorderly thicket of flowers and
bushes, in a manner reminiscent of representations of the birth of Venus. Unlike the
goddess of love, Monet's "Venus," transformed into a nature goddess, rises not from
the sea but from plants the artist himself had grown in their garden. This modern
Venus's erotic connotation is symbolized by the manner in which she poses with her
arms raised, as though in the act of arranging the vivid red blossom in her hair, a posi-
tion that calls attention to her breasts and shapely figure, as she assumes a time-honored
pose utilized by the old masters to emphasize the model's sexiness. Although Goya's
Nude Maja and her clothed counterpart are recumbent, they constitute one of the most
celebrated examples of the type. Like Goya's maja, Camille looks straight out at the
viewer, but her expression, more enigmatic than seductive, is quite at variance with the
bold glance Goya's model directs at us. Camille seems unaware of the presence of her
attendant "Cupid," Jean (now graduated into short trousers), who lies sprawled in the
foreground, physically separated from his mother not only by the flowery bower that
encloses her but also by his lack of attention to her; distracted, perhaps by watching
an unseen bird or insect or by the movements of his father working nearby, this little
Cupid does not interact with his Venus-mother.[18]

The seeming alienation between mother and child suggested in this work, as well
as in other compositions of 1873 featuring the pair, would prove to be a leitmotif in all
of Monet's subsequent compositions showing Camille and Jean. If Monet intended the
composition to convey a sexual charge, as seems likely, he did not in the process present
Camille in a compromising situation. To the contrary, she appears in her real-life role
of suburban housewife, posing in the privacy of her own backyard; any eroticism she
radiates is presumably directed at the artist who paints her, who happens to be her own
husband. The composition impresses one as a very private work, and it is not surprising
that Monet retained it in his personal collection, unexhibited, throughout his lifetime.
It was certainly unique in his entire oeuvre.

The Artist's Garden at Argenteuil (*The Dahlias*) (figure 8.7), from the same summer,
also hints at erotic connotations, much more subtly expressed than in the picture just
discussed. An exuberant growth of tall, mature dahlia plants, bright with varicolored
flowers, commands roughly two-thirds of the pictorial space. Their dominance is coun-
tered by the more geometric shape of the neighboring house, with its odd roofline and
prominent chimneys, as well as by the trees at the two edges of the canvas. Beyond the
dahlias, near the fence separating the two gardens, a couple stands facing one another
in close physical proximity. They appear to be holding hands (or the man may be clasp-
ing the woman by the arm), but their images are so small and indistinct that one can
identify their sexes only by their costumes: the woman's white dress and hat, the man's
black suit and straw boater.

The composition poses a number of questions. Why did Monet decide to portray the

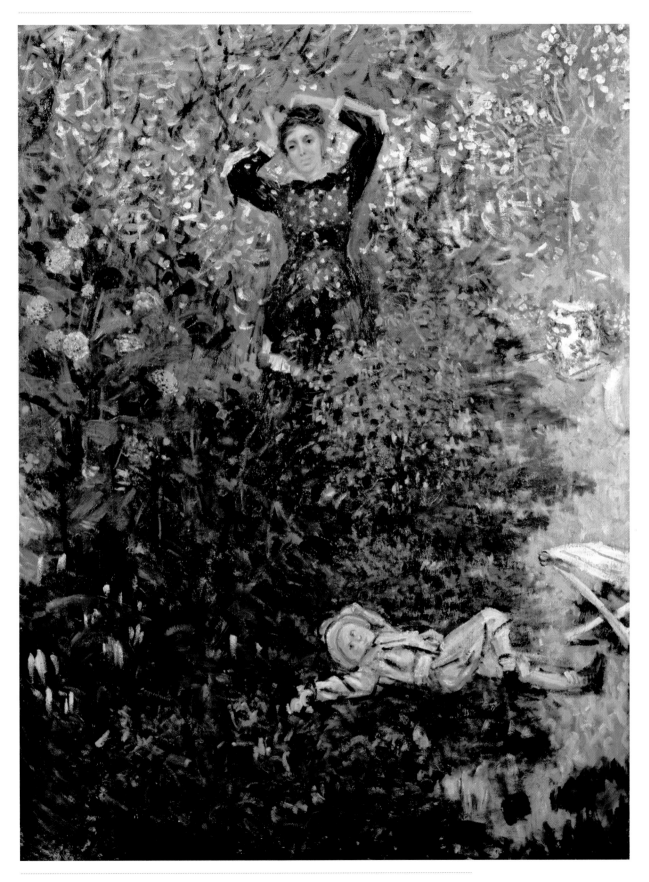

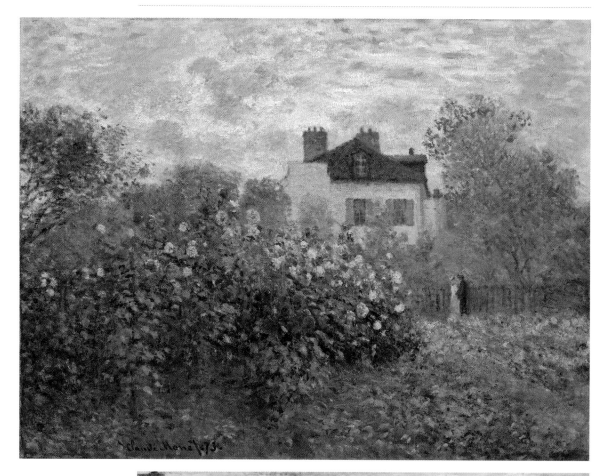

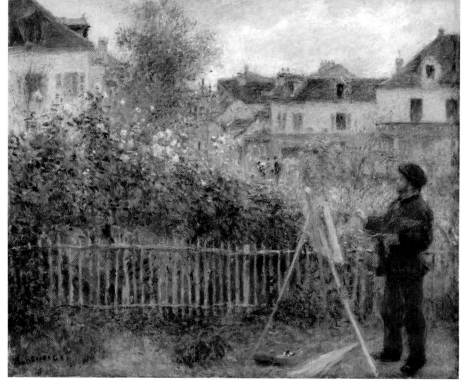

8.7. (*top*) Claude Monet, *The Artist's Garden in Argenteuil (A Corner of the Garden with Dahlias)*, 1873, gift of Janice H. Levin in honor of the 50th anniversary of the National Gallery of Art. Image courtesy of the Board of Trustees, National Gallery of Art, Washington

8.8. (*bottom*) Pierre-Auguste Renoir, *Monet Painting in His Argenteuil Garden*, 1873, Wadsworth Atheneum Museum of Art, Hartford, CT, bequest of Anne Parrish Titzell

couple so anonymously when, in reality they were almost certainly modeled on Camille and Renoir? Was it because Renoir served as a surrogate for the artist himself? Despite the fact that their figures consist of nothing more than a few quick brushstrokes, the couple's intimate position suggests a romantic tryst. But why would lovers choose to meet at a spot adjoining the home of neighbors, who could easily spy on them through one of the three windows facing their trysting place? In fact, as Renoir's *Monet Painting in His Argenteuil Garden* (figure 8.8, executed at approximately the same time and place) reveals, the setting of *The Artist's Garden at Argenteuil* was evidently more urban and public than Monet suggests; even the rich tangle of dahlias may have been part of his neighbor's garden, rather than his own![19] Throughout his career, Monet reshaped reality in accord with his artistic vision. *The Artist's Garden at Argenteuil* provides eloquent evidence of this talent.

Like *Camille and Jean Monet in the Garden*, *The Artist's Garden at Argenteuil* hints at Monet's sexual feelings; however, his invariable reticence about revealing such emotions in his oeuvre clouds his meaning. In any case, the erotic undertones of both compositions challenge theories about marital discord between Camille and Claude at this time, advanced by several contemporary critics. To the contrary, both pictures support Eugène Boudin's observation that "Monet seems to be happy with his life, despite the resistance his painting meets with."[20]

That same summer, Monet executed two puzzling paintings representing Camille in the context of their house at Argenteuil. As its title indicates, *Camille Monet at the Window, Argenteuil* (figure 8.9) portrays Mme. Monet inside the home, standing, immobile, looking directly out from a window so tall that it extends beyond the top edge of the picture plane. She is clad, as usual, in an elegant costume—in this instance a warm beige-pink outfit with ruffles cascading down either side of the bodice, and a straw cloche trimmed with a white flower. As in many of his representations of his wife, Monet has barely delineated Camille's features; one can discern her dark eyes, but her image cannot be described as a portrait. She appears surrounded by a riot of flowers, permitting us to view only her upper torso. In addition to the vigorous blooms springing from the window box and flowerbed just beneath it, the artist has heaped up other planters filled with blooming plants, including three of the blue-and-white pots featured in so many works from this period. Additional flowering planters surround Camille's image; taller plants, placed on either side of the model, echo the vertical sweep of the open shutters (painted with great freedom and exquisite technique in soft brick-reds and blues), while the blossoms beneath the window add horizontal balance, as do the cross-braces of the shutters.

Once again Monet presents us with a painted enigma. If Camille again symbolizes Flora, as the abundance of flowers and blossoms surrounding her suggests, she is a captive Flora, confined to her well-appointed home (note the ornate mirror and what appears to be a Japanese scroll on the wall behind her), surrounded by anthropomorphic floral guardians that seemingly prohibit her access to the outside world. *Camille at the*

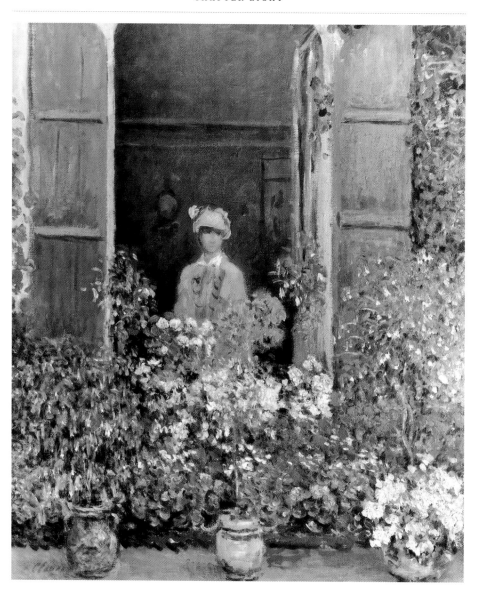

8.9. Claude Monet,
*Camille Monet at the
Window, Argenteuil,*
1873, Virginia Museum
of Fine Arts, Rich-
mond, Collection of Mr.
and Mrs. Paul Mellon

Window forcibly recalls the artist's earlier depiction of her in *The Red Kerchief* (figure
6.5).[21] That composition depicts Camille as a poignant figure: standing alone in wintry
snow and cold, she looks sadly through French doors to the interior, where the artist
paints her image.

Virginia Spate's observations about *Springtime (The Reader)* (1872), which she
describes as establishing "[Camille's] identity as someone to whom the casual observer
has no access" while emphasizing "her private subjection to the artist in the world of his
creation," might well be applied to the two pictures under consideration here.[22] When
Monet portrayed his mistress in *The Red Kerchief*, she had no access to society because
her status as an unmarried mother made her an outcast in the bourgeois social world
of nineteenth-century France. By 1873, when he painted *Camille Monet at the Window*,
her social position had been transformed. As the wife of a prosperous artist and the
mother of a charming (and legitimized) son, Camille now enjoyed new respectability

and comfort. But one aspect of her life remained unchanged: her role as the artist's muse and principal female model continued. As Spate points out, this special role required her constantly to be at her husband's beck and call, ever ready to participate "in the world of his creation."

In view of the intensely personal connotations of *The Red Kerchief* and *Camille Monet at the Window*, it is scarcely surprising that the artist kept both works sequestered in his private collection throughout his lifetime.[23]

The Artist's House at Argenteuil (figure 8.10) provides a view of a summer afternoon in the small earthly paradise Monet had established behind his home. Flowers blaze everywhere: in plantings alongside the house, in the circular geranium bed glimpsed at left, as well as in the five blue-and-white pots lined up on either side of the doorway. The house itself seems almost alive with growth, with its window box brimming with red and white blossoms and the ivy vigorously climbing around the doorway and on up the walls to the roofline. Lush trees and bushes beyond the shadowed area of the path luxuriate in the bright sunshine; like the little clouds dotting the bright blue sky above, they seem to sway in response to a gentle breeze.

Alone on the gravel path surrounding the house, Jean wears a white dress with a black sash and a straw hat. He stands stock-still in the blue-mauve shadow that the afternoon sun casts on the gravel. He faces away from the viewer, holding a hoop. The boy's inactivity—his absolute stillness—seems quite unchildlike, creating an uncanny

8.10. Claude Monet, *The Artist's House at Argenteuil*, 1873, The Art Institute of Chicago, Mr. and Mrs. Martin A. Ryerson Collection

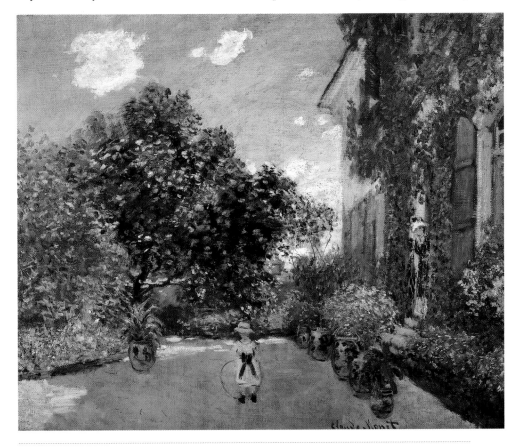

impression of solitude and vulnerability in the midst of the vigorous plant growth sprouting everywhere around him. Even the green plant in the lone blue-and-white pot, carefully positioned near the circular flowerbed to counterbalance Jean's form, seems more lively than the child, as its leaves move in the breeze. Directly across from this planter (at the right edge of the base of a compositional triangle with Jean at its apex), Camille stands in the doorway leading to the garden by a brief flight of steps. Her immobility—she seems almost physically attached to the door-frame—echoes that of her son. Because Jean's head is at the level of his mother's feet, we cannot but be aware that she does not attend to him but faces outward, gazing toward the viewer—and the painter who depicts her. It seems a decidedly odd way to represent one's family, but it exemplifies a pattern that Monet would invariably follow when depicting mother and child as emotionally, if not physically, distant from one another.[24]

The underlying air of melancholy implicit in the painting recalls that hoops have long been represented in art and literature as symbolic of the cycle of life and the inevitability of death.[25] Is Jean's black sash premonitory of the family's impending mourning for M. Doncieux?

Because Jean still wears a unisex outfit in *The Artist's House at Argenteuil*, the picture was presumably painted before August 8—when he turned six and graduated to short trousers—and therefore approximately six weeks prior to the death of Camille's father, which occurred on September 22. M. Doncieux was confined to a nursing home at the time of his death, so his health must have been failing for some time before then.[26] We do not know whether Camille visited her father during the last weeks of his life, but the fact that her relationship with her family had been mended following her belated marriage surely meant that she was kept apprised of his deteriorating condition. Does the enigmatic character of *The Artist's House at Argenteuil* reflect the tense situation the Monets were experiencing in the weeks preceding M. Doncieux's death?

DEATH ENTERS THE GARDEN

On September 23, Monet wrote Pissarro:

> Sad news awaited my wife on her return from Pontoise: her father died yesterday.
>
> Naturally, we are obliged to go into mourning, and I find myself in a moment of [financial] embarrassment. I would be very pleased if you could obtain the payment [due me] from M. Duret.[27]

Although M. Doncieux had made Camille his sole heir, his estate did not have sufficient assets to satisfy all his testamentary provisions, leading to legal disputes involving Camille, her (half?) sister Geneviève, and her mother, that were not definitively settled until October 28, 1874. As previously noted, Mme. Monet initially received only four thousand of the twelve thousand due her.[28]

At a time roughly concurrent with this sequence of events, Monet began to paint

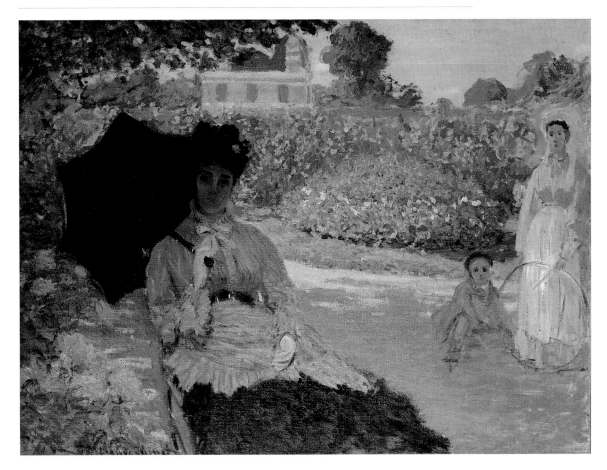

8.11. Claude Monet, *Camille in the Garden with Jean and His Nanny*, 1873, private collection, Switzerland

three major works representing his wife in the family garden: *Camille in the Garden with Jean and His Nanny* (figure 8.11), *The Bench* (figure 8.12), and the large decorative panel *The Luncheon* (figure 8.13). All three compositions prominently feature the circular bank of red geraniums, surrounded by a gravel path. Years earlier, Monet had selected a similar circular flowerbed on his aunt's property, also planted with red geraniums, as the setting for *Jeanne-Marguerite Lecadre in the Garden at Sainte-Adresse* (1867; figure 4.1). The fact that he created virtually identical flowerbeds in the gardens of both Argenteuil homes constitutes an implicit and perhaps unwitting memorial to Aunt Lecadre.[29]

Judging from the mature condition of the vegetation and the mellow afternoon light characteristic of the delightful days of Indian summer, we can infer that the compositions were initiated in late September, in the order just listed, and completed within a short period. *Camille in the Garden with Jean and His Nanny* and *The Bench*, painted on canvases of virtually identical size (ca. 24 × 32 in), possess many common features and were evidently painted as pendants. Mme. Monet figures prominently in both works, seated in the left foreground in *Camille in the Garden*, on the right in *The Bench*; two additional personae appear in both pictures. Even Monet's signatures follow the left-right symmetry, although only *Camille in the Garden* is dated.[30] Monet never exhibited the two pictures together, but in a letter written decades later he confirmed that they had indeed been conceived as a pair: "This work [*The Bench*] was painted in 1872 [sic]

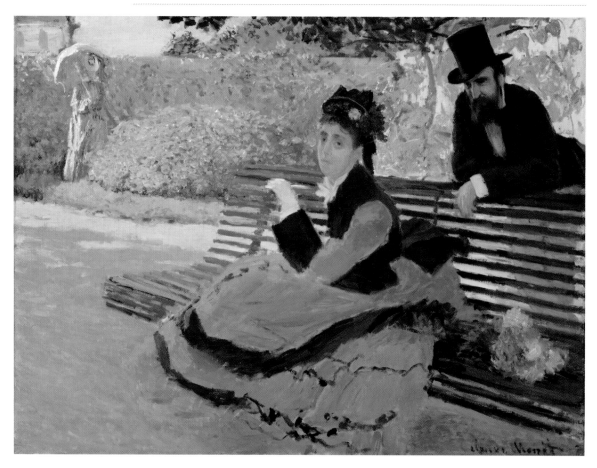

8.12. Claude Monet,
*Camille Monet on a
Garden Bench (The
Bench)*, 1873, The
Metropolitan Museum
of Art, New York,
Walter H. and Leonore
Annenberg Collection,
gift of Walter H. and
Leonore Annenberg,
2002, bequest of Walter
H. Annenberg, 2002.
©The Metropolitan
Museum of Art/Art
Resource, NY

at my home in Argenteuil. The personages are my first wife, her [woman] friend, and a neighbor. Two paintings of this same genre must exist."[31]

These three compositions have always been considered particularly problematic to decipher; like *The Luncheon* of 1868–69, they involve scenes the artist staged to convey personal symbolic meanings. They are often studied individually, but it is very likely that they constitute components of a sequential narrative. As previously noted, all three compositions depict essentially the same area of the garden, although the artist varied his sight-lines somewhat in each instance. In these paintings Monet's symbolic subject matter is human existence, specifically Camille's experience of her father's terminal illness and death. None of the three compositions represents Mme. Monet in an all-black costume, although we know from the artist's letter to Pissarro that the family went into mourning as soon as the news of M. Doncieux's death reached them. We can only conclude either that she was not expected to dress entirely in black during the prescribed mourning period (a possibility supported by Colin Bailey's account of contemporary mourning customs among the bourgeoisie) or that the artist, preferring not to portray her clad entirely in funereal black in the lush garden setting, carefully selected the costumes in which she appears.[32]

Whatever dress contemporary mourning rituals prescribed, it is noteworthy that in the first two pictures in this sequence Camille's clothing and accessories prominently

feature black.[33] In *Camille in the Garden with Jean and His Nanny*, Mme. Monet's under-skirt, hat, and parasol are black, her tunic and overskirt soft gray. In *The Bench* she wears a still more elaborate high-fashion costume that combines a black velvet tunic with elaborate tiered skirts and sleeves of taupe silk, all lavishly trimmed in black velvet. Her high toque, likewise black velvet, is trimmed with flowers and ribbons.[34] Her male visitor's frock coat and top hat in the latter painting are also black, as are his mustache and beard.

Monet has rendered Camille's facial expression in the two pendant paintings in a highly unusual fashion. The young beauty of *Women in the Garden* and *Springtime* (*The Reader*) has been supplanted by an autumnal Camille, older and far less attractive. The flower-petal-like profile of her chapeau in *Camille in the Garden* suggests that her face should form the heart of the flower, but she now seems a faded blossom whose incarnation as Flora is no longer appropriate. Little Jean, dressed in a pale blue suit, sits half-sprawled on the gravel path several feet behind his mother. The hoop (the time-honored symbol of the cycle of life) that Jean held in *The Artist's Garden at Argenteuil* reappears in this composition, but the child, once again motionless, ignores his toy, now held by his white-clad nurse, who stands beside him. Monet painted Jean's

8.13. Claude Monet, *The Luncheon*, ca. 1873, Musée d'Orsay, Paris. Réunion des Musées Nationaux / Art Resource, NY

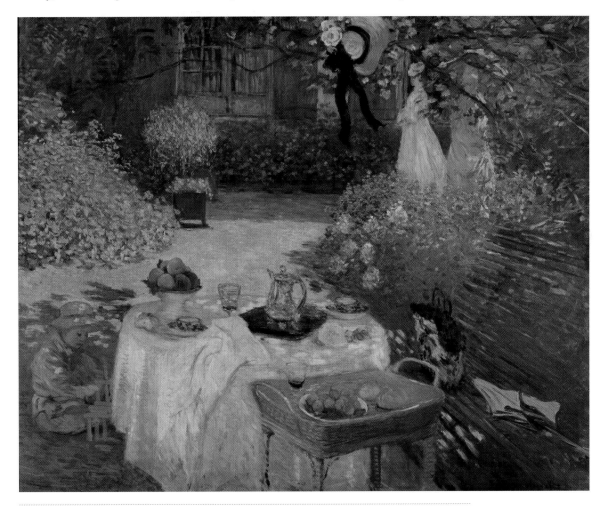

form and face rapidly and cursorily; nevertheless, one cannot miss the child's wistful expression as he stares out at us with black-button-like eyes that match his black beret (most likely a token of familial mourning that middle-class children of the day were expected to wear). Remarkably, all three personages ignore one another, directing their gaze instead toward the viewer. Camille's expression seems somber, preoccupied, even sad. Lost in her own world, she appears as unaware of her son and his nanny as of the flowery bower in which she is seated.[35]

The Bench represents Camille seated on a slatted bench in the right foreground; a black-bearded gentleman stands close behind her, leaning casually over the back of the bench toward her, his left hand dangling provocatively as though he itches to touch her. A bouquet of flowers—presumably a gift of the visitor—lies next to Mme. Monet. Rather than greeting her caller, Camille, with her sorrowful, distressed expression, seems to implore protection against the unwelcome caller from an unseen person beyond the picture plane. A third personage, a woman in blue who holds a green parasol to shield her from the bright sunlight, stands at the far left, near the garden wall. With her facial features undelineated and her presence ignored by the other participants, her role in this painted drama—beyond providing compositional balance to the prominent foreground figures and demonstrating Monet's skill in showing the flattening effects of sunlight on the figure—requires clarification.

Although critics have been unanimous in praising the skill with which Monet renders the play of light and atmosphere on the personae of *The Bench*, they have disagreed widely about its meaning. Bailey, for example, labels it "one of the most enigmatic and disconcerting works in Monet's oeuvre. The use of language is masterful; but what is Monet trying to say?"[36]

The role of the male visitor—and even the question of his true identity—has also puzzled scholars. As already noted, Monet described the man simply as a neighbor, but the entry for the painting in the recent edition of the catalogue raisonné (w 281) cites a letter found in the Durand-Ruel archives, dated August 1, 1908, and addressed to Hugo von Tschudi (then director of the Berlin National-Galerie), that identifies the model as Eugène Manet. If Monet's memory (rather than that of Durand-Ruel's correspondent) was accurate, *The Bench* constitutes a rare instance in which he used an unknown to model for such a key role in a composition. Whatever the man's real-life identity, the fact that he has been permitted access to this private walled garden and leans so familiarly over the back of the bench on which Mme. Monet is seated indicates that he cannot be read as a strange intruder into Camille's private world.[37] Why then does the man's appearance so alarm Camille, who appears distressed, even frightened? Pointedly turning away, she ignores him, his proffered bouquet, and the visitor's card (or letter), presumably his, which she grasps in her gloved left hand, held in an awkward position.

Camille's response makes sense only if we recognize that the visitor represents not a person with a real-life identity but a symbolic persona assigned by the artist. Although the painting demands psychological interpretation, scholars have generally resisted

attempts to penetrate Monet's symbolism. Robert Gordon and Andrew Forge note that Camille "looks dolefully away" from her visitor, but they devote the remainder of their discussion to formal matters. Paul Hayes Tucker wonders whether the scene represents a tryst (as many popular illustrations of generically similar scenes did) or a quarrel— "but [if so] what does it mean?" Virginia Spate rejects Tucker's idea (and presumably any other psychological interpretation), arguing that such responses "miss the point of [Monet's] determined anti-narrativity."[38]

Joel Isaacson (correctly, in my opinion) links the iconography of *The Bench* with the loss of Camille's father and interprets the visitor as the personification of Death: "In Monet's naturalistic world, there is a place for innuendo and the evocation of mood, but there is no room for symbol that cannot be disguised as factual representation; if Death enters the scene . . . he does so in the form of a caller who has first presented his visiting card."[39] Bailey responds to Isaacson by criticizing various aspects of his discussion without providing any satisfactory counterproposal to this suggestion that the caller represents Death: "It is also clear that a strictly biographical reading diminishes the painting and fails to explain the uncertainty and agitation that create its singular mood. Even so, Isaacson's discussion focuses attention on the major issues—costume and narrative— and it is here that some key to the painting's meaning might be discovered."[40]

Bailey's response seems deeply ambivalent. Why does a "biographical," or, more accurately, a psychological, approach diminish the painting? It does not negate the importance of formal or other nonbiographical analyses but does provide a logical explanation for the "uncertainty and agitation" that Bailey continues to question. If Monet intended the gentleman caller to represent Death, use of a model unlikely to be recognized by viewers would be consonant with the artist's recollection that a neighbor (rather than Eugène Manet, as has sometimes been proposed) posed for this figure.[41]

If we accept Isaacson's interpretation of this scene, the matronly appearing woman standing beyond the geranium bed holding an open parasol might best be understood as an allusion to Camille's mother, the other person most affected by M. Doncieux's death. (The omission of a figure representing Geneviève would, in this light, constitute an allusion to her dubious paternity.) Camille's refusal to face her visitor—or accept his proffered bouquet—denotes the universal first reaction to unbearable news: its denial.

The third painting in this sequence, *The Luncheon*, is a much larger work (approximately 64 × 84 in), suggesting that Monet may have initiated it as a public statement, perhaps even a Salon contender—a notion he soon dismissed if he had ever entertained it. In line with the decorative program of the composition, he eliminated all direct references to his wife's mourning. Yet the painting features the same segment of the garden (albeit viewed from a slightly different perspective, and later in the autumn, as the overgrown, leggy condition of the geranium bed attests), the same slatted bench, and three of the figures who peopled one or both of the related compositions. This time Jean, rather than his mother, occupies the foreground spot, seated on the garden path to the left of the luncheon table, deep in the dappled shade of the nearby tree, which also

shelters the table. At the upper right are the images of two women who "float behind the tree," to borrow Isaacson's felicitous description of their almost hallucinatory quality.[42] Although Monet did not delineate the facial features of either woman, Camille surely posed for the slimmer figure in white, while her more ample companion, clad in pale peach, most likely the same unidentified friend who appeared in *The Bench*, once again symbolizes Mme. Doncieux.[43]

The Luncheon is actually misnamed, for the meal is already over.[44] The place settings for earlier courses have been removed, and the dessert course has been abandoned largely untouched. Only a silver coffeepot, a pair of cups and saucers, an almost empty wineglass, a half-eaten brioche, an untouched bowl of fruit, a discarded napkin, and a single full-blown pale-peach rose and bud remain on the table. The nearby serving cart holds additional fruit, a bundt cake with several slices missing, and a second wineglass, also partially empty.[45] Two people have evidently had a meal at the table, one sitting on the bench, the other occupying a chair now removed, along with the dishes used earlier, by a servant. A woman's white parasol and black-and-white handbag have been left behind on the bench.

Camille and her guest are portrayed near the garden facade of the house, which serves as the backdrop for the scene; its shadow provides only partial protection from the late-afternoon sun, and its dappled light plays on the women's costumes, touching them with bluish highlights. Both wear hats that match the colors of their dresses; the woman in peach (whose costume echoes the color of the roses lying on the table) shades herself with her parasol; its blue lining matches the trim on the nearby window. The predominantly white accessories abandoned on the bench presumably belong to Camille, the woman of the house.

Bailey claims that with *The Luncheon* Monet "finally resolves the challenge of narrative by virtually suppressing the figures altogether. Here the women are reduced to staffage, barely visible behind the branches of the overhanging trees; Jean plays contentedly by the same garden bench, but his presence there is an afterthought."[46] By contrast, the reading of the painting presented here emphasizes both the importance of its implicit narrative and the roles of its personae. For example, symbols of mourning recur throughout the work. The missing chair, the half-eaten roll, the abandoned wineglasses, coffee cups, and napkins—all these features recall the traditional symbolism of numerous seventeenth-century Dutch *memento mori* still life arrangements. Even the white rosebush adjacent to the bench, with its overblown flowers, participates in the motif, seemingly overrunning the right edge of the bench's slatted back just as vegetation covers—and often destroys—monuments of the past. Perhaps the most notable among these symbols is the broad-brimmed woman's straw hat suspended from a tree branch above the bench. The hat, trimmed with two overblown white roses and a broad black velvet ribbon with dangling streamers, continues the litany of death references. Both women represented in the background wear hats, dispelling any notion that the chapeau in the foreground has been casually removed by one of them and hung on the

tree during the luncheon (a highly unlikely scenario in any case). After a Roman Catholic cardinal dies, his hat is suspended from the vault of his home cathedral until it disintegrates. Monet, a baptized but lapsed Catholic (like myself), would have been familiar with this custom, which he adapts to communicate a similar meaning. This leaves us with the question, why does he feature a woman's hat to make this point (though its shape does resemble the broad-brimmed hats cardinals receive at their investiture but probably never wear during their lifetime)?

A second unanswered question concerns the significance of Jean's image, half-hidden in the left corner of the picture. Compositionally, his form serves to balance those of the women in the upper right, but some other image or device could have conceivably served the same purpose. Jean, M. Doncieux's only grandchild, is present because of his psychological role in the drama of his grandfather's death. Several commentators have stressed that the painting depicts the boy in utter solitude, complete aloneness. But if we slip out of the fictional narrative of the painting, we immediately realize that Jean's father was standing at his easel just a few feet away.

These two conundrums can be resolved if we consider these unanswered questions together: For Monet, the significance of his father-in-law's death was that it reminded him of the loss of his beloved mother, the tragedy of his adolescence. It is *her* symbolic hat that hangs from the "cathedral vault" of the painter's inner world. In *The Luncheon* Jean represents his father's alter ego, Monet's own feeling of abandonment following the loss of his mother. The boy's activity, as he builds a structure from his Froebel blocks, reenacts his father's own attempt to deal with his mourning by creating art. Spate has rightly labeled his artistic activity *reparative*.[47]

The Luncheon functions on two levels: it works both as a beautiful decoration and as a minihistory of Monet's discovery of the reparative function of his great artistic talent. He created his repeated depictions of Camille's bereavement as a consequence of empathy for her suffering, but at a deeper level his identification with his wife reanimated his still unresolved mourning for his mother. (This interpretation is buttressed by the fact that he had previously used an image of Camille as the vehicle for expressing his feelings following the death of his father. *Meditation* [figure 7.9], painted shortly after *père* Monet's death, depicts Camille clad entirely in black and lost in sorrowful preoccupations.)

Small wonder that following the intimate revelations implicit in the three pictures Monet created shortly after M. Doncieux's death, he interrupted his production of figure paintings; he did not return to them until 1875. Not long after the artist completed *The Luncheon*, Renoir came for a visit. His presence provided Monet with welcome relief; accompanied by his old friend and painting partner, he explored the artistic possibilities of the beautiful Argenteuil autumn (w 288–91).

Camille as Collective Muse

During the first half of 1874, Monet was distracted by journeys and projects that interfered with his normal level of productivity. Accompanied by Camille (and presumably Jean), the artist celebrated the Christmas holiday season by returning to his Norman roots, lingering in Le Havre until past January 28, the seventeenth anniversary of his mother's death—neither that fact nor his decision to take up marine painting once again (w 294–97) should be considered coincidental. It will be recalled that following his mother's death, the bereaved adolescent spent Sundays and school vacations roaming the seashore and sketching.[1]

During the 1873–74 holiday, Monet also enjoyed reunions with his elder brother, Léon, and painted his portrait (w 297a). Prior to an estrangement that occurred many years later, the Monet brothers kept in contact, enjoying such reunions during the artist's working trips to Normandy and perhaps on undocumented occasions as well. Léon admired and collected his brother's paintings, and he retained Claude's portrait of him throughout his lifetime.

Following his return from Le Havre, Monet must have been frantically busy finalizing plans for the inaugural exhibition of the Impressionists, which he had played the leading role in conceiving and organizing and which was scheduled to open in Paris on April 15. It seems difficult to believe that during these months he would have absented himself from Argenteuil, with its easy access to Paris, to undertake the lengthy working trip to Amsterdam to paint the twelve views of the city and its ports (w 298–309) that the catalogue raisonné assigns to this period.[2]

Whether Monet was in France or Holland during February and March, the historic inaugural exhibition of the Impressionists opened on schedule on April 15, housed in a space at 35 boulevard des Capucines recently vacated by the photographer Nadar. The exposition, which ran until May 15, featured 165 works by thirty participants, including a number of artists only loosely associated with Monet and his circle, several of them largely forgotten today. The modest catalog (really no more than a checklist of participants and their works) identified the group as members of the "Societé Anonyme des artistes, peintres, sculpteurs, graveurs, etc." Monet showed five paintings and seven (unidentified) pastels; two of the oils, *The Luncheon* (1868–69) and *Poppies at Argenteuil* (1873), which represent Camille and Jean, are illustrated and discussed in chapters 6 and 8, respectively; the other works Monet chose were *Fishing Boats Leaving the Port of Le Havre* (1874; w 296), *The Boulevard des Capucines* (1873; w 292 or 293), and the celebrated *Impression, Sunrise* (1873; w 263), which would provide the Impressionist movement with its enduring name.

The exhibition attracted considerable public and critical attention; more than fifty notices and articles appeared, running the gamut from relatively positive evaluations to the inevitable negative tirades penned by the most conservative critics. Reviews that mentioned or discussed Monet's works singled out *The Luncheon*, the largest, most ambitious—and most conservative—canvas he showed, for qualified praise. But even the friendlier critics found his full-fledged Impressionist paintings difficult to comprehend or enjoy.[3]

None of the publicity generated by the exhibition resulted in increased sales for Monet and his colleagues; unfortunately, the show coincided with a downturn in the economy that forced Paul Durand-Ruel to stop purchasing Monet's paintings, although the dealer steered customers his way. Edouard Manet also proved enormously helpful, introducing Monet to the opera star Jean-Baptiste Faure, who purchased three large early paintings from the artist, followed by several more recent works, all at good prices. Ernest Hoschedé resumed buying, purchasing, among other works, Monet's *Impression, Sunrise*. Such purchases notwithstanding, Monet's total income for 1874 dropped to 10,500 francs, down approximately 60 percent from the previous year but still far above the annual salary of the average French professional. With characteristic improvidence, Monet, who was having difficulty paying the rent on his current home at Argenteuil and had to ask Manet for a loan to meet his April deadline, nonetheless signed a lease to move on October first to a larger, more expensive house, then under construction.[4]

By the summer of 1874, freed from the distractions of the responsibilities for the initial Impressionist exhibition, Monet threw himself wholeheartedly into his art, depicting favorite sites in and around Argenteuil. John Rewald points out that these paintings reflect a new level of mastery and vigor in Monet's art, displaying more luminosity and employing a brighter, richer palette.[5] Many of these scenes of the Seine at Argenteuil and its bridges (among them w 311–15) are now regarded as icons of the so-called classic phase of Impressionism.

MONET'S DEPICTIONS OF CAMILLE IN THE SUMMER OF '74

In marked contrast to the frequency with which Camille had posed for her husband in 1873 and would model for him during the following two years, she appears in only two paintings Monet executed in 1874: *By the Bridge at Argenteuil* (figure 9.1) and *Meadow at Bezons* (figure 9.2). Yet Manet and Renoir, who both spent lengthy vacations in the area that summer, repeatedly made use of Camille's talents as a model. It is not clear whether Monet executed *By the Bridge at Argenteuil* and *Meadow at Bezons* before, during, or after the sojourns of Manet and Renoir in the area, but one wonders whether the conservative character of these paintings constituted Monet's response to the novel visions of Camille created by his colleagues. Whatever their precise chronological relationship to the Manet-Renoir portraits, Monet's pictures of 1874 featuring Camille, although carefully composed and executed, neither break new artistic ground nor pres-

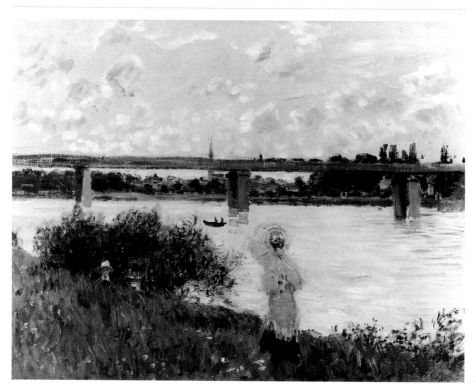

9.1. (*top*) Claude Monet, *By the Bridge at Argenteuil*, 1874, Saint Louis Art Museum, gift of Sydney M. Shoenberg Sr.

9.2. (*bottom*) Claude Monet, *Meadow at Bezons (Summer)*, 1874, Nationalgalerie, Staatliche Museen zu Berlin, Berlin. Bildarchive Preussischer Kulturbesitz / Art Resource, NY

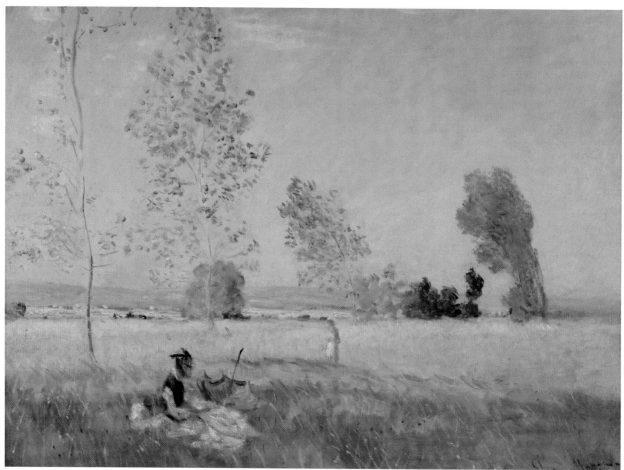

ent new conceptions of her role in his art and life. Rather, they constitute variations on themes he had previously explored in works featuring her. *By the Bridge at Argenteuil* shows Camille and Jean strolling along the Gennevilliers bank of the Seine near the railway bridge, with the town itself in the background. The overcast sky, whose rose-buff clouds alternate with smaller patches of blue, bleaches its reflecting mirror, the Seine, depriving it of the more vivid interplay of sky and water visible in a number of Monet's other compositions from those weeks. (See, for example, W 312, 313, 318, and 325.) As usual, he depicts the river as a beautiful, unspoiled stream, virtually devoid of traffic—except for a tiny boat shown passing beneath the bridge—a situation extremely unlikely in midsummer on the river at Argenteuil, increasingly burdened with traffic and pollution. Equally implausibly, Camille and Jean have this section of the riverbank entirely to themselves; fellow passersby, surely present in reality, have no place in Monet's idealized world. The isolated character of the setting underscores the mutual aloofness of mother and son, trademarks of the artist's portrayals of his family. The painting also underscores his insistence on presenting Argenteuil and its river as idyllic and unspoiled, a utopia that one could quickly access from Paris to stroll its riverbank or prairies in delicious solitude.[6]

The other composition for which Camille posed that summer, *Meadow at Bezons*, repeats the twin themes of isolation and idealization operative in *By the Bridge at Argenteuil*. The three individuals depicted in *Meadow at Bezons* seem unaware of one another, and the meadow is represented as a pristine space where no intruders disturb the tranquillity of the personae. *Meadow at Bezons* shows Camille seated alone in the foreground, in the shade of an unseen grove of trees (represented only as dusky shadows extending across the foreground of the picture plane). She is clothed in a diaphanous white dress, with black weskit and matching black-and-white bonnet. With her open, upended green parasol resting on the grass beside her, she seems completely absorbed in the book on her lap. Camille's pose recalls the composition Monet had painted four years earlier, *Springtime* (*The Reader*) (figure 8.3). But that composition renders her face and form in close focus. By contrast, *Meadow at Bezons* depicts her in much smaller scale, with her facial features completely hidden by her inclined head and hat. Her costume has been so rapidly, sketchily, and thinly painted that one can almost count the number of individual strokes composing her skirt. Camille's presence in this meadow seems almost hallucinatory, as though she were about to merge with the grasses surrounding her. (Did Monet paint the meadow before executing the figures?) Neither Jean, standing in the middle ground, nor the third person, seated beneath a distant tree, is depicted in clearly recognizable detail. (The third model has never been identified but appears so diminutive that one wonders whether Jean might have posed for both figures.) Both he and the more distant personage function primarily to bind the composition together, leading the eye to the distant river and broad sky beyond the meadow.

Despite the thematic and chronological connections it shares with Monet's *By the Bridge at Argenteuil*, *Meadow at Bezons* impresses one as a more lyrical, poetic compo-

sition. The meadow grasses, rendered primarily in soft yellows and gray-greens, bow in the breezes agitating the trees and hazy clouds that form a quasi-transparent veil over the heavens. The work clearly found favor with its creator, who included it (as *La Prairie*) in the second Impressionist exhibition, mounted in 1876, where it attracted favorable responses from several critics, who praised its color scheme, limpid atmosphere, and accurate rendition of air and space. Zola proclaimed it "full of simplicity and an inexplicable charm."[7]

The presence of his colleagues Renoir and Manet, who spent lengthy vacations in the area that summer, no doubt further stimulated Monet's creativity—and competitiveness. Renoir, who had vacationed *chez* Monet in 1872, was once again their houseguest, while Manet sojourned at a family property in Gennevilliers, just across the river from Argenteuil. Manet's experiences painting with his younger colleagues, especially Monet, deeply influenced the older artist, who became a convert to *plein air* painting, adopting the vivid colors, flickering brushwork, and bright light characteristic of the Impressionists, but without sacrificing his own artistic integrity.[8]

The first composition Manet executed during these weeks was *The Monet Family in Their Garden at Argenteuil* (figure 9.3), for which Camille, Jean, and Monet himself posed. Renoir, who arrived while the painting session was in progress, quickly joined Manet, producing *Mme. Monet and Her Son* (figure 9.4). More than fifty years later, Monet regaled Marc Elder with his reconstruction of that joint session:

> This delightful painting by Renoir [*Mme. Monet and Her Son*], of which I am the happy owner today, portrays my first wife. It was done in our garden at Argenteuil. One day, Manet, enthralled by the color and the light, undertook an outdoor painting of figures under the trees. During the sitting, Renoir arrived. He, too, was caught up in the spirit of the moment. He asked me for palette, brush, and canvas, and there he was, painting away alongside Manet. The latter was watching him out of the corner of his eye, and from time to time came over for a closer look at the canvas. Then he made a face, passed discreetly near me, and whispered in my ear about Renoir: "He has no talent, that boy! Since you're his friend, tell him to give up painting!" Wasn't that amusing of Manet?[9]

In an alternative version of the incident, which Monet related to Renoir, Manet made his critical comments only *after* Renoir had left the scene.[10]

By the time Monet repeated this story to Elder, no one else present on that long-ago afternoon was still alive, not even his son Jean, and Monet's account—whether factual, apocryphal, or a blend of both—went unchallenged. His recollection that Manet and Renoir had painted side by side in Monet's garden is confirmed by the visual evidence, for Camille and Jean appear in identical costumes and similar poses in the two pictures. Mme. Monet, attired with characteristic elegance in a white summer dress and matching hat trimmed with cerise flowers and black velvet ribbons, sits on the grass in a relaxed pose, chin in hand and skirts spread about her, exposing her crossed feet and

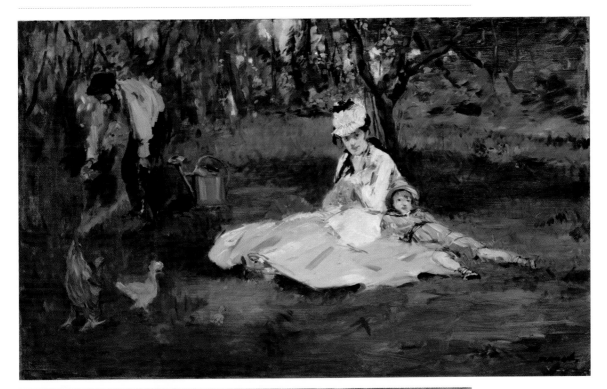

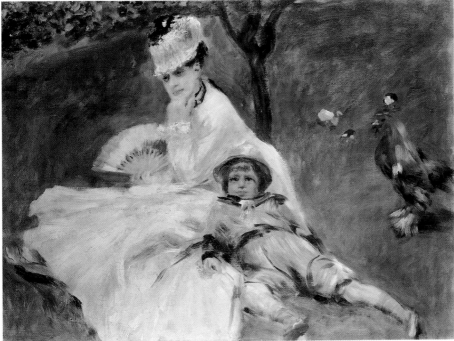

9.3. (*top*) Edouard Manet, *The Monet Family in Their Garden at Argenteuil*, 1874, The Metropolitan Museum of Art, New York, bequest of Joan Whitney Payson. 1975 ©The Metropolitan Museum of Art/Art Resource, NY

9.4. (*bottom*) Pierre-Auguste Renoir, *Madame Monet and Her Son*, 1874, Alisa Mellon Bruce Collection. Image courtesy of the Board of Trustees, National Gallery of Art, Washington

little yellow slippers. Seven-year-old Jean, clad in a blue sailor suit and straw hat, leans comfortably against his mother's lap, his arms nestled in her skirt, his legs akimbo. As Monet's account implies, Manet had probably determined the poses of the models and, in view of his well-known attention to such details, most likely selected their costumes as well.[11]

Despite the fact that the models were depicted from the same setup, the two artists' versions reveal surprising dissimilarities, most notably the higher degree of organization evident in Manet's picture, which provides a more encompassing, carefully composed, realistic vision of the garden than Renoir's. Working on a smaller support ($19\frac{7}{8}$ × $26\frac{1}{4}$ in) than Manet ($24 \times 39\frac{1}{2}$ in), and presumably more rushed, Renoir chose to zoom in on his models, rendering them from such a close vantage point that the right border of Camille's skirt is cut off by the lower right edge of the canvas. Although Renoir represented mother and son very charmingly, he treated the background garden in a hasty, rather cavalier manner, so that the tree behind Camille seems to spring from her vertebrae, while the grassy area beyond the pair appears to rise up as though it might sweep the models away in a sea of grass. Manet's tighter organization is also reflected in the clever way he incorporates the fowls roaming the garden into his composition: The cock, hen, and chick marching across the foreground of the picture plane function as witty parallels to the physical and psychological relationships among the Monet family members. Although Renoir includes the birds, they perform no obvious compositional or iconographic function in his work; in fact, as Paul Tucker suggests, they may add to the spatial confusion.[12]

Manet depicts Monet in the left foreground watering geranium plants, but he is nowhere to be seen in Renoir's picture. Monet's retrospective account implied, without stating it explicitly, that both pictures were executed during a single sitting; the thinned paint and free brushwork in both certainly attest to the rapidity with which they were painted. But this assumption does not jibe with the conclusion—also widely accepted—that while Monet's colleagues portrayed his wife and child, he depicted Manet at work in the garden (w 342; present whereabouts unknown). How could Monet simultaneously pose for Manet and depict him? A letter that Emile Zola sent his friend Antoine Guillemet on July 28 suggests the solution: "I do not see anybody and am without any news. Manet, who is painting a study at Monet's in Argenteuil, has disappeared." As Moffett proposes, the picture Zola refers to must be *The Monet Family in Their Garden at Argenteuil*.[13] Zola's comment suggests that Manet worked on the picture during several sessions, a procedure more in keeping with his usual practice. Such a chronological reconstruction would explain why his composition appears more deliberate and ambitious, its surface more carefully developed, than that of Renoir, which probably *was* completed in a single session. It could also explain Monet's absence from Renoir's composition: when he came upon the scene, Renoir discovered his host painting, not posing, his chores as Manet's model presumably completed, or at least interrupted for the day, while he depicted Manet at work.

But Monet's failure to join his colleagues in portraying Camille and Jean in the garden at Argenteuil, where he so often represented them, puzzles. Why did he elect instead to paint Manet? There is no simple answer to this question, for Monet's behavior was determined by complex motives. The anecdote he related to Elder many years later provides hints about Monet's attitudes toward his two friends, which played into his

decision. His account deprecates Renoir's abilities (revealing that the elderly Monet's competitiveness with his friend had not ended with the latter's death), while elevating Monet's own status to that of confidant and artistic peer of Manet, to whom the latter could reveal his assessment of Renoir as a talentless "boy." (Renoir was thirty-three at the time!) As previously noted, in other tales reported long after Manet's death Monet gleefully described the older artist's frustration when their similar names caused critics to misidentify compositions by Monet as those of Manet. But in the real world of 1874, as opposed to the realm of mythic memories, Monet may have felt less comfortable about going "mano a mano" with Manet, widely revered among his colleagues as the leading figure of the artistic avant-garde. Although by 1874 he felt comfortable enough with Manet to ask him for a loan, Monet's relationship with Manet was less intimate and more deferential than with Renoir, arguably his closest friend—and frequent house-guest—who evidently treated the Monet residence as a second home.[14]

Although Monet never painted in tandem with Manet to represent the same motif, similarities of locale evident in several compositions by both artists dating from that summer suggest that they sometimes worked in close physical proximity. But having painted side by side with Renoir on several occasions, Monet did join forces with him again that summer, when they simultaneously executed their individual variations on two identical motifs, *Regatta at Argenteuil* and *Regatta at Argenteuil* (figures 9.5 and 9.6). Monet's version of the latter scene, with its feathery brushstrokes and softer, hazier vision of the scene than characterized his usual approach, suggests that Renoir influenced Monet that summer, just as Monet influenced Manet. (The soft, feathery facture of *Meadow at Bezons* also seems reminiscent of Renoir's typical *tache*.)

But another, more deeply personal concern operated to deter Monet from joining his colleagues in portraying his wife and son in the family garden. The poses assumed by Camille and Jean (whether dictated by Manet or initially assumed spontaneously and seized upon by him) reflect a deep affection and physical closeness that would have been completely off-putting for Monet. As this study has repeatedly emphasized and numerous paintings confirm, the artist's personal and pictorial psychology forbade representing such tender interactions between mother and child—or, for that matter, between any two individuals. (This prohibition remained in effect throughout his lifetime; none of the figurative paintings he created during the 1880s and early 1890s represent intimate physical or emotional contact between his subjects.)

MANET'S REPRESENTATIONS OF CAMILLE

Evidently pleased with his representation of *The Monet Family in the Garden at Argenteuil*, Manet asked the couple to pose for him again, this time seated in Monet's new floating atelier.[15] The artist was very proud of the studio boat and painted from it several times that summer, perhaps sometimes accompanied by Camille. Seeing them together in the floating atelier may have inspired Manet to represent them in that setting. Manet

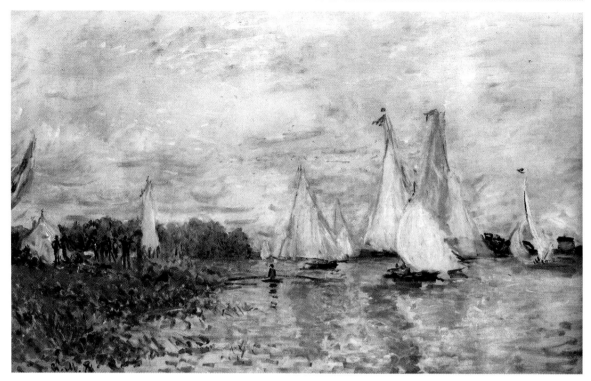

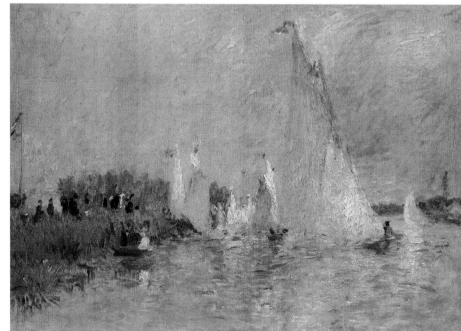

9.5. (*top*) Claude Monet, *Regatta at Argenteuil*, 1874, private collection

9.6. (*bottom*) Pierre-Auguste Renoir, *Regatta at Argenteuil*, 1874, Alisa Mellon Bruce Collection. Image courtesy of the Board of Trustees, National Gallery of Art, Washington

initiated two versions of the motif, *Claude and Camille Monet in His Studio Boat* (figure 9.7) and *Claude Monet Painting in His Studio Boat* (figure 9.8). Neither picture was ever completed, and the larger of the two, *Claude and Camille Monet in His Studio Boat*, was never carried beyond the level of a sketch. The smaller oil, *Monet Painting in His Studio Boat*, though more highly worked, was never fully realized either, apparently because Manet decided to switch to the larger canvas with the hope of submitting it to the Salon

of 1875.[16] Manet abandoned both pictures when Monet rebelled, claiming that posing interfered with his own work in progress. (It seems ironic that Monet, so demanding of the time and endurance of his own models, should prove so impatient when the tables were turned, but it was very much in character.)

Both works depict the couple seated in their boat; they wear the same white outfits with black accents in both versions. Monet sports casual working garb, while Camille, as usual, appears more formally and elegantly attired in a two-piece costume trimmed in black; her large straw bonnet is also edged in black; her face and hat are covered with a transparent veil as protection against errant breezes.[17]

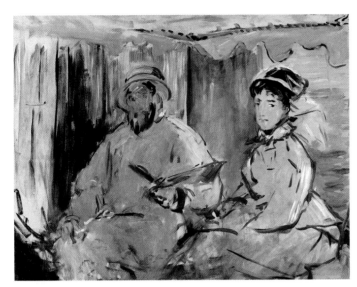

9.7. (*top*) Edouard Manet, *Claude and Camille Monet in His Studio Boat*, 1874, Staatsgalerie Stuttgart. ©Staatsgalerie Stuttgart

9.8. (*bottom*) Edouard Manet, *Monet Painting on His Studio Boat*, 1874, Neue Pinakothek, Munich

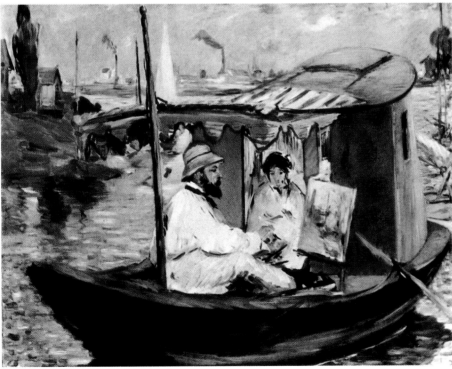

As its title suggests, *Claude Monet Painting in His Studio Boat* features the artist as the protagonist, with Camille assuming a secondary location and role. Monet, shown in full profile view, sits with his legs comfortably extended; brush in hand and palette at knee level, he seemingly contemplates adding another stroke to the canvas propped before him on a small easel. Camille is seated at the entrance to the cabin, a spot from which she would neither interfere with her husband's movements nor distract him visually. Represented on a smaller scale than her spouse, with neither her face nor her form as clearly delineated or brightly illuminated, Camille assumes, literally and symbolically, the modest, subservient position and demeanor that contemporary society prescribed for wives. Manet no doubt intended to bring her image to a higher degree of finish had he completed the picture, but in its definitive state Camille appears as a passive, demure presence, a muse who inspires merely by being rather than by acting—or interacting—with her artist husband.

Manet abandoned the larger painting, *Claude and Camille Monet in His Studio Boat*, after doing little more than outlining the composition in vigorous black-and-white strokes, which indicate rather than precisely define his sitters' features and positions, and applying thin washes of color to suggest their clothing, the cabin, and the canopy covering the boat's forequarter. (Although Manet's compositions both feature this awning, none of Monet's representations of his studio boat include this detail, which may have been added at Manet's request.) Manet shows his subjects, who share the narrow seating space available in the prow, from such a close viewpoint that their lower limbs and feet are invisible. Monet is again portrayed with brush and palette in hand, as though actively working on the canvas positioned at his knee. But something or someone (presumably Manet asking him to look up) has momentarily distracted the artist from the task at hand, and he gazes directly at the viewer with an expression more suggestive of annoyance than curiosity. Camille, seated in profile, perches at the edge of the narrow space she shares with her husband, as though attempting to interfere as little as possible with his freedom of movement. But their shared space is so tight that their bodies and clothing touch at several points. Like her spouse, Camille directs her attention outward, turning toward us as though attracted by the same incident that caught Claude's attention. Her ramrod-straight posture and wary, almost hostile gaze suggest her inner tension in this situation. Does her reaction primarily reflect awareness of her husband's increasing annoyance, as he maintained a pose that showed him painting but actually prevented him from doing so, or was the source of her unease more complex in nature? Whatever the motivations underlying Monet's refusal to continue (to which I shall return), Manet graciously ended the session, presenting both versions to the sitters.[18]

Why did Monet turn so mulish when posing for Manet? After all, he had repeatedly modeled for Renoir, who completed several portraits of his friend, including one picture executed *en plein air*, *Monet Painting in His Argenteuil Garden* (1873; figure 8.8), a composition that, like Manet's unfinished pictures, portrays Monet working at his

easel. (Renoir's other portraits of Monet were executed indoors.) Was Monet's refusal to continue posing for Manet due less to impatience than to his strong emotional reaction to the specific composition Manet devised, which once again violated fundamental inhibitions governing his representations of Camille? Manet's paintings both represent Mme. Monet on the water, a realm in which her husband *never* depicted her in identifiable form, no matter how much time she actually spent accompanying her husband in the studio boat. As this text has repeatedly demonstrated, in Monet's art Camille symbolized Nature, the earthly realm: the prairies around Argenteuil, its riverside promenades. and—above all—the family garden were her proper provinces; the watery world belonged exclusively to the artist and his beloved dead women. Manet's request that the Monets pose side by side in the floating atelier not only made explicit Camille's role as her husband's muse and creative partner, who might accompany him in his boat even when he was not conveying her to a spot where he planned to portray her, but simultaneously violated another of his prohibitions: depicting his beloved ones in intimate physical or psychological contact with another—including with himself.

Well aware of Monet's resistance to posing for him, if not its underlying cause, Manet never again attempted to paint his friend, but he did make use of Camille's modeling talents for two additional paintings executed that summer. *The Seine at Argenteuil* (figure 9.9) shows a woman and child standing side by side on the Petit-Gennevilliers banks of the Seine, gazing at the water without interacting with one another. Although we cannot see their faces, several scholars have proposed that Camille and Jean Monet probably posed for the figures—an identification that seems completely convincing.[19]

9.9. Edouard Manet, *The Seine at Argenteuil*, 1874, private collection, on long-term loan to the Courtauld Institute Gallery, London

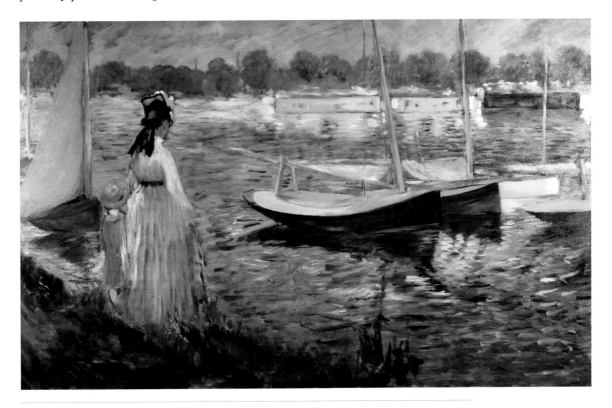

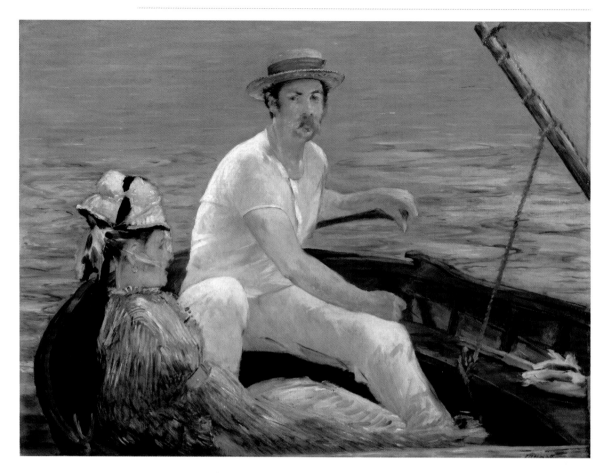

9.10. Edouard Manet, *Boating*, 1874, The Metropolitan Museum of Art, New York, bequest of Mrs. H. O. Havemayer. 1929 ©The Metropolitan Museum of Art/Art Resource, NY

Every aspect of *The Seine at Argenteuil* reveals Manet at his most Monet-like. The flickering brushwork of the sparkling blue water, its surface ruffled by gentle breezes that fracture the reflections of the boats, the free treatment of the soft green trees lining the far shore, and the virtually complete absence of any sign of the traffic (and pollution) on river and shore certainly present on such a splendid summer day—all recall similar compositions by Monet, such as his contemporary *By the Bridge at Argenteuil* (figure 9.1), also painted on the Gennevilliers shore, albeit from a different locale and under more overcast conditions. Above all, the seeming lack of any physical or emotional contact between the woman and child in *The Seine at Argenteuil* is quintessentially Monetesque and diametrically opposed to the manner in which Manet had portrayed Camille and Jean in *The Monet Family in Their Garden at Argenteuil*.

Until now, no one has suggested that Mme. Monet also posed for the woman shown in *Boating* (figure 9.10), who has never before been identified and is often presumed to have been a professional model. I cannot claim to have unearthed new documentation definitively proving that Camille posed for this figure; my assumption is based primarily on visual evidence present in this painting and *The Seine at Argenteuil*.

This identification is based in part on the marked similarities between Mme. Monet's coloring and features as we know them from numerous images of her and those of the model. Like Camille, the woman shown in *Boating* possesses very dark, almost black

hair and brown eyes; her shapely nose and firm chin also recall Camille's features. Manet has carefully delineated the model's colorful blue-and-white striped dress, which closely resembles the costume Mme. Monet wears in Monet's *Camille Monet and a Child in the Garden at Argenteuil* (figure 10.3), painted the following year. The broad tan belt the model wears in *Boating* must have been specified by Manet, who shows Camille wearing a similar black belt in *The Seine at Argenteuil*, a fashion accessory absent from all other images of Mme. Monet. Although the dress she wears in the latter picture has very muted stripes, the pattern, as well as the neckline and sleeves, resembles the costume worn by the model of *Boating* and could conceivably have been the same dress, deliberately grayed down in *The Seine at Argenteuil* to contrast more forcefully with the intense blue of the river. (Jean's outfit is also gray.)[20]

The female figures in both *The Seine at Argenteuil* and *Boating* wear the same chapeau, which was certainly selected by Manet, to whose wife it belonged. Like Matisse, Manet was a "hat man" who enjoyed portraying women in lavish chapeaux that complemented their charms. Ample visual evidence attests to Manet's special fondness for this lovely white hat, with its crown of matching flowers and black trim and ribbons. Manet repeatedly depicted his wife wearing this hat, in *The Swallows* (Stiftung E. B. Bührle, Zurich) and *On the Beach*, both painted on the Atlantic coast in 1873, and in the pastel *Mme Manet on a Blue Sofa* (1874; Musée du Louvre, Cabinet des Dessins). However, the favored hat perches rather awkwardly atop the head of the model in *Boating*, almost as though it were too small for her. Camille obviously had heavy hair, and the upswept hairstyle she favored during this period, terminating in a large chignon near the crown of her head, would have made Mme. Manet's hat a tight fit. Furthermore, it seems difficult to believe that her husband would have proposed, or that Mme. Manet would have consented, to lend her hat to an unknown—and possibly unhygienic—professional model. (The professional model who posed for Manet's *Argenteuil* [Musée des Beaux-Arts, Tournai], executed during those same weeks, obviously wears her own rather ridiculous chapeau, with its white, sail-like trim.)[21]

Arguably the most celebrated of the paintings Manet completed that summer, *Boating* represents a young couple enjoying a sail on a brisk, sunny day. By radically cropping the boat, Manet has brought us into intimate contact with his personae, creating the illusion that we too share the exhilarating experience of cutting rapidly through the water in a strong breeze. *Boating* constitutes a masterpiece of illusionist painting. To represent a vessel actually under brisk sail, Manet presumably would have had to work from another fast-moving boat, a physical impossibility; he surely executed the picture with the painted boat securely moored. Despite its seeming spontaneity, *Boating* is highly organized and carefully composed; like *Argenteuil*, it may have been worked on in Manet's studio as well as on site. Radiographs reveal that Manet made changes in the pose of the male model, his brother-in-law Rodolphe Leenhoff, who gazes at the viewer with a serious expression befitting his role as the "pilot" of the vessel.[22] His companion, depicted in pure profile with her lips slightly parted, gazes raptly into the

distance as though fascinated by something occurring on the opposite bank. She leans back against the hull of the boat in a relaxed manner that seems less restrained, perhaps even less "proper," than contemporary behavioral standards for bourgeois ladies dictated. (One scholar perceives the poses of both figures as "vaguely sexual" and labels Camille's position "unladylike and vulnerable.")[23]

CAMILLE AS DEPICTED BY RENOIR

During the sojourns *chez* Monet between 1872 and 1874, Renoir repeatedly portrayed his host and hostess. (Interestingly, he never showed the couple together, and *Mme. Monet and Her Son in the Garden at Argenteuil* is his only portrait of Jean.) Unfortunately, Renoir did not date any of these pictures, an omission that has given rise to considerable debate over their precise chronology. I agree with those scholars who have tentatively dated both *Mme. Monet Reading "Le Figaro"* (figure 9.11) and *Portrait of Camille Reading* (figure 9.12) to 1874. Additional support for dating these two compositions to 1874 comes from the fact that Monet—who routinely showed his wife decked out in the latest fashions—portrayed her in this dressing gown in *Camille Embroidering* (1874–75; figure 10.2). Whether they were executed that summer or a year or two earlier has no relevance for the major point made here: that both works depict very different aspects of Camille's personality from those depicted by her husband.

Both these pictures represent Mme. Monet clad in a gorgeous blue silk dressing gown decorated with broad bands of rich gold embroidery. Although the robe covers her from head to toe and masks the shape of her body, it is a costume that she, like other middle-class women of the period, would have worn only in the privacy of her home. She might, however, appear in such attire before an intimate friend, like Renoir, when entertaining informally *chez elle*.

Mme. Monet Reading "Le Figaro" shows Camille reclining on a sofa or daybed as she peruses the daily paper. Her pose is, of course, a variation on the time-honored motif of the reclining nude in which so many female models have been depicted through the centuries. Around 1872–74, Manet, Morisot, and Renoir all reexplored this motif, but with an important difference: now the "reclining ladies" portrayed were all fully clothed members of the bourgeoisie. Manet executed two such works, *Lady with Fans: Portrait of Nina de Callias* (Musée d'Orsay) and *Mme. Manet on a Blue Sofa*. Berthe Morisot with her pastel *Portrait of Mme. Hubard* (Ordrupgaardsamlingen, Copenhagen) and Renoir with *Mme. Monet Reading "Le Figaro"* provided their own variations on the theme of the respectable, fully clothed reclining woman.[24]

Renoir's depictions of Camille in the blue dressing gown both incorporate another time-honored theme: they depict her reading, a device long associated with defining the sitter's status as a middle-class woman who possesses the leisure to devote herself to such pursuits, while servants carry out the menial household tasks.[25] However, he departs from this convention in *Mme. Monet Reading "Le Figaro"* by showing her

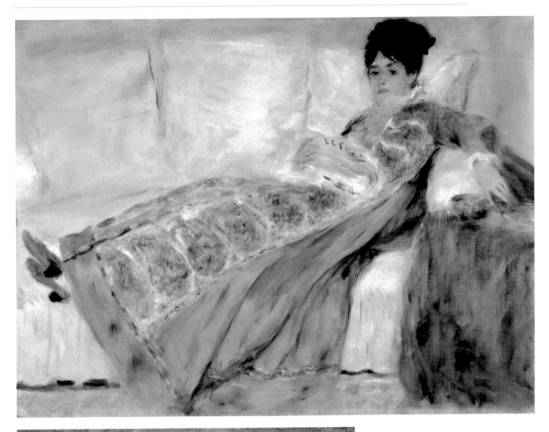

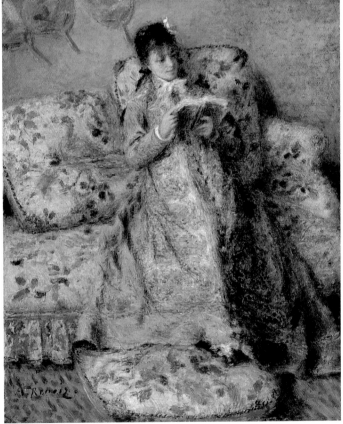

9.11. (*top*) Pierre-
Auguste Renoir,
*Madame Monet Read-
ing "Le Figaro,"* ca.
1874, Museu Calouste
Gulbenkian, Lisbon/
Bridgeman Art Library

9.12. (*bottom*) Pierre-
Auguste Renoir,
*Madame Monet Read-
ing,* ca. 1873–74,
Sterling and Francine
Clark Art Institute,
Williamstown, MA

perusing a newspaper (albeit the impeccably conservative *Le Figaro*) rather than a book, more properly a light novel, traditionally considered appropriate reading matter for middle-class women. (Renoir himself adhered to the older convention in other compositions showing women reading, as did many of his colleagues, notably including Monet, who repeatedly represented Camille with a book but never a newspaper. Indeed, he symbolically associated *Le Figaro* with himself in his ambitious *Luncheon* of 1868–69 (figure 6.3), which features a folded copy of the journal lying next to the place setting reserved for—but not yet occupied by—the artist himself.)

One can readily appreciate why Camille's gorgeous robe attracted Renoir, fabricated as it is of a rich blue (its hue echoed by the background wall) with wide bands of golden appliqué repeated in the narrow band appliqué that runs around the skirt of the garment and merges with the horizontal black band (or shadow) Renoir uses to define the edge of the sofa's ruffled white slipcover. The latter device helps to anchor Camille's body, depicted at a sharp diagonal with her feet barely positioned on the edge of the sofa and her upper body reclining against a back cushion. Her left hand dangles loosely over the divan's arm, barely touching the sofa table and—not so coincidentally—highlighting a bright red trim on the cuff of her gown, which matches the carmine of her lips and the decorative box resting on the tabletop. Both this picture and its companion are brushed in so freely, with such thin paint, that the viewer cannot identify the precise design of the large oval appliqués on her robe. In contrast to the loose facture that captures her costume and setting, Renoir represents Camille's facial features and raven hair far more precisely. As though interrupted by an unexpected visitor (another time-honored device), who is, of course, the artist himself, Camille looks up from her newspaper with a glance that is simultaneously candid and provocative but does not suggest a lack of decorum in her behavior or relationship with Renoir. Her lively, penetrating expression, far different from the face she "wears" in her husband's representations—should probably be attributed to Renoir's ability to tune in to feminine psychology, revealing the underlying sexuality of his subjects, whether they were bourgeois housewives or professional models (whose conduct was often far from straitlaced). Perhaps not surprisingly, Monet sequestered the picture in his private collection, unexhibited throughout his lifetime.

Renoir's companion picture, *Portrait of Camille Reading*, represents her in an even more informal—and intimate—moment. She is shown in the same costume as in *Mme. Monet Reading "Le Figaro"* and posing on the same couch, now stripped of its white slipcover to reveal its luscious underlying upholstery, a richly patterned fabric with deep pink cabbage roses and large-scale birds printed on a cream ground. (The sole bird clearly delineated resembles a peacock in body shape but not in coloring, with its cerise breast and blackish back and tail.) In order to coordinate other aspects of his color scheme with the upholstery, Renoir has rendered both Camille's robe and the wall behind her in richer, deeper blues than in *Mme. Monet Reading "Le Figaro"*; the narrow ribbon of pale bluish-gray flooring visible in the latter picture has given way here to a

lively—almost garish—carpet in a vivid, tigerlike orange-and-black pattern. He has further enlivened the wall behind Camille by showing three brightly colored Japanese fans of the inexpensive variety known as *ushiwa*. (Similar fans would make another appearance in Monet's *La Japonaise*, 1875–76.)

Rather than again representing Mme. Monet in a reclining position, this time Renoir depicted her seated in a very relaxed manner, leaning against one of the couch's loose back cushions with her feet resting on a second cushion, tossed on the floor. Immersed in her reading of a softcover book, presumably a novel, Camille appears totally unaware of the presence of the artist. Precisely because she felt so comfortable with Renoir, he was able to capture her in such a private moment, before her morning toilette had been completed and she had arranged her hair, which she wears in a loose ponytail tied with a black ribbon. The flower tucked in her hair recalls the much larger blossom sported by Manet's *Olympia*, a reference Renoir may have intended as an homage to the older artist's precedent-shattering composition. The flower might have added a coquettish—or even suggestive—note to Camille's portrait, were she not pictured as so oblivious to the artist's—or spectator's—presence.

None of Monet's portrayals of Camille, either as mistress or as wife, conveys a level of relaxed intimacy comparable to Renoir's achievement in the *Portrait of Camille Reading*. (Nor, one might add, did Monet ever depict Camille with her hair unbound.) When Monet represents his wife, one is always aware that one views a fictive moment captured in paint, rather than the painterly equivalent of a twentieth-century "candid camera" shot—an effect Renoir created so well in his *Portrait of Camille Reading*.

MONET'S MYSTERIOUS BOAT PICTURE

During the late summer or early autumn of 1874, Monet executed a composition that arguably constituted his response to Manet's pictures featuring Camille on the Seine. *The Studio Boat* (figure 9.13) represents his floating atelier lying at anchor between two tether poles near the Petit Gennevilliers bank of the Seine. In contrast to the vivid colors and exuberant character of many of the pictures Monet created that summer, this work seems rather somber, with the craft's green cabin providing the only bright note in what appears to be an autumnal scene. In this silent world no creature stirs; scarcely a ripple ruffles the water's surface to disturb the reflections of the villa and wooded promenade depicted on the opposite bank. Utterly alone in its quiet watery universe, the vessel projects a haunting quality, tempting one to anthropomorphize and read into its inert form human qualities of poignancy, loneliness, and meditation. This response may be less bizarre than it seems, for Monet's studio boat sometimes functioned as his symbolic self-image. Close observation, however, reveals the boat is not deserted but occupied: a half-hidden personage can be discerned just inside the cabin. Her clothing suggests that the concealed figure is Camille, who appears to be standing, looking through one of the boat's primitive windows to the opposite shore. The exact hue and pattern of her costume are difficult to discern with

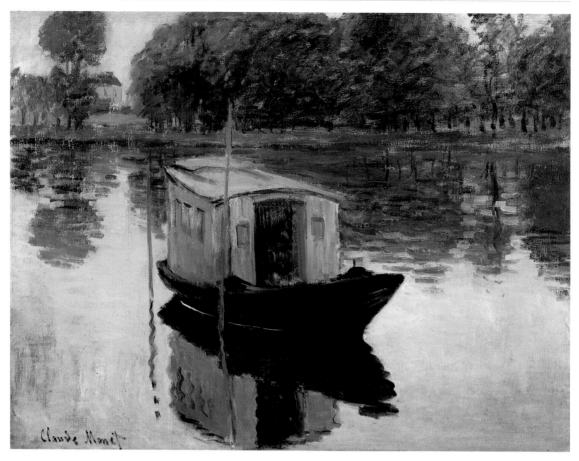

9.13. Claude Monet, *The Studio Boat*, 1874, Collection Kröller-Müller Museum, Otterlo, the Netherlands

certainty, but she appears to be wearing the same blue-and-white striped dress as in Manet's *Boating* and in her husband's 1875 portrait of her with a child in the garden. Tucker suggests that this "vaguely-defined figure" may be Monet himself, but the model is clearly a woman, whose white petticoat peeps beneath the hemline of her dress.[26]

Was this painting Monet's response to Manet's depictions of Mme. Monet on the Seine? By creating this semicovert image in which Camille is utterly alone, Monet could undo the images of intimacy portrayed by Manet in his paintings of the floating studio. By making Camille so difficult to identify, Monet could also reassure himself that he was not violating his magical conviction that the watery world of his imagination was the exclusive province of his beloved dead mother and aunt.

As previously noted, neither of Monet's two pictures of Camille executed during the summer of 1874 presents her in a novel context. Rather, it was Monet's colleagues, Manet and Renoir, who represented Mme. Monet in roles and situations in which her husband neither had cast her in the past nor would depict her in their future collaborations. Did Camille feel less constrained when posing for Monet's friends than for her husband? Perhaps so. What one can assert with complete confidence is that the versatility Camille demonstrated in responding to the widely varying demands of the three artists provides vivid proof of her outstanding talents as model and muse.

Camille Ascendant; Camille Redux

THE CONTEXT

In October 1874 the Monets took possession of their new Argenteuil home, conveniently located across from the railroad station. In agreeing to pay the significant increase in rent the new lease required (1,400 francs per annum, versus 1,000 for their first Argenteuil home), Monet displayed his characteristic lack of fiscal prudence. His income, which had declined significantly in 1874, continued its downward slide in 1875. The uncertain political situation in France, which reverberated through the economy, did not help the art market.[1]

In an attempt to increase revenue and gain publicity, Monet, Morisot, Renoir, and Sisley decided to offer a large selection of their paintings at auction. The sale, which took place at the Hôtel Drouot in Paris on March 24, proved to be a financial and public-relations disaster; police had to be called to restrain the hostile crowds, and bids were so low that Monet was forced to buy back a number of his own works.[2]

To help make ends meet, Monet depended, as usual, on the generosity of friends, especially Manet, who received several typically piteous letters requesting loans. He responded by purchasing several paintings from Monet, as well as attempting to interest others in his friend's art.[3] In order to settle his debt to a Parisian art supply dealer, Monet forced Camille to transfer in advance two thousand francs from her inheritance, which she was not due to receive until 1877. Despite all these efforts, his income for 1875 amounted only to 9,765 francs.

Fortunately, the downward course of his finances had no effect on Monet's creativity or productivity, and 1875 proved to be an unusually rich period in his career, during which he turned out one marvelous picture after another, including the expressionistic, anthropomorphic *Train Engine in the Snow* (w 356), which he retained in his private collection until his death, and that grim but superb composition, unique in his oeuvre, *The Coal Dockers* (w 364). The powerful impact of this painting, undiminished by time, demonstrates that, had Monet been so inclined, he could have produced searing visions of the plight of contemporary underclass laborers.[4]

In addition to these explorations of highly original themes, Monet effectively reinterpreted more characteristic motifs, painting outdoors in bad weather as well as good and producing numerous views of Argenteuil in snow (w 348–55 and 357–62). Realism and idealism often play strikingly opposed roles in these representations of wintry Argenteuil. Although several pictures (such as w 353, 353a, and 357) present a poetic vision of an unblemished, snowy landscape, others (like 354–55 and 358–59) show how snowfalls quickly turned the town's unpaved roads and walkways to muck, making getting around difficult and unpleasant for its inhabitants.

The advent of spring inspired Monet to return to the more idyllic visions of the town's waterways and paths (w 368–75), which remain as pristine and uncrowded in his paintings of 1875 as in similar compositions executed in previous years. His representations of moored sailboats, especially the trio with red hulls (w 368–70), rank among the most celebrated of his works from this period.

The outpouring of creativity Monet enjoyed that year reflected his relief at finding himself alone once more after devoting so much time and energy the previous summer to his multiple duties as host, model, and colleague during the prolonged visits of Manet and Renoir to the area. Basking in his solitude, Monet resolved to avoid working side by side with fellow artists in the future.[5] Obviously, the fact that he was not responsible for any group project as time-consuming as organizing the inaugural Impressionist Exhibition of 1874 also permitted Monet to devote himself more wholeheartedly to his art.

The departure of his friends also restored Monet's exclusive access to the services of his principal model and artistic partner, Camille, and he made ample use of her talents, portraying her, either as the primary subject or as an incidental figure, in no fewer than twelve works, a series that included two of his most famous compositions, *The Stroll* (*Woman with a Parasol*) (figure 10.5) and *La Japonaise* (*Camille Monet in Japanese Costume*) (figure 11.1), both discussed below.

CAMILLE AS HOUSEHOLD MADONNA

As soon as the Monets were settled in their new home (which seems to have been quite well furnished, despite the family's straitened financial situation), the artist used his new domicile as the setting for the haunting *A Corner of the Apartment* (figure 10.1). It shows Jean as a forlorn little fellow, half hidden in the obscure light of the long hall, where he stands turned wistfully toward his father. In a reversal of Monet's typical compositions featuring mother and son, Camille, rather than Jean, appears here as the more distant, uninvolved figure, barely discernible in the dim light of the room at the far end of the hall. Monet underscored the emotional isolation of his personae by positioning himself and his easel relatively far from both models, perhaps working just inside the small conservatory that would serve as the setting for his picture *Camille Embroidering*. Both compositions make effective symbolic use of the multiple (three?) sets of chintz drapes, with their identical bright floral patterns. These are tied back in a manner reminiscent of gothic arches, a device that lends an underlying religious aura to *A Corner of the Apartment*, in which Camille appears as a Madonna-like persona, situated in her own special niche and removed from ordinary humans.

Monet made the Madonna symbolism more explicit in *Camille Embroidering* (figure 10.2), which represents her alone in the little conservatory, seated before its large window, as she works on an embroidery or tapestry secured in a freestanding wooden frame. We the spectators, like the artist portraying her, are figuratively separated from her special place by another of those sets of floral drapes tied in a manner recalling

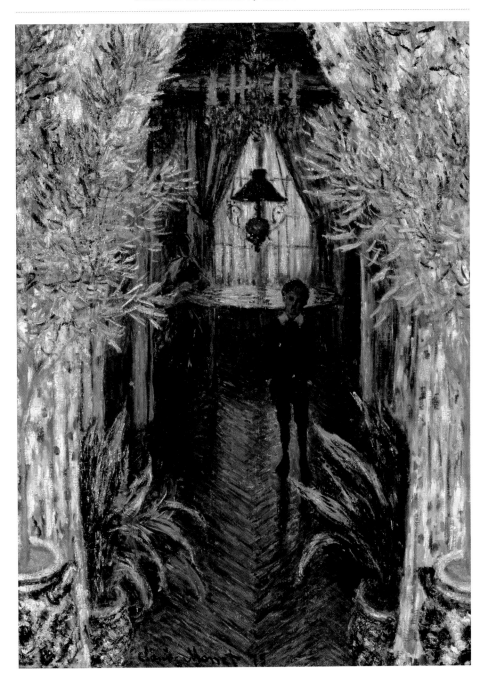

10.1. Claude Monet, *A Corner of the Apartment*, 1875, Musée d'Orsay, Paris, Réunion des Musées Nationaux / Art Resource, NY

gothic arches. Two potted plants with tall, spiky leaves, positioned directly anterior to the drapes, further separate and define Camille's special niche while simultaneously functioning rather like anthropomorphic "guardian figures," protecting the "Madonna" from intrusion. Another pair of plants (the same tall, feathery ones visible in the foreground of *A Corner of the Apartment*) hover protectively above Camille as she bends to her task. Her "special" place again evokes associations to gothic chapels, in this instance, one dedicated to the Virgin, which invariably feature paintings or statues of the Madonna. Camille's dressing gown—the same beautiful blue robe with its rich gold-embroidered panels and border that she wore when posing for Renoir—underscores

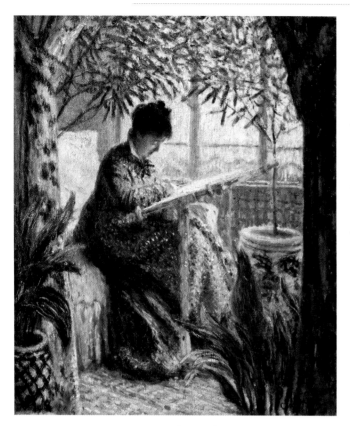

10.2. Claude Monet, *Camille Embroidering*, 1875, Barnes Foundation, Merion, PA / Bridgeman Art Library

the similarities between her image and that of the Virgin, portrayed in countless Renaissance altarpieces wearing a blue mantle similarly trimmed in gold.

The plants that surround Mme. Monet, as well as the rich floral patterns of the draperies defining her "sacred" area, anticipate certain characteristics of another Madonna-like image of her created several months later, *Camille Monet and a Child in the Garden at Argenteuil* (figure 10.3). This composition reinterprets the popular Renaissance theme representing the Madonna in an enclosed garden, which signifies her unsullied virginity (figure 10.4). As though intent on underscoring his sitter's symbolic role, Monet has supplied Camille with a stand-in for the infant Jesus (usually shown on his mother's lap in Renaissance representations of this theme) in the person of a toddler presumably "borrowed" from a friend or neighbor to pose. (However, the ribbon or flower in the child's hair—if not the unisex dress—suggests that the model was in reality a little girl.)[6]

For this composition, Mme. Monet again donned the blue-and-white striped gown she wore the previous summer when posing for Manet's *Boating* and, probably, for Monet's *Studio Boat*. In *Camille Monet and a Child in the Garden*, Monet has transformed the regularity of the gown's striped pattern into myriad irregular, broken strokes of blue and white, with added touches of pink and mauve reflected from the garden path, creating a virtuoso display of his Impressionist technique. The toddler's harmonizing blue outfit is similarly enriched with flickering touches of white and mauve, which complement Camille's costume as well as the predominant mauve of the gravel path on which the child sits, a quiet, pyramidal form, dutifully absorbed in the picture book on her lap. (The artist either enjoyed especially good fortune with his young model or successfully bribed her to maintain this quiet pose—no small accomplishment with a child of this age.) He positioned both models before a segment of a flowerbed (probably the large circular one bordered by a gravel path shown in many other paintings from the Argenteuil years, especially compositions depicting Camille), sparkling with a profusion of brilliant red, pink, and white blossoms and rich green foliage. By posing Mme. Monet on a low stool, with the child at her right seated on the gravel path, Monet exaggerated the actual height of the flowerbed, creating an illusion of the high, protective walls and plantings that typically symbolize the unsullied virginity of the Madonna in Renaissance representations of the motif.

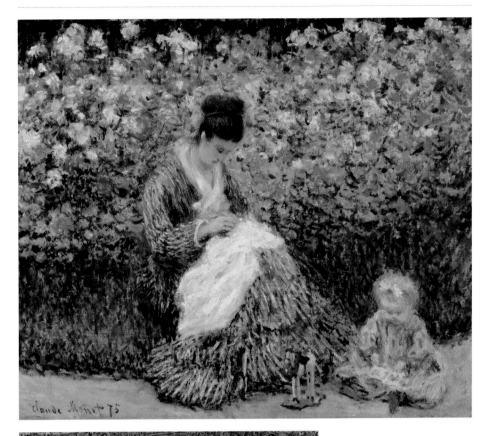

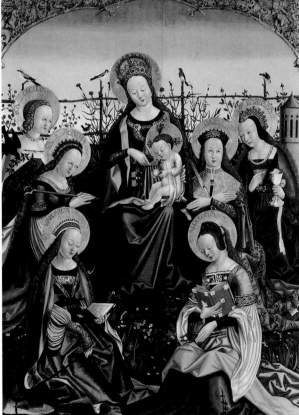

10.3. (*top*) Claude Monet, *Camille Monet and a Child in the Garden at Argenteuil*, 1875. © Museum of Fine Arts, Boston

10.4. (*bottom*) South German, *Triptych of the Virgin and Child with Saints*, 1505/15, center panel, The Art Institute of Chicago, Mr. and Mrs. Martin A. Ryerson Collection

Monet's exploration of this theme did not extend to depicting his updated "Madonna and Child" in a mutually affectionate relationship, unlike Renaissance counterparts, which show the baby Jesus on Mary's lap, sometimes engaging in playful interactions with her. Instead Monet's deep-seated need to portray mother and child as alienated from one another prevailed even when he posed Camille with someone else's child. Despite the rightward shift of her body, which puts her into relative physical proximity to the toddler, Mme. Monet appears as absorbed in her sewing as the youngster with her picture book.

In *Camille Monet and a Child in the Garden*, as well as in its earlier "wintry" counterpart, Monet fuses two time-honored motifs: the woman sewing and the Madonna in an enclosed space. Of the two, *Camille Monet and a Child in the Garden* more successfully modernizes this twinned theme. Appearing as spontaneous as if dashed off in a single sitting, the painting's brilliant illumination, bright hues, and bold facture make it more radical and less genrelike than *Camille Embroidering*, which lacks the bravura effect of its summertime counterpart, presumably painted primarily *en plein air*. Despite the brilliant technique that distinguishes *Camille Monet and a Child in the Garden*, this composition, like *Camille Embroidering*, represents the model in the time-honored iconography of the woman sewing, invariably a symbol of her bourgeois status and leisure time, a theme also favored by Monet's colleagues Renoir and, especially, Pissarro. It remained for Paul Gauguin to treat this motif in a completely new and radical manner, when he portrayed the family governess stitching in the nude in his 1880 canvas *Suzanne Sewing*.[7]

What inspired Monet suddenly to represent his wife as a modern Madonna? Although he had typically shown her in the Argenteuil years as a proper, elegantly garbed middle-class lady, he had never before depicted her so explicitly as a contemporary reincarnation of the Virgin. Did his experiences during the summer of 1874, when *politesse* forced him to share Camille's services as model with Manet and Renoir—sessions she had obviously enjoyed—stir up Monet's repressed oedipal rivalry, especially vis-à-vis Manet, with his status as the leading avant-garde artist? Although not sufficiently senior to Monet to have been his biological father, Manet may have symbolized such a figure to his younger colleague, who later reacted to this fantasized oedipal struggle by emphasizing Camille's special "virginal" status as a Madonna-like personage, secluded within the protective confines of the garden *he* had erected around her and available solely to him, not only as model but as sexual object. Perhaps creating these two images of Camille as modern Madonna sufficed, because he never again explored this iconography. Indeed, the last portrait of Mme. Monet he began that year, but did not complete until early in 1876, *La Japonaise (Camille Monet in Japanese Costume)*, would express the alternative fantasy, of the woman as sexually available.

Monet featured Camille in several other compositions painted that summer, posing either in the family garden (w 384–86) or in nearby meadows (w 379, 379a). Although quite charming, none of these compositions equal the dynamism or originality of *The*

Stroll (to be discussed below). Indeed, one of these paintings, *Young Women in a Bed of Dahlias* (W 383, Národní Galerie v Praze, Prague), seems rather contrived. It depicts Mme. Monet immersed in a clump of dahlias, with only her head visible. An unidentified adolescent girl stands at the far left, leaning into the dahlias as if in the act of plucking a flower. One wonders what Monet had in mind in composing this painting. Surely he did not intend to portray Camille as Nature; the isolation of the dahlia clump, the presence of another model, and—above all—Mme. Monet's unintentionally risible hat rule out such an interpretation. As Marianne Alphant wittily observes, the composition reduces Camille's image to a visage and a chapeau floating among the heads of dahlias.[8] The artist certainly would not have concurred with the judgments of Alphant and me, for he selected the picture to show in the second exhibition organized by the Impressionists, indicating that he considered the work particularly successful.

THE STROLL (WOMAN WITH A PARASOL)

One tends to remember *The Stroll* (figure 10.5) as a monumental work, although its actual dimensions (39⅜ × 31⅞ in.) are quite modest. The expansion the painting acquires (at least in my own memory) attests to its high quality and powerful impact. As he often did during the Argenteuil years, Monet chose a location in a seemingly unspoiled meadow near the town. The glory of the picture stems from the skill and freedom with which he executed the composition, the sheer joy in his own expertise that he must have felt as he captured to perfection the atmosphere of an ideal day in late spring, bright and breezy, cool and clear. Poised at the summit of a small rise, Mme. Monet and her son stand silhouetted against a bright blue sky studded with vaporous, scudding clouds. They look down at the artist (and by extension at the viewer), who has set up his easel at the foot of the rise. Thick with wild grasses and flowers, the hill illustrates the regenerative powers of nature, crowned by Camille, a modern-day Primavera, presiding over her domain, her white gown reflecting, mirrorlike, the hues of sun, plants, and sky.

In contrast to many of Monet's representations of Camille as a passive, pensive, even melancholy personage, *The Stroll* records her more vivacious aspect, the lively manner Renoir and Manet had captured when she posed for them the previous summer. The varied emotional tones Mme. Monet projects from one composition—and painter—to another attests to her abilities as a model of unusual talent, a key participant in evoking the range of affective responses required by her husband or his colleagues.

In *The Stroll*, as she had in the earlier *Camille*, Mme. Monet and her partner once again accomplished the feat of portraying her as if in motion, caught as she whirls to face us, an action echoed by the hem of her dress (defined by heavy, broken black brushstrokes), which seems to anticipate her impending postural change. Winds and clouds also play key roles in enhancing the illusion that both the natural realm and its presid-

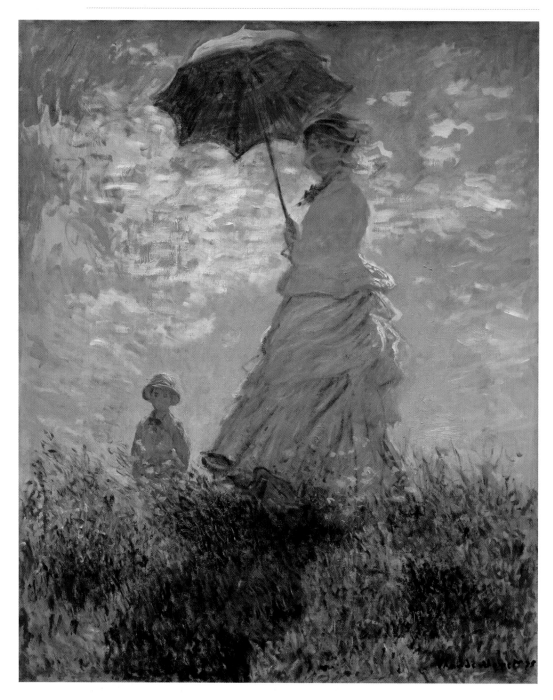

10.5. Claude Monet, *Woman with a Parasol—Madame Monet and Her Son (The Stroll)*, 1875, Collection of Mr. and Mrs. Paul Mellon. Image courtesy of the Board of Trustees, National Gallery of Art, Washington

ing goddess are in motion. The zephyrs—as Monet represents them—simultaneously blow in opposite directions, whipping Camille's veil behind her while swirling her skirts forward around her torso.

In contrast to the detail with which Monet renders his models' costumes and the characteristics of the rise on which they pose, with its rich, wild growth of grasses and flowers captured in myriad brisk, overlapping, varicolored strokes, he represents the sky with the freedom and daring of a master in complete command of his medium. Virtually formless, propelled by brisk breezes that continuously move them across the sky

before they can assume even temporary shape or character, the vaporous cloud streams also function as a miniabstraction within the context of a representational painting. Despite their seeming autonomy as abstractions, Monet's clouds do not detract from the painting as a unified gestalt; rather, their continuous motion remains subservient to the thematic integrity of the composition, which is as much a depiction of light and wind as of persons and place.

Although Monet portrayed Camille's personality in a new light in *The Stroll*, no comparable change occurred in his representation of her relationship with Jean; as usual, they are shown as seemingly unaware of one another despite their physical proximity. Jean, by that time nearly eight years of age and a seasoned model accustomed to complying with his father's professional demands, however much they departed from his usual behavior vis-à-vis his mother, stands behind and slightly below Camille, facing the viewer with serene confidence and nonchalance. Despite the success of *The Stroll*, which might have tempted Monet to retain it in his private collection, as he did with many other depictions of Camille, he sold it to Georges de Bellio in November 1876, when his chronic cash shortage was especially severe.

CAMILLE REDUX

The beautiful painting continued to haunt the artist long after it had left his possession, and memories of it resurfaced eleven years later when he suddenly created two closely related variations on *The Stroll*: *Study of a Figure Outdoors (Facing Left)* (figure 10.6) and *Study of a Figure Outdoors (Facing Right)* (figure 10.7). Both pictures depict Suzanne Hoschedé, then eighteen, posed atop an embankment on the Île aux Orties, a tiny island located conveniently close to Giverny, where the artist, his sons, and Mme. Hoschedé and her six children had lived since 1883.

The creation of these figurative works closely followed two traumatic episodes in Monet's personal life during the late winter and early spring of 1886. Although Alice Hoschedé had remained at Monet's side ever since the death of Camille, their relationship had continued to be a stormy, uncomfortable one for both partners. Ernest Hoschedé, who had long since ceased contributing to the support of his family, visited Alice and the children only rarely, but his infrequent appearances invariably precipitated crises between the lovers. His visit on February 19, 1886, ostensibly to celebrate Alice's birthday but in reality to cause trouble, threatened to sever their relationship permanently. Monet, unable to endure encountering Hoschedé, fled to Etretat shortly before Ernest's arrival; too upset to work productively, he sent Alice a series of highly emotional letters, pouring out his anguished feelings over their potential estrangement. The immediate crisis resolved itself on February 26, when Alice wrote Monet, pledging herself to remain at his side.[9]

Monet's return to figurative painting represented an abrupt shift in his artistic interests. For several years he had spent long campaigns away from home concentrating

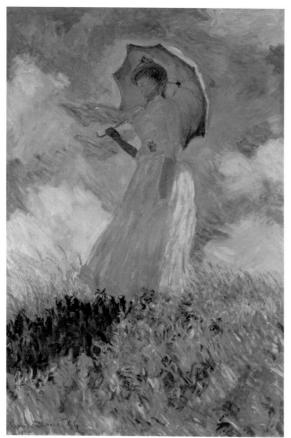 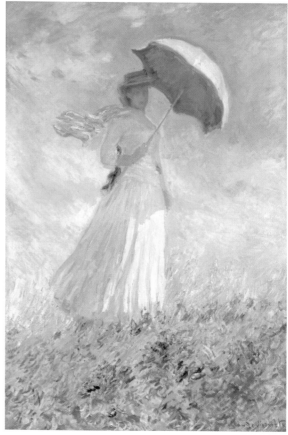

10.6.(*left*) Claude Monet, *Study of a Figure Outdoors (Facing Left)*, 1886, Musée d'Orsay, Paris, Réunion des Musées Nationaux/ Art Resource, NY

10.7. (*right*) Claude Monet, *Study of a Figure Outdoors (Facing Right)*, 1886, Musée d'Orsay, Paris, Réunion des Musées Nationaux/Art Resource, NY

on seascapes and landscapes in which the human figure played virtually no role. Most scholars have linked his renewed interest in figuration to a confluence of factors, including contemporary figurative paintings by Pissarro and Renoir, and—above all—the dramatic effect of Georges Seurat's revolutionary machine-size composition *Sunday on the Island of the Grande Jatte* (1884–86), showing multiple contemporary figures in an outdoor setting, executed (at least partially) in a novel style featuring myriad tiny dots of paint. Seurat exhibited his revolutionary painting at the Eighth—and final—Impressionist Exhibition, which opened on May 1, 1886. Although Monet, Caillebotte, Renoir, and Sisley did not participate in the show, Monet surely visited the exhibition and studied Seurat's painted challenge to Impressionism at first hand.[10]

That spring the Impressionists, whose former camaraderie had long been rent by quarrels and defections, were dealt another blow with the publication of Emile Zola's roman à clef *L'Oeuvre* (translated as *The Masterpiece*), the story of the failed painter Claude Lantier. As previously noted, the novel utilized material from the personal and professional histories of Cézanne, Manet, and (although less often emphasized by critics) Monet. Similarities between aspects of Monet's own earlier life and career and that of Lantier were readily recognized by the artist.[11] Not surprisingly, Monet found Zola's novel extremely disturbing, a fact he confessed to the novelist in a highly ambivalent congratulatory letter:

You were kind enough to send me *L'Œuvre*. . . . I have always had great pleasure in reading your books, and this one interested me doubly because it raises questions of art for which we have been fighting for such a long time. I have just read it, and I remain troubled, disturbed, I confess to you.

You took care, intentionally, that not one of your characters should resemble any of us, but in spite of that, I am afraid that our enemies among the press and the public may use the name of Manet, or at least our names, to make us out to be failures, something which you did not have in mind, I refuse to believe it.

I have read *L'Œuvre* with very great pleasure, discovering old memories on each page. . . . but in the moment of succeeding, I fear our enemies may make use of your book to deal us a knockout blow.[12]

After reading the novel, Cézanne, who had been Zola's intimate friend since childhood, permanently broke off all contact with him; Monet, Pissarro, and Renoir also subsequently avoided Zola, although Monet and Pissarro both rallied to the novelist's support in 1897–98, when he took up the desperate cause of Captain Dreyfus. However, Monet limited his participation to supportive letters to Zola and did not travel to Paris when the novelist was put on trial for his advocacy.[13]

Perusing Zola's novel forcibly reminded Monet of Camille, their life together, and the numerous paintings for which she had posed. These memories played a key role in directing Monet's attention once again to figurative painting. The close relationship between *The Stroll* and Monet's twin representations of Suzanne has been universally recognized. Like *The Stroll*, the depictions of Suzanne, also painted from low vantage points, have her clad in a white dress with a chapeau secured by a greenish veil. She holds a white parasol with a green lining, virtually identical to the one with which Camille posed. Depicted on a bright day in late spring or early summer, Suzanne also stands atop a rise rich with a tangle of wild flowers and grasses, their hues reflected in her white gown. As in *The Stroll*, in both images of Suzanne sportive breezes rustle her skirt, toy with her veil, and propel puffy clouds across the blue sky. But a fundamental contrast separates Monet's two models: Camille is an active participant in the creative effort, Suzanne a passive one. Never strong (and destined to die at age thirty from an undiagnosed neurological disease), Suzanne found posing for the demanding artist exhausting; once she even fainted. Not surprisingly, then, the compositions reflect the model's passivity; they are beautiful decorations, but they convey neither the verve nor the joie de vivre suggested by Camille's motion-charged image. In fact, both representations veil Suzanne's features, as if deliberately deemphasizing her individuality. Did Monet consciously or unconsciously make this decision to confirm his fantasy that Camille, magically resurrected, was once again posing for him? Whatever his motives, he transformed the magic of *The Stroll*, with its perfect integration of portraiture and atmospheric conditions, into beautiful decorations featuring a generic personage acted upon by, rather than interacting with, her surroundings. Small wonder that Monet himself later compared them to his numerous depictions of grain stacks, informing a

critic viewing his highly successful one-man exhibition of 1891, where the two figure studies were hung above fifteen paintings of grain stacks: "It's the same woman, but [each picture] painted in a different atmosphere. I could have done fifteen portraits of [Suzanne], just like with the haystacks. To me, only the surroundings give true value to the subject."[14]

According to Jean-Pierre Hoschedé, and confirmed by his sister Germaine Hoschedé-Salerou, Monet was inspired to paint Suzanne when he spied her standing atop the embankment on the Île aux Orties (along with Germaine, Mme. Hoschedé, and Michel). Although Monet captured all four figures in a quick sketch (w 1075, private collection), only the presence of Suzanne made an impression on him. "But that's just like Camille at Argenteuil! Well, tomorrow we'll come back and you shall pose there," he informed the young woman.[15]

Of course Suzanne was not Camille, as Monet soon bitterly realized—a conclusion that led him to kick a hole through one of the completed paintings in a fit of dissatisfaction. Having vented his spleen, he later repaired the canvas and revised his opinion of the twin paintings, which he came to view as studies of atmosphere more than of the person depicted. He retained the two pictures throughout his lifetime, showed them together in the exhibition held by Durand-Ruel in 1891, and in his old age proudly displayed them in the onetime studio that he devoted to exhibiting figurative works.[16] Wildenstein expresses skepticism about the story that one of the paintings was damaged, but careful examination of the canvas has revealed that *Study of a Figure Outdoors (Facing Left)* has a long horizontal tear in the grassy area, masked by overpainting.[17]

Camille's Captive Samurai

THE CONTEXT

"Well, he's got himself a piece of junk," Monet fumed when Georges Bernheim asked whether the artist was aware that Paul Rosenberg had just purchased *La Japonaise* (*Camille Monet in Japanese Costume*), painted in 1875–76 (figure 11.1).

> "Junk?" [repeated Bernheim in astonishment]. "Yes junk; it was only a fantasy. I had exhibited *Camille* [*The Woman in Green*], which had had a very big success at the Salon, and it was suggested that I try to repeat it. I was tempted when they showed me a marvelous robe with gold embroidery more than an inch thick." [René Gimpel, who witnessed this incident, asked the painter if he was serious, and he replied,] "Absolutely." He showed us a photograph of the painting. I admired the head and found it beautiful. He told us with a certain artistic pride: "Look at those materials!" He informed us that it was a portrait of his first wife, who was a brunette and who put on a blond wig that day.[1]

Why did the elderly Monet deprecate *La Japonaise* in such strong language? And why did he ignore Gimpel's admiring comment about the beauty of Mme. Monet's head, calling the dealer's attention instead to the skill with which he had painted the robe she wears? Although the translator has rendered Monet's original term, *saleté*, as "junk," the word carries much stronger connotations in French and might more accurately—if less discreetly—be translated as "dirt," "filth," or "smut." Did Monet retrospectively view the picture as an obscenity? Such a judgment had certainly been far from his mind forty-four years earlier, on October 18, 1875, when he wrote the friendly critic Philippe Burty announcing that he had a painting in process depicting "one of the famous robes of an actor. It is superb to do" (WL 84).

Monet's comments to Bernheim suggest that he may have initiated *La Japonaise* with submission to the official Salon in mind, hoping to create *un succès fou* comparable to that he had enjoyed when he showed *Camille* in that venue in 1866. He certainly needed such a boost in 1875, when his income fell to 9,765 francs, a level far below his earnings during the first Argenteuil years.[2] If Monet had briefly contemplated submitting *La Japonaise* to the Salon, however, he soon abandoned the idea, deciding instead to show the picture in the second exhibition organized by the Impressionists, which ran from March 30 to April 30, 1876, on the premises of Durand-Ruel's Paris gallery. Monet exhibited eighteen works, only eight of them for sale, the other ten having been borrowed back from collectors. In addition to *La Japonaise*, he included five other paintings for which Camille had posed: *Springtime* (*The Reader*) (1872; figure 8.3), *The*

Luncheon (shown as *Panneau décoratif*, 1873; figure 8.13), *Meadow at Bezons* (1874; figure 9.2), *Young Women in a Bed of Dahlias* (exhibited as *The Dahlias*, 1875; w 383), and *The Stroll* (1875; figure 10.5).[3] The exhibition was widely—though by no means entirely

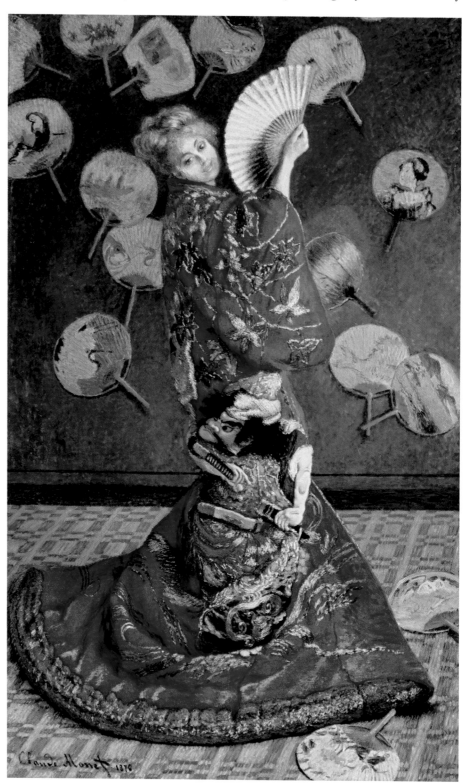

11.1. Claude Monet, *La Japonaise (Camille Monet in Japanese Costume)*, 1876. ©Museum of Fine Arts, Boston, MA, 1951 Purchase Fund / The Bridgeman Art Library

favorably—reviewed.[4] That the works exhibited by Monet, whose role as leader of the Impressionist school was widely recognized, should receive considerable critical attention scarcely surprises, but the high proportion of commentaries devoted *entirely* to *La Japonaise* is striking. Although several critics praised the painting (while typically confessing that they found it puzzling or mysterious), many of the reviews were not only sarcastic but inaccurate. Louis Enault, for example, ridiculed the kimono as appearing to be made of wool or cotton, although he was certain it was made of silk.[5] Only the most knowledgeable and friendly critics who discussed *La Japonaise* commented about any of the other paintings Monet exhibited. A few reviewers did refer to *The Stroll* in favorable terms, but no one except Pierre Dax (who simply proclaimed the picture "very remarkable") so much as mentioned *The Luncheon*, another large-scale, ambitious, enigmatic work also depicting Camille.[6]

Whether by previous plan, because he was encouraged by the attention *La Japonaise* attracted, or for other motives, halfway through the exhibition period Monet withdrew the canvas to include it in a sale (apparently organized by Ernest Hoschedé, perhaps in conjunction with the artist), where it allegedly sold for 2,020 francs, a price far exceeding that commanded by any of Monet's previous paintings except for *Women in the Garden*. However—as Charles Stuckey suggests—the "buyer" may have been Monet himself. An enigmatic letter the artist dispatched to Gustave Manet on May 7, 1876, probably refers to this pseudo-sale: "I would be very obliged to you if you would not repeat to anyone what I told you on the subject of *La Japonaise*. I have promised to keep it quiet, it would inconvenience me. I count, then, on your discretion and, in case you may already have dropped a word to Dubois, recommend to him the most complete silence, otherwise, there would be endless gossip and annoyances for me."[7]

Whatever the facts of its putative purchase of 1876, *La Japonaise* resurfaced—still in the artist's possession—in a sale held almost exactly one year later (April 19, 1877), when it was acquired by Comte Jean de Rosti for an unknown sum. Shortly before the sale, Monet noted in his ledger the receipt of four hundred francs from an otherwise unidentified "Jacob" as an advance toward the purchase of *La Japonaise*. Wildenstein labels this entry inexplicable, but perhaps it is inexplicable only if one assumes that Monet had actually sold the canvas in 1876.[8] The real question may be, why did the artist enact that phantom transaction, apparently buying his own painting?

CAMILLE AND LA JAPONAISE

As Monet himself observed, *La Japonaise* shares many commonalities with *Camille* (figure 2.1).[9] Possessing virtually identical dimensions (91 $\frac{1}{4}$ × 56 and 89 $\frac{1}{4}$ × 58 $\frac{1}{8}$ inches respectively) and painted with equal care, both compositions feature full-length, life-size representations of Mme. Monet in an interior. Both also emphasize costume. In *Camille*, the model wears the latest fashion of 1866; as *La Japonaise*, she appears in a brilliant red kimono thickly encrusted with embroideries, most notably the image of a

fierce male figure. The two compositions share another, more disquieting characteristic: both imply that the protagonist, far from being a proper bourgeois lady, lives by plying her sexuality. In view of Camille's pivotal role in the artist's private life, his decision twice to depict her in such questionable roles merits further exploration, a topic to be pursued below.

In contrast to the draped background of *Camille*, which merely suggests an interior without revealing any details, Monet's Japanese fantasy comes complete with props emphasizing its Oriental (or, more accurately, its deliberately pseudo-Oriental) flavor. The kimono-clad model stands on a woven straw matting (*goza*) with a pattern of blue squares on an off-white ground; the harmonizing bluish background is decorated with traditional summer fans (*uchiwa*), which roughly outline the silhouette of her figure. The fans depict various figures and scenes, but Monet has reproduced them too indistinctly to permit one to draw any conclusion about whether they were selected with a particular theme or motif in mind.[10] Rather than being firmly attached to their supporting wall, the *uchiwa* appear to be in constant motion, lending a disquietingly unstable air to the pictorial atmosphere and suggesting that the two fans at the protagonist's feet may have become dislodged and fallen in their gyrations.[11] In *La Japonaise*, Camille holds another fan in her right hand; this large, folding fan has frequently been misidentified as a dance fan but is in fact a *sensu*, designed only to stir a cooling breeze, exactly the use to which Camille seemingly puts it in the painting.[12]

Despite their shared emphasis on costume, clothing plays very different roles in *Camille* and *La Japonaise*. In the earlier painting, the model strikes a pose widely recognized as based on popular fashion prints of the period. Although several critics who reviewed the 1866 Salon depreciated *Camille* as the portrait of a dress rather than of a woman, none of them interpreted the celebrated green gown as possessing any special iconographic significance other than its obvious emphasis on the fashionable. Not so the kimono Camille wears in *La Japonaise*, a composition that—as we know from Monet's own testimony—owes its very existence to his fascination with the garish robe it depicts, which attracted considerable critical interest.

In choosing to represent a Western woman in kimono Monet was scarcely breaking new artistic ground. Japanese fever had hit the artistic world more than a decade earlier, and during the first half of the 1860s painters—prominent among them James McNeill Whistler and J. J. Tissot—produced a number of pictures featuring models clad in Japanese kimonos. Whistler showed the most celebrated of his works of this type, *The Princess from the Land of Porcelain* (figure 11.2), in the Paris Salon of 1865, where Monet—who had had two large marines accepted for the exposition himself— would certainly have seen it. He probably knew Whistler personally by 1866 and may have been familiar with some of the latter's other treatments of orientalizing themes as well.[13] In contrast to Whistler's works in this genre, which have stood the test of time, Tissot's representations of kimono-clad models impress modern-day critics as blatantly Western and quite dated. The most amusing of his paintings of this type, *Japanese Girl*

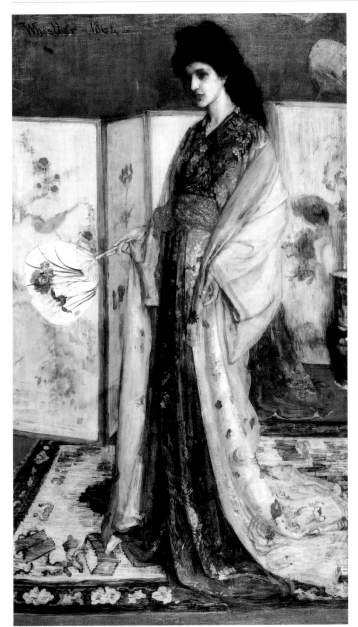

11.2. (*left*) Jacques Joseph (James) Whistler, *The Princess from the Land of Porcelain*, 1864, Freer Gallery of Art, Smithsonian Institution, Washington, DC, gift of Charles Lang Freer

11.3. (*right*) Jacques Tissot, *Japanese Girl Bathing*, 1864. ©Musée des Beaux-Arts de Dijon

Bathing (1864; figure 11.3), reduces the kimono to the status of an ancillary prop, seemingly introduced to give Tissot (but not the model!) cover for painting a nude that might best be classified as soft-core pornography.[14]

We do not know precisely when Monet acquired his first Japanese prints, but, as noted earlier, by the late 1860s he was consciously attempting to incorporate stylistic elements derived from these works into his own art. He continued to incorporate elements derived from woodblock prints in his later compositions, but such influences are more evident in the marines, landscapes, and representations of the water garden at Giverny (itself largely modeled on Japanese prototypes) than in the relatively few figurative paintings he executed following Camille's death in 1879.[15]

If depictions of kimono-clad women had become "old hat" long before Monet conceived of *La Japonaise*, what motivated him to create this picture? Most certainly he did not intend—as Whistler presumably had—to create a convincing fusion of visual and stylistic elements of East and West, for the painting seems to parody both Western art and Japanese prints with equal freedom. Monet, who owned numerous prints of courtesans (at least by the time he lived in Giverny), must have been well aware that woodblock artists characteristically represented courtesans (as they typically did women in general, whatever their social status) with rather impassive facial expressions far removed from the "come-hither" smile Camille wears in *La Japonaise*.[16] Every aspect of the painting—from the exaggerated realism, to the fierce little fellow embroidered on the kimono's visible right-side panel, to the agitated movements of the *uchiwa*, to Camille's blond wig and simpering expression—suggests that the composition was created in a spirit of raillery (perhaps specifically intended as a send-up of Tissot's earlier attempts in this genre), reminding us that Monet began his juvenile career as a caricaturist.[17] However, the inspiration for using the blond wig may have originated with Camille herself, once again playing the role of the artist's active collaborator. At least Monet's comment, as recalled by Gimpel, that Camille, though really a brunette, "put on a blond wig that day" suggests that in this instance as in many others, she helped to shape the composition that featured her. (Presumably she was not fully aware of the sexual implications of the painting discerned by contemporary critics.)

The kimono represented in *La Japonaise* was originally imported for a kabuki drama staged during the Universal Exposition of 1867.[18] The enthusiastic tone of the artist's letter of October 10, 1875 (cited above), suggests that he had acquired the robe, presumably from a dealer in Orientalia, only shortly before initiating the composition inspired by it. An entry in his ledger dated July 1877, noting that he had just sold two Japanese robes along with other items, makes one wonder whether the kimono featured in *La Japonaise* remained in the cash-starved artist's possession for very long after he completed the painting.[19]

No kabuki robes predating the early nineteenth century have come down to us, and relatively few of those that do survive feature human (or mythic) personages comparable in scale and prominence to the manikin gracing the kimono of *La Japonaise*.[20] Perhaps figurated costumes of this type never existed in great numbers in the first place. By contrast, a relatively large number of robes decorated with comparably large-scale embroideries featuring animals, birds, sea creatures, landscapes, and mythic scenes have been preserved.[21] Among the rare nineteenth-century figurated costumes extant, a robe embroidered with the image of a member of the Taira (or Heike) clan (figure 11.4), enacting an episode from volume 6 of *The Tale of Heike*, seems especially comparable to the figure represented in *La Japonaise*.[22] Not only are both kimonos *uchikake* (loose outer robes, designed to be worn without an obi), but both depict exaggeratedly fierce, threatening figures in the act of drawing their sword as they prepare to attack an enemy. Unlike the protagonist of the Taira kimono, the manikin depicted in *La Japonaise* has

not (at least to date) been identified with any specific hero or villain; rather, he apparently represents a generic samurai image, vested with the characteristic twin long and short swords invariably worn by these warriors.[23] The placement of the two protagonists on their respective robes is also quite different; the Taira figure fills roughly the upper two-thirds of the back of the kimono bearing his image. In scale and placement, the samurai of *La Japonaise* seems more comparable to the secondary personage featured on the left side panel of the Taira costume: a Buddhist priest (only partially visible in figure 11.4) shown lighting a lantern. Additional lanterns embroidered on the sleeves and alternate side panel of the robe provide a unifying thematic thrust, linking all sections of the kimono to the central motif; the hero's predominant size and position on the back of his kimono, as well as the incorporation of related motifs on other sections of the garment, characterize designs found on nineteenth-century costumes featuring similarly oversize embroideries, no matter what their subject matter.[24] So far as one can judge from the incomplete view of Camille's robe represented in *La Japonaise*, this costume did not follow the typical arrangement; instead of being reserved for the key

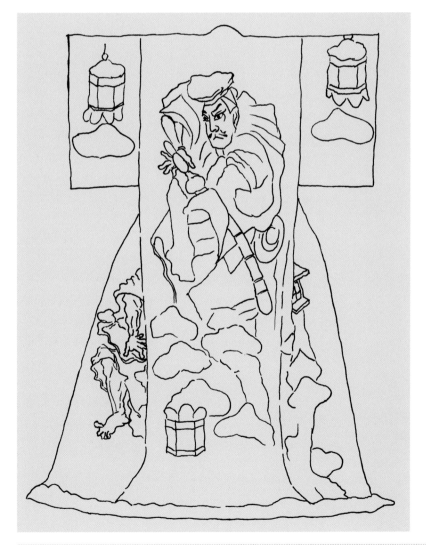

11.4. William Conger (b. 1937), sketch of detail of nineteenth-century kimono, 2008. Courtesy William Conger

figure, the back of the kimono appears to be decorated with a relatively small embroidered square (its motif too indistinct to decipher) located at the level of Camille's derrière. The upper half of the back, the visible right sleeve. and presumably the unseen left one are richly embossed with falling leaves worked in blue-black, silver, and other hues, affording striking contrast to the intense red background of the kimono. (Could these falling leaves have inspired Monet to echo their movement in the background *uchiwa?*) Although the unseen left side of the robe presumably depicted the foe whom the samurai was about to attack, Monet chose to immortalize only the little warrior, consigning the image of his opponent to oblivion.

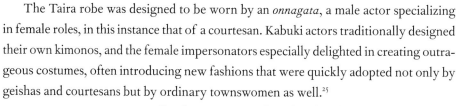

11.5. Claude Monet, *La Japonaise (Camille Monet in Japanese Costume)*, 1876, detail. © Museum of Fine Arts, Boston, 1951 Purchase Fund / Bridgeman Art Library

The Taira robe was designed to be worn by an *onnagata*, a male actor specializing in female roles, in this instance that of a courtesan. Kabuki actors traditionally designed their own kimonos, and the female impersonators especially delighted in creating outrageous costumes, often introducing new fashions that were quickly adopted not only by geishas and courtesans but by ordinary townswomen as well.[25]

Like the costume embroidered with the image of Taira, the robe pictured in *La Japonaise* is a woman's *uchikake*, designed for an *onnagata* enacting the role of a courtesan. (All female roles in kabuki dramas are played by males.) As his letter of October 24 reveals, Monet was certainly aware that the costume he pictured had belonged to a male actor. Did he also realize that the robe identified the wearer as a high-level prostitute? No evidence survives to confirm that Monet had attended any of the kabuki performances staged in Paris during the Universal Exposition of 1867.[26] However, the coquettish smile Camille wears in *La Japonaise* suggests that the artist did comprehend the sexual symbolism implicit in the costume. Although several critics of the 1876 exhibition mentioned that the kimono featured in *La Japonaise* had belonged to an actor, no one alluded to the fact that it had been designed for an *onnagata* playing a courtesan. The snide comments made by two reviewers reveal that not everyone overlooked (or, more likely, most delicately refrained from commenting on) the erotic symbolism inherent in Camille's expression, plus the warrior's provocative placement at her crotch level—a sexual implication underscored by the fact that the manikin is shown in the act of unsheathing his sword (figure 11.5). Simon Boubée described the composition as depicting "a Chinese [sic] in a red robe who has two heads; one of a demi-mondaine on the shoulders, another of a monster, placed—we do not dare to say where." Émile Poncheron sarcastically commented: "The painter perhaps decided it was good taste to drape [the model]

so that the section of the robe on which the warrior's head is embroidered is applied precisely to that portion of the body given over to the care of M. Purgon [presumably a well-known gynecologist of the period]. It is difficult to be more indelicate."[27]

These assessments surely embarrassed Monet, who may have been further mortified by overhearing visitors to the exposition remarking on the sexual suggestiveness of the composition. Did the artist's chagrin lead him abruptly to withdraw *La Japonaise* from the show, concoct the face-saving fable of its "purchase" at auction (for a record-breaking sum), and sequester it at Argenteuil, hidden from public view until the embarrassing publicity generated by the work had died down? This hypothesis would explain why he still had the picture in his possession a year after its purported sale and would also provide a plausible interpretation for his enigmatic letter to Gustave Manet (quoted above) enjoining silence on the subject of *La Japonaise*.

Why did Monet choose to represent his wife in such a compromising manner? Virginia Spate suggests that, desperate over his financial troubles, he may have mimicked the kind of coy eroticism characteristic of some Salon art.[28] In creating *La Japonaise*, Monet required Camille to assume a persona apparently alien to her real-life personality, at least as we know her from numerous other portraits painted by the artist himself, as well as those of Manet and Renoir. Did Monet rationalize that visitors to the 1876 exposition would realize that the picture was intended as a visual joke? Whatever his conscious motives, *La Japonaise* constitutes an unique experiment in his oeuvre, for characteristically he refrained from introducing erotic elements into his paintings. Unlike his friends, including Bazille, Courbet, Degas, Manet, and Renoir (not to mention numerous contemporary academic painters), Monet never depicted the female nude; even his private sketchbooks are innocent of drawings of naked women or female anatomy.

The only other picture in which he portrayed his wife in a pose that might be interpreted as seductive was *Camille and Jean Monet in the Garden at Argenteuil* (figure 8.6). Whether or not he intended that enigmatic work to convey a sexual charge, he did not in the process place his wife in a potentially embarrassing situation, for he retained the picture in his private collection, unexhibited throughout his lifetime.[29]

As noted earlier, although *Camille* was perceived by the more conservative critics of the period as the portrait of a prostitute, their interpretation derived primarily from the fact that Monet identified the model by her first name and from gossip circulating in the art world, rather than from stylistic features of the composition itself. Unlike either the canvas representing Mme. Monet and her son in the garden or *La Japonaise*, which both depict the model looking directly at the viewer, in *Camille* she faces away from the spectator, seemingly lost in her own thoughts. However one reads her expression, it cannot be characterized as provocative. As previously noted, Monet's willingness to expose Camille to potential public embarrassment by calling the painting by her first name constitutes a measure of the deep ambivalence he felt toward the young woman, whom he was reluctant to marry despite her total commitment to him and consequent estrangement from her family of origin.

La Japonaise, painted five years after the couple's belated marriage, represents Mme. Monet as a rather frivolous, flirtatious, bewigged European woman pretending to be a Japanese geisha or courtesan. Monet's decision once again to represent his wife in such a manner suggests that the ambivalence toward Camille he had experienced earlier in their relationship continued to bubble just below the surface throughout their marriage (and had perhaps been reawakened by her collaboration with Manet and Renoir, who depicted quite different aspects of her personality from those Monet chose to highlight).

Did Monet select the kimono immortalized in *La Japonaise* precisely because he resonated with the image of the samurai on an emotional level? Several critics who reviewed the 1876 exposition commented on the startling realism of the warrior's image, which impressed them as more carefully modeled and lifelike than that of Camille herself. In the most extreme interpretation of this type, Marius Chaumelin described the "grotesque Japanese" as making "impotent efforts" to disengage himself from the robe while the model smilingly mocks his struggles.³⁰ Despite the critic's deprecatory tone, his observation has a certain validity, for the diminutive warrior does indeed appear remarkably lifelike, although his exaggerated ferocity seems (at least to this viewer) more risible than threatening. His size and placement at the model's midthigh level recall that of a child of about four hovering close to his mother for protection while playing at being a fearless warrior, or (more plausible in the light of Monet's adult behavior) having a temper tantrum while his mother looks on, half-amused at this childish display of fury.³¹

As if to ward off the implications of such a childish attachment and behavior, Monet has painted the embroidered figure in a way that makes him appear to be a distinct personage, seemingly independent of the "mother's" robe, an impression the artist has underscored by depicting the samurai's elbows as extending *beyond* the edges of the kimono. Although the little samurai's aggressiveness was no doubt represented in exaggerated fashion on the original costume, Monet may have employed his skill as a caricaturist to emphasize the joke. This injection of humor permitted him to represent his complex feelings toward Camille in an open manner, revealing his conflicting perceptions of her as both mother figure and sexual object. Once the exhibition opened, he discovered to his chagrin that spectators didn't get the joke. Did the snide comments of Poncheron, Boubée, and others make Monet more aware of—and acutely embarrassed by—the deeply personal symbolism encoded in *La Japonaise?* Such a sequence of events seems the most likely explanation of his subsequent behavior vis-à-vis the painting.

La Japonaise would prove to be the last large-scale portrait of his wife that Monet would execute prior to her premature death in September 1879. It seems extremely unlikely that as early as the autumn of 1875, when she posed for this picture, Camille could already have been experiencing symptoms of the slow-growing malignancy that would eventually kill her. Nonetheless, as Marianne Alphant has perceptively observed, *La Japonaise* "heralds the decline of the figure with Monet. Perhaps also the decline of Camille."³²

The Muse of the Past, the Muse of the Future

THE CONTEXT

The year 1876 brought no improvement in Monet's financial situation. Always shameless about begging for financial help, he composed a series of the pleading letters that had by this time become virtually formulaic, imploring friends and patrons to come to his assistance either by loaning him money or by purchasing paintings. Edouard Manet's brother Gustave (1835–84) responded, advancing fifteen hundred francs to Monet, who put up fifteen pictures as collateral. The independently wealthy painter Gustave Caillebotte (1848–94), who participated in the second exhibition organized by the Impressionists (and would assume a leading role in arranging future shows by the group), became an enthusiastic collector, frequently paying in advance for canvases Monet had not yet completed. The homeopathic physician Georges de Bellio also began buying directly from Monet, as did Victor Chocquet, the friend and patron of Cézanne.[1] Monet was far from the only painter experiencing financial trouble at the time: the art market had begun a downward spiral, precipitated by weakness in the French economy that would be exacerbated during the following period.

In May, Monet suddenly decided to spend several weeks painting in Paris, where he had not worked since 1873, when he had executed two views of the Boulevard des Capucines (w 292–93) from the vantage point of Nadar's studio. The motives underlying this decision remain unclear: was it determined by Monet's growing disenchantment with the deterioration of Argenteuil and its surroundings, by his hope that a change of motif would stimulate new sales, or (as some scholars have speculated) by difficulties in his relationship with Camille?[2]

By the time he left for Paris, Monet's relationship with Chocquet was so cordial that he was able to paint four views of the Tuileries (w 401–4) from his patron's apartment, which overlooked the park. Carefully eliminating any pictorial references to the burnt-out Tuileries Palace, destroyed during the Commune uprising of 1871, Monet focused on aspects of the beautiful surrounding gardens, laid out by André Le Nôtre in the seventeenth century.[3] During this same Parisian sojourn, Monet also executed three views of the chic Parc Monceau (w 398–400) from a ground-level perspective; once again he eliminated any features that would have detracted from his vision of the spot as an idyllic urban retreat from the modern world.[4] One version of *The Parc Monceau* (w 399; The Metropolitan Museum of Art, New York) is of particular psychological interest because the small figure of the young mother who appears in the middle distance strolling toward the spectator, hand in hand with her child, is believed by some to

represent Alice Raingo Hoschedé (1844–1911) and her youngest child, three-year-old Germaine (1873–1968). If correct, this identification would indicate that the artist was already personally acquainted with Mme. Hoschedé, the wife of his leading patron, Ernest Hoschedé (1837–91). If the woman is indeed Mme. Hoschedé, as the catalogue raisonné entry (W 399) proposes, Monet portrayed her in a very flattering light as a tall, slim, elegant figure, an interpretation as selective as his views of the park itself: As surviving photographs attest, by the late 1870s Alice already appeared plump and matronly; ten years later she would be well on her way to obesity.[5] If Monet hoped that depicting his patron's wife in such a flattering fashion would result in the sale of the work to her husband, his expectation was soon realized, for Ernest purchased the painting in 1877.

As the tender greens of the vegetation and the soft light playing over their sun-dappled surfaces suggest, Monet must have executed (or brought to near completion) all seven of the Parisian pictures during the same brief, highly productive weeks he spent in the capital in the late spring of 1876. By June 7 he was back in Argenteuil, writing Dr. de Bellio, urging him to come and see his new views of Paris (WL 89–90). Evidently Monet's pleas were effective, because his records indicate that de Bellio purchased both a version of the Tuileries gardens and one of the Parc Monceau (W 398 and 401) in June 1876.

MONET'S FINAL DEPICTIONS OF THE LIVING CAMILLE

Back at home, Monet returned for the last time to a theme he had frequently explored during his Argenteuil years: representations of Camille in the family garden. These compositions show a close generic relationship to similar pictures created a year previously, when he had depicted her strolling along the garden path holding a parasol (W 385) and resting in its central grassy plot (bordered at the rear by mature trees), both alone (W 384) and accompanied by Jean and a maid (W 386).

The series of 1875 featuring Mme. Monet in outdoor settings included four compositions situating her in meadows near Argenteuil or, in the most celebrated of these compositions, *The Stroll* (figure 10.5), poised on a hilltop with Jean beside her. By contrast, in 1876 the artist portrayed his wife only once outside the intimate confines of the family garden: *In the Meadow* (figure 12.1) represents her reclining on the slope of a small rise covered with a rich carpet of wildflowers and grasses that almost totally conceals her lower body (indicated only by a scribble of bluish-white brushstrokes meant to represent her form and clothing, a shorthand notation intended, effectively, to be filled in by the viewer's eye). Just a scrap of sky is shown along the upper left edge of the canvas. The site may be identical to that depicted in *The Stroll*. *In the Meadow* represents Mme. Monet from a more relaxed, closer vantage point, in her final representation as a symbol of Nature, immersed in wild grasses and green and yellow blossoms—a pastoral area destined soon to disappear forever from the environs of Argenteuil as its urbanization accelerated.

The other images of Camille the artist produced that summer (w 410–15) all show her seated or strolling within the private confines of the family garden.[6] Spate suggests that some of the paintings showing Camille strolling along the garden paths convey "an impression of strain and lassitude which suggests that the first signs of the illness from which she was to die in 1879 may have communicated themselves to the painter, who seems to have watched her so dispassionately."[7] Whether the artist viewed his wife's decline "so dispassionately" is debatable. That he recognized that the changes in her health affected their intimate relationship is suggested by the psychological message encoded in *Gladioli* (figure 12.2), which portrays her as a distant figure, standing in a grassy area that is visually and symbolically walled off from the artist and viewer by the flowerbed separating her from us, especially the row of tall, spiky gladioli, floral guardian figures that seemingly deny direct access to her physical person.

12.1. Claude Monet, *In the Meadow*, 1876, private collection. ©Christie's Images Ltd. 2009

12.2. Claude Monet, *Gladioli*, ca. 1876, City of Detroit Purchase. ©1983 The Detroit Institute of Arts

Although those scholars who have hazarded any diagnosis of Camille's fatal illness have concluded that she suffered from cancer of the uterus, my oncological consultant believes that Mme. Monet's disease probably originated as cervical cancer, a diagnosis favored by her age (she was then twenty-eight or twenty-nine) as well as by the duration of her illness, approximately three years. The earliest symptoms of this disease may include hemorrhaging, pain or bleeding with intercourse, and abnormal vaginal discharges.[8] Such symptoms would certainly have interfered with normal sexual relations between the couple, a situation perhaps communicated in *Gladioli*. Her increasing physical debilitation and resultant psychosexual dysfunction might also help to account for the growing alienation between husband and wife perceived by several scholars, and perhaps implicit in Tucker's evaluation of these garden pictures of 1876 as a kind of artistic retreat, mostly "not up to [Monet's] usual level of compositional innovation or painterly strength."[9]

THE ADVENT OF A NEW MUSE

In the late summer of 1876, Monet received what must have seemed to be the most prestigious and profitable commission of his career: His patrons Ernest and Alice Hoschedé invited him to spend several months at their country home, the opulent Château de Rottembourg at Montgeron, to paint four large decorative panels for their dining room. Monet eagerly accepted the invitation and spent several months *chez* Hoschedé. We do not know the precise dates of his arrival at or departure from Montgeron. Charles Stuckey, who dates the paintings showing Camille in the family garden (w 410–15) to August (a thesis compatible with the full-blown growth of the flowerbeds depicted), believes that Monet did not leave for Montgeron until September.[10] The dates on Monet's correspondence fit Stuckey's thesis: he dispatched five letters from Argenteuil in July (WL 91–95); a gap occurs in his surviving letters from July 25 (WL 95) to mid-November, when he wrote to de Bellio from Montgeron (WL 96). Another letter, addressed to Gustave Manet from the chateau (WL 97), demonstrates that Monet was still in residence there on December 4. With one exception (discussed below), Mme. Monet remained behind in Argenteuil, where Jean was enrolled in a local school.

How pleasant the artist must have found life at the chateau, where he could indulge his taste for good food, fine wine, and lively conversation in tandem with his zeal for work. His host thoughtfully provided studio space for the artist in one of the chateau's pavilions, so Monet could paint rain or shine. And paint he did! Inspired by the peaceful, pristine character of the estate with its beautiful gardens and pond, he responded with an outburst of productivity.[11] In addition to executing the four decorative panels (w 416, 418, 420, and 433), among the largest canvases (all circa 68 × 68 in) he had produced to date, plus studies for two of them (w 417, 419), Monet painted several additional views of the estate (w 421, 431–32) as well as depictions of the river at Yerres (w 422–25), near Montgeron, where Hoschedé owned a cottage. During one or more visits home Monet

even found time to execute five oils depicting the Petit Bras of the Seine at Argenteuil in autumn (w 426–30).

There was only one problem with Monet's commission, a difficulty the artist should have recognized but conveniently overlooked, probably because he suffered from the same character defect himself: His patron was teetering on the verge of total bankruptcy. Hoschedé had responded to the death of his father (on May 29, 1874) by plunging into what appears to have been a hypomanic state, indulging in such wild extravagances and showing such poor business acumen that he was finally forced out of the family firm. By July 1877 he had lost everything, even the Château de Rottembourg, which had been part of his wife's inheritance. (Hoschedé's bankruptcy, though declared in 1877, was not confirmed by the court of appeals until April 8, 1878.)[12] Although Monet may not have been cognizant of the full extent of Hoschedé's financial troubles, he was certainly aware that as early as January 1874 his patron's straitened circumstances had forced him to auction off eighty-four works from his collection, including pictures by Pissarro, Sisley, and Monet. Perhaps the fact that the Impressionists' paintings all brought relatively good prices at that time reassured Monet about Hoschedé's solvency. On April 14, 1876, another auction, evidently again organized by Hoschedé, featured additional works from his collection, plus three paintings by Monet (allegedly including *La Japonaise*). Unable to pay for all the decorative canvases he had commissioned from Monet, Hoschedé apparently took delivery only of *The Turkeys* (w 416) plus four smaller preparatory studies.[13] Even as he faced total ruin, Hoschedé continued to purchase pictures by Monet, buying directly from the artist as well as from Durand-Ruel.

Monet executed all four decorative panels with verve and seeming spontaneity.[14] Arguably the most beautiful—and certainly the most fascinating from a psychological perspective—is *The Pond at Montgeron* (figure 12.3). Preoccupied from adolescence with representing water and its reflections, Monet was naturally attracted to the pictorial possibilities presented by the pool not far from the garden facade of the chateau. By omitting any indication of its near bank in this picture, he increased the apparent size of the pond, which occupies two-thirds of the picture plane with its sparkling surface and with rippling reflections of the vegetation—and figures—visible on the opposite shore. The spontaneity of Monet's brushstrokes, which permits gray underpainting to show throughout the watery area, lends this large composition the freedom of a sketch, although we know that the artist had in fact executed a preliminary study (w 419) before embarking on the full-size canvas.

The Pond at Montgeron not only shows the far bank and provides a glimpse of the garden facade of the chateau but also, most significantly, includes images of Mme. Hoschedé and three of her five children. The person shown nearest her, half-reclining in the grass, would presumably be Marthe (1864–1923), the eldest child; although the figure seems rather large for a twelve-year-old, no other plausible identification suggests itself; an attending servant surely would not have behaved with such informality.[15]

12.3. Claude Monet, *The Pond at Montgeron*, 1876–77, State Hermitage Museum, St. Petersburg, Russia. Scala/Art Resource, NY

In *The Pond at Montgeron*, Mme. Hoschedé, wearing what appears to be a simple country dress of blue-gray, somewhat incongruously topped by an elaborate hat trimmed with red flowers, is portrayed (and reflected in the water) as if fishing in the pond. Her rather generalized, barely discernible image recalls certain of Monet's representations of Camille such as the one in *By the Bridge at Argenteuil* (figure 9.1). But Mme. Hoschedé's figure seems far more furtive and difficult to discern.

Like many of Monet's compositions featuring Mme. Monet, his initial representation(s) of Mme. Hoschedé associate her with nature and domesticity.[16] But the fact that he shows Mme. Hoschedé fishing stands in stark contrast to his representations of his wife. Whether depicted on riverbank or ocean shore, she is never portrayed in even such indirect contact with the water as fishing. With the sole exception of *The River* (figure 5.1), where she seems to be gazing at the opposite bank rather than at the stream,

Monet never portrayed Camille directly facing the river; similarly, in the "honeymoon pictures" executed on the beach at Trouville, she invariably appears turned away from the ocean. (See chapter 7.)

Speculations abound concerning the degree of intimacy that developed between Mme. Hoschedé and Monet during his lengthy sojourn at Montgeron, and about the paternity of her youngest child, Jean-Pierre Hoschedé, born August 21, 1877. Marianne Alphant, who provides extensive excerpts from the still unpublished diary Mme. Hoschedé kept during this period, is convinced that the couple fell in love during these months, when Ernest Hoschedé, in a vain attempt to salvage his desperate financial situation, spent much of his time in Paris, away from his wife and family. Alphant even provides a speculative date for the consummation of the couple's putative love affair: October 8, a hypothesis based on Mme. Hoschedé's uncharacteristically joyous journal entry that day, which she called the happiest she had spent in many years.[17] Her diary never mentions Monet or posing for him. Neither does she allude to any other visitors, or to the lavish lifestyle the family then enjoyed. Rather, her diary reveals only her pathology (mourning the deaths of family members that had occurred several years earlier) as well as her morbid fears that some terrible disaster would befall her husband or children. One can scarcely quarrel with Alphant's description of Mme. Hoschedé as a very neurotic, apprehensive woman.[18]

There can be no doubt that Monet and Alice Hoschedé were strongly attracted to one another, but whether they acknowledged these feelings to themselves or to one another, much less engaged in a clandestine affair so early in their relationship, remains an unresolved question. As Tucker points out, questions about the precise nature of Monet's early relationship with the woman who would later become his mistress and eventually his second wife seem destined to remain unanswered absent further documentation. Although Tucker does not commit himself on this question, his repeated emphasis on Mme. Hoschedé's religiosity as a possible impediment to such conduct suggests that he does not believe the couple became lovers as early as 1876—an opinion with which I am in full agreement.[19]

The four large canvases Monet executed for the Hoschedés are sometimes described as relatively traditional pastoral pictures, but this judgment contradicts the equally frequent observation that *The Pond at Montgeron* prefigures the late Nymphéas series of 1907–8. The prophetic character of this composition demonstrates that Mme. Hoschedé had already begun to exert a strong positive influence on Monet's creativity—in other words, she had begun to function as muse-in-waiting. Did the artist embark on this new relationship because he already sensed, if only subliminally, that Camille was failing, fading along with the summer flowers among which he had recently portrayed her in the garden at Argenteuil? His behavior recalls the fact that the woman who would become Adolphe Monet's mistress, and finally his second wife, entered the family household as a servant during the months immediately preceding the death of the artist's mother. Like father, like son?

CAMILLE'S CONDITION IN LATE 1876

Although the garden pictures of 1876 featuring Camille may reflect the lassitude and discomfort associated with the early stages of her illness, the first surviving document referring to her condition occurs in a letter that Monet sent to Edouard Manet: "I am grief stricken. When I returned yesterday, I found my wife very ill. The doctor was obliged to come several times. I saw my landlord this morning, and it was only by begging him that I got him to agree to wait until Monday [for the rent]" (WL 98). Monet devoted the remainder of his letter to another of his constantly reiterated pleas for financial help to save the family from eviction, adding that he did not believe his wife could tolerate the trauma of being evicted.

Monet next directed an urgent request for help to the homeopathic physician Dr. de Bellio:

> New misfortunes overwhelm me; it was not enough to be short of money, here my wife is ill, gravely ill, since the [local] physician wanted to have the opinion of another doctor: I am very frightened, for they do not hide the seriousness of the illness from me, and my wife and I would be very happy if you were willing to advise us, for they are talking about having to do an operation, which greatly terrifies my wife. I can't tell you the exact name of the illness, but it concerns ulcerations of the uterus. . . . I will come to see you tomorrow morning (Sunday) and, as I hope, you will be willing to give me your support, I will furnish the necessary explanations. Until tomorrow then. Best to you. (WL 99)

In his agitated state, Monet failed to date either letter, but both must have been written around December 1, 1876. The fact that Monet noted that he wrote his letter to de Bellio on a Saturday evening indicates that he returned to Argenteuil shortly before Friday, December 1, 1876, to try to scrape together the rent, only to find his wife in acute distress. His comments to the homeopathic physician reveal that the Monets did not really understand the nature (and severity) of Camille's illness.[20]

Whether as a result of Dr. de Bellio's conservative advice, or because Camille was too terrified of the proposed surgery, she did not have a hysterectomy (the procedure the consulting physician presumably would have recommended). It is impossible to declare definitively that such an operation would have saved her life, but her failure to undergo surgery certainly sealed her death warrant.

MONET'S FINAL PORTRAIT OF CAMILLE

Blanche Hoschedé Monet's brief reminiscences about Claude Monet's sojourn at Rottembourg (written decades later) do not mention that Mme. Monet visited the chateau during (or shortly after) her husband's residence there.[21] At the end of 1876 or the beginning of 1877, Monet executed *Camille Holding a Posy of Violets* (figure 12.4),

the final representation of his wife he would paint during her lifetime.[22] At about the same time, at the chateau at Rottembourg, he created *Germaine Hoschedé with Her Doll* (figure 12.5). The fact that the portraits of Camille and Germaine seem to have been painted more or less contemporaneously *suggests* that the Monets may have spent the year-end holidays of 1876–77 as the Hoschedés' guests. If so, the portrait of Germaine may have been intended as a gift to her parents, and Camille's would very likely have been her holiday present.

The moods of Monet's two sitters could not have been more different. Three-year-old Germaine (1873–1968), clutching her favorite doll, appears poised and composed, pleased to be invited to participate in this "adult" activity—she was the only Hoschedé child selected for such elaborate pictorial treatment. (A contemporaneous image of a child, treated more sketchily than that of Germaine and identified only as *Portrait of a Young Girl* [w 435], presumably represents an older sister of Germaine's, perhaps Suzanne.)[23]

Monet evidently exercised his special talent for eliciting the cooperation of child sitters when Germaine sat for him, as the charming results he achieved demonstrate.[24] Perhaps he had such phenomenal luck because he did not demand that she pose for a long period. The composition emphasizes, even exaggerates, Germaine's diminutive size by showing her perched on the oversized armchair with her feet barely reaching the edge of the seat cushion and the back of the chair towering above her head, extending even beyond the top edge of the picture plane. Camille's portrait, though neither signed

12.4. (*left*) Claude Monet, *Camille Holding a Posy of Violets*, 1877, private collection / Bridgeman Library

12.5. (*right*) Claude Monet, *Germaine Hoschedé with Her Doll*, 1877, Wildenstein Institute Archives, Paris

nor dated, was most likely painted around the same time; perhaps Monet worked on it between sessions with his young model.[25]

Camille Holding a Posy of Violets presents an unusually penetrating study of Mme. Monet's personality and attitude. Very few of the many paintings in which Monet featured his wife could be described as true portraits, as the term is usually understood. As Isaacson observes, the relatively few works falling into the latter category present Camille as a sober, pensive, or melancholy young woman.[26] *Camille Holding a Posy of Violets* shows the sitter elegantly garbed in a blue-black dress and matching hat; the latter's bright red floral trim echoes the similar hue of the large flowers featured in the sofa fabric. The wall behind Mme. Monet, depicted in virtually the same deep blue as her costume, is enlivened by the coordinating red-white tones of the triptych on display there (too sketchily rendered to be identifiable) and the drapery panel visible along the right edge of the canvas, fabricated from the same red and white fabric as the sofa covering. Already experiencing early symptoms of her fatal illness, Camille appears prematurely aged by physical (and psychological) suffering; the freshness of her youthful beauty, displayed to particular effect in *Women in the Garden* (1866–67; figure 3.1) and *Springtime* (1872; figure 8.3), has been replaced by a dignified matronly appearance. With tilted head and firmly closed lips she regards the artist with an appraising gaze, which suggests that she recognizes all too well her husband's character weaknesses. The flirtatious character of Monet's interactions with Mme. Hoschedé cannot have escaped Camille's notice. Did she regard her husband's decision to portray her yet again as a kind of sop, designed to allay any suspicions she might harbor concerning his romantic interest in his hostess? If so, his attempt failed: Camille's expression reveals that she was well aware of the psychological minuet of flirtation being danced before her eyes. Nor can she have failed to understand the difference between the luxurious lifestyle her husband enjoyed as the Hoschedés' houseguest and the straitened circumstances under which Jean and she lived at Argenteuil, where the family owed tradesmen, service providers, and—all too frequently—the landlord, leading to repeated threats of eviction. In leaving Camille to deal with these problems without his support, Monet had been following the behavioral pattern he had repeated throughout their relationship, beginning in 1867, when he left her in Paris, pregnant and penniless, while he retreated to the comforts of his aunt's summer home in Sainte Adresse.[27]

One wonders whether the artist permitted himself consciously to decipher the silent message conveyed by Camille's expression—a message accurately recorded in this carefully executed portrait, a work that once again demonstrates his extraordinary skill as a portraitist: his ability to communicate the psychological state of his model. Whether his own composition spoke to the artist on a deeply personal level or not, he was certainly aware of its high quality, for he selected it, along with the portrait of Germaine, to include in the Impressionist Exhibition of 1877. Subsequently he neither exhibited nor sold the painting but retained it in his private collection throughout his lifetime. It did not enter the art market until 1950.[28]

Camille and Argenteuil
in Decline

CHAPTER THIRTEEN

The Course of Camille's
Final Illness and Its Repercussions
in Monet's Art

THE CONTEXT

Both Camille and Argenteuil were sick. Increasingly disabled and unable to participate in joint creative efforts with her husband, Mme. Monet could no longer serve as the artist's muse.[1] Monet's interest in figurative painting waned in tandem with Camille's physical condition, and except for occasional portraits of family members and friends, he executed relatively few figurative works for several years after she became ill. He did not return to depicting the human figure in a sustained fashion until 1886, when he began using Mme. Hoschedé's daughters, especially Suzanne, as his models.

In January 1877, Monet embarked on another project that, like the sojourn *chez* Hoschedé, would again require sustained absences from home. He had long dreamed of creating a series of paintings depicting various aspects of the Gare Saint-Lazare, one of the largest and busiest of the new railroad stations in France.[2] Thanks to the generosity of his friend Gustave Caillebotte, who assumed full responsibility for the lease, Monet acquired a two-room Parisian pied-à-terre at 17 rue Moncey, close to the terminal.[3]

Working at an incredible pace, Monet created twelve views of the interior and surroundings of the Gare Saint-Lazare between January and April 1877 (w 438–49). Completing this Herculean task in such a short period must have required every ounce of Monet's prodigious energy. Most likely he spent several nights a week in his Parisian digs and visited his wife and son primarily on weekends, when Jean would have been at liberty from school. As Charles Stuckey points out, the canvases Monet executed at the railroad station constitute an important creative breakthrough in his career, prefiguring his evolution into the serial painter he would become.[4]

The third group exhibition—and the first in which the Impressionists identified themselves by that title—opened on April 4, 1877.[5] Monet exhibited thirty paintings, more than any other participant and including a number from the Saint-Lazare series.[6] He included four figurative paintings: the portrait of Germaine Hoschedé (figure 12.5, shown as *Portrait d'enfant*), plus three featuring Mme. Monet: *Camille Holding a Posy of Violets* (1877; figure 12.4, identified only as *Portrait*), *In the Meadow* (1876; figure 12.1), and *A Corner of the Apartment* (1875; figure 10.1). Camille's portrait was ignored by all critics, perhaps put off by her rather grim expression. The apartment interior was the only figurative painting that attracted much critical attention, most of it negative;

only Pierre Vernon, the critic of *La Petite Presse*, praised it, but even he failed to comment on its unusual psychological ambience.[7] It was, of course, Monet's bold new works from the Saint-Lazare series that provoked considerable ridicule from reviewers; however, certain more sophisticated critics mentioned them positively, if briefly. Several reviewers cited the *Arrival of the Normandy Train, Gare Saint-Lazare* (figure 13.1), arguably the most representative of the series.[8]

Any hopes that interest generated by the exhibition and its attendant publicity would result in increased sales were dashed by the severe recession that swept France; precipitated by the advent of a conservative government, the downturn began in May 1877 and lasted throughout 1878. Durand-Ruel, whose own financial situation was increasingly problematic, rented out his gallery premises, eliminating an important public venue where Monet and his colleagues could show their pictures.

The total bankruptcy of Monet's chief patron, Ernest Hoschedé, who owed the artist large sums, compounded his financial difficulties.[9] Despite his growing financial problems, Monet's account book lists his 1877 income as 15,797 francs—a figure that would have been his highest since the banner year of 1873, and that seems difficult to accept at face value. In fact, his real sales may have amounted to about 9,000 francs, not counting advances of over 2,000 francs by Caillebotte and others. As Wildenstein points out, from 1874 on, Monet's account book was "black with IOUs," making it increasingly difficult to decipher. Whatever the artist's actual income that year, it was insufficient to meet the rather lavish lifestyle his family continued to maintain.[10]

Nor were Monet's problems in 1877 limited to the financial realm: that June he impregnated Camille. Wildenstein assumes that the difficulties Mme. Monet experienced during the late stages of her pregnancy "were apparently quite distinct from the grave illness that might be dated to the early months of the pregnancy; it is difficult to believe that, if they had preceded it, Monet would have risked a pregnancy immediately

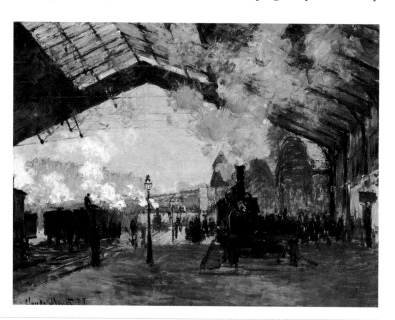

13.1. Claude Monet, *Arrival of the Normandy Train, Gare Saint-Lazare*, 1877, The Art Institute of Chicago, Mr. and Mrs. Martin A. Ryerson Collection

afterward, when his wife had not borne a child for ten years."[11] To the contrary, Camille was ill *before* she became pregnant, and despite any possible medical prohibition against having intercourse, the couple obviously continued to have sexual relations that spring, resulting in an unplanned pregnancy, which cannot have helped her condition. Comments Monet made in letters written during the last trimester of his wife's pregnancy not only emphasize her deteriorating condition but reveal that much uncertainty existed concerning her due date. Everyone involved, including consulting physicians, predicted that Camille would reach full term in January or February; in fact, she did not give birth to Michel until March 17, 1878. Obviously, neither she nor her husband knew precisely when Michel had been conceived, most likely because Camille's menstrual cycle had become quite irregular or interim uterine bleeding had occurred, confusing doctors and the prospective parents alike. (None of Monet's letters from this period indicate that the doctors' predictions were based on the possibility of a premature delivery.)

That summer, Monet painted his four final views of Argenteuil (w 450–53), showing the promenade along the riverbank looking down stream. He had executed several works featuring this site during his first year at Argenteuil (w 221–24); now he returned to the area for his adieu to the town. However, he painted the early and late series from very different vantage points. The 1872 works, such as *The Promenade at Argenteuil* (figure 13.2), permit the viewer easy visual access to the scene. The 1877 pictures depict the promenade on a slight rise, veering off the picture plane at the right, so that the spectator can no longer gain symbolic entry to the area; it is rendered inaccessible not only by its position but by the tangle of flowers in the immediately foreground. This prohibition is presented most forcefully in *Flowered Riverbank, Argenteuil* (figure 13.3), the most celebrated (and perhaps the last) of the series, by the picket fence that runs diagonally across the lower right foreground. The close-up view of the flower garden reveals the full extent of its unkempt, shapeless condition. What a sad contrast these plantings present to the carefully cultivated gardens Monet had fashioned for his two Argenteuil homes. Now he chose to paint a garden that was neither his nor beautiful, and to position himself *behind* the picket fence partially visible in the foreground so that he, like his spectators, was prohibited from entering the pathway. Despite their apparent vigor, the full-blown flowers, about to shed their petals or already transformed into dry pods, suggest death and decay rather than youth and fertility. Was Monet drawn to this spot precisely because it reminded him of greater Argenteuil, facing the impending loss of the last vestiges of its pastoral character—and of Camille, whose health continued to deteriorate even as her womb harbored the beginnings of a new life?

Despite the shaggy appearance of the site, through his artistry Monet cloaked its ugly reality, transforming one of those windless, polluted days, when the very air, heavy with sulfuric contaminations, turns a nasty yellow, into a superb painting—pollution into poetry. But this immense effort could not be endlessly repeated, and after completing *Argenteuil, the Bank in Flower*, Monet laid down his brush. That year he painted no more.

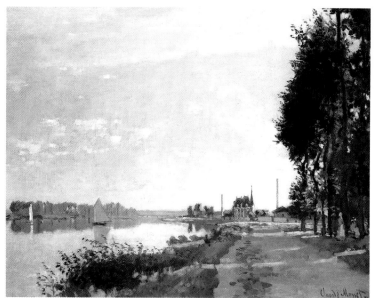

13.2. (*top*) Claude Monet, *The Promenade at Argenteuil*, 1872, Alisa Mellon Bruce Collection. Image courtesy of the Board of Trustees, National Gallery of Art, Washington

13.3. (*bottom*) Claude Monet, *Flowered Riverbank, Argenteuil*, 1877, Pola Museum of Art, Pola Art Foundation

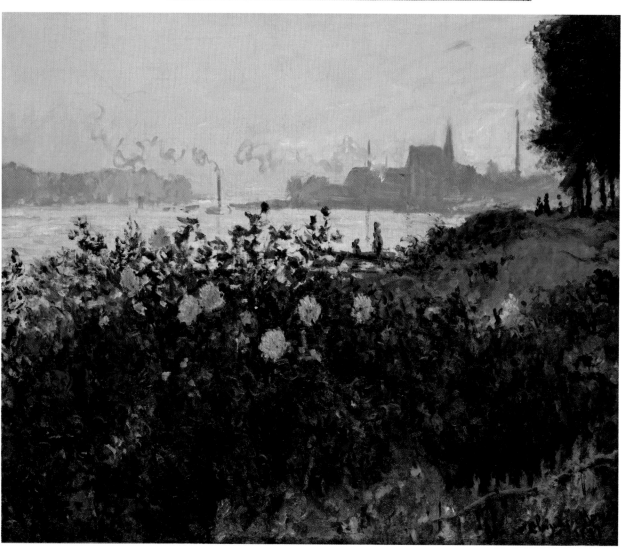

CAMILLE'S DECLINE AND DEATH

How to account for the long fallow period that overtook Monet during the latter half of 1877? It is true that producing the Gare Saint-Lazare series in just three months must have been grueling, but the artist was a man of extraordinary energy, stamina, and dedication to his work. Under happier circumstances he undoubtedly would have recovered rapidly from that marathon effort and returned to his usual productive mode. The uncertain nature of Camille's health and their financial situation took its toll. Although he apparently spent a fair amount of time in his Parisian studio, to which he repeatedly invited patrons to view his latest paintings, he produced no new works there.[12] Neither Argenteuil nor Paris inspired, and his creative hiatus continued as 1877 wore on to its close.

Camille's condition had become quite precarious by the last trimester of her pregnancy. Threatened with eviction for nonpayment of rent and erroneously convinced by their physician that Camille's delivery was imminent, Monet sent forth a series of letters pleading for patrons to purchase pictures or grant loans.[13] Thanks to loans from de Bellio, Caillebotte, and Manet, the Monets were able to leave Argenteuil in late January without having their possessions seized.[14] Monet did not escape entirely unscathed, for he was forced to consign the unfinished version of his *Luncheon on the Grass* (1865) to the far-from-tender care of his landlord.

The Monets relocated to a spacious Parisian apartment at 26 rue d'Edinbourgh; once settled, the artist sent forth a new batch of letters pleading for outright loans or offering paintings for modest sums.[15] Meanwhile, Camille's probable due date continued to puzzle. Were the physicians consulted confused about her delivery date because physiological changes caused by her malignancy made accurate diagnosis uncertain? Shortly before she gave birth, Manet, Caillebotte, and de Bellio together raised one thousand francs.[16]

On March 17, 1878, Camille safely delivered her second son, whom the parents named Michel. The receipt of the thousand francs from his friends by no means put an end to Monet's pleas of impoverishment. In one of the most dramatic of these missives, he implored Zola:

> Would you be willing to help me? We don't have a single sou in the house, not even enough to make soup today, and in addition my wife does not feel well and requires much care, for, as you probably know, she gave birth to a superb boy.
>
> Could you lend me two or three louis, or even only one . . . ? (WL 129).

The letter he sent Eugène Murer contains additional references to Camille's fragile state and the artist's need to devote so much of his time to nursing her that he could not think of painting.[17]

Truth be told, far from devoting most of his days to caring for Camille, Monet, released from the creative paralysis that had gripped him during the latter half of 1877,

had returned to painting with renewed zest, finding inspiration in sites close to home, such as the island of the Grande-Jatte, where he executed eleven paintings (W 454–64). Some of these compositions, such as *Springtime through the Branches* (figure 13.4), with their implicit theme of rebirth, suggest that the fact that Camille had safely delivered a full-term child temporarily lulled the artist into convincing himself that she would soon recover her health, ending his sterile period.

From the Grande-Jatte Monet returned briefly to Paris, depicting the Parc Monceau (W 466–68) and representing the rue Montorgueil and the rue Saint-Denis (W 469–70), decked out for the June 30 holiday celebrating the renaissance of France following the Franco-Prussian War. The cheerful theme of these two works, celebrating the rebirth of the country, provides additional support for the conjecture that Michel's birth played a significant role in restoring Monet's creativity.[18]

That August, Monet left Paris for a painting campaign in the country. Who cared for Mme. Monet and the children during his absence? Surely she had some help from a resident domestic. However well or badly his wife and children fared, Monet enjoyed his brief respite from family responsibilities and problems, glorying in his solitude and the pictorial possibilities provided by Vétheuil, an unspoiled old town on the Seine with a small, stable population and no industry. The site provided lovely views of the river and the town, with its ancient stone houses. The Vétheuil church, with its beautiful Renaissance facade fronting the water, would be featured in many works Monet would create during the next three and a half years.

Enchanted with Vétheuil, the artist found a little house there, which the Monet and Hoschedé families, both in financial distress, agreed to share, a decision that would alter the entire course of the future for the adults and children alike. The tutor and maid, disgusted over nonpayment of wages, soon quit, but the cook stayed on.[19]

The unseasonably cold, rainy autumn added to the discomfort everyone experienced in the overcrowded house. Camille, increasingly fragile, was especially vulnerable to the uncomfortable conditions. On September 26 Monet wrote to Dr. de Bellio, reporting that his wife was constantly ill and growing progressively weaker. He asked whether it wouldn't be prudent to wean Michel, whom Camille was breast-feeding, because he was getting "bad milk" from his mother and nursing him "weakens my wife further."[20]

The Monet and Hoschedé families soon relocated to a larger house; its garden sloped down to the Seine, providing a convenient mooring for the artist's boats. At least initially, Ernest Hoschedé assumed responsibility for the annual rent of six hundred francs, but he soon began spending most of his time in Paris, leaving Monet as the sole adult male in the household.[21]

Precisely what Monet earned that year remains unclear, but it was again insufficient for the family's needs, leading to his usual series of written pleas to friends and patrons for purchases or loans.[22] Caillebotte again came to Monet's assistance, repeatedly advancing him money as well as paying for the lease on another Parisian pied-

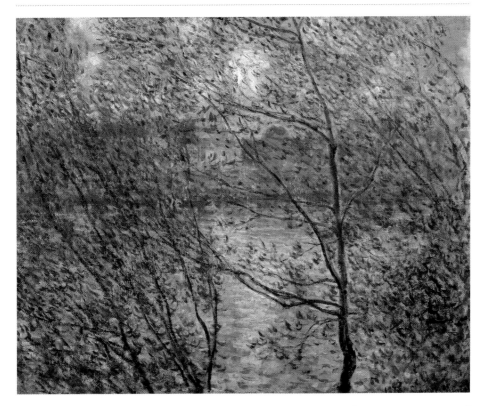

13.4. Claude Monet, *Springtime through the Branches*, 1878, Musée Marmottan, Paris. Bridgeman-Giraudon/ Art Resource, NY

à-terre, which provided the artist not only with a convenient place to invite potential buyers but also with a retreat from the problems facing him at home.[23]

On December 30, Monet wrote de Bellio, lamenting that the close of the year found him so impoverished that he could not buy a single present for his family (WL 148). Fortunately, he could use his art to create precious gifts for the two adult women of the household. On December 31, he presented Mme. Hoschedé with a portrait of her youngest child, Jean-Pierre (figure 13.5), then sixteen months of age. Represented as a charming, self-confident—perhaps even a bit cheeky—curly-haired darling, he appears as the beloved, pampered little fellow he surely was. At the same time Monet executed the *Portrait of Michel Monet as a Baby* (W 504; Musée Marmottan), his corresponding gift for Camille. Always a sensitive portraitist, Monet captured the nine-month-old's anxious expression; far from distracting the viewer from Michel's bewilderment, the frilly bonnet and ruffled collar he wears serve only to emphasize the incongruity between his inner state and his outward appearance. Pictorial New Year's gifts of this type often had special significance for the artist, reflecting the key role in his life of the female recipient. In this instance Monet paid homage to both his past and his future muse.[24] Both these intimate works remained in the Monet-Hoschedé family collections throughout the lives of their subjects.

Monet's letters from the first half of 1879 detail his discouragement and inability to work because caring for Camille consumed all his time and energy.[25] His claims to this effect are belied by his extraordinary productivity throughout the final year of Camille's life. Between August or September 1878, when he completed his first view

13.5. Claude Monet, *Jean-Pierre Hoschedé*, 1878, Wildenstein Institute Archives, Paris

of the Vétheuil church, and the end of December, he executed thirty-three paintings (w 473–505). His rate of production accelerated during the months immediately preceding his wife's death. Between January and September 5 (when he portrayed Camille on her deathbed) he produced thirty-seven pictures (w 506–43), varying from melancholy views of Vétheuil in snowy weather to poetic depictions of the Seine at Lavacourt and idyllic views of fruit trees in bloom. Generally of very high quality, these works provide mute testimony to the comfort Monet derived from immersing himself in nature during this stressful period in his life. The profusion of paintings of the Seine remind us of the critical role that sketching the sea had played in comforting the bereaved adolescent following his mother's death.

Several compositions painted that summer prefigure stylistic changes that would become more prominent following Camille's death. The river plays the predominant role in these pictures, which reflect Vétheuil and its church viewed from a distant (unseen) vantage point across the water. The shimmering, reflective surface of the Seine dominates these pictures spatially, as exemplified by *Vétheuil in Summertime* (figure 13.6). That style represents an evolution from the period of Monet's "classic" Impressionist years. It suggests an attempt to gain distance from himself and his emotional turmoil and provides clear demonstrations of the ways in which the creations of a master can simultaneously function as superb paintings and as self-healing.

Except for the inclusion of a few tiny personages shown trudging along the road to Vétheuil or boating on the Seine, these compositions present an unpeopled world in which Monet is alone with nature. The sole exception, *Poppy Field near Vétheuil* (figure 13.7), completed in late May or early June, shows three small children frolicking amid flowers. Most likely Michel, "Bébé Jean," and Germaine served as models for the trio, but neither they nor the additional three persons shown in the distance (the woman holding an umbrella—Mme. Hoschedé?—another little girl, and a taller boy, perhaps Geneviève and Jacques?) can be positively identified. The painting recalls that joyous work of 1873, *Poppies at Argenteuil* (figure 8.5), representing Camille and Jean progressing through a field of wild poppies, a similarity that surely did not escape the artist's attention and may have directly inspired the later variant.

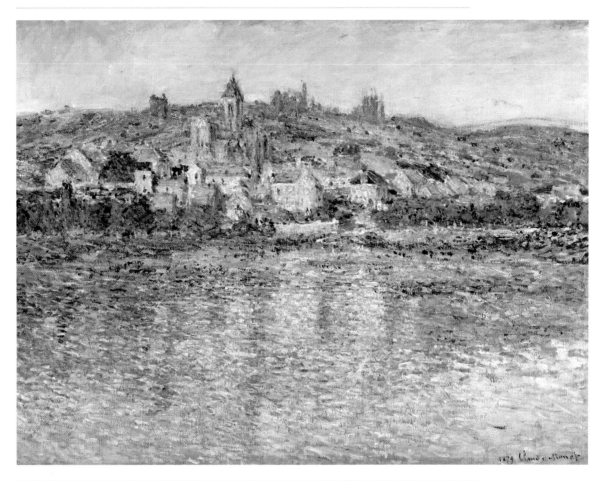

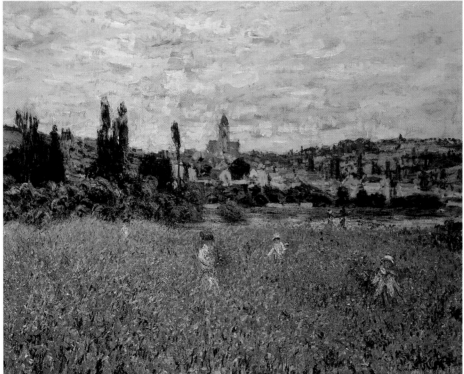

13.6. (*top*) Claude
Monet, *Vétheuil
in Summertime*,
1879, Art Gallery
of Ontario, Toronto,
Canada / Bridgeman
Art Library

13.7. (*bottom*) Claude
Monet, *Poppy Field
near Vétheuil*, ca. 1879,
Foundation E. G.
Bührle Collection,
Zürich

Monet not only kept on working outdoors until the final weeks of Camille's life but also, thanks to Caillebotte's intervention, finally agreed to participate in the fourth Impressionist exhibition.[26] He chose twenty-nine paintings for the exhibition, ranging in date from 1865 to recently completed works. The selection provided virtually a miniretrospective of his career—except for one significant omission: none of his selections featured Camille. This omission provides additional evidence that her role as his muse had definitively ended and had become too painful to recall. Instead he chose two paintings from 1867, *Jeanne-Marguerite Lecadre in the Garden* (figure 4.1; listed in the catalog as *The Garden*) and *Garden at Sainte-Adresse* (figure 4.2), both featuring images of Monet's cousin Jeanne-Marguerite Lecadre, which I have interpreted as substitutes for portraits of Camille.[27]

Monet never saw his works installed in the exhibition. In view of Camille's increasingly perilous condition, one might assume that he was reluctant to undertake any expedition away from home. A lengthy letter he sent Ernest Hoschedé on May 14 suggests another—perhaps primary—motive: Monet's unwillingness to lose a moment of good weather when he might be working outdoors:

> I do not know if in Paris the weather is the same as here; it is probable, and so you will be able to understand my discouragement. I am heartbroken, and I absolutely must share with you all my disquiet; for nearly two months, I have given myself a lot of trouble, without result. I have not lost an hour and would have reproached myself to have taken a day to come see our exhibition, *just out of fear of losing a single good painting session, an hour of sun.* I alone can know my anxieties and the trouble that I give myself to finish canvases that don't even satisfy me and please so few people. In a word, I am absolutely discouraged, not seeing or hoping in any future. . . . I cannot hope to earn enough with my paintings to sustain the life we live at Vétheuil. That is, unhappily, a certain fact. I believe that, more than that, we cannot be very agreeable company for Mme. Hoschedé and you, me always more and more sour, and my wife nearly always ill. I feel all too well the void that is being created around me, and the impossibility of facing up to my part of the expenses if we were to continue living together.
>
> I am sorry to speak to you thus [but] believe me, I see everything in black, in pain. Please believe all the sorrow I have in causing you trouble. (WL 158; italics mine)

Hoschedé immediately returned to Vétheuil to reassure Monet, a journey documented by a letter to his mother posted on May 16 from Vétheuil and describing the pitiable condition of Mme. Monet.[28] The communal arrangement continued unchanged. Following this brief visit, Hoschedé again absented himself from the tragic events occurring at Vétheuil, leaving Monet, by default, as sole resident paterfamilias.

Statements attesting to Monet's utter discouragement and hopelessness, which almost invariably appear in his letters from this period (see also WL 159–60), would lead some to assume that he was suffering from an acute, disabling depression. Not so.

No one suffering from a true melancholia, as the term is clinically defined, could possibly have created the splendid body of work Monet executed during the final months of Camille's life, as well as in the period immediately following her death. To experience great sorrow and stress is not the same as to succumb to a debilitating depression; Monet's inner turmoil did not prevent him from working ceaselessly, nor did his turbulent feelings infect the serene quality of the paintings he executed during the spring and summer of 1879. No doubt the supportive presence of Mme. Hoschedé during this period insulated the artist from experiencing the black despair and creative paralysis that would overwhelm him decades later when, following Alice's death, no muse-in-waiting was at hand. (For details consult the epilogue, "The Memorial Garden of Claude Monet.") Monet's situation in 1878–79 parallels that of his father during the months immediately preceding the death of the artist's mother, when the young domestic who would become Monet *père*'s companion, the mother of his only daughter, and finally his wife was already a member of the household.[29]

As the summer wore on, Camille's agonies increased as the debts continued to accumulate, the demands of the creditors to grow ever more shrill, and Monet's sales to shrink to a new low. He sold only two pictures that summer.[30] By mid-July, Monet was so penniless that he was even running out of paint; he spent several desperate days in Paris in a futile effort to drum up business. He returned to Vétheuil utterly discouraged, prompting Mme. Hoschedé to write reproachful letters to her husband, upbraiding him for continuing to absent himself from Vétheuil.[31]

Only assistance from the unfailingly generous Caillebotte enabled Monet to stave off complete disaster. Between July and December 1879, he advanced Monet two thousand more francs, bringing his total loans to Monet in 1879 to an astounding forty-seven hundred francs, plus the additional three hundred francs he paid for pictures purchased. When one adds to that the amount Monet realized from sales of paintings to other collectors, purchases that occurred both before and after the dreadful summer hiatus, one can only ask once again, where did all the money go? His proficiency as a painter was more than matched by his talent as a spendthrift.[32]

By August the situation had grown so dire that the errant Hoschedé rejoined his family.[33] On August 19 Monet dispatched a dramatic letter to Dr. de Bellio, soliciting his medical advice and financial aid:

> I had always hoped for better days, but today I must abandon all hope. My poor wife suffers more and more, and I believe it is impossible to be weaker. Not only does she no longer have the strength to stand or walk, but she cannot take nourishment anymore, although she still has some appetite. It is necessary to be continually at her bedside to watch out for her smallest desires, in the hopes of calming her sufferings. And the saddest thing is that we cannot always satisfy her wishes for lack of money. I haven't been able to paint for a month now, lacking all colors, but that's the least of it. What frightens me now is to see my wife's life so compromised, and to watch her suffer so without being able to help her. She is no longer

losing blood, but water in abundance. The ulceration seems to be cured, but she always has metritis and dyspepsia. Her belly and legs are swollen, and often also her face. With all that continuous vomiting and choking, it is enough to make one agonize [with her], especially when one has no strength of one's own left. If, after my description, you have any advice to give, please do so, and it will be followed to the letter. But what I also ask you, dear Monsieur, is to come to our aid with your purse. We are without the least resource. I have some canvases, take them at any price you wish. Please do not remain deaf to our prayers. Send us two or three hundred francs, which would help us out, and with another one hundred francs, I could buy the canvases and colors that I lack for work. (WL 161)

De Bellio's response was cold and disapproving: "With your permission, I went round to the rue Vintimille [studio] to see your paintings and I must tell you in all honesty, as you expect of me, that it is not possible to think of making money on paintings so far from completion. My dear friend, you are stuck in a vicious circle, and I don't know how you will get out of it." He addressed Monet's pleas for advice about Camille in a brief footnote: "I am very sorry to hear that Mme. Monet is in the sad state of which you paint so black a picture. But let us hope that with care, with a great deal of care, she will recover."[34]

De Bellio's words imply that Monet's negligence had played a major role in Camille's decline.[35] But the homeopathic physician's suggestion that tender loving care might have cured Mme. Monet again demonstrates his lack of medical acumen. By that time the cancer had spread throughout her body; the fact that she vomited continuously suggests that she would not even have been able to tolerate the administration of painkilling opium drops, then available only in oral form (assuming that the attending physician had prescribed the drug and the money to purchase it was at hand).

No doubt Monet's conduct during the twilight of Camille's life was far from being beyond reproach. As previously noted, his astounding productivity from January to mid-July 1879 demonstrates that he routinely relegated primary responsibility for his wife's daily care to Mme. Hoschedé. Even after he stopped working and was free to devote more time and attention to Camille's emotional and physical needs, Monet evidently continued to rely heavily on Alice, who noted in a letter to her mother-in-law, dated August 26, "Mme. Monet's terrible illness takes up all my time, except for the children and the piano lessons." Camille's suffering, she added, was so horrible that death would be a deliverance for her.[36]

On August 31 Mme. Hoschedé, a fervent Catholic, sent for the Vétheuil priest to sanctify the marriage of the Monets, who had been joined only in a civil ceremony; this restored Camille to good standing in the church and enabled her to receive the last sacraments. Following her interment, Alice informed her mother-in-law, "Yes, one great happiness for me amongst all this sadness was to see my poor friend receive her God with faith and conviction and receive the last sacraments." (One wonders whether poor Camille derived the same degree of comfort from "receiving her God" that Alice self-

righteously enjoyed from masterminding this reconciliation.) Mme. Hoschedé's actions not only attest to her piety (and controlling nature) but provide added evidence that her affair with Claude did not begin during Camille's lifetime. In the eyes of the church, the Monets' civil ceremony would not have been considered a marriage at all, and they would have been condemned as living in sin. Why, if Claude and Alice's liaison had predated these events, as is frequently asserted, would she have insisted that the Monets' union be blessed by the church, an action that would have rendered her alleged affair with the artist doubly adulterous—and doubly sinful in the eyes of the church?

On the morning of September 5, Camille's long agony finally came to an end. Alice, always somewhat ghoulish in her characteristic preoccupation with illness and death, described the patient's final agony to her mother-in-law in graphic terms: "The poor woman suffered greatly; her death was long and horrible, and she was conscious until the last minute. It was heartrending to see her bid a sad farewell to her children." Wildenstein ironically queries, "No mention of a farewell to her husband. Had she nothing to say to him?" To which one might respond, did Mme. Hoschedé ever leave the couple alone long enough for them to exchange tender goodbyes? She seems to have been omnipresent during Camille's last days, and when absent in person to have delegated responsibility for the death watch to her older daughters (presumably Blanche and Marthe, then fifteen and fourteen, respectively), who were even required to assist in keeping vigil over Mme. Monet's corpse for the two days that preceded her burial. "These have been great lessons for them," she informed her mother-in-law, "and they will experience soon enough all the sadness of this world."[37]

On the afternoon of September 5, Monet wrote Dr. de Bellio:

> My poor wife succumbed this morning at 10:30, after having suffered horribly. I am shocked to find myself alone with two children.
>
> I have to ask you another favor . . . would you please reclaim from the pawnbroker the little medallion for which I am [enclosing] the ticket. It is the only souvenir that my wife was able to keep, and I would like to put it around her neck before she leaves. Would you please do this for me; have it sent by mail to the rue des Blancs-Manteaux before two o'clock. This way, I will receive it before she is put into the coffin. (WL 163)

Camille's burial took place on Sunday afternoon September 7, with the Abbé Amaury in attendance.[38] Wildenstein pointedly mentions that the abbé "gave absolution to her who had been *The Woman in Green*," implying that this was unusual; in point of fact, it is part of the standard Catholic burial service. As he also notes, because of the destruction of all documents relevant to Camille's life, we have no idea whether her mother (or sister) attended the funeral, or had even been informed of her fatal illness.[39]

CHAPTER FOURTEEN
Death and Transfiguration

THE CONTEXT

Hounded by worsening financial problems, Monet could not even grieve for Camille in peace. Two quarters in arrears on rent, the compound Monet-Hoschedé family faced eviction unless payment was promptly forthcoming. (Caillebotte again came to Monet's rescue; between mid-September and December 1879 he advanced Monet six hundred francs plus another seven hundred, the latter presumably earmarked for the annual rent due on the Paris studio Caillebotte had secured for his friend.)

Neither Monet's internal turmoil nor his financial difficulties kept him from painting, and he was quite productive during the months immediately following Camille's death, thanks to the presence of his new muse. Whatever Mme. Hoschedé's characterological faults, she believed in Monet's genius and admired his diligence—qualities notably lacking in her husband.

At Caillebotte's urging, Monet traveled to Paris on October 11 with seventeen of his recent paintings; he succeeded in selling at least eight, for a total of around a thousand francs. This enabled him to pay the rent and avoid eviction. Hoschedé, for his part, remained in Paris. In mid-November, Monet wrote to Ernest, urging him to return to Vétheuil to quiet the "absurd noise" circulating about the artist's relationship with Alice. Ernest reacted by demanding that his wife and children rejoin him in Paris. One wonders how serious this suggestion could possibly have been; as Alice pointed out in her somewhat evasive response, the family could not manage to pay expenses in Vétheuil, let alone in Paris. In fact, Ernest was both jobless and penniless, and Monet sent his last few francs to him—a generous gesture he could ill afford to make.[1]

Even the weather seemed to conspire against Monet; the winter—which would prove to be the most severe ever recorded in France—brought bitter cold and heavy snow; the Seine rose, flooding the landing dock Monet used to launch his studio boat. (Fortunately, it suffered little damage.) Enormous blocks of ice floated down the river, until the temperature dropped to minus 25 degrees centigrade on December 10 and the Seine froze solid. The biting cold did not prevent Monet from venturing outdoors to record the unique appearance of the frozen river (w 552–58).

Problems caused by the weather naturally resulted in increased prices for necessities; soon the compound family could not even afford a sack of potatoes. Meanwhile, indignant creditors hounded Monet and Mme. Hoschedé. To add to their problems, several of the children fell ill. Alice, that once-pampered rich woman, now endured undreamed-of hardships. Small wonder that she developed severe, recurring headaches.[2]

Around mid-December Ernest Hoschedé sent Monet a recriminating letter. Alice responded in defense of the painter: "I shan't reply to the reproaches you make about

M. Monet, who is as unhappy as anyone when there is a lack of money here, and who was fortunately able to help us last month. He is working hard." Ernest did not join his family for their bleak Christmas, although Alice warned him that his continued absence was "loosening tongues throughout the neighborhood." She wrote her husband virtually daily during the holiday season, but he neither responded nor appeared. He finally showed up to celebrate the New Year with his family but returned to Paris a few days later.

Borrowing the small sum necessary for train fare, Monet once again set off for Paris on December 29, carrying a group of still lifes and snow scenes. The trip was a success: sales totaled more than one thousand francs. More important, the dealer, Georges Petit, purchased a still life and a "winter effect" for high prices and advised Monet to charge more for his work in the future. The painter lost no time putting this recommendation into effect, informing de Bellio of the change in his price structure in a letter of January 8, 1880 (WL 170). As Wildenstein notes, the artist's slogan now became "Buy less, pay more."[3] Monet's total income for December reached 1,625 francs, and the New Year began on a more hopeful note.

Rising temperatures brought another catastrophic weather change: On January 5 the Seine suddenly thawed with a thunderous roar, and rushing ice blocks wrought a wide path of destruction, wiping out small islands and damaging properties on both shores, especially at Lavacourt, but doing little harm to the artist's residence at Vétheuil. Monet's fascination with the terrible beauty of the scene quickly led to action, resulting in the creation of the Débâcle series (W 559–77).

But the New Year also brought new problems. Monet, who had been debating about following Renoir's example and submitting to the official Salon rather than participating in the fifth exhibition of the Independents, was stunned by a nasty, satirical article that appeared in the January 24 edition of *Le Gaulois*, a journal that had usually been supportive of the Impressionists. An insider had evidently tipped off the author of the "Tout Paris" column, who announced that the "funeral" of Claude Monet would be celebrated on May 1 (the official opening date of the Salon)—a defection that would allegedly damage the Impressionist movement and was contrasted with the loyalty of Mary Cassatt, Gustave Caillebotte, Edgar Degas, Camille Pissarro, Jean-Louis Forain, and Jean-François Raffaelli. The (deliberately?) inaccurate biographical sketch that followed described Monet as living at Vétheuil with his family, "a charming wife" (a snide reference to Alice), "two pretty babes," and Ernest Hoschedé, portrayed as ruined by injudicious purchases of inferior Impressionist works; reduced to the role of "a platonic admirer, [Hoschedé] spends his life in the studio of Claude Monet, who clothes, lodges, feeds, and . . . puts up with him."

Monet immediately responded to this slanderous article, firing off an indignant letter to *Le Gaulois*. At his urging, Hoschedé allegedly followed suit, but their letters were never published. The paper's sole response was to print a brief notice in its "Miscellaneous News" column, stating that Hoschedé was not living at Monet's expense.

The February issue of *L'Artiste* reprinted the *Le Gaulois* piece virtually unchanged, and the slur to Mme. Hoschedé's reputation went unchallenged. Monet, who suspected Pissarro as the possible source for the story, sent him a letter on February 2 indignantly demanding the identity of the culprit and what had motivated him. Pissarro responded, reassuring Monet that he and his friends condemned the journalist who had attacked Hoschedé "with such animosity." He ended by expressing confidence that Monet would not "leave us" to defect to the Salon.[4]

Financial matters continued to be precarious; the cook quit over wages due and sued Hoschedé for the three hundred francs owed her. In mid-February Monet had to borrow the train fare for another trip to Paris to sell paintings. It again proved successful: he sold two pictures for five hundred francs each, one of them to Georges Petit. This helped to bring Monet's income for the month to 1,150 francs, enabling him to contribute his share of the joint household expenses as well as to pay down some old debts. Hoschedé, meanwhile, remained in Paris, not even rejoining his family for Easter.[5]

Contrary to Pissarro's wishful thinking, Monet eventually decided to apply to the Salon again, rather than to participate in the fifth exhibition of the Independents; he submitted *Lavacourt* (w 578; Dallas Museum) and *Ice Floes* (*Floating Ice*) (figure 14.1) to the jury; they rejected the latter and showed *Lavacourt*. Despite its virtually invisible position, a few discerning critics noticed the painting and praised its delicacy and luminosity.[6]

Georges Charpentier, the wealthy, cultivated art patron who published leading avant-garde authors as well as *La Vie Moderne* and other progressive journals, invited Monet to exhibit in the gallery adjacent to the periodical's offices. Charpentier was an important patron of Renoir, who probably played a leading role in securing the invitation for Monet. (Their friendship had rekindled after Monet followed Renoir's example

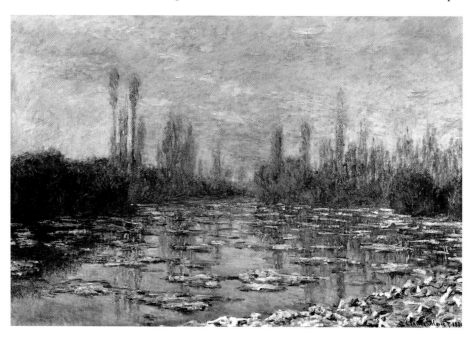

14.1. Claude Monet,
Ice Floes, 1880,
Shelburne Museum,
Shelburne, VT.
©The Shelburne
Museum

and showed at the Salon—although, unlike Renoir, he would never do so again.)[7]

As part of the publicity campaign to heighten interest in the exhibition, Émile Taboureux, a journalist associated with *La Vie Moderne*, interviewed Monet at Vétheuil. During their conversation, Monet introduced the myth he would repeat for decades, claiming that he had no studio but worked exclusively before nature.[8]

Well publicized by Théodore Duret's catalog, plus articles timed to appear concurrently in *La Vie Moderne*, the show at Charpentier's gallery, which opened on June 8 and ran for an entire month, was popular and well attended. Monet selected eighteen pictures to exhibit, many of them already in private collections. In a gesture of defiance toward the Salon, he hung *Ice Floes* (*Floating Ice*), rejected by that august body, so that it was the first work the visitor encountered. Monet chose a wide range of works dating from 1867 to the spring of 1880, with an emphasis on recent works. In contrast to the Impressionist Exhibition of 1879, where he showed no representations of Camille, he included the early nocturnal scene from 1868 depicting her, along with M. and Mme. Sisley, in the Monet family dining room, illuminated by a single hanging lamp (either W 129 or 130). However, these two compositions focus on the play of light on the figures rather than on their individuality.[9]

Whether by coincidence or design, the final section of Emile Zola's provocative tripartite review "Naturalism in the Salon" appeared in *Le Voltaire* on June 21, while Monet's exhibition was in full swing. Zola provided a thumbnail history of Impressionism, singling out Monet for special consideration as the most important member of the school, while criticizing him for working too hastily and offering mere sketches for sale (an invalid charge) rather than devoting several months to creating a single major painting. Paradoxically, Zola concluded by predicting that Monet would someday be recognized as a great artist.[10]

Mme. Charpentier purchased *Floating Ice* for fifteen hundred francs (to be paid in three installments), a larger sum than Monet had ever earned for a single work, with the exception of the much larger *Women in the Garden* (1866), for which Frédéric Bazille had paid twenty-five hundred francs.

Monet's participation in the Salon, followed by his successful one-man exhibition, aroused the ire of Degas, who denounced Monet's "frantic self-advertising." In April, Caillebotte ceased paying the rent for Monet's Paris studio; whether this was in reaction to his friend's defection to the Salon remains unclear, for he continued advancing sums to Monet through February 1881, when he made his last recorded disbursement.[11] Degas's criticism was but one symptom of the dissension destroying the cohesion of the Impressionist group. Their fifth exhibition—which opened on April 1 minus the participation of Cézanne, Monet, Renoir, and Sisley—proved to be their weakest and was panned by reviewers. Although in his interview with Taboureux, Monet asserted that he had always been, and wanted always to remain, an Impressionist, he was evidently referring to his style of painting rather than to his membership in a group of like-minded artists.[12]

Monet's income for 1880 would eventually total 13,938 francs, a significant improvement over recent years; nonetheless, his problems with creditors continued, and he soon resumed his begging letters to patrons.[13]

That August, Monet participated in an exhibition in Le Havre, mounted by Les amis des arts, where he showed *Lavacourt* plus three other canvases. These brought nasty reviews rather than generating sales as he had hoped. Truly a prophet is without honor in his own country.[14]

Around September 10, Monet visited his brother in Rouen and subsequently accompanied Léon to his vacation home at Petites-Dalles, on the Normandy coast. Monet painted views of its spectacular cliffs and roiling seas (w 621–24), initiating an exploration of the awesome beauties of the coast that would preoccupy him for several years.

His productivity continued throughout the fall and early winter—but so did problems with money. The death of Ernest Hoschedé's mother on December 10 led Monet and Alice to worry that creditors would carry off whatever had survived Ernest's depredations. To their relief, Ernest finally got a regular job as general manager of an elegant new monthly magazine, *L'Art de la Mode*. He was soon replaced in this position but was subsequently named editor-in-chief. Except for brief Easter and July holiday visits, he continued to absent himself from his family.[15]

DEATH AND TRANSFIGURATION

Decades after the fact, Monet recounted to Georges Clemenceau the circumstances surrounding the creation of his portrait of *Camille Monet on Her Deathbed* (figure 14.2). Clemenceau had stimulated this memory by contrasting Monet's almost supernatural perceptual abilities with his own limited skills in viewing the world around him:

> You cannot know how close you are to the truth. What you describe is the obsession, the joy, the torment of my days. To the point that, one day, when I was at the deathbed of a lady who had been, and still was, very dear to me, I found myself staring at the tragic countenance, automatically trying to identify the sequence, the proportions of light and shade in the colors that death had imposed on [her] immobile face. Shades of blue, yellow, gray, and I don't know what. That's what I had become. It would have been perfectly natural to have wanted to portray the last sight of one who was to leave us forever. But even before the thought occurred to record the face that meant so much to me, my first involuntary reflex was to tremble at the shock of the colors. In spite of myself, my reflexes drew me into the unconscious operation that is but the daily order of my life. Pity me, my friend.[16]

We have no way of measuring the accuracy of Clemenceau's later reconstruction of Monet's account, which, in turn, involved the artist's own memory of events that had occurred decades earlier. The fact that Clemenceau was the artist's most intimate friend and confidant during his final decades supports the supposition that his account fairly

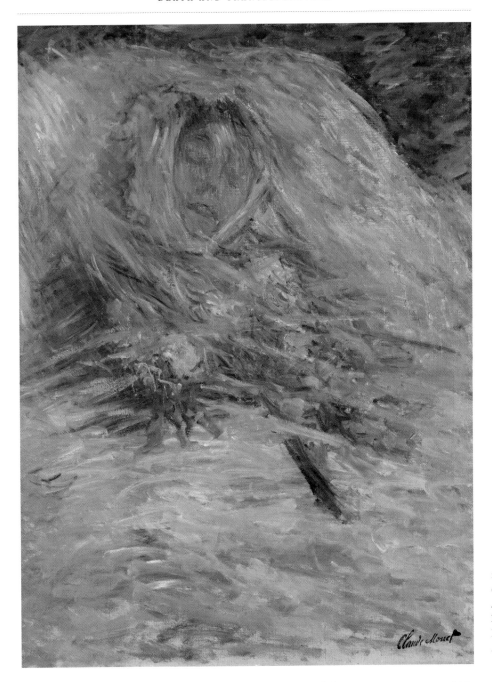

14.2. Claude Monet, *Camille Monet on Her Deathbed*, 1879, Musée d'Orsay, Paris. Erich Lessing / Art Resource, NY

accurately reflects the gist of Monet's reconstruction of that tragic moment and his artistic response to it.

Monet's statement, as filtered through Clemenceau, suggests that the artist painted Camille's deathbed portrait in a fever of impulsive activity. In reality his preparations must have been more measured. He evidently did not initiate the project until Camille's body had been washed and prepared for her wake. Furthermore, he had to move the necessary painting tools to her bedside. It is notable that he selected an extra-large canvas (90 × 68 in) for this portrait—a size he would also utilize for a number of the still life pictures executed in the months immediately following his wife's death.

The portrait represents Mme. Monet on her deathbed, her upper body clad in a dark-colored tweedy jacket or robe and her face bound in a white wrapping. (It is unclear whether it was added posthumously, to prevent her lower jaw from sagging—as normally occurs following death unless countermeasures prevent it.) Camille's mouth is slightly open, her lips drawn back. But the effect is not that of a grimace; to the contrary, she appears peaceful, as if a half-smile has crossed her face during a dream. The carmine of her lips (aided by cosmetics applied after death?) and the tiny dabs of creamy beige dotted here and there over her features relieve the grayish pallor of death, which, as Monet later recalled, was gradually replacing her normal flesh tones—a process she seems to be undergoing even as we contemplate the painting. The plentiful flower gardens and fields in which Monet had so often portrayed his wife during her lifetime have been reduced to a bouquet of dried flowers—a poignant reminder of the posy of violets she holds in the final portrait Monet painted of his beloved model during her lifetime (figure 12.4).[17]

Monet depicts Camille's features with sufficient definition for us to read her visage, but he veils her image with bold, sweeping strokes of blue, interspersed here and there with bright creamy-yellowish hues and touches of rose, vermilion, and orange. These strokes originate high on the left corner of the canvas and move diagonally across Camille's form. (The foreground of the picture, which only vaguely suggests the bed-clothing covering her lower body, was painted more rapidly and skimpily, with hurried horizontal strokes that leave portions of the bare canvas visible.)

Camille on Her Deathbed has elicited widely varying interpretations, from descriptions of it as caricaturelike to assertions that it is an angelic image.[18] For me, the brushstrokes covering Camille's form resemble a transparent veil of water, as if her body were floating Ophelia-like just beneath the surface of a clear stream. She, who during her lifetime was exclusively identified in Monet's art with the earth and its fecundity, has been permitted by death to join the artist's long-dead mother, with whom he fantasized that he would be eternally reunited, encased in a buoy and floating forever on the surface of the sea. As Joel Isaacson observes, the fact that Monet identifies the subject of the deathbed portrait only as "a lady who had been, and still was, very dear to me" makes it "not unlikely that this image . . . contained as well the memory of his mother"—and, one might add, perhaps also of Aunt Lecadre, whom he remembered tenderly long after her death.[19] The painting evoked similar associations in a later publication by Steven Levine, who notes that Monet "memorialized the death of Camille with a watery portrait." More fancifully, he compares Monet's dead spouse to his "spurned and silenced Echo."[20] Virginia Spate also calls attention to the relationship between aspects of Camille's image and the much later *Water Lilies, Reflections of Willows* (1916–19; W 1862) and "the age-old association between water and death."[21]

In Clemenceau's reconstruction, Monet berates himself for becoming so engrossed in the changes death was producing in Camille's skin tones and obsessed with recording them that his grief was temporarily forgotten. If Monet really felt guilty over his reaction, he certainly should not have; resuming his identity as artist rather than grief-

stricken spouse permitted him to distance himself temporarily from his sorrow, while creating an image of moving tenderness and poignancy. The guilt he expressed so many years later may actually have reflected an upsurge of unresolved emotion over the ambivalence he had shown to Camille throughout their life together, from the time of her pregnancy with Jean to the months immediately preceding her death, when he left much of her care to Mme. Hoschedé.

Camille Monet on Her Deathbed joined the artist's collection of Monets, which included numerous other images of Camille. (Following her death, he sold none of the depictions of his deceased wife still in his possession.) At least during the last years of his life, Monet exhibited a number of these pictures (as well as several representations of the Hoschedé daughters) in the disused studio at Giverny, nicknamed "the studio of the human figure." But for some time he kept Camille's deathbed portrait in his chamber, where he encountered it on a daily basis. Did he hang the picture above his bed, in the spot where his more pious contemporaries would have placed a crucifix? Or did he position it across the room, where it would have been the first thing he saw on awakening? Not only did he keep his ultimate vision of Camille in his bedroom, but he invited the American artist Theodore Robinson (1850–96), with whom he had become quite close, to view it there.[22] Were other intimates—including Clemenceau—also invited to such private showings? It seems likely, as does the conclusion that the painting, once a symbol of sorrow and loss, had evolved into a work in which he took great pride. (One cannot but wonder how Alice Hoschedé Monet, who was insanely jealous of Camille, reacted when she saw this painting enshrined in Monet's most private domain.)

In the three months immediately following the loss of Camille, Monet worked exclusively indoors, executing a splendid series of still lifes. Did he stay at home because he felt his children needed the reassurance of his constant presence, because of the unusually cold, rainy weather, or because—as one scholar suggests—landscape painting was so intimately connected in his inner world with the presence of Camille that he could not immediately bear to return to outdoor subjects?[23] The fact that still life paintings, a traditional "safe" subject, sold better than landscapes no doubt also played an important role in Monet's choice of subject matter at a time when he was being hounded by creditors. These still lifes are all very carefully composed and executed, no doubt in part as a response to criticisms by Zola and others of the supposedly unfinished character of his landscapes. But their deliberateness, their heavily coated surfaces, also reflect the artist's meditations about Camille.

Still Life with Apples and Grapes (figure 14.3), begun in the fall of 1879 but dated 1880 (and probably exhibited at *La Vie Moderne*), constitutes a prime example of these works. It also provides a study in contrasts between its carefully worked surface and its unusual viewpoint, with its close-up, angled representation of the tabletop on which the fruit is displayed.[24] Further contrasts exist within the composition, between the tightly organized arrangement of the fruits in the basket and the seemingly random dispersal of the apples and grapes resting on the tablecloth. The composition also emphasizes

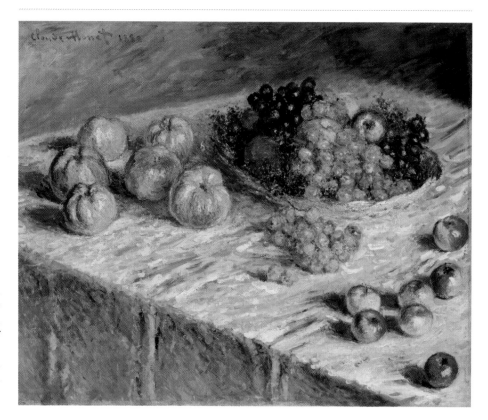

14.3. Claude Monet,
*Still Life with Apples
and Grapes*, 1880,
The Art Institute of
Chicago, Mr. and Mrs.
Martin A. Ryerson
Collection

the differences between the varieties of apples displayed; the larger variety on the left, with irregular contours and deep folds, is rendered in softer yellows, reds, and occasional pale greens, while the small apples in the right foreground, with their smoother, rounder shapes, have brighter red-green skins. The tablecloth, worked with vigorous, parallel impasto strokes that run vertically down the picture plane, intermingles creams and blues with touches of darker shades, which nonetheless create an overall bluish cast. *Still life* is actually something of a misnomer for this painting, for the entire composition seems to be in motion, propelled by the tablecloth, whose forward movement suggests a cascade or waterfall about to sweep the fruits over the edge to their destruction, beginning with the smallest apples nearest the edge and culminating in the doomed voyage of the shallow, heavily loaded basket.[25]

Two other still lifes of fruit executed around the same time (w 544–45) evoke similar associations: in both, loose clusters of grapes hover dangerously near the table edge, as if about to be swept "overboard" before the spectator's gaze. *Still Life with Apples and Grapes* not only shares the mournful, watery connotations of *Camille Monet on Her Deathbed* (and is painted on the same size support, as are w 544–45) but also evokes the destructive power of water (absent from Camille's portrait), paralleling the sense of instability and loss pervading Monet's inner world during the months following her death. In a letter to de Bellio from the second half of October, the artist portrayed his plight in dramatic—indeed melodramatic—terms: "I am more to be pitied than you could imagine and [am] very unfortunate; therefore do not refuse me, for I must return

to Vétheuil immediately, otherwise I will lose all courage, and all that is left for me is to renounce an intolerable existence" (WL 167).

It seems extremely unlikely that Monet's veiled suicidal threat could have been serious.[26] However, the fact that the artist entertained such ideas even briefly correlates with the destructive undertones implicit in the still-life compositions he then had in process, with their representations of "doomed" fruits. If the crises facing Monet were real enough, so was his capacity for self-pity, not the most attractive aspect of his personality but one that had probably been engraved in his character at an early age. Decades later he concluded his recollection to Clemenceau with "Pity me my friend," echoing the plea he had made to de Bellio.

More somber—and poignant—than the fruit paintings, a trio of still lifes of dead birds, executed around the end of the year, insistently evokes associations to mortality—human as well as avian. Painted on the same large supports as the depiction of the dead Camille and the fruit still lifes, they also utilize the identical tabletop setting featured in the latter and are executed with equal meticulousness. *Still Life with Pheasants and Plovers* (figure 14.4) represents two lapwings (or plovers) laid out next to a brace of pheasants, more impressive in their size and plumage. Just as death equalizes all creatures, great and small, powerful and helpless, so death negates the differences between the splendid pheasants, with their beautiful plumage, and the more modest lapwings. The insistent parallel forward thrust of the strokes rendering the tablecloth again suggests rushing water, but the immobile carcasses of the dead birds seem impervious to this thrust.

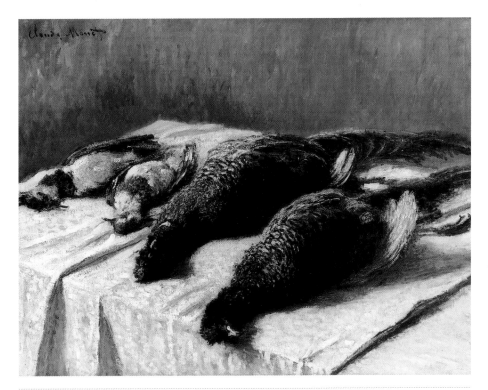

14.4. Claude Monet, *Still Life with Pheasants and Plovers*, 1879, Minneapolis Institute of Arts, gift of Anne Pierce Rogers in memory of John DeCoster Rogers

The fact that Monet was inspired to paint dead game at this critical stage in his life, a subject he had not essayed since the very beginning of his career, cannot be coincidental. None of the three early still lifes featuring dead birds, painted around 1861–62 (W 7, 10, and 11), conveys the mournful character of their later counterparts. The most elaborate of the early trio, *Hunting Trophy* (W 10), represents a clutch of dead birds, including a pheasant. But the clutter of hunting equipment surrounding their bodies, plus the presence of the live dog in the foreground, gazing wistfully at these forbidden temptations, negates the dark connotations so prominent in the 1879–80 pictures, with their unwavering emphasis on mortality. As Spate observes, even if Monet had been forced to paint still lifes for economic reasons (as John House contends), they still hint at "intimate meanings: the *Pheasants and Plovers* [*Pheasants and Lapwings*] suggest an association between the strangely juxtaposed pairs of large and small birds in their inert, unequivocal deadness, and the destruction of Monet's family as a living unity of two adults and two children."[27]

The subzero weather of December, which transformed the Seine into an unbroken sheet of ice, mobilized the artist; lured by this unique occurrence, he finally returned to landscape painting, braving deep snow and extreme cold to depict the river of ice (W 552–54). Monet's perseverance under such conditions testifies to his capacity to endure extreme physical discomfort in the service of his art. Perhaps working in this forbidding atmosphere, producing river scenes unparalleled during his wife's lifetime, was what permitted him to take up landscape painting once again. Did his grim tolerance of these Siberian conditions also act as a kind of penance, an expiation for sins of commission and omission committed against Camille? If so, remorse spurred creativity, for these pictures possess an austere beauty unique in Monet's oeuvre. The artist was clearly very proud of them, for he exhibited two of them, *Frost, Gray Weather* (W 553) and *Frost, near Vétheuil* (which Monet originally called *Frost, Effect of Sun*, a more descriptive title; figure 14.5) in his 1880 one-man show. Both pictures (along with W 554 and 556) prominently feature a disused rowboat locked in the ice, next to a tangle of denuded bushes. Boats, especially the artist's floating atelier, had intimate autobiographical associations for Monet, not infrequently serving as symbolic self-portraits. Here the "captive" boat parallels Monet's own feelings of chilled entrapment and abandonment following Camille's death.

The great thaw, which began in late December, reached Vétheuil on January 5, creating a sea of rapidly moving ice blocks of tremendous destructive force. The dramatic phenomenon fired Monet's enthusiasm; his eagerness to capture the unique situation resulted in the long series of masterworks (W 559–76) now known collectively as La Débâcle (The Ice Floes). Another dip in temperature following on the heels of the thaw preserved the partially frozen state of the river, permitting Monet to prolong his serial explorations into February.[28]

Monet described the fantastic phenomenon that so intrigued him matter-of-factly enough: "Here we had a terrible *débâcle*, and of course I tried to make something of

14.5. Claude Monet, *Frost, near Vétheuil*, 1880, Musée d'Orsay, Paris. Réunion des Musées Nationaux / Art Resource, NY

it," he informed de Bellio on January 8, early in the evolution of the series (WL 170). But if this verbal description was prosaic, the paintings he created are sheer poetry, their austere majesty transforming the destructive swath the ice blocks had initially wrought as they swallowed small islands and laid waste the adjacent shoreline. (The initial destructive force of the ice blocks is depicted most graphically in *Break-up of the Ice, Gray Weather* [W 560], which shows huge blocks of ice piling up on the Île Musard, breaking and damaging trees.) Perhaps it would be more accurate to compare the Débâcle series to a musical composition than to a literary one, for these paintings constitute a remarkable set of variations on a single theme, representing the ice-laden river from varied locations and viewpoints in weather ranging from wintry sunshine to frosty grayness. Seemingly spontaneous yet carefully composed, the paintings reflect the success of Monet's advance "scouting expeditions" to study the river from various vantage points.

Creations of wondrous beauty, yet melancholy, the Débâcle set emphasizes the artist's utter aloneness in a frozen universe, where neither humans nor animals venture, and even the abandoned boat depicted in *Frost, near Vétheuil* and its companions has disappeared.[29]

The Ice Floes (W 576; Musée du Petit Palais), one of four paintings (W 567, 569–71) representing the same scene in varying weather and light conditions, depicts a small branch of the Seine between the Moisson islands. Illuminated by the late afternoon sun, the scene glows with soft yellows and oranges, suffusing water and land. The ice blocks with their irregular, rounded forms flow placidly toward the (vaguely represented)

islands, whose denuded trees, rising skeletally against the golden sky, cast long reflections on the river, gently caressing the ice floes and providing vertical counterpoints to the broad expanse of water opening before us. Obviously well pleased with the composition, Monet selected it as the model for the larger studio version, *Ice Floes* or *Floating Ice* (W 568), designed for submission to (and rejected by) the 1880 Salon.[30]

Monet terminated his meditations on the ice floes with four works representing the setting sun on the Seine, viewed from the Vétheuil bank with Lavacourt in the distance and the tip of the Île Musard visible on the right (W 574–77). As he had with *Ice Floes*, Monet repeated this motif with variations in a larger-scale version, probably executed at the same time as his two Salon submissions and also primarily a studio creation. Did he briefly contemplate sending *Sunset on the Seine in Winter* (figure 14.6) to the Salon in lieu of one of the works he finally selected? The fact that he executed all three paintings on supports of roughly the same large dimensions (ca. 100 × 150 in) suggests that this may have been the case. If so, he quickly thought better of the idea, as his letter of March 8 to Duret reveals. After informing Duret that he intended to follow his advice and submit to the Salon, Monet added: "I am working furiously on three large paintings, only two [of them] for the Salon, for one of the three is too much to my own taste, and I have in its place made a wiser choice, more bourgeois" (WL 173).

14.6. Claude Monet, *Sunset on the Seine in Winter*, 1880, Pola Museum of Art, Pola Art Foundation

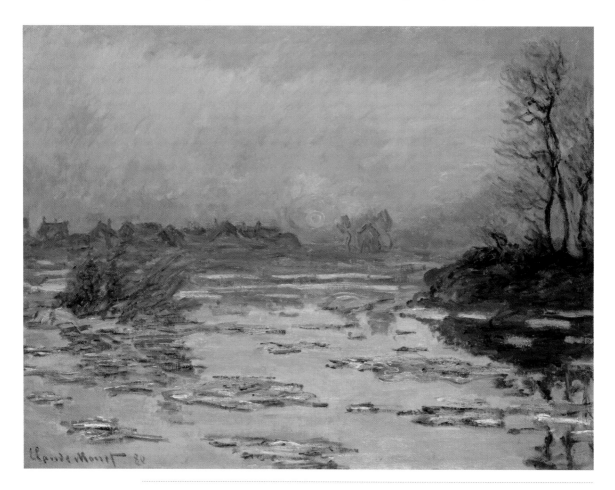

A canny judge of such matters, Monet was undoubtedly correct in deciding against sending *Sunset on the Seine* to the Salon, for the composition preserves the broad, sketchlike facture of the two smaller versions along with their melancholy atmosphere. Indeed, the painting has an almost ghostlike quality; Lavacourt, vaguely visible through the hazy light, might be a city of the dead, an impression reinforced by the weathered appearance of the vegetation—the scrubby bushes in the water, bending rightward as if bowed in eternal sorrow, and the puny trees on the island, stretching their bony branches heavenward. The two distant boats and their occupants do not counter the overall gloomy sensation; crafts and rowers, sketchily rendered in unrelieved black, untouched by the rays of the setting sun (which illuminates sky and water with its fiery hues), might well be navigating the Styx rather than the Seine.

Despite its mournful tone, *Sunset on the Seine* was Monet's personal favorite ("too much to my own taste") among the trio he had in progress in March 1880, a partiality reflected in his decision to present *Sunset* (W 577), one of the four preparatory studies for the large version, to Mme. Hoschedé; it remained in the family's private collection until the death of Alice's last surviving child, Germaine Salerou, in 1968. The least detailed, most broadly painted of the quartet, it is also the most somber, portraying the last gasp of the setting sun highlighted by the skeletal tree branches that seem almost to embrace it as they stretch across the darkening sky and surround the glowing orb. By the time Monet executed this sketch, the dwindling ice floes had virtually disappeared and the Seine again flowed freely. The changed state of the river paralleled the artist's own emotional state; like the ice floes, his heart had thawed, and his acute period of mourning had ended.

In an unusual admission, Monet confessed to Duret, in a letter written the following July, that he was working very well and in a good "vein" (WL 191). His self-evaluation was quite accurate. The arrival of warm weather, his acceptance at the Salon, the success of his exhibition at La Vie Moderne, and the better prices his works now commanded combined to raise the artist's spirits, and he was extremely prolific during the second half of 1880, producing charming views of Vétheuil, its meadows, riverbanks, and islets—compositions filled with sunshine, flowers, and the delights of the beautiful spring and summer that followed the terrible winter of 1879–80 (W 589–616).

That spring Monet painted *Woman Seated under Willows* (figure 14.7), showing his model posed in a verdant meadow, surrounded by willows in tender leaf. Although the figure was certainly modeled on Mme. Hoschedé, the artist depicted her facial features with such delicate vagueness as to render her virtually unidentifiable, a treatment no doubt designed to protect her reputation. Did his model's lack of definitiveness also assist the artist in imagining that his sitter was Camille, who had posed for several similar compositions during the Argenteuil years? Whatever his motives for veiling Mme. Hoschedé's features, the painting provides concrete evidence of the deepening relationship between the artist and his new muse. Her presence—her loyalty and admiration for his work—was essential in enabling Monet to avoid the pathological mourning

14.7. Claude Monet, *Woman Seated under Willows*, 1880, Chester Dale Collection. Image courtesy of the Board of Trustees, National Gallery of Art, Washington

and creative paralysis that would seize him following *her* death decades later, when no replacement muse was at hand.[31]

Around the turn of the year, perhaps once again in commemoration of the New Year, Monet portrayed his two boys. Jean's tragic countenance (figure 14.8) conveys all too graphically his continued mourning over the loss of his mother, a trauma that probably left its impact on him throughout his future life.[32] One would expect such a tragedy to have a far more profound impact on Michel, only eighteen months of age when his mother died, too young to experience the conscious mourning suffered by his older brother. Michel's portrait (figure 14.9) certainly does not represent him as

the insouciant little fellow one might expect of a child not yet three. His expression appears serious, even somber. Monet's representations of his sons demonstrate not only his great skill as a portraitist but his empathic response to the sufferings of his half-orphaned boys as well. The fact that these portraits were executed at a time of year close to the anniversary of his own mother's death endows them with additional personal significance for their creator, who had likewise experienced the premature death of his mother, as well as of his wife.

14.8. (*left*) Claude Monet, *Jean Monet*, 1880, Musée Marmottan, Paris / Bridgeman Art Library

14.9. (*right*) Claude Monet, *Michel Wearing a Bonnet with Pompom*, 1880, Musée Marmottan, Paris. Bridgeman-Giraudon / Art Resource, NY

CONCLUSION

The direct relationship between the Débâcle paintings and the water lily compositions that would become the magnificent obsession of Monet's old age has been universally recognized. The extremely high quality of the pictures he produced in the months immediately following Camille's loss demonstrates that even in death she inspired Monet to new levels of creativity. Arguably, no pictures from the Débâcle group more directly anticipate the Nymphéas paintings than the subset known collectively as The Ice Floes. Personal favorites of Monet's at the time of their creation, they indelibly etched themselves in his visual memory, to reemerge decades later as the theme that would consume his final period.

Although he had been far from an ideal husband, Monet did endow Camille with an unique reciprocal gift: immortality. Her body has been dust for well over a century, but in Monet's art Camille lives on, forever young and beautiful, the fairest flower in the artist's garden (figure 8.3).

I shall always be here, near you
Among the flowers.
Love me, Alfredo, love me as much as I love you.
Goodbye.

VIOLETTA'S FAREWELL
IN VERDI'S *LA TRAVIATA*, ACT 2, SCENE 1

The Memorial Garden
of Claude Monet

A skilled landscape architect as well as a superb landscape painter, Claude Monet embellished the gardens of the various rental properties he occupied for any length of time. He was able to indulge this passion to the full after 1890, when he purchased Giverny, the only home he would ever own and where he would spend the remainder of his long life. He had resided there since 1883, together with his compound family: his two sons, his mistress Alice Hoschedé, and her six children. (A second critical change in Monet's life occurred in 1892, when he was finally able to marry Alice following the death of her first husband, thus regularizing a relationship that had often been filled with guilt and conflict.)[1]

Although a number of the plantings and trees at Giverny had displeased him, Monet could not remove these aesthetic offenders until he owned the property; after gaining ownership he immediately set to work, transforming the flower gardens lining the paths into glorious assemblages featuring flowers that bloomed in sequence from early spring until late autumn. By the late 1890s, the Giverny gardens were so extensive that Monet employed six full-time gardeners plus a head gardener.

The severe winter of 1892–93 brought heavy snows and bitter cold, causing ice to build up on the Seine; the river eventually froze solid, then thawed, producing a *débâcle*. Eager to return to outdoor painting as a respite from his labors on the Rouen Cathedral series (all executed indoors between 1891 and 1893, from windows overlooking the edifice) and delighted by the icy conditions of the river, Monet was inspired to capture these unusual effects, as he had in the terrible winter of 1879–80 immediately following Camille's death. Hardy as ever, Monet braved the frigid weather, working from an unknown date in January until mid-February 1893 (when he returned to Rouen and the cathedral paintings).[2]

During these weeks, he painted thirteen views of the Seine as it froze and thawed. He executed eight of these compositions (w 1333–40) from the banks of the Seine at Bennecourt, a spot sufficiently distant from Giverny to require transportation by horse and carriage, rather than on foot. Wildenstein suggests that "since Monet knew that he could find his classic motifs as close [to Giverny] as Port-Villez [where he painted additional views of the icy river (w 1341–44)], one is almost tempted to think that Bennecourt was chosen because of a literary memory, that of the beautiful snow effects painted [there] by Claude Lantier in [Zola's novel] *L'Oeuvre* published a few years before."[3]

Monet had other, more intimate associations with the area, where he had depicted Camille in *On the Bank of the Seine, Bennecourt (The River)* (figure 5.1) and where,

following their threatened ejection from the inn for failure to pay, he had abandoned his mistress and their child without making adequate provisions for their care while he returned to his family of origin and the creature comforts available at Sainte-Adresse.

The unusual weather conditions of the winter of 1893 must have forcibly recalled still more painful reminders of Camille, especially regarding his often negligent treatment of her during the final months of her life. The terrible winter of 1879–80 following her death, when the Seine also froze and thawed, had inspired him to capture the melancholy beauty of the initial Débâcle series, widely recognized as precedents for the great Nymphéas cycle to come, and the same conclusions apply to the paintings executed at Bennecourt in 1893, as *Floating Ice on the Seine Near Bennecourt* (w 1340, Walker Gallery, Liverpool) attests.

The Bennecourt Débâcle compositions were created in the context of Monet's plans for establishing a water garden. No doubt he had entertained the dream of creating such a garden for several years before carrying out his plan. But even before completing the ice floe paintings of 1893 he took steps to make that dream a reality. On February 5 he signed the deed of sale for a parcel of land that lay across the railroad tracks from the south border of his property; this area, added to meadowland he had previously acquired, provided adequate space for constructing the water garden. He also applied for permission to divert water from the river Ru (a branch of the Epte, adjacent to his property) to supply the water-lily pond with a constant source of fresh water, as well as to build two bridges across the pond. As Wildenstein notes, the notarized documents must have been prepared in advance, but no evidence indicates that they were initiated before the artist began the Bennecourt pictures. From its inception, the water-lily project was inexorably linked to memories of death—especially that of Camille.

As soon as the objections of government officials and locals to the diversion of the Ru had been resolved, Monet had the pond excavated and the two bridges constructed, one of them copied from a Japanese prototype. In its definitive form, the water garden would assume an explicitly Asian character, in contrast to the more traditional Western nature of the flower gardens.[4] In addition to the Japanese bridge, the water garden would eventually feature many plantings imported from Japan, including gingko, bamboo, and fruit trees, as well as water-lily plants. These flowers are akin to the lotus, held sacred in many cultures and connected with death by the Symbolist poets, including Stéphane Mallarmé. It seems very likely that Monet held similar associations to these flowers, regarded by Buddhists as symbols of the "western paradise."[5] However, as Paul Tucker points out, in addition to its Eastern plantings, the water garden would eventually include weeping willows, trees additionally associated with death in Western culture. Reflections of the willows would play a prominent role in Monet's definitive water-lily cycle now installed in the Orangerie.[6]

On July 5, 1899, Monet wrote Gustave Geffroy, claiming that he had not worked for eighteen months (WL 1468). This claim may have been somewhat exaggerated, but the first months of 1899 were marked by two sad events that deeply moved Monet and

would preempt his time and energy. Alfred Sisley, the friend of his youth, died on January 29, impoverished. Monet, concerned about the future of Sisley's children, promised to arrange a benefit sale and memorial exhibition to ameliorate their situation.[7] Eight days after Sisley's death, Suzanne Butler, who had been his favorite and his preferred model among the Hoschedé sisters, passed away after a long illness—a loss from which her mother never fully recovered and which also profoundly moved the artist.

More pleasant events also took Monet away from his easel in 1899. That spring and summer his paintings were featured in seven exhibitions, including individual and group shows—two held abroad, the others in Paris—and Monet played an active role in selecting the works involved. For a group exhibition at the Georges Petit Gallery, he chose eighteen paintings covering a wide chronological range, including two early compositions portraying the first Mme. Monet: *Camille* (*Woman in a Green Dress*) (1866; figure 2.1) and *The Luncheon* (1868–69; figure 6.3).[8]

Not until late July did Monet take up his paintbrushes again, when he executed a series of canvases featuring the Japanese bridge, viewed from traditional linear perspectives (w 1509–20); unlike the 1897–98 *Water Lilies*, these compositions include plantings lining the banks, as well as their watery reflections.

Three successive working trips to London, undertaken between 1899 and 1901, again diverted Monet's painterly attention from his water garden.[9] Back at Giverny in the spring of 1900, however, following his second lengthy London trip, Monet returned to painting outdoors and to the twin motif of his two gardens, portraying the flowerbeds adjoining the paths of his Western garden, lush with bright blooms (w 1621–27), and the Japanese bridge of his Oriental garden, represented from various viewpoints and in diverse weather conditions (figure 15.1).[10]

Increasingly dissatisfied with the size of the water garden, on May 10, 1901, Monet signed the deed of purchase for land on the south side of the Ru, which would permit its expansion. That July he rented a vacant house at nearby Lavacourt for approximately three months; he had the place furnished and boats transported to the area, although he never stayed there overnight but made the daily round trip by auto instead, accompanied by Alice and other family members and friends, who enjoyed picnic outings while Monet worked. Enchanted anew with a favorite motif from his residence at Vétheuil in 1879–81, he again represented the town dominated by its splendid church, captured in the bright summer light from a

15.1. Claude Monet, *Water Lily Pool*, 1900, The Art Institute of Chicago, Mr. and Mrs. Lewis Larned Coburn Memorial Collection

vantage point across the river, most likely in or around the rental house (w 1935–49). Monet evidently found this campaign far more time consuming than he had anticipated, for he complained to Durand-Ruel that the series took him all summer. In the midst of this campaign, on August 13 he petitioned the prefect of the Eure for permission to divert additional water from the Ru, as part of his expansion plan.[11]

Can it be yet another coincidence that, preoccupied with plans to enlarge his water-lily garden, Monet once again returned to an area filled with memories of Camille's final illness and the site of her neglected tomb?[12] The enlargement and redesign of the pond, like its inception, was thus integrally connected with the death of Camille. Or was the order reversed? Did he return to Bennecourt in 1893 and to Vétheuil in 1901 because he *was already preoccupied with memories of Camille* before initiating, then enlarging, the two water-lily garden projects? There is no evidence that Monet visited Camille's grave site or had it refurbished. Why should he? He was planning a far more beautiful, symbolic tomb for her at Giverny, and he cared no more for her actual grave than he would for his own. (His instructions about his own funeral and burial would be as simple as possible, and his modest grave in the Catholic cemetery at Giverny is singularly unpretentious, as is that of his second wife, who was interred next to her first husband rather than Monet.)

Official permission to divert additional water from the Ru arrived around November 1901, and early the following February, under the artist's intense—indeed obsessive—supervision, the changes, which involved removing tons of earth and virtually tripling the size of the pond, were rapidly completed. He capped the expansion by having a small artificial island added to the enlarged pond. By the end of February 1902, Monet was able to add many more new water lilies to the pond, as well as other plantings on the surrounding banks.[13]

Pleased with the new configuration of his water garden, Monet executed numerous paintings of the pond and its environs between the summer of 1903 and the autumn of 1908 (when Alice and he left for a lengthy vacation in Venice). The series (w 1654–91, 1693–1735) encompasses a variety of formats (round, square, vertical) and viewpoints: The earlier pictures in the group often provide glimpses of the opposite bank, showing overhanging tree branches or, in a few instances, views of the Japanese bridge and its environs, but these elements disappeared as the series progressed and the surface of the pond assumed pride of place. Monet scholars typically cite the canvases painted during 1907–8 as the most original and experimental of the entire group; painted on large, rectangular panels, they depict the horizontal surface of the pond as though it were vertical. These compositions depict a world in which reflections of trees, clouds, and sky seemingly float gently among the water lilies (figure 15.2), depicted in various seasons, times, and light conditions. Typically delicate in palette, they play on subtle contrasts in hues, presenting a serene and peaceful watery universe for our contemplation.

A photograph of the water-lily pond, shot by the artist himself around 1905, shows Monet's head and shoulders reflected in its waters (figure 15.3). Both Steven Levine

and Virginia Spate cite this photograph as evidence of the underlying narcissistic significance of the artist's lifelong preoccupation with water reflections. Indeed, Levine constructed his extensive psychological portrait of Monet's life and oeuvre around the concept of the artist as Narcissus. By contrast, as the foregoing text has emphasized, I believe that Monet's preoccupation with watery reflections sprang from his reaction to his mother's death and his ensuing fantasy that he would float forever in the form of a buoy on the surface of the mother/sea. Obsessed by his beautiful water garden, Monet

15.2. Claude Monet, *Water Lilies*, 1907, Museum of Fine Arts, Houston / Bridgeman Art Library

15.3. *Giverny Pond with Monet's Shadow*, 1905, Collection Toulgouat. © Philippe Piguet

substituted his pond for the sea and the water lilies for his fantasized buoy; the water garden, then, would function as his own symbolic tomb, as well as that of his beloved dead women—his mother, Aunt Lecadre, Camille, and eventually Alice.[14]

From the end of September until early December 1908, the Monets spent a delightful holiday in Venice; there he started, but, as was now his practice, did not finish in situ, three dozen paintings.[15] But their sojourn in Venice marked the end of a happy period in the lives of the Monets and the beginning of an artistic paralysis that would hold Claude in a viselike grip for more than five years. The onset of his fallow period coincided with health problems that plagued both partners. The prolonged indisposition of Mme. Monet, which began during the first weeks of 1909, would prove to be the first of several crises she would experience before finally succumbing to myelogenous leukemia on May 19, 1911.[16] Monet, too, was unwell, suffering from vertigo and recurrent headaches that he complained had been plaguing him for more than a year and that would continue to trouble him.[17]

If 1909 brought trouble, it also occasioned a great artistic triumph: Durand-Ruel's exhibition of forty-eight of Monet's *Water Lilies*, which opened on May 6 and was extended to June 12, proved to be a major public and critical success, generating large crowds and acclaim from leading critics; a number of the reviewers referred to the artist's dream of seeing a circular room filled with paintings of water and flowers, a fantasy he obviously shared with many admirers.[18]

The new year, however, brought new woes: Alice again fell gravely ill, and the terrible floods that followed the torrential rains of December and January severely damaged both the flower and water gardens. Unlike poor Alice, the gardens quickly

recovered, although the banks of the lily pond required reinforcement that permanently altered its shape into its present form.

Alice's death plunged Monet into an extended period of mourning that was no doubt exacerbated by his increasing awareness of a progressive loss of the fabled visual acuity that had moved even Cézanne to envy. By 1912, the deterioration of his vision (already apparent by 1908) had become so pronounced that he sought professional help, only to learn that he was suffering from double cataracts, not yet operable at that time.

Between 1909 and the spring of his artistic rebirth, Monet had accomplished little beyond completing the Venetian pictures and executing nine new compositions (w 1777–81), several of them small studies rather than finished paintings. The most impressive—and largest—pictures completed during this fallow period are the trio painted in 1913 (w 1779–81) representing the rose arches at Giverny, viewed from the water-lily pond (figure 15.4).[19]

A third hammer blow of fate soon struck. The artist's son Jean, ravaged by progressive cerebral degeneration, most likely general paresis (tertiary syphilis), had become

15.4. Claude Monet, *Flowering Arches, Giverny*, 1913, Phoenix Art Museum, gift of Mr. and Mrs. Donald D. Harrington

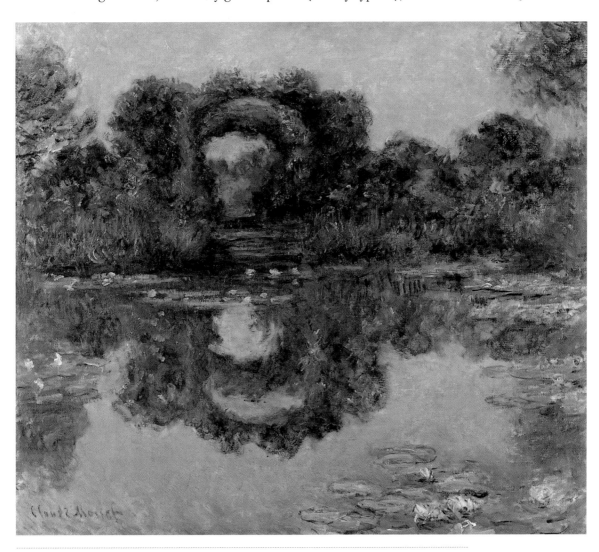

too incapacitated to work, and in November 1912 his wife, Monet's stepdaughter Blanche Hoschedé-Monet, brought her psychotic husband back to Giverny to live. Although the artist purchased a separate villa for Jean and Blanche, they spent most of their waking hours with him at their childhood residence. Jean's dementia grew rapidly worse, and Monet's gloom and depression increased in tandem with his son's decline; the latter's death, on February 9, 1914, can only have come as a relief to all concerned.[20]

If his wife's death had plunged Monet into a period of artistic paralysis, that of his son sparked an amazing renaissance in his creativity. The reason for this discrepancy is not difficult to divine: immediately following her husband's demise, Blanche announced her decision to stay on at the bereaved artist's side to ensure his physical and emotional well-being. "It will be a consolation to us both," Monet wrote his friend Geffroy on February 16, 1914 (WL 2103). Indeed! With his new companion at his side, Monet was not merely consoled but rejuvenated, his creativity rekindled. "I am feeling marvelous and obsessed with the desire to paint," he commented to Geffroy on April 30, 1914. "I am even counting on undertaking some great things, of which you will see some tentative old examples that I've rediscovered in a basement. [Georges] Clemenceau [by this time a very close friend] has seen them and is astonished" (WL 2216). Clemenceau—perhaps prompted by hints from the artist—immediately suggested a Water Lily cycle for his dining room. From this conversation, Clemenceau later noted, came the germ of the Grandes Décorations, the extensive water-lily murals today installed in the Musée de l'Orangerie, Paris.[21]

Energized by the presence of his new companion, Monet now conceived of grand plans. It soon became clear that from the moment he rediscovered the "basement paintings" (apparently those dating from ca. 1897–99), he had the creation of a sequence of large-scale water-lily paintings in mind. He quickly became absorbed in the grand project; even the progression of his cataracts seemed to him "provisionally checked," and he figured out ways to work around his visual handicap, rapidly creating a series of new representations of the water-lily garden, of great size (described by one viewer as 2 × 3 or even 2 × 5 meters), in a new style. Such were the transformative effects of the companionship of a new muse, able and willing to devote herself entirely to assisting her aged stepfather in his grand plan. See figure 15.5, showing Blanche standing at the artist's side as he paints outdoors.[22]

Although Monet was deeply distressed by the outbreak of World War I and the depar-

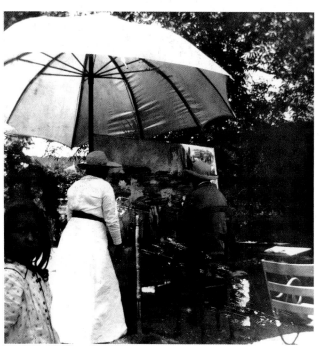

15.5. Claude Monet at work in the garden at Giverny with Blanche Hoschédé Monet looking on, 1915. © Philippe Piguet

ture of family members for the service, his rediscovered zeal for painting did not desert him, and he remained at Giverny with Blanche, working quietly throughout the war.[23] It soon became apparent that the scope of the project he had in mind would require the construction of a new studio large enough to permit him to work indoors during inclement weather, as well as to arrange the huge canvases in sequence so that he could ascertain their effect as a continuous decorative ensemble. With this scheme in mind, he acquired additional land and the necessary permits to construct a new studio of enormous dimensions. The ugliness of this atelier, completed in October 1915, appalled Monet, but it proved very functional, enabling him to work year round on his great cycle.

It is not possible to determine the precise number, chronology, or identity of all the canvases relating to Monet's grand decorative scheme that he had executed by war's end (see figure 15.6).[24] He was, by 1917, deeply engrossed in the project—a progression documented by photographs made in his new studio sometime that year, showing at least twelve large-scale paintings arranged in interrelated clusters.[25] Monet suffered several significant personal losses during 1917: his cousin Jeanne-Marguerite Lecadre (whom he had depicted long ago in the garden at Saint-Adresse), Octave Mirbeau, Edgar Degas, and his brother Léon all passed away that year. Mirbeau's death affected Monet far more than that of his estranged brother; he did not attend Léon's funeral, contenting himself with sending a rather formal condolence note to the widow (WL 2236).[26]

The day after the armistice was signed on November 11, 1918, Monet wrote his good friend Clemenceau ("the tiger of France," who as war minister, had seen the conflict through to its successful end and had been named prime minister on November 5, 1917), offering to donate two new decorative panels to the state to celebrate the French victory (WL 2287). Clemenceau responded by traveling to Giverny (accompanied by another close friend of the artist, Gustave Geffroy) to propose the much more ambitious donation of twelve large decorative panels. Monet eventually agreed to the proposal but made his gift contingent on the government's purchase of his early painting *Women in the Garden* (figure 3.1, rejected decades earlier by the Salon of 1867) for the exorbitant sum of 200,000 francs—a condition to which the state agreed. When the time came, Monet found it difficult to part with this beautiful souvenir of his youth—and that of Camille, who had posed for the painting.

The official agreement between Monet and the Ministry of Fine Arts was signed on April 12, 1922; it specified that nineteen Water Lily panels would be installed in a Claude Monet Museum in Paris, to be housed in a pavilion constructed by the state in the garden of the Hôtel Biron (now the Musée Rodin). This agreement, however, required Monet

15.6. Claude Monet, *Waterlilies: Clear Morning with Willows*, 1914–26, Musée de l'Orangerie, Paris. Réunion des Musées Nationaux / Art Resource, NY

to modify the selection and arrangement of the canvases he had originally planned to donate. This epilogue is not the place to review in any detail the problems that subsequently threatened the donation. As Charles Stuckey points out, shifts in the political climate (especially Clemenceau's fall from power in 1920), disagreements with the architect assigned to the project, the artist's failing eyesight and his increasing irritability, moodiness, and susceptibility to obsessional doubts (which led him to destroy an unknown number of paintings originally intended for the donation) all added to the uncertainties and problems surrounding the donation.[27]

Thanks to the support of family and friends, especially Clemenceau (who alternately bullied and encouraged the artist) and Blanche Monet, whose role in sustaining her beloved stepfather cannot be overestimated, Monet persevered until the end, even though the pavilion in the garden of the Hôtel Biron never became a reality and the two rooms on the lower level of the Orangerie, proposed by the state as a substitute, required further changes in the size and number of the great canvases. This last proposed change understandably upset Monet greatly; fearing that it would compromise his entire design plan, he threatened to revoke the donation but eventually simmered down and even decided to increase the number of canvases to fill the two available rooms rather than just one.[28]

His increasing visual problems finally forced Monet to agree to surgery. The three cataract operations he underwent in 1923 were by no means unqualified successes and required the use of special spectacles to counteract postoperative difficulties in perceiving colors accurately. (He was a *terrible* patient, whose anxious, uncooperative behavior during surgery surely did nothing to guarantee a good outcome.)

By 1924 Clemenceau, realizing that the grand decorations were now essentially complete, urged Monet to stop obsessively fiddling with the paintings and ship them to the Orangerie. Instead, early the following year Monet once again threatened to revoke the donation. Clemenceau initially responded by denouncing Monet and breaking off all contact with him, but soon relented and returned to his cajoling role; the artist finally promised to send the ensemble in the spring of 1926.

By the beginning of 1926, Monet was experiencing an uncharacteristic lack of energy, diagnosed as an incurable cancer of the left lung—no doubt the result of decades of chain smoking. Soon too weak even to tour his garden, Monet accurately predicted to Clemenceau that the latter would see the gardens in bloom next spring without him.

Clemenceau continued his protective oversight during the last days of Monet's life. Present at the artist's deathbed on December 5, his friend allegedly witnessed the artist's final gesture: No longer able to speak, Monet (who had refused to relinquish control of his great decorations prior to his death) held up two fingers, indicating the depth of the frames he wanted for the canvases when they were installed in the Orangerie. Then he breathed his last, symbolically joining the spirits of his beloved dead women, to float forever on the surface of his water-lily pond (figure 15.7).

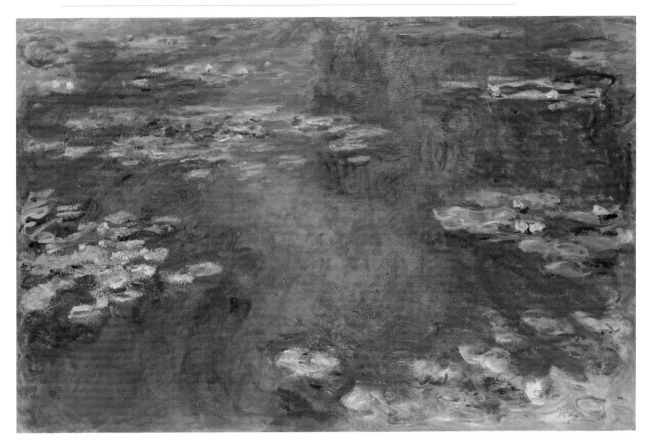

Vigorously pushed by Clemenceau, the French state rapidly completed the installation of the murals, which were unveiled on May 17, 1927. Today visitors who enter these rooms can immerse themselves in the watery universe that Monet executed three times over: when he initiated, then enlarged, the water-lily garden and finally when he captured it forever in the fiction of paint.

15.7. Claude Monet, *Water Lily Pond*, 1917–22, The Art Institute of Chicago, gift of Mrs. Harvey Kaplan

The most frequent citations (and all but one designated through abbreviations) come from Daniel Wildenstein, *Claude Monet, biographie et catalogue raisonné* (Lausanne), vol. I, 1974; vol. II, 1979; vol. III, 1979; vol. IV, 1985; vol. V, 1991.

In 1996 Wildenstein published a trilingual edition (French, English, German) in Cologne. Volume I is entitled *Monet, or the Triumph of Impressionism* and contains biographical material but not the letters and *pièces justificatives* included in the original French edition. Volumes II–IV, titled *Monet catalogue raisonné*, consist of an updated catalog. In the present volume Monet's works are designated by the numbers Wildenstein assigned to them in 1996; all other information derives from the original French edition.

ABBREVIATIONS

BL followed by an arabic number refers to one of the letters of Fréderic Bazille in his *Correspondance*, ed. Didier Vatuone (Montpellier, France, 1992).

W followed by an arabic number refers to one or more of Monet's paintings.

W followed by a roman numeral refers to a volume of the French edition.

WD followed by an arabic number refers to one of Monet's drawings, cataloged in W V.

WL followed by an arabic number refers to one of Monet's letters as quoted in the French edition.

WP followed by an arabic number refers to one of Monet's pastels, cataloged in W V.

WPJ followed by an arabic number refers to a specific *pièce justificative* in the French edition.

PREFACE AND ACKNOWLEDGMENTS

1. See Mary Mathews Gedo, *Picasso: Art as Autobiography* (Chicago, 1980). See also John Gedo and Mary Mathews Gedo, *Perspectives on Creativity: The Biographical Method* (Norwood, NJ, 1992).

PROLOGUE

1. Quoted in François Thiébault-Sisson, "Claude Monet: An Interview," English version of an article that originally appeared in *Le Temps*, November 27, 1900 (New York, 1900?), n.p., no trans. listed.

2. See, for example, Claire Joyes, *Claude Monet: Life at Giverny* (New York, 1985), pp. 61–66.

3. The Lecadre clan, whose male members included physicians and attorneys as well as leading businessmen, enjoyed considerable renown in Le Havre. By joining his brother-in-law's firm, Adolphe Monet increased not only his income but also the social status of his immediate family. In other words, the Monets benefited from what sociologists formerly termed "glory by contamination." For information about the Lecadres, see W I, p. 2 and passim.

4. Paul Hayes Tucker, *Monet at Argenteuil* (New Haven, CT, 1982), p. 47.

5. For example, in 1889–90 Monet devoted a great deal of time and effort to organizing and leading the successful campaign to have Edouard Manet's *Olympia* donated to the state. For details, consult W III, pp. 30, 32–33. See also Marianne Alphant, *Claude Monet, une vie dans le paysage*

(Paris, 1993), pp. 465–81, and Paul Hayes Tucker, *Monet in the '90s: The Series Paintings*, exh. cat. (New Haven, CT, 1989), pp. 56–61.

René Gimpel, *Diary of an Art Dealer*, trans. Joseph Rosenberg (New York, 1963), remarks several times on Monet's generosity as a host as well as his prowess as a trencherman. In his entry for January 30, 1919, Gimpel states that Durand-Ruel had informed him that Monet never achieved the personal wealth that Renoir amassed because "Monet always was a Sybarite. You get the best cuisine in France at his house. He's had a chef for twenty-five years." In the entry dated October 9, 1920, Gimpel described the "marvelous" lunch he had enjoyed at Monet's that day: "First some hors d'oeuvres with the best Normandy butter, a succulent veal risotto with spinach, two chickens for five people; the first one roasted, which nobody touched; the second extraordinary, done with black olives; then a tart, a real tidbit, and fruit as beautiful as flowers. Monet has always adored the table."

6. In my judgment, certain character traits of Alice Hoschedé, such as her obsessiveness, scrupulosity, jealousy, and controllingness, tilted Monet's behavior in an unfavorable direction, bringing to the fore his own obsessional tendencies—previously held in check—especially in the form of doubts about the value of specific works or groups of works. I am not prepared to discuss whether these developments came about by way of direct identification with Mme. Hoschedé or as a consequence of her failure to suppress these tendencies in Monet.

For the most complete information about Mme. Hoschedé's attitudes and behavior, consult Alphant 1993, whose numerous references include lengthy excerpts from Mme. Hoschedé's private day journal, as well as details about her life prior to her first husband's bankruptcy.

7. Théophile Beguin Billecocq, "Le Grand Journal du Comte Beguin Bellecocq, ministère plénipotentiaire (1825–1906): Chronique d'une vie bien remplie," manuscript, cited in James A. Ganz and Richard Kendall, *Monet: Pastels and Drawings* (New Haven, CT, 2007).

8. Ibid., pp. 13–16, 23, 30–31, 58.

9. Ibid., p. 14.

10. Ibid., p. 13

11. Ibid., p. 14

12. See John Rewald, *Studies in Impressionism*, ed. Irene Gordon and Frances Weitzenhoffer (New York, 1986), p. 73.

13. For details about Monet's failed petitions and his subsequent enrollment in the Académie Suisse, consult w 1, pp. 6–9.

14. For a discussion of the inhibited individual, see Sigmund Freud, "Inhibitions, Symptoms and Anxiety," in *Standard Edition* (London, 1959), 20:87–172.

15. Clemenceau later recalled that he and Monet met in the Latin Quarter, presumably during 1860, when the artist frequented the Brasserie des Martyrs. For his account, see Georges Clemenceau, *Claude Monet, cinquante ans d'amitié* (Paris, 1928), p. 119. Their period of real intimacy, however, dated from the 1890s until Monet's death. For a concise overview of their relationship, see André Wormser, "Claude Monet et Georges Clemenceau: Une singulière amitié," in *Aspects of Monet*, ed. John Rewald and F. Weitzenhoffer (New York, 1984), pp. 190–217.

16. For Clemenceau's personal reminiscences about this period, see *Claude Monet: Les Nymphéas* (Paris, 1928). See also Charles F. Stuckey and Robert Gordon, "Blossoms and Blunders: Monet and the State," *Art in America* 67 (January-February and September 1979): 102, 117–25, 109–25. w IV, which covers the final years of Monet's career, contains extensive material on the Nymphéas

project, along with the related catalogue raisonné and letters.

17. René Gimpel, "At Giverny with Claude Monet," trans. A. Sharkey, *Art in America* 15, no. 4 (June 1927): 172–73.

18. Quoted in Jean Renoir, *Renoir, My Father*, trans. by R. and D. Weaver (Boston, 1962), pp. 111–12.

19. The complex triangular relationship involving the artist and the Hoschedés will be discussed in later chapters.

20. Like St. Francis, Monet craved blessed solitude, and he spent many long periods alone, away from Giverny and his familial responsibilities there. To cite just one example: in 1884 he painted at various sites on the Mediterranean coast from January 17 until mid-April. Although, as was his custom, he wrote to Mme. Hoschedé nightly, always addressing her formally as "Chère Madame" and as "vous," not "tu," he ignored her threats to leave him if he did not return immediately.

In 1886, a year of crisis in his relationship with his mistress, Monet worked away from home, primarily at a relatively remote site in Brittany, Belle-Île, from September 15 until November 29.

21. Quoted in J. Renoir, 1962, p. 113.

22. He made this claim to Gimpel (1927, p. 172). Charles M. Mount, *Monet* (New York, 1966), pp. 395–96 (who did not know the actual date of Mme. Monet's death at the time), reported that during his interview with the artist's "grandson," James Butler, the latter confirmed that Monet had also told him that he had been twelve when he lost his mother. Butler, son of Monet's stepdaughter, Suzanne Hoschedé-Butler, and the painter Theodore Butler, spent much of his childhood at Giverny, in close contact with the artist and his family. Although Mount's eccentric biography of the artist is usually ignored these days, there seems to be no reason to doubt the accuracy of his report of Butler's statement. The parapraxis the artist committed in the interview with Gimpel apparently was not an isolated slip but a recurrent variant of his mythic recasting of his past.

23. W I., pp. 3–4.

24. w Ibid. According to Beguin Billecocq, many of these jaunts were in the company of his cousin Théodore Billecocq (1817–1915). See Ganz and Kendall, 2007, p. 23. When Monet's mother died, he was invited to the Beguin Billecocq home in Paris (in March 1854) in an obvious effort to cheer him up. Later he spent parts of several vacations with them, starting in 1856, through 1860. See Ganz and Kendall 2007, p. 19.

25. Quoted by Gustave Geffroy, *Monet, sa vie, son oeuvre*, reprint ed. (Paris, 1980), p. 8.

26. No information about Oscar-Claude's early relationship with Aunt Lecadre has survived. However, it seems likely that this childless woman early showed a partiality for this nephew whose artistic talent mirrored her own interests—for she was an amateur painter and kept a studio, which the adolescent Monet was welcome to use. Shortly after the death of Mme. Monet, Adolphe and his two sons went to live with the Lacadre family in Le Havre. The death of her husband, Jacques Lecadre (1795–1858), which followed closely on that of Monet's mother, no doubt further increased Aunt Lecadre's interest in Oscar-Claude. She arranged for him to continue his artistic education after he left the municipal school. Later, Mme. Lecadre repeatedly consulted her acquaintance the painter Armand Gautier (then considered a rising star on the Parisian horizon) for advice about how Monet might best advance his training and career. For details about her relationship with Monet before 1862, see w I, pp. 4, 7.

27. Ganz and Kendall, 2007, p. 26.

28. For details about Monet's career as a caricaturist, including the catalogue raisonné of his surviving work in this genre, consult w v, pp. 134–51, D. 451–515.

29. Thiébault-Sisson, 1900. Note, however, that in the summer of 1859, Théophile Beguin gave Monet five hundred francs to buy art supplies—the first of many gifts of that kind. See Ganz and Kendall, 2007, p. 58.

30. WL 1162, dated August 22, 1892.

31. Thiébault-Sisson, 1900.

32. See WL 2–4. For a perceptive assessment of Boudin's role in Monet's artistic development, consult Joel Isaacson, "The Early Paintings of Claude Monet," PhD diss., University of California, Berkeley, 1967, pp. 21–25.

33. Monet traveled to Paris in May 1859 to visit the annual Salon. From the capital he sent two lengthy epistles to Boudin (WL 1, 2), describing the Salon and providing details about his two visits to Troyon. Troyon advised the youth to spend a month or two in the capital, concentrating on improving his drawing skills, then return to Le Havre to make landscape studies in the countryside. With the coming of winter, Troyon counseled, Monet should return to Paris and revisit him to show the older artist his recent work, then enter the atelier of Thomas Couture.

 It seems likely that Monet followed the timetable prescribed by Troyon and spent the latter half of 1859 in Le Havre, before making a definitive move to the capital early in 1860. Unfortunately, little solid evidence concerning his whereabouts and activities between June 1859 and January 1860 has come to light thus far, leading some scholars to assume that he remained in Paris throughout most of this period.

34. For this observation, see w I, pp. 7–8. See also WL 3, to Boudin, dated February 20, 1860, in which Monet claims that Couture has totally abandoned painting, adding that his defection is no loss, for the paintings he showed in the Salon Intime of Romantic and Barbizon Art (which Monet had recently visited) were very bad.

35. Thiébault-Sisson, 1900. For the exact date of Monet's return to Paris, see Ganz and Kendall, 2007, p. 63.

36. Geffroy, 1980, pp. 13–20.

37. See w I, p. 10; Monet evidently received this gift shortly before his departure for Paris in 1860, perhaps as a birthday or Christmas present from his aunt. In what was probably another of his mythic reconstructions of the past, Monet later claimed to Marc Elder that he had discovered the painting lying forgotten in a corner of his aunt's studio and that she had no idea that it was the work of an important artist. Monet, of course, immediately recognized the painting as a Daubigny but did not share this knowledge with the donor. For details, consult Marc Elder (pseud. Marcel Tendron), *A Giverny, chez Claude Monet* (Paris, 1924), pp. 23–24.

 If factual, this incident would not be an isolated instance of Monet's exploitative behavior toward his aunt, for he repeatedly repaid her kindness with duplicity. Did he unconsciously transfer to Aunt Lecadre some of the anger and ambivalence he really experienced toward the mother who had "deserted" him through death?

38. Quoted in Geffroy, 1980, p. 19.

39. Alphant (1993, p. 65), who checked the relevant annual census records, discovered that Célestine Vatine, then twenty-two years of age, was already working for the Monets as a live-in maid in 1856. Alphant speculated that *père* Monet's liaison with Célestine preceded the death of Mme. Monet, then fifty-one and already in ill health. (She died on January 28, 1857.) Although no

hard evidence has come to light to support Alphant's theory, her hunch may well be correct. Adolphe Monet did not acknowledge paternity of Marie—whose birth certificate lists her father as unknown—until shortly before his death.

40. For his observation, consult W I, p. 12.

41. Ibid., pp. 12–13.

42. François Thiébault-Sisson, "Autour de Claude Monet, anecdotes et souvenirs," part 1 of 2, *Le Temps*, December 29, 1926.

43. For this quote, consult André Arnyvelde, "Chez le peintre de la lumière," *Je sais tout*, January 15, 1914, p. 32.

44. Quoted in Clemenceau, 1928, p. 17.

45. Quoted in Thiébault-Sisson, 1926. Monet did, however, send Beguin Billecocq some drawings from Algeria. See Ganz and Kendall, 2007, p. 68.

46. Gimpel (1963, p. 339) reported hearing this tale from Durand-Ruel on September 23, 1927.

47. To Thiébault-Sisson (1926) Monet reported that when he was sent home, he was greeted "like the prodigal son, with much tenderness, and this time my father paid for a substitute."

To Arnyvelde (1914) he stated: "Back in Le Havre, I worked so furiously that my parents were finally won over. They bought me a replacement and gave me permission to learn my craft in Paris."

To Geffroy (1980, pp. 31–32) the artist spoke about "his parents who loved him and were not intractable," buying him a replacement.

48. For quotations from this letter, dated October 30, 1862, see W I, p. 20.

49. Contrast this reminiscence as quoted in Thiébault-Sisson, 1900, with the account he published in 1926.

50. Thiébault-Sisson, 1900.

51. Ibid.

52. Thiébault-Sisson, 1926.

53. For Wildenstein's reconstruction of Monet's activities while a student of Gleyre, see W I, pp. 21–26. See also Frédéric Bazille, *Correspondance*, ed. Didier Vatuone (Montpellier, 1992), for his letters of 1863, especially no. 34, pp. 67–69, dated December 8, 1863, in which Bazille mentions that Villa and Monet were the only fellow students from Gleyre's studio with whom he enjoyed a close social relationship. In letter no. 38, pp. 74–76, written around January 20, 1864, Bazille informed his father that both M. Gleyre and his atelier were "malade" but that the master—then experiencing severe visual problems—planned to keep the academy open for the remaining six months of the current term. The atelier closed permanently in July 1864.

54. For quotations from this letter, dated March 20, 1863, see W I, pp. 23–24 and n. 127.

55. Thiébault-Sisson, 1900.

56. Ibid.

57. See Bazille, 1992, letter no. 38, pp. 74–76.

CHAPTER ONE

1. Bazille returned to Paris at the end of June to study for his second medical examination, which he failed, as he had the first. His family, bowing to the inevitable, gave him permission to abandon medicine and devote himself exclusively to art. In August, Bazille returned to Montpellier to visit his family, and he stayed there until November. For his activities and correspondence during the

period, see François Daulte, *Bazille et son temps* (Geneva, 1952), pp. 39–42, and, for his letters of 1864, Frédéric Bazille, *Correspondance*, ed. Didier Vatuone (Montpellier, ca. 1992), pp. 91–101, especially letters 52–56.

Monet stayed on in Normandy, working primarily at Honfleur and continuing to lodge at the Ferme Saint-Simeon until about mid-November. In letters to Bazille, he described himself as working hard and pleased with his progress, if not the results. "It's through observation and reflection that one finds one's way." His relationship with his family of origin, already strained, came to a head during a visit to Sainte-Adresse in October, when a bitter quarrel erupted, leading his father (and Aunt Lecadre?) to terminate his monthly stipends and tell him to get out and not come back soon. See W 1, pp. 27–28, and WL 8–13. The quotation comes from WL 8.

2. Before he could return to Paris, Monet had to settle the large bill he had run up at the Ferme Saint-Simeon. In a letter to Bazille, dated October 14 (WL 11), he described the sum rather vaguely as seven or eight hundred francs. After the rupture with his family, Monet dared not ask them for help, so he turned to Bazille for assistance, arranging to send three recent studies to him in Montpellier in the hope that they might interest the well-known local art patron and collector Alfred Bruyas. When this stratagem failed and Bazille did not respond promptly to Monet's (previously relatively subtle) requests for loans, he turned rather abrasive in a letter of November 6 (WL 14), virtually demanding that Bazille respond to him immediately and send him some money. Perhaps the rather aggressive tone of this missive should have given Bazille pause, but he good-naturedly overlooked Monet's bad behavior and evidently did loan him some money. Following Monet's return to Paris, Bazille also asked the family friend and collector Commandant Hippolyte Lejosne to help him place some of Monet's pictures. Monet's financial situation soon radically improved, when he received commissions to paint five pictures (at least three of them for four hundred francs each). That windfall, plus whatever Bazille had managed to send him, should have enabled Monet to settle his entire bill at Saint Simeon with ease; given his history in these matters, however, one wonders whether he paid only a portion of his debt and "forgot" the remainder. For details, consult W 1, 27–28, and WL 14–15. Bazille's letters to Monet have been lost.

3. Monet's quarrel with his family was evidently soon patched up, for his father visited him in Paris in mid-December and contributed 250 francs to help pay the rent of the new studio. The two friends signed their joint lease that December. Monet was thrilled that Eugène Delacroix (1798–1863) had worked in the rue de Furstenberg until his death. However, his later claim that Bazille and he had watched Delacroix at work was another bit of Monet mythology. See W 1, pp. 28–29 and nn. 176–77.

In his interview with Thiébault-Sisson in 1900, Monet claimed that his father and aunt did not resume their financial assistance until he scored his great success at the 1866 Salon. From his correspondence of 1866 (reviewed in the following chapter) we know that his aunt continued to send him monthly stipends throughout 1866. Whether she resumed these payments in 1865 (or had never suspended them) is unclear. We do not know whether his father also restored Monet's monthly allowance in 1865.

4. That is exactly what Bazille did in the summer of 1865, when he used *The Coastline at Sainte-Adresse* (W 22), a work Monet had painted the previous year, as the direct model for one of two pictures commissioned by Bazille's uncle. See Dianne W. Pitman, "Overlapping Frames," in Kermit S. Champa and Dianne W. Pitman, *Monet and Bazille: A Collaboration* (Atlanta, 1999), pp. 19–65.

5. See, for example, Champa, "A Complicated Codependence," in Champa and Pitman, 1999, pp. 67–93. Consult also Norma Broude, "Outing Impressionism: Homosexuality and Homosocial Bonding in the Work of Caillebotte and Bazille," in *Gustave Caillebotte and the Fashioning of Identity in Impressionist Paris*, ed. Broude (New Brunswick, NJ, 2002), esp. p. 164, in which she notes that questions about Bazille's sexual orientation may never be answerable, "given the fact that the primary sources . . . are remarkably, and not surprisingly, opaque."

6. For a brief summary of Bazille's background, see J. Patrice Marandel, ed., *Frédéric Bazille and Early Impressionism* (Chicago, 1978), pp. 11–12. For a more detailed account, see Daulte, 1952, esp. pp. 1–26, and Valérie Bajou, *Frédéric Bazille, 1841–1870*, 2 vols. (Aix-en-Provence, ca. 1993).

7. Daulte, 1952, p. 47, n. 1, reproduces an excerpt from a letter Renoir sent Bazille on July 3, 1865, in which he already employed the familiar address. Renoir's lower-class background may have made him more ready to *tutoyer* his friends.

8. According to Claire Joyes (*Claude Monet: Life at Giverny* [New York, 1985], p. 61), Michel Monet and Jean-Pierre Hoschedé, his stepson, "for some strange reason felt embarrassed, and always spoke to him in the third person, addressing him as *il* or *on*. They would say, '*On va au marais?*' meaning Father [or Monet], are you going to the marsh?" Monet always required long periods of solitude and frequently made working trips away from home, especially in the 1880s and 1890s, communicating with the Hoschedé-Monet ménage only by letter. A number of these solitary expeditions took him back to the seacoast of Normandy, recalling his solitary adolescent expeditions along the seashore following his mother's death.

9. W 1, p. 28 and n. 175.

10. During the final years of his life Monet displayed paintings of Camille and other family members in his disused second studio. Earlier, according to Joyes (1985, pp. 42–43), he kept pictures "representing every period of his work" in his first studio-salon at Giverny. To the author's knowledge, no complete set of photos of either studio exists, and it remains unclear how many paintings of Camille Monet dared to exhibit during the lifetime of the jealous Alice Hoschedé-Monet. The third studio was not erected until 1915, four years after her death, so she never saw the definitive arrangement of figurative paintings displayed in the disused studio.

11. See W 1, p. 31, for his delightful tongue-in-cheek commentary on Mme. Doncieux's "arrangement" with M. de Pritelly. In W 1, p. 46 and n. 355 and p. 64, nn. 452–59, he characterizes Camille's dowry as very modest and notes that at the time of her marriage to Monet (in 1870) the Doncieux family occupied a modest rental apartment and did not own a single building.

12. For their varied opinions of this subject, see R. Z. Niess, *Zola, Cézanne, and Manet: A Study of "L'Oeuvre"* (Ann Arbor, MI, 1968), and Kermit S. Champa, *Masterpiece Studies: Manet, Zola, and Monet* (University Park, PA, ca. 1994), pp. 51–90. Consult also Joy Newton, "Claude Lantier et Stanislas Lépine," in *Emile Zola and the Arts: Centennial of the Publication of "L'Oeuvre,"* ed. J.-M. Guieu and A. Hilton (Washington, DC, 1988), pp. 15–24.

13. Walter published several articles on this subject. See especially "Emile Zola et Claude Monet," *Les Cahiers Naturalistes* 26 (1964): 51–61, in which he listed the numerous similarities linking Monet's history with that of Zola's fictive hero.

14. Ibid., pp. 58–59. Walter also subscribes to this view, noting that Christine "owes much to Camille, like her a young woman from a good family who prefers to a future of bourgeois certitudes a difficult existence at the side of the artist she loves."

15. In Zola's review "Les réalistes du Salon," *L'Evènement*, May 11, 1866, which lavished praise on

Monet's *Camille* (*Woman in a Green Dress*), the critic claimed, "I don't know M. Monet, I don't even think I've seen a single canvas of his." However, as Walter (1964, p. 51) noted, the accuracy of this statement is open to question. In his recent biography of the novelist, Frederick Brown (*Zola: A Life*, Johns Hopkins paperback ed. [Baltimore, 1996], pp. 116–17) states that during Cézanne's second Paris sojourn (which lasted from November 1862 to mid-1864) Zola and Cézanne "frequented the studios of Les Batignolles, cultivating Renoir, Bazille, Fantin-Latour, Monet, and Degas." Zola's public disclaimer aside, it seems quite possible that he had been an eyewitness to Monet's struggles over the *Luncheon*.

16. Monet's successful campaign to regain control of the canvas was set in motion when Flament wrote him a dunning letter in January of 1884. Forcibly reminded of the existence of his unfinished "machine," Monet successfully petitioned his dealer, Durand-Ruel, to advance a sum sufficient to satisfy Flament's demands and enable the artist to regain control of the canvas. For details, see W II, p. 24, and WL 393, 404, and especially 442. One wonders whether Monet's interest in reclaiming his canvas was rekindled by viewing Manet's version of this motif, which was included in the memorial retrospective of Manet's oeuvre held at the École des Beaux-Arts January 6–28, 1884. Monet (who had been one of Manet's pallbearers) attended the opening of the memorial exhibition. For details see W II, pp. 16–17.

17. Around 1952 Michel Monet sold the central fragment of the *Luncheon* to a Paris dealer. It subsequently entered a private French collection until 1986, when it was donated to the state. Michel's action defied his father's intentions, as a comment by Gustave Geffroy (*Monet, sa vie, son oeuvre*, reprint ed. [Paris, 1980], p. 39), who surely spoke for the artist, indicates: "This vast picture is still in his studio on the day when I write these lines, and I hope that it will leave it only to go to the Luxembourg, then to the Louvre, its natural place, for it is a date in the history of painting at the same time that it is an extraordinarily energetic and beautiful assertion of a talent that searches for and finds its way."

18. Quoted by the Duc de Trévise, "Le pélerinage de Giverny: L'atelier des 'figures en plein air,'" *La Revue de l'Art Ancien et Moderne*, February 1927, pp. 212–22.

19. Except for including relatively tiny images of local folks as genre touches in landscapes and marines, Monet's experience as a figure painter had been limited to a handful of portraits, primarily of relatives and friends. See, for example, W 42–45, 53a, 54. (In a letter to an art dealer written in 1907, Monet dated the *Portrait of Victor Jacquemont* [w 54] to 1868 or 1869.)

20. For the complete text, see Charles Baudelaire, *The Painter of Modern Life and Other Essays*, trans. and ed. Jonathan Mayne (New York, 1964), pp. 1–40.

21. As Paul Hayes Tucker observes ("Of Sites and Subjects and Meaning in Monet's Art," in *Monet: A Retrospective* [Tokyo, 1994], p. 24 and n. 8, p. 227), Monet scholars have generally rejected Wildenstein's contention that the artist did not meet Camille until 1866. That Wildenstein, usually so psychologically astute, should have missed the connection between the initiation of the Monet-Doncieux liaison and that of the great project seems quite puzzling. Even the little lock of hair (*patte de cheveux*) in front of Camille's ear, which Wildenstein cites as her identifying characteristic, is clearly visible in the sole surviving partial study (w 64) for the *Luncheon*. Both in the Moscow study and in the fragments of the definitive painting this lock has been—perhaps deliberately—rendered less obvious.

22. Marianne Alphant (1993, p. 157) perceptively links two disparate bits of information found in Wildenstein to suggest that Camille may have had some sort of connection with the contem-

porary theater. In W V, p. 134, the author quotes from the diary of Théophile Beguin Billecocq, who reported that in April 1868 "M. et Mme. Monet," friends of Théodore Billecocq, had participated in amateur theatrical representations staged in Beguin Billecocq's salon. Decades later, in a letter to Sasha Guitry (dated April 23, 1923), Monet asked Guitry to procure four tickets for the farewell performance of the comedienne Marie Samary, who had been "the intimate friend of my first wife, and of whom I have always retained fond memories" (WL 3065 [2522a]).

23. See Joel Isaacson, *Monet: Le déjeuner sur l'herbe* (London, 1972), pp. 47–50 and illus. 26–27. Discussions of the roles played by fashion plates in Monet's figure paintings of 1865–67 can be found in all major studies of the artist's career. Mark Roskill was probably the first to call attention to this fact in "Early Impressionism and the Fashion Plate," *Burlington Magazine* 112, no. 807 (June 1970): 391–95. For a more extensive exploration of the role of contemporary fashion in nineteenth-century French art, see Valerie Steele, *Paris Fashion: A Cultural History* (New York, 1988), esp. pp. 99–132.

24. For Suzanne's experiences, as recalled by her sister Germaine Hoschedé-Salerou, see W II, p. 50 and n. 519.

25. Monet traveled to Paris for the opening of the Salon but returned to Chailly immediately after. Bazille noted in a letter to his mother written around May 5 (BL 66), that Monet had enjoyed a degree of success at the Salon greater than he could have hoped: "Several very talented painters, whom [Monet] doesn't know have written him complimentary letters." For quotations from reviews of the 1865 Salon containing favorable mentions of Monet's paintings, *Mouth of the Seine at Honfleur* (W 51) and *The Pointe de La Hève at Low Tide* (W 52), see Gary Tinterow and Henri Loyrette, *Origins of Impressionism* (New York, 1994), cat. no. 118, p. 421. Consult also Steven Z. Levine, *Monet and His Critics* (New York, 1976), pp. 5–6. For an account of the manner in which Monet celebrated this success *chez* Count Beguin Billecocq, see James A. Ganz and Richard Kendall, *Monet: Pastels and Drawings* (New Haven, CT, 2007), p. 96.

26. Works displayed at the Salon were hung in alphabetical order in accord with the artists' names; the physical proximity of Manet's and Monet's canvases, coupled with the close correspondence of their names, evidently resulted in some confusion. Monet continued to relish the memory of this artistic victory over Manet until the end of his life; in his 1900 interview with François Thiébault-Sisson, the artist gleefully recalled Manet's enraged reaction to having been confused with him.

27. See WL 17. Monet's use of the first-person plural undoubtedly refers to Camille and himself. In view of her continual presence, it is scarcely surprising that none of Monet's correspondence from this period ever alludes to problems about securing female models.

28. For the original text, consult WL 20. Bazille, lingering in Paris to finish the pictures commissioned by his uncle and enjoying outings to Bougival with Renoir, seemed in no hurry to comply with Monet's requests.

29. See Bazille's letters of August 18 (to his mother) and August 31 (to his father) for the details. Consult BL 69, 70, 72.

30. Quoted in Jean Aubry, *Eugène Boudin* (Paris, 1922), p. 62.

31. Geffroy, 1980, p. 40.

32. Monet's recollection about Courbet may have been colored by, or fused with, memories of slightly later events involving his father, who would adopt an intransigent attitude about Camille's pregnancy.

33. W I, p. 31 and n. 212.

34. For his perceptive interpretation of Joseph Conrad's novella *The Secret Sharer* (1909), see Bernard Meyer, *Joseph Conrad: A Psychoanalytic Biography* (Princeton, NJ, 1967).

35. However, in the same letter to his brother (BL 74) Bazille revealed that the move had been demanded by the landlord: "I was profoundly in error in believing that we had paid two terms in advance [for the studio. In fact], we had paid only one, . . . so we are absolutely being shown the door on the fifteenth of January."

 Bazille's father questioned his son's motives for the move: "I regret, for your sake, your separation from Monet; it seems that he was [such] a worker that he must have made you blush for your laziness, and when you are alone, I greatly fear that a good number of mornings and even whole days will pass in a 'dolce farniente' [sic] that will do little to advance your paintings for the Exposition" (BL 75).

 Contrary to these paternal accusations, Bazille noted to his brother (also in BL 74) that he was working "well" on his intended Salon submission, which had garnered compliments from "maître Courbet."

36. According to the editors of the Bazille correspondence, p. 117, n. 1, Monet and Bazille did not quit the rue de Furstenberg quarters until February 4, 1866.

37. Quoted in Thiébault-Sisson, "Claude Monet," *Le Temps*, April 6, 1920.

38. Re Manet's change of title, see Tinterow, in Tinterow and Loyrette, 1994, p. 131 and n. 11, who points out that

 after seeing or hearing about Monet's enormous *Déjeuner sur l'herbe*, destined for the Salon of 1866 but never submitted, Manet changed the title of his painting from *Le Bain* to *Déjeuner sur l'herbe*, the title used in Manet's 1867 exhibition [at] the Pont de l'Alma. . . . No doubt Manet wanted to capitalize on the new vogue for painting plein air picnics. . . . More important, Manet probably wished to remind that he, and not the young upstart from Le Havre, was the preeminent painter of modern life.

39. Geffroy, 1980, pp. 38–39. For further details about Manet's *Luncheon*, see Françoise Cachin, "Le déjeuner sur l'herbe," in Françoise Cachin and Charles S. Moffett with Michel Melot, *Manet, 1832–1883* (New York, 1983), cat. no. 62, p. 168.

40. For his discussion of the artist as *flâneur*, see Robert L. Herbert, *Impressionism: Art, Leisure, and Parisian Society* (New Haven, CT, 1988), pp. 33–43; Herbert cites Manet as a leading example of the type.

41. His earliest extant statement reflecting this idea occurred in a letter to Bazille dated October 16, 1864. Describing a "simple study" done entirely from nature, Monet commented: "You will find in it perhaps a certain connection with Corot, but it is certainly as a result of no imitation whatsoever that it is like that. The motif and especially the calm and vaporous effect is the only reason for it. I did it as conscientiously as possible without thinking of any painting. Furthermore you know that that is not my system" (WL 11).

42. Virtually all Monet scholars have discussed these connections. To cite just three examples: Isaacson, 1972, pp. 39–40; Herbert, 1988, pp. 175–76; and Virginia Spate, *Claude Monet: Life and Work* (New York, 1992), pp. 31–37. Japanese prints, popular engravings, and contemporary photographs have also been suggested as possible influences on Monet's conception of the *Luncheon*.

43. The deep recession represented in one of Monet's earlier sketches (published by Gabriel Sarraute, "Contributions à l'étude du *Déjeuner sur l'herbe* de Monet," *Bulletin du laboratoire du Musée du*

Louvre, June 1958, pp. 46–51, and Isaacson, 1972, pp. 59–62) no longer appears in his later version of the composition. Without explanation, Wildenstein (w v, d106, no. 2, recto) declared that the drawing "cannot be attributed to Monet." (In the absence of convincing evidence to the contrary, it is difficult to imagine who, if not Monet, could have executed this drawing.) Prior to the publication of Wildenstein's pronouncement, scholars regularly identified this sketch as an autograph.

Watteau's *La Perspective* had entered an English collection around 1846, so Monet could not have known the painting firsthand, but he could have been familiar with—or even owned a copy of—the print by Louis Crépy. For the history of *La Perspective,*, see M. M. Grasselli and P. Rosenberg, *Watteau: 1684–1721* (Washington, DC, 1984), no. 25, pp. 300–304.

The eighteenth-century depiction of this theme most often cited in conjunction with Monet's *Luncheon* is, in fact, van Loo's *Halt of the Hunting Party* (1737, Musée du Louvre). See Isaacson, 1972, p. 39, or Herbert, 1988, p. 176.

If underlying links connecting Monet's *Luncheon* with the *fête galante* genre persist even in the definitive canvas, his composition is totally devoid of the overt sensuality permeating Watteau's portrayals of courtiers at play. The picnic motif or hunt breakfast held little appeal for Watteau, and it remained for his follower Nicolas Lancret (1690–1743) to play a key role in the development of this theme.

44. Courbet painted the picture in Frankfurt, during a lengthy sojourn in Germany. For details, consult P. Courthion, *Tout l'oeuvre peint de Courbet* (Paris, 1995), no. 223, p. 85. Now part of the collection of the Wallraf-Richartz Museum in Cologne, it may never have left Germany after Courbet completed it. See Tinterow, 1994, pp. 128–29 and n. 8: "The elevation of personal experience to huge canvases and the use of summary execution to express it—elements of Courbet's '*Déjeuner sur l'herbe*'—were strategies later adopted by Manet and Monet in their essays in the genre."

45. Isaacson, 1972, pp. 55–56.

46. For the rise of popular lithography in nineteenth-century France, see the exhibition catalog *The Cult of Images: Baudelaire and the 19th-Century Media Explosion* (Santa Barbara, CA, 1977). For additional illustrations depicting al fresco picnickers engaging in vulgar behavior, see nos. 20, 66, and 80 in this catalog.

47. As Isaacson (1972, p. 41) observes, "Monet's *Déjeuner*, true to the social dynamic of its time and accurately reflecting the artist's own middle-class status, expresses the simple pleasures of the hitherto disenfranchised. The right to leisure rather than the privilege of pleasure, the paradisal world of the gods come to roost on earth—such is the larger subject of Monet's *Déjeuner sur l'herbe*."

48. For perceptive comments on Monet's forest scenes of 1865 and their relationship to contemporary photography as well as to similar paintings by contemporary artists, see Tinterow, 1994, pp. 73–78 and nn. 119–20, pp. 422–23.

49. Bazille's procrastination about returning to Chailly to take up his modeling chores forced Monet to devise a working method that permitted him to add the images of male protagonists rapidly, as opportunities presented themselves; he could have asked any visiting male friend whose appearance seemed suitable to pose for him briefly. Isaacson (1972, p. 111, n. 84) suggests that the seated figure on the right could depict Sisley, who may have visited Chailly during Bazille's second stay.

50. Isaacson (1972, p. 62) observes that the Moscow study shows

 that in assembling and juxtaposing his outdoor studies the artist did not confine him-
 self to work in the studio; the canvas, despite its four-foot by six-foot dimensions, was
 undoubtedly worked on outdoors as well. If Monet did not carry it the mile and a half
 to his chosen site in Fontainebleau forest, he must have posed his figures under similar
 lighting conditions near the inn at Chailly, where he was staying. The painting, as one
 sees it today, displays a tonal veracity and a delicacy of nuances which can be explained
 in no other way than by assuming a process of painstaking observation and execution
 directly before the motif. Not Boudin's gray harmonies, not the value-oriented canvases
 of Courbet and Manet, not Monet's previous work prepares one for the variety of tonal
 and coloristic description to be found in the Moscow sketch.

51. For the radiographic studies showing the changes Monet made on the left fragment, see Hélène Adhémar, "Modifications apportées par Monet à son *Déjeuner sur l'herbe* de 1865 à 1866," *Bulletin du Laboratoire de Musée du Louvre*, no. 3, June 1958, pp. 37–41. Isaacson (1972, pp. 66–77) suggests that the modifications to the figure in gray reflected Monet's greater interest in locating his personae in space, a change "so firm and so clearly intended to enhance the spatial effect of the painting that one may assume that similarly directed changes were introduced in the lost right-hand section."

52. See Robert Gordon and Andrew Forge, *Monet* (New York, 1983), pp. 25–26. For a more positive interpretation of the vertical fragment of the *Luncheon*, see Tucker, 1994, p. 56.

53. Courbet, who enjoyed close ties to Baudelaire and was no doubt familiar with the latter's ideas before the critic committed them to print, had responded to his friend's dictum to create a new art reflecting "the heroism of modern life" by producing a series of narrative pictures representing the artist in self-aggrandizing roles, most famously in *The Painter's Studio*, 1855 (Musée du Louvre).

54. Herbert (1988, p. 176) suggests that this carving constituted "a middle-class echo of the statues of love that Watteau painted among his dawdling *gallants*."

55. Herbert (ibid., p. 174) points out that Parisians could easily have reached sites similar to those inhabited by Monet's personae, because excursion services were available "at Fontainebleau, Melun, and Chailly, which provided transport, drink, and food. The costumed man with a food hamper . . . is presumably representative of such a service."

56. Perhaps it was Monet's introduction of these "camouflaged" images of Camille that led Wildenstein to conclude that she did not pose for the female figures in the *Luncheon*.

CHAPTER TWO

1. Listed only as *Camille* in the catalog of the 1866 Salon, the painting has since been known under a variety of longer titles, including *Camille in a Green Dress* and *Camille (Woman in Green)*. The Kunsthalle Bremen, which owns the painting, calls it simply *Camille*, as its creator wished.

2. Virtually every Monet scholar has mentioned the role fashion prints played in both the *Luncheon* and *Camille*. See, for example, Paul Hayes Tucker, *Claude Monet: Life and Art* (New Haven, CT, 1995), p. 24 and fig. 31. For the most extensive exploration and illustrations of the relationship of *Camille* to contemporary fashion plates, consult Andrea Mayerhofen-Llanes in *Monet und Camille: Frauenportraits im Impressionismus*, ed. Dorothee Hansen (Munich, 2005), pp. 214–27; its illustrations 53–55 feature gowns and fur-trimmed jackets virtually identical to those Doncieux wears in

Camille. (Most likely her outfit was rented for the project.) An English translation, complete except for photos, was issued in conjunction with the German version (*Monet: Camille; Female Portraits in Impressionism*, trans. Birgit Haase [Munich, 2005], pp. 71–76). For the material about fashion plates, see Hansen, 2005, cat. no. 18, pp. 94–99 in German, pp. 34–35 in English. The relationship of *Camille* to figurative paintings by Courbet and Manet has also been widely noted. See, for example, Joel Isaacson, *The Early Paintings of Claude Monet* (Ann Arbor, MI, 1988), pp. 140–43.

3. Neither in the 1865 nor in the 1866 Salon did Monet identify himself as the student of Gleyre, Boudin, or any other mentor. By contrast, Bazille, who showed his *Still Life with Fish* in 1866, listed himself as the pupil of Gleyre. Renoir did the same.

4. For reproductions of the caricatures by Félix Y. Bertall and André Gill, see Charles F. Stuckey, ed., *Monet: A Retrospective* (New York, 1985), p. 33. The caption beneath Gill's caricature reads: "Monet or Manet?—Monet. But it is to Manet that we owe this Monet." Zola's article "Les réalistes du Salon," which appeared in *L'Événement*, May 11, 1866, was reprinted in *Emile Zola: Salons,* ed. F. M. W. Hemmings and R. Niess (Paris, 1959), pp. 70–71. For Thoré-Bürger's review, see "Salon de 1866," in *Salons de W. Bürger, 1861 à 1868* (Paris, 1870), pp. 285–86. Castagnary's review, "Salon de 1866," was reprinted in Jules Antoine Castagnary, *Salons, 1857–1870,* 2 vols. (Paris, 1892), vol. 1, 224, 240. For d'Hervilly's complete poem, consult "Les poèmes du Salon: *Camille*," *L'Artiste,* June 15, 1866, p. 207. For a general review of the critical responses to *Camille* see Steven Z. Levine, *Monet and His Critics* (New York, 1976), pp. 7–9. In May or June 1866, Bazille wrote his family that Monet was enjoying "un succès fou" at the Salon (reproduced in W I, PJ 12).

5. For this quote, see Zola, 1866, p. 71.

6. For details, see W I, pp. 31–32, nn. 223–24, and WL 23–26, all addressed to Armand Gautier, who acted as Monet's intermediary in regaining his aunt's favor.

7. Thoré-Bürger, 1870, pp. 285–86. The English translation was published in Stuckey, 1985, p. 35.

8. For the extensive conservation work carried out by the Bremen museum, consult Bettina Landgrebe, "Die Restaurierung des Gemaldes *Camille* von Claude Monet, 1866," pp. 276–85 in Hansen, 2005. For the English version (complete, except for the illustrations), see Landgrebe, "Restoration of Claude Monet's *Camille,* 1866," pp. 90–96 in Haase, trans., 2005. Their findings revealed that the painting had been severely overcleaned at some past time and that successive thick coats of varnish (along with dirt) had artificially darkened the work.

9. Landgrebe, "Restoration," 2005, pp. 90–92.

10. The story that Monet painted the picture in only four days has often been accepted at face value, including by Wildenstein (W I, p. 32). Although Tucker (1995, p. 24) does not credit Monet with inventing the account, he notes: "[Thoré's] story is obviously apocryphal, since the painting is quite ambitious—Camille is life size—and has a very complex paint surface."

11. François Thiébault-Sisson, "Claude Monet," *Le Temps,* April 6, 1920.

12. Gustave Geffroy, *Monet, sa vie, son oeuvre,* reprint ed. (Paris, 1980), p. 42.

13. To cite an extreme example of the insensitivity of contemporary critics to Camille's ambiguous expression: Edmont About, although impressed by Monet's treatment of the model's costume, complained: "A gown is no more a painting than a correctly written phrase is a book." Quoted in ibid., p. 43. For contrasting readings of Camille's expression, compare Joel Isaacson, *Observation and Reflection: Claude Monet* (Oxford, 1978), pp. 198–99, and Virginia Spate, *Claude Monet: Life and Work* (New York, 1992), p. 39.

14. Stevens may have been aware that *Hesitation* failed to project the emotional tone he sought, for the woman's head shows considerable evidence of repainting.

15. Quoted from Emile Zola, *The Masterpiece* (Oxford, 1993; rev. Eng. trans. of *L'Oeuvre*), pp. 94–95. Charles Merrill Mount reproduces a passage reportedly found among Zola's unpublished preparatory notes for the novel, which describes Christine's physical appearance in ways that closely resemble that of the real-life Camille: "Brunette, black hair, black eyes. The face with an appearance of a great sadness, of a great tenderness. . . . But basically passionate, the jaw a little prominent, very strong." Quoted in *Monet* (New York, 1966), p. 315. *Camille with a Small Dog*, reproduced and discussed below, depicts her strong chin more emphatically than does *Camille*.

16. Spate (1992, pp. 38–39) points to the repercussions the painting's title evoked, citing Charles Blanc's interpretation of *Camille* as the portrait of a demimondaine as typical of conservative critics

> who tended to read any avant-garde Realist work as immoral and characteristic of nineteenth-century city dwellers' scrutiny of the traces by which one may recognize unknown lives. Camille's face appears hard, and this, with her rich clothes flaunted in the shadows, could easily have aroused such associations in a society saturated with graphic illustrations of women of doubtful morals, *particularly since the painting was catalogued under her given name, Camille, as would have been done only for a woman of questionable status* [italics mine].

17. Sexual contacts between artists and models were extremely common in nineteenth-century France. Eugène Delacroix's youthful journal entries contain repeated references to such experiences. One of the leading female characters in Zola's *L'Oeuvre*, Irma Bécot, is depicted as a particularly amoral artist's model who is also a professional prostitute. By contrast, Zola portrays Christine, arguably based on the real-life Camille, as a sexual innocent, deeply embarrassed by the artist's scrutiny the first time she poses for her future lover.

It is of interest that the irregular relationship between Monet and Camille did not trouble the aristocratic Théophile Beguin Billecocq, who found her "ravishing." He added, "This young woman had an excellent manner, wearing elegant but simple outfits and engaging in conversation." See James A. Ganz and Richard Kendall, *Monet: Pastels and Drawings* (New Haven, CT, 2007), p. 136.

18. Léon Billot, "Exposition des Beaux-Arts," *Journal du Havre*, October 9, 1868.

19. For her comments, see Hansen et al., 2005, cat. 2, pp. 45–46 in the German catalog and p. 19 in the English version. Hansen believes that Monet executed this painting just before initiating *Camille*.

CHAPTER THREE

1. W I, p. 35.

2. Wildenstein, among others, holds to the two-model theory. Some scholars also believe that only three of the four costumes worn by the models in *Women in the Garden* are identical with those of *Luncheon*. However, in the Moscow *Luncheon* study, Camille appears in the same beige suit with black trim (this time pictured from the front), the white dress with its elaborate black trim and yellow ribbon (shown on the seated model); the sheer black-and-white and green-and-white muslin frocks worn by the two seated figures in the *Luncheon* study also reappear in *Women in the Garden*, worn, respectively, by the personage standing at the left (whose chapeau with trailing

ribbons was popularly known as the "follow me boys" type) and the woman at the rear, reaching toward the rosebush.

3. For Monet's brief description, see Gustave Geffroy, *Monet, sa vie, son oeuvre*, reprint ed. (Paris, 1980), p. 48, and Duc de Trévise, "Le pèlerinage de Giverny: L'atelier des 'figures en plein air,'" *La Revue de l'Art Ancien et Moderne*, January-February 1927, p. 121. A number of modern scholars have also accepted Monet's explanation as accurate. As the prominent contemporary painter William Conger has pointed out (personal communication), the width and depth of such a trench would have required careful calibration so that it could have accommodated the rolled-up canvas while permitting the artist to get close enough to work on it without tumbling into his own pit, which would have to be carefully lined with wooden planks or heavy canvas to protect the painting from coming into contact with the damp earth. Some means of protecting the picture from rain would also have been needed, since a freshly painted canvas cannot simply be rolled up.

4. Trévise, 1927, p. 121.

5. François Thiébault-Sisson, "Claude Monet: An Interview," English version of an article that originally appeared in *Le Temps*, November 27, 1900 (New York, 1900?), n.p., no trans. listed.

6. For a more complete discussion of Monet as a *plein air* painter, consult John House, *Nature into Art* (New Haven, CT, 1986), pp. 135–44. For his description of the method Daubigny used to paint his big canvas *Villeneuve-sur-mer*, originally executed in 1864 but now dated 1872, see pp. 135–36 and n. 15, p. 240).

7. Thiébault-Sisson, 1900.

8. See René Gimpel, *Diary of an Art Dealer*, trans. Joseph Rosenberg (New York, 1963), pp. 72–73. Still later, Monet told Thiébault-Sisson that he had lost "over 200 paintings, both signed and unsigned" to various creditors *over a six-year period*—a much more reasonable figure, as Wildenstein observes. See François Thiébault-Sisson, "Autour de Claude Monet, anecdotes et souvenirs," part 1 of 2, *Le Temps*, December 29, 1926, quoted in Charles F. Stuckey, ed., *Monet: A Retrospective* (New York, 1985), p. 344, and w 1, p. 36, n. 246.

9. See w 1, p. 35. Questions about the correct dating of w 68 and 69 are discussed in the following chapter.

10. Gustave Cohan, *Eugène Boudin, sa vie, son oeuvre* (Paris, 1900), pp. 61–62. See also w 1, p. 35 and n. 240 for questions about the date of this letter.

11. See WL 29. Monet also requested that Bazille send both the Salon version of *Camille* and its smaller (unfinished) replica. Instead of shipping the pictures himself, Bazille evidently left them with Zacharie Astruc, to whom Monet wrote on December 22 (WL 30) inquiring whether he had the packet of paintings, because the dealer who had commissioned the replica of *Camille* was pressing Monet for the painting or return of the purchase price.

12. For Dubourg's letter, dated February 2, 1867, from Honfleur, see w 1, PJ 13.

13. The quotes come, respectively, from Madeleine Hours, "Manière et matière des impressionistes," p. 24, and Lola Faillant, "L'écriture picturale et la photographie," p. 44, in *Laboratoire de Recherche des Musées de France, Annales* (Paris, 1974).

14. See Joel Isaacson, *Observation and Reflection: Claude Monet* (Oxford, 1978), p. 196, nos. 12–13.

15. Paul Hayes Tucker, *Claude Monet: Life and Art* (New Haven, CT, 1995), p. 32, provides a succinct discussion of the many seemingly contradictory elements in the painting.

16. Valerie Steele, *Paris Fashion: A Cultural History* (New York, 1988), pp. 124–27, argues that Monet

not only chose a fashion-print subject but "treats it in true fashion-plate style." She also suggests that Monet may have originally gotten the idea of using fashion plates from Eugène Boudin, who probably used such illustrations for his paintings showing fashionable women on the beach.

17. Consult "Frédéric Bazille's Correspondence, 1862–70," trans. Paula Prokopoff-Giannini, in *Frédéric Bazille and Early Impressionism* (Chicago, 1978), p. 173, n. 56. Whether Camille accompanied Monet to Paris or arrived later is unclear. Whatever their arrangement, the lovers lived separately during the weeks Monet spent *chez* Bazille.

18. In his haste to complete the marine by the Salon deadline, Monet, basing his composition in part on two smaller works painted in situ (w 75–76), executed the entire picture in his atelier.

19. The Salon and the fine-arts segments of the International Exposition were designed to complement each other, with the international artistic selections featuring retrospectives of art produced during the past twelve years, while the Salon would display recent works. For a detailed discussion of the historical contexts of the 1867 Salon and International Exposition, see Patricia Mainardi, *Art and Politics of the Second Empire: The Universal Expositions of 1855 and 1867* (New Haven, CT, 1987), esp. pp. 128–38. See also Mainardi, *The End of the Salon: Art and the State in the Early Third Republic* (New York, 1993), p. 41.

20. See w 1, 41, and BL 89 and 90. This plan would bear fruit seven years later, when the Impressionists and their colleagues staged the first exhibition of the "Independents."

21. See w 1, 36, and n. 249. Monet, who reported this incident to Marc Elder decades later, is the sole source for the story, which may well be apocryphal.

22. Monet later claimed he showed the *Port of Honfleur* in the shop of a M. Hagerman and *Women in the Garden* at that of Latouche. Wildenstein points out that various authors have supplied varying reports of Monet's accounts about this episode—including the venues involved—for which no firm documentation exists. See w 1, p. 36 and n. 253, and John Rewald, *The History of Impressionism*, 4th rev. ed. (New York, 1973), p. 197.

23. Duc de Trévise, 1927, p. 121.

24. Thiébault-Sisson, 1900, n.p.

25. Quoted from WL 33; for additional details about the exhibitions mounted by Courbet and Manet, consult Rewald, 1973, pp. 171–73, and Mainardi, 1987, p. 138.

26. For his illuminating discussion of the impact of *Women in the Garden* on Monet's peers, see Gary Tinterow and Henri Loyrette, *Origins of Impressionism* (New York, 1994), pp. 137–47; the quote occurs on p. 138. Tinterow also notes, on p. 141, "This [Monet's] new fluid painting style became the vehicle for Renoir's genre paintings over the next few years."

27. Tucker, 1995, pp. 217–18, provides a pithy account of Monet's negotiations with the state over *Women in the Garden*. For details about Bazille's purchase of this painting in 1867 and its eventual return to Monet, consult chapter 4, below.

CHAPTER FOUR

1. In WL 33, Monet mentions that Camille was expecting to deliver on July 25; however, Jean arrived two weeks later, on August 8, indicating that Camille had probably conceived the previous November.

2. Monet's and Bazille's letters to *père* Monet, as well as the latter's response to his son, have been lost, but the senior Monet's prolix letter to Bazille (penned in great haste and filled with run-on

sentences) has been preserved; it is reproduced in Gustave Poulain, *Bazille et ses amis* (Paris, 1932), p. 77.

3. In his letter to Bazille, *père* Monet stressed that Aunt Lecadre's advanced age required that her internal harmony not be disturbed. However, as w 1, p. 37, n. 260, dryly observes, the fact that he nonetheless arranged for Claude to stay with his aunt, rather than in the family home, suggests that his father's situation "remained precarious."

4. See w 1, p. 37 and nn. 262–63.

5. Forty-odd years later, Georges Braque and Pablo Picasso would develop an even more intimate partnership of this type, a unique psychological twinship that insulated them against the stresses inherent in effecting an even more daring artistic revolution: the invention of Cubism. For details, see Mary Mathews Gedo, *Picasso: Art as Autobiography* (Chicago, 1980), esp. pp. 81–104.

6. For a current definition of conversion hysteria, consult "Conversion Disorders" in *A Task Force Report of the American Psychiatric Association*, vol. 3 (Washington, DC, 1989), pp. 2153–54. See also Otto Kernberg, *Psychiatry*, vol. 1 (New York, 1989), pp. 1–11, and J. C. Nemiah, *The New Harvard Guide to Psychiatry* (Cambridge, MA, 1988), pp. 234–58.

7. Monet himself was not present on August 11, when Jean's birth was registered, and two friends, Zacharie Astruc and Alfred Hatté (who had rented the room to Camille), duly perjured themselves to sign the document declaring Jean legitimate. Monet wrote Bazille from Sainte-Adresse on August 12; concerned about rousing parental anxieties by staying away for very long, he had evidently left Paris before Jean's birth was registered. See w 1, p. 37 and n. 266.

8. See WL 38, dated August 20, 1867. Bazille's response has not been preserved; presumably he acceded to Monet's rude demands for prompt financial aid. The next recorded letter Monet sent Bazille was written months later. If he sent additional hectoring letters to Bazille that summer and autumn—which seems likely—they have been lost.

9. Collins's novel originally appeared in installments (November 1859–August 1860) in *All the Year Round*, the weekly periodical edited by his friend Charles Dickens. Harper and Brothers simultaneously published the serialized version in *Harper's Weekly*. It was issued in volume form by Sampson Low in England and, virtually simultaneously, by Harper Brothers in the United States. For additional information, consult Kirk H. Beetz, *Wilkie Collins: An Annotated Bibliography, 1889–1976* (London, 1978), pp. 9–10. For a succinct discussion of the novel, plus a brief biography of its creator, consult Nicholas Rance, introduction to *The Woman in White*, Everyman's Library (New York, 1991), pp. v–xxxvi.

10. As Gary Tinterow puts this, "The flat planes of color-bright green grass, deep blue sky—punctuated by touches of brilliant orange, red, and white flowers relate the painting to the *Garden at Sainte-Adresse*, which was certainly painted in 1867" (*Origins of Impressionism* [New York, 1994], no. 138, p. 434). Anne Distel also argues for the 1867 date in *Hommage à Claude Monet* (Paris, 1980), no. 14, pp. 77–78. The authors of the catalog entry for *Jeanne-Marguerite LeCadre in the Garden at Sainte-Adresse* in *Claude Monet: Tableaux des Musées d'USSR*, French ed. (Paris, 1990), no. 5, pp. 100–101, flatly declare: "[Wildenstein] is wrong, it seems to us, in dating the painting from 1866 [rather than 1867]."

11. Frederick Brown (*Zola: A Life* [Baltimore, 1995], p. 434) reports that a sale of four thousand copies for a French novel of this period was considered phenomenal. According to the *Bibliothèque Nationale*, vol. 30, two different printings of *La femme en blanc* appeared in 1861, both based on the E.-D. Forgues translation. The Schiller Press issued what was presumably a folio

edition of the novel, while E. Jung-Treuttel published a two-volume version intended for wider distribution. The latter edition proved enormously popular; it was reprinted twice in 1862, and additional impressions appeared in 1863, 1869, 1873, and 1877.

12. According to Beetz, 1978, pp. 9–10, in addition to the French translation, the novel quickly appeared in German, Italian, and Russian; pirated editions also circulated widely.

13. The summary of the novel that follows constitutes only the sketchiest outline of the convoluted plot of Collins's tale, with its dependence on myriad coincidences.

14. A second instance of illegitimacy plays a critical role in the plot: in the closing pages of the novel, we learn that Laura's husband had also been born out of wedlock.

15. In support of their contention that the painting should be dated 1867, the authors of *Claude Monet: Tableaux des Musées d'USSR*, compare Jeanne-Marguerite's costume with illustrations of French fashion prints from 1867 showing models wearing virtually identical costumes, also without crinolines; they describe Jeanne-Marguerite as "noted for her elegance."

16. Hokusai's *The Sazaido of the Golyaku Rakan-ji Temple* has been frequently cited as a source. See, for example, John House, *Nature into Art* (New Haven, CT, 1986), pp. 47–51. We do not know whether Monet owned this print in 1867, but it was certainly part of his collection by the time of Giverny; it is reproduced in G. Aitken and M. Delafond, *La collection d'estampes japonaises de Claude Monet à Giverny* (Paris, 1983), no. 59, p. 92. Monet himself called the picture his "Chinese painting with flags in it" in a letter to Bazille written around December 1868 (WL 45). The terms *Chinese* and *Japanese* were used interchangeably at the time.

17. The man may have been Jeanne-Marguerite's fiancé, or husband, her cousin Paul Eugène Lecadre. Marianne Alphant (*Claude Monet, une vie dans le paysage* [Paris, 1993], p. 43) identifies the setting as the terrace of a nautical club, which makes sense in view of the flags. The 1996 edition of the catalogue raisonné (W 95) describes the setting as "the terrace of a property situated just below what is now known as the Alphonse-Karr path at Sainte-Adresse."

18. Virginia Spate, *Claude Monet: Life and Work* (New York, 1992), pp. 48–49.

19. Joel Isaacson, *Observation and Reflection: Claude Monet* (Oxford, 1978), no. 21, pp. 199–200.

20. See René Gimpel, *Diary of an Art Dealer*, trans. Joseph Rosenberg (New York, 1963), p. 152; undated entry from 1920.

21. Tinterow, 1994, no. 136, p. 433, notes: "Since Monet never exhibited the paintings side-by-side, the contrast between them was not intended as a social manifesto but provided instead differing conditions by which the same scene, convenient to his father's house, could be observed."

22. For another interpretation of the paintings discussed here, one that emphasizes Monet's awareness of the potential appeal of such compositions to tourists, see Robert L. Herbert, *Monet on the Normandy Coast: Tourism and Painting, 1867–1886* (New Haven, CT, 1994), pp. 9–19. Both Tinterow, 1994, pp. 64–66, and Herbert provide lively discussions of the relationship of Monet's art to earlier Dutch painting, as well as to the work of Jongkind, Boudin, Courbet, and others.

23. For the authors' comments, as well as a photograph of the x-ray, see *Claude Monet*, 1990, pp. 100–101. The 1974 edition of the catalogue raisonné, unlike the more recent edition, includes a photograph of the composition showing the male figure, but it does not identify him.

24. W I, p. 38.

25. For this material, see W I, pp. 37–38; WL 39; and, for Bazille's letters, WPJ 15 and 16.

26. In gratitude to his teacher and friend Eugène Boudin, Monet organized a group of colleagues to attend the first auction of Boudin's work, held at the Hôtel Drouot in Paris that March, to help

drive up his prices. As Wildenstein notes (w I, p. 38 and no. 282), it was the least Monet could do. For the quotation from Boudin's letter to F. Martin, dated March 26, consult Jean Aubry, *Eugène Boudin* (Paris, 1922), p. 66.

27. Charles F. Stuckey, *Claude Monet, 1840–1926* (Chicago, 1995), p. 193, reports that records of Jean's baptism at Sainte-Marie des Batignolles, on April 2, 1868, list Bazille and Vellay as godparents. For the information about the nurse, see Ruth Butler, *Hidden in the Shadow of the Masters* (New Haven, CT, 2008), p. 134. Butler quotes an unpublished passage from the journal, to which she was given privileged access.

28. Alphant, 1993, pp. 36–37, describes infant Jean as "vigilant" and "somber"; she correlates his expression with her conviction that the artist's mother was cold and unloving, an interpretation at odds with the one presented here.

CHAPTER FIVE

1. See, for example, William C. Seitz, *Claude Monet* (New York, 1960), p. 56, and Joel Isaacson, *Observation and Reflection: Claude Monet* (Oxford, 1978), nos. 24–25, p. 200. For brevity's sake, the painting will be referred to throughout the chapter as *The River*, the title by which it was long known prior to the identification of its site, which was not precisely Bennecourt but its dependency, the hamlet of Gloton.

2. Thanks to Daubigny, Monet's fellow avant-garde artists (with the exception of Cézanne, whose works were totally rejected) Bazille, Manet, and Pissarro all had both their paintings accepted by the jury. See w I, p. 39, and w I, PJ 23, for Eugène Boudin's letter of January 18, 1869, relating Daubigny's account of his encounter with Nieuwerkerke over Monet's paintings. See also John Rewald, *The History of Impressionism*, 4th rev. ed. (New York, 1973), pp. 185–86, and Patricia Mainardi, *The End of the Salon: Art and the State in the Early Third Republic* (New York, 1993), pp. 41–42.

3. Originally published in *L'Évènement Illustré* (May-June 1868), the review is reproduced in *Emile Zola: Salons*, ed. F. M. J. Hemmings and R. J. Niess (Geneva, 1959), pp. 129–32.

4. w I, p. 39, suggests that Monet decided to move to Gloton "to escape the Parisian air and influences." As noted above, Monet also needed to escape his creditors. For Zola's recommendation of Gloton, see Rodolphe Walter, "Emile Zola et Claude Monet," *Les Cahiers Naturalistes* 26 (1964): 52.

5. Rodolphe Walter ("Emile Zola à Bennecourt en 1868: Les vacances d'un chroniqueur," *Les Cahiers Naturalistes* 37 [1969]: 29), reports that in the June 17 issue of *L'Évènement Illustré*, under "Chroniqueur," Zola reports that he has left Paris for Gloton and is lodged above the blacksmith's shop. For Zola's holidays near Bennecourt, see Fredrick Brown, *Zola: A Life* (Baltimore, 1995), p. 141. Antoine Guillemet, a painter who was the son of a wealthy wine merchant, was a close friend of Cézanne; he was also friendly with many other avant-garde artists, including Monet. According to Rewald, 1973, p. 180, Guillemet had visited Monet at Sainte-Adresse during the previous summer.

6. Rodolphe Walter ("Aux sources de l'Impressionisme, Bennecourt," *L'Oeil*, no. 393 [1988], p. 36) states: "Under the eyes of his friends [Monet brought to] fruition the masterpiece long designated as *The River*."

7. Monet's letter (wL 40) exaggerated his situation. The Dumonts certainly did not throw him out "naked as a worm." Nor did he find some new shelter for Camille and Jean; they continued to

reside at the inn, as Guillemet's letters to Zola, quoted below, reveal. As Walter points out (1988, p. 36), Monet actually returned to Le Havre "as much to reenter into his family's good graces . . . as to rejoin his patron, Louis-Joachim Gaudibert." Mostly likely he joined his father and aunt at the latter's summer place at Sainte-Adresse. During the next few weeks, he rapidly executed five new pictures (w 112–16), three of them (w 112–14) depicting the seaside there.

8. The exhibition was mounted by the Georges Petit Gallery to coincide with the International Exposition held in Paris that summer. For the reconstructed catalog, see *Claude Monet–Auguste Rodin, centenaire de l'exposition de 1889* (Paris, 1989). Monet showed 145 oils covering every phase of his career.

9. The quotations come, respectively, from Andrew Forge, *Monet* (Chicago, 1995), p. 16, and Seitz, 1960, p. 78. See also Isaacson, 1978, nos. 24–25, p. 200, and Walter, "Emile Zola et Claude Monet," pp. 52–53.

10. For example, Charles F. Stuckey ("Monet's Art and the Act of Vision," in *Aspects of Monet*, ed. John Rewald and Frances Weitzenhoffer [New York, 1984], pp. 108–21, esp. pp. 114–16) describes the painting as "left incomplete." Forge (1995, p. 16) argues that it constitutes "a firm pictorial statement fully intended," presenting an entirely new conception of completeness "built out of the sketcher's rough and reductive marks." Stuckey (ibid., p. 116) identifies the women on the opposite bank as amateur painters sketching with "their view back towards Monet and his model. [They] also tend a little white dog, excited by some cows that have wandered to the water's edge." Walter (1988, p. 35) identifies the women as laundresses.

11. Complete x-rays were taken in 1973 as part of an extensive conservation procedure, including removal of discolored surface film, old varnish, and overpaint, as well as replacing an old lining with a new linen backing. Unfortunately, no photographs were taken of the picture after the old overpainting had been removed and before new inpainting had been applied. The report also noted that a tear at the left center had been filled in with white lead, rendering it barely visible on x-ray. The history of this tear is unknown. A second set of x-rays was taken in 1998 with new, more powerful equipment. The findings did not, however, reveal substantial differences from the older x-radiographs.

12. Monet used a purchased canvas of the finest quality linen, prestretched and covered with a commercial gray-white ground by the manufacturer. Its unusual proportions (approximately 32 × 39 ⅛ inches) suggest that the artist used a support traditionally employed for figure painting, which he turned 90 degrees before setting to work.

13. The tree at the far left covers a broadly brushed area of paint originally depicting the Seine, which also appears to flow through Camille's figure. After laying in the underpainting and establishing his horizon line, Monet, perhaps painting wet into wet, modulated the general river shapes and reflections, along with details of the landscapes of the island and the Gloton shore.

14. Walter, 1988, p. 31, reproduces a detailed map of the region as it appeared in 1867–68, demarcating the precise site of the painting.

15. The little ferry boat, barely visible between the two trees, may be another tribute to Zola. Walter (ibid., p. 35) notes that Zola frequently booked this ferry.

16. Whether during that revision or during later modifications, Monet smoothed out the terrain that had been the base of the hill, transforming it into a neat parallel slope; its slight descending angle is echoed by that of the boat ramp below. Both now direct attention to the heart of the painting.

17. For Stuckey (1984, p. 115) this feature constitutes further proof that Monet abandoned *The River* unfinished, while Forge (1995, p. 17) argues that this discrepancy "represents an earlier moment. Time, weather moved on, and so did he. Monet had what he wanted on the canvas, and there was no compelling reason to correct it."

18. Seitz, 1960, p. 78.

19. Increasing the size of Camille's head required a proportionate enlargement of her torso, especially her lower body, accomplished primarily by adding sketchily rendered strokes to—and around—her skirt (which had been rather loosely defined in the first place). The bold yellow-green strokes added immediately behind her figure, as well as her nearby hat, may also be meant to distract the viewer from the fact that Camille's lower body is so ambiguously represented. The extension of her right arm was accomplished equally vaguely, and her hand is not depicted at all. Conservator Frank Zuccari demonstrated the alterations in the size of Camille's profile and torso via his skillful use of Adobe Photoshop, which permits transparent layering of images.

20. Curator Groom only half facetiously called it "Camille's little goat beard," while conservator Lennon characterized Monet's rendition of his mistress's face as "almost caricatural," a shocking contrast to the care with which other aspects of the work, such as the screen of leaves, were executed. Although these features are visible on the surface of the definitive painting, they require close observation and may go unnoticed by many viewers.

21. The artist moved the tree forward, nearer Camille, by elongating its trunk and painting out the branches of the other tree, which had previously overlapped it. He shortened the leftmost tree by covering its lower trunk with dark green paint. Perhaps Monet selected the sharp cobalt blue for the added river water in an effort to balance the bright yellow-orange tones representing the play of sunbeams on the tree at the far left.

22. For the complete text of Guillemet's letters to Zola, consult w II, PJ, A, p. 293. In a later letter to Zola, dated August 18, also quoted in PJ, A, Guillemet noted: "At the Dumonts' there is great unease about defaults on the Monet notes, now overdue, and the above-named painter has sneaked out of Le Havre. They'll set the telegraph in motion. It'll be terrible." No extant record reveals whether the Dumonts carried out this threat or whether Monet ever paid the rest of his bill. Given his history in these matters, it seems unlikely. For Monet's location after he "sneaked out of Le Havre," see WL 41, which reveals that, together with Camille and Jean, he was hidden away in a hotel at Fécamp.

23. The quotation comes from *The Masterpiece*, the English version of *L'Oeuvre*, trans. Thomas Walton, rev. Roger Pearson (Oxford, 1993), pp. 171–72. Although Walter does not cite this specific passage, he draws many comparisons between the history of Zola's fictional artist-hero Claude Lantier and that of Monet. Walter (1964, pp. 58–59, and 1969, pp. 29–39) also points out how Zola's own experiences in the Bennecourt area in 1868 (recorded in his articles for *L'Évènement Illustré* at the time) were subsequently reworked and ascribed to Lantier.

24. Robert Gordon and Andrew Forge (*Monet* [New York, 1983], p. 74) also describe Camille's pose as "rooted."

25. Walter (1988, p. 36). Wildenstein (w I, p. 39) describes the act as a serious suicidal attempt: "Monet gave way to an unthinking act of despair, but was too good a swimmer to drown in a branch of the Seine in midsummer."

CHAPTER SIX

1. As w 1, p. 7, notes, Monet had known the prominent Gaudibert family socially before they became his patrons. In a letter to Boudin (WL 13), written around the end of October or the beginning of November 1864, Monet reported that M. Gaudibert (presumably Gaudibert *père*) had commissioned two panels from him. Both w 1, p. 28 and n. 169, and BL 57 report that Monet had been offered four hundred francs each for three pictures from a generous "amateur." Whether this referred to Gaudibert *père* or *fils* (or an unidentified patron) is not known.

2. Quoted from WL 42, September 3, 1868. How Bazille managed to send Monet forty francs in addition to his regular payment is puzzling; his parents kept him on a fairly tight allowance, which did not allow for many extra luxuries—or assistance to friends.

3. The senior Gaudiberts proclaimed Monet's initial attempt to portray their son "scrappy and vulgar." Nonetheless, Mme. Gaudibert, who seems to have played the dominant role in aesthetic matters, paid the artist for this portrait, as well as for the three he executed at the Château des Ardennes. The fact that neither of Monet's representations of the younger Gaudibert has survived suggests that his second attempt to depict his patron likewise failed to please Mme. Gaudibert. For details, consult w 1, pp. 40–41 and nn. 300, 307.

4. The elder Gaudiberts also reacted unenthusiastically to the portrait of their daughter-in-law, which had cost Monet so much effort. Wildenstein (ibid.) believes that their reaction may have played a causal role in the brief depression Monet suffered during this period. See also the entry for "Madame Gaudibert" in *Hommage*, ed. Hélène Adhemar (Paris, 1982), cat. no. 19, pp. 87–89.

5. M. F. Martin, a member of the exposition jury who was friendly to Monet, predicted to Boudin in a letter of October 6, 1868 (penned around the time the jury was convening), that Monet would win a silver medal. See w PJ 22, 23, 25. For details about the jury proceedings, see w 1, p. 41, n. 304.

6. Quoted from WL 43, written at the end of October or beginning of November. Although Monet alluded to the "superb articles" appearing in the press, he did not mention Billot's snide inferences about the morals of the model who posed for *Camille*.

7. Several Monet scholars have argued that his was a depressive personality. See, for example, Steven Z. Levine, "Monet, Madness, and Melancholy," in *Psychoanalytic Perspectives on Art*, vol. 2, ed. Mary Mathews Gedo (Hillsdale, NJ, 1987), pp. 111–32. See also Steven Z. Levine, *Monet, Narcissus, and Self-Reflection* (Chicago, 1994), for his more extensive exposition of Monet's character and career. For a succinct description of depression by a well-known psychiatrist, see Gerald L. Klerman, "Depression and Related Disorders of Mood (Affective Disorder)," in *The New Harvard Guide to Psychiatry*, ed. A. M. Nicholi Jr. (Cambridge, MA, 1988), pp. 309–16. As Klerman's discussion makes clear, Monet's depression was far milder and more quickly resolved than the typical cases seen by professionals.

8. For these letters (all written early in 1869), see WL 45–48. Monet initially asked Bazille to forward paintings he evidently hoped to sell, as well as canvases he planned to reuse. By the time he penned WL 46, he increased his demands; claiming that he was completely fundless, he also asked Bazille send him supplies of nine different colors, emphasizing that he needed a great deal of four basic colors, such as ivory black. He made no mention of how Bazille was to pay for this purchase. Evidently Bazille sent the paints along promptly, for Monet did not mention them again. Not until WL 48, dated February 10, 1869, did he acknowledge receiving a packet of large paintings, but not the smaller pictures, which he hoped to sell to his patron (Gaudibert?), who had rejected the other works as too large.

9. The sale took place in late 1868 or early 1869; Monet informed Bazille of these events in WL 46, dated January 11, 1869.

10. Paul Hayes Tucker (*Claude Monet: Life and Art* [New Haven, CT, 1995], p. 37) notes: "*Luncheon* is a kind of modernized version of a Jan Vermeer or a Jan Steen or an updated François Boucher or Jean-Baptiste Chardin with echoes of Courbet's later dinner scene [*After Dinner at Ornans*, 1848–49]." Virginia Spate (*Claude Monet: Life and Work* [New York, 1992], p. 60, and n. 140, p. 321) compares Monet's painting not only to Boucher's composition but also to Manet's *Luncheon in the Studio* (1868), shown in the Salon of 1869. Monet may have known Manet's painting intimately, for he reportedly posed briefly for the seated bearded figure. For details, consult F. Cachet, in Cachet, C. Moffett, et al., *Manet* (New York, 1983), cat. no. 109, pp. 290–94, esp. 292.

11. The tyrannical juror Gérôme played a leading role in engineering Monet's complete rejection. Daubigny resigned from the jury in protest. Not all of Monet's friends fared so badly. For details, consult John Rewald, *The History of Impressionism*, 4th rev. ed. (New York, 1973), pp. 216–18, and nn. 40–43, p. 237. For Monet's reaction to his rejection for the 1869 Salon, see Ruth Butler, *Hidden in the Shadow of the Masters* (New Haven, CT, 2008), p. 145.

12. Both paintings assign prominent roles to children, to whom their mothers attend; Boucher represents two children, the younger being spoon-fed by the visitor while the mother turns toward her little daughter. By contrast, Jean Monet (who had no sibling at that time) reigns alone, holding his own spoon aloft. Although his mother looks attentively at Jean, he disregards her, staring instead at some point at the far left beyond the picture plane—perhaps at his father, busy recording the scene. The elaborate mantelpiece and mirror represented by Boucher have no counterparts in Monet's composition; however, the dining room at Etretat did boast a fireplace with a modest mantel, visible in Monet's two nocturnal interiors. If *The Luncheon* (which depicts the identical table and chairs shown in those works) was painted in the same room, the furniture must have been moved near a large window not shown in the two nighttime scenes. On this problem, see John Rewald, "Notes sur deux tableaux de Claude Monet," *Gazette des Beaux Arts*, ser. 6, 70 (October 1967): 245–48.

13. According to Alastair Laing (in Alastair Laing et. al., *François Boucher, 1703–1770* [New York, 1986], cat. no. 33, pp. 179–82), this tradition goes back to the Duclos sale of 1857. The woman on the right (who closely resembles other images of his wife painted by the artist) has been identified as Mme. Boucher, while the woman on the left, who seems more integrated into the household than an ordinary visitor, may be the artist's sister. Pierre Rosenberg (*French Painting, 1710–1774* [Toledo, Ohio, 1974], cat. no. 9, pp. 23–24) notes that the children are believed to represent Boucher's first two offspring, Jeanne-Elizabeth Victoire and Juste-Nathan, then age four and three, respectively. The servant has even been identified as Boucher himself. This identification is more speculative, but Laing points out that even Louis XV "took special pleasure in making coffee in the intimacy of the petits appartements," so there was a precedent for Boucher to portray himself in this role. Laing also observes that the placement and attitude of this figure are "scarcely those of a deferential servant or waiter," adding weight to the speculation that he may be based on the artist himself. Laing concludes: "In balance it is probably wiser to see [*Le déjeuner*] as a genre picture, in which Boucher may have taken his family as convenient models." He also describes the scene as a breakfast, with coffee being served. But Rosenberg points out that despite its title, the composition does not represent a luncheon or breakfast but simply two women drinking chocolate, a reading that seems convincing.

14. Wildenstein (w 257) assigns *The Red Cape* to 1873, but such a late date seems incompatible with the formal characteristics of the work, typically those of the late 1860s. John House (*Monet*, 2nd ed. [Oxford, 1981], cat. no. 8, n.p.) states, "*The Red Cape* was probably painted at Etretat in the winter of 1868–9, at about the same time as *The Luncheon*." Kermit S. Champa (*Studies in Early Impressionism* [New Haven, CT, 1973]) remarks, "The dating of [*The Red Cape*] has never been securely fixed, but its color choices (which are closely related to the *Mme. Gaudibert*), its domestic subject matter, and the open quality of its technical effect all seem to suggest that it was painted [at Etretat] at some point after *Mme. Gaudibert* and before the large indoor *Déjeuner*." However, in Kermit S. Champa and Dianne W. Pitman, *Monet and Bazille: A Collaboration* (Atlanta, 1999), p. 93, fig. 53, he dates it less definitively to 1868–70. The Cleveland Museum of Art, which owns the work, dates it "probably late 1860s–early 1870s." Wildenstein says the painting was executed "in the first house the Monets occupied at Argenteuil," evidently basing his conclusion on a similar French door in the Argenteuil home. However, the French door depicted in *The Red Cape* opens at ground level, as is clearly evident from Camille's position, whereas the comparable door in the Argenteuil home was situated above ground level and could be entered only by mounting several steps, as depicted in *The Artist's Home at Argenteuil* (w 284), *The Luncheon* (w 285), and *Camille Monet at the Window* (W. 287), all painted in 1873. The color scheme and facture in these and other paintings from 1873 differ markedly from those of *The Red Cape*. Close study of Camille's facial features in *The Red Cape* reveals that the artist has represented her with the unnaturally high eyebrows and elongated face typical of women depicted in Japanese prints. Although the artist continued to be influenced by Japanese sources long after completing *The Red Cape*, such allusions had become more subtle by 1873. Never again did Monet "orientalize" Camille's features—least of all in *La Japonaise*.

15. Camille's bulky figure resembles that of a woman in the second trimester of pregnancy. In the absence of any evidence that she was again pregnant, her appearance should probably be regarded as an illusion created by the style of her jacket and the multiple layers of clothing beneath it. Or did the artist represent Camille not as she looked in the winter of 1868 but as she had appeared a year earlier, when pregnant with Jean? If so, he portrayed her as though he had obeyed the paternal dictum that he should abandon her and their unborn child.

16. The painting can be seen in the photograph taken in 1920, reproduced as figure 1.6, showing Monet and the Duc de Trévise standing before the *Luncheon on the Grass* (1865) with *The Red Cape* hung just to its left (and partially obscured by Monet's body).

17. See Tucker, 1995, p. 38; Tucker also poses a series of provocative questions about *The Luncheon*.

18. This methodology was suggested by my psychoanalyst consultant, J. E. Gedo, M.D. For another perspective on the painting, which partially agrees with that presented here, see Anne M. Wagner, "Why Monet Gave Up Figure Painting," *Art Bulletin* 76, no. 4 (December 1994): 613–29.

19. House (1981, no. 7) suggests: "Many elements—the loaf of bread, the newspaper, the novels on the back table—overlap the edges of their supports, to heighten this sense of immediacy." One might also argue that the somewhat precarious positions of these objects reflect the instability of the family's financial and social situation at the time of the painting's creation.

20. During the first half of the 1870s, Renoir repeatedly depicted Monet wearing this hat, both indoors and out. See, for example, the *Portrait of Monet Reading* (1872, Musée Marmottan). Manet also showed his friend in this headgear in *The Monet Family in Their Garden at Argenteuil* (1874). In *The Luncheon* Camille's sewing basket rests on the seat of the chair from which Monet's hat

hangs, and Jean's dilapidated doll lies beneath it. The chair thus symbolically represents all three members of Monet's nuclear family.

21. X-ray studies carried out by the Department of Conservation of the Frankfurt museum and reported by Wagner (1994, pp. 617–18) confirm that Bazille's sketch accurately reflects an earlier version of the composition.

22. Tucker (1995, p. 38) notes: "Even if Camille posed for both bourgeois women, as others have claimed, the painting still does not seem to make sense." See also Spate, 1992, p. 60, who believes that Camille posed for both figures. She describes the painting as a "domestic idyll" (despite its enigmatic and disturbing elements?). The catalog entry for *The Luncheon* (W 132) states: "Camille posed standing on the left, and possibly for the seated woman."

23. In Bazille's sketch, the maid's body impinges on that of the mother; according to Wagner (1994, p. 618), x-rays show that Camille's figure was moved lower and to the right.

24. Jean Renoir, *Renoir, My Father* (Boston, 1962), p. 113.

25. Certain viewers respond to the pathos of Camille's expression as though confronting a living person rather than a painted image. For example, an internist friend reported that the mother of a young AIDS victim, whom he had treated prior to the youth's death, conveyed her gratitude by writing the physician a note on a card reproducing *The Red Cape*, a choice suggesting to the physician that the mother saw Camille as in a similar state of bereavement and identified with her.

26. Could the top hat, partially visible on the sideboard shelf at the right rear of the painting, be a veiled reference to Monet *père*? There is certainly no male visitor represented in *The Luncheon* to whom it might belong, and Monet's own hat is prominently featured. If the top hat is a reference to Alphonse Monet, does the fact that it is visually cut in half by the picture's edge signify his waning influence and importance in his son's life?

27. Boucher's painting changed hands five times between 1739 and 1884; in 1857 it was purchased by an anonymous collector (probably Camille Marcille), who owned it until 1881. It is possible that Monet saw the original composition during this period.

CHAPTER SEVEN

1. See W 1, pp. 42–43, and, for Boudin's description of the fervent public response to the Sainte-Adresse picture, his letter of April 25, 1869, quoted in Jean Aubry, *Eugène Boudin* (orig. 1922; Paris, 1987), p. 74.

2. Following his rejection at the Salon, Monet had reluctantly concluded that it was necessary to live within easy access of Paris in order to receive maximum benefits from "mon petit talent," as he explained to his patron Arsène Houssaye, in WL 49, dated June 2, 1869.

3. In his letter to Martin of April 25, 1869, quoted in Aubry, 1987, p. 74, Boudin noted that Monet "claims" (*prétend*) that his aunt had cut off his monthly support. His word choice suggests that he doubted Monet's story, but the break with Aunt Lecadre was both real and permanent, and her nephew never saw his aunt again before her death on July 7, 1870. Gaudibert also died in 1870; we have no information concerning his final illness or its duration.

4. See W 1, p. 42.

5. See W 1, p. 43, and WL 50–53.

6. For Monet's La Grenouillère series, see W 134–37 and, questionably, 138 and 138a, discussed below. See also Richard Brettell, *Impression: Painting Quickly in France* (New Haven, CT, 2000), cat. nos. 69–70, pp. 115–16, or his discussion of W 134 and 135, in which he points out that "Monet preserves

the sense of urgency and rapidity of execution throughout all stages of the process of creation. At least four separate periods of attack must have been required, with at least a day between each. . . . Yet Monet was careful to preserve the intensity of *plein air* painting throughout the process."

7. For other instances of Monet's reversion to such a quasi-caricatural style, see his later portraits of three service people: *père* and *mère* Paul (w 744–45), proprietors of the inn at Pourville where Monet stayed while painting in the area in 1882, and Poly (w 1122), a fisherman who assisted Monet during his residence at Belle-Île in 1886. All three portraits are affectionate, but their humorous character not only recalls the artist's juvenile caricatures but reminds one that these individuals were not the artist's social peers.

8. See Roland Pickvance et al., *Monet in Holland* (Zwolle, Netherlands, 1986), Pickvance pairs *Houses on the Achterzaan* with *Garden House on the Banks of the Zaan* (cat. nos. 7 and 9, pp. 116–19), pointing out that both works represent Camille in the identical gown and holding the same pink parasol. These works are cataloged as w 187 (*The Zaan at Zaandam*) and w 138 (*The Landing Stage*).

9. For Monet's depictions of the area around Louveciennes, see w 145, 147–48. Because so much of Pissarro's oeuvre from this period was lost during the war of 1870, we do not know whether Monet and he painted sites near his home side by side, although that seems likely.

10. w I, p. 45.

11. His last surviving letter to Bazille (who volunteered for service in the war of 1870 and was killed in battle on November 28, 1870), penned on Dec. 8, also reflects Monet's improved mood—and better relations with Frédéric: "My dear friend: I wasn't able to come on Sunday, as I told you, because of the snow, from which I wished to profit in order to make some studies. I am going to come tomorrow or [the day after]" (wL 54).

12. See Gary Tinterow, *Origins of Impressionism* (New York, 1994), cat. no. 146, pp. 439–40, who suggests that Monet may have chosen the version of *La Grenouillère* (w 136) formerly in the Arnold collection in Berlin and apparently destroyed during World War II.

13. For details of the 1870 Salon, see John Rewald, *The History of Impressionism*, 4th rev. ed. (New York, 1973), pp. 239–48 and notes. As he points out: "It almost seems as if the jury members had particularly resented Daubigny's consistent defense of Monet, for of the entire Batignolles group, he was singled out for special ostracism. Both of Monet's paintings were refused, whereas Manet, Berthe Morisot, Pissarro, Renoir, and Fantin [Latour] all had two canvases accepted, Bazille and Degas one each" (p. 240). This would prove to be the last Salon held under the auspices of the Second Empire before the disastrous Franco-Prussian War brought that regime to an end. See also w I, p. 46 and nn. 343–47; Wildenstein points out that "the more perceptive critics wrote encouraging words about [Monet's rejected paintings]."

14. For details, see w I, pp. 45–6 and notes.

15. For Mount's rather melodramatic account, see Charles M. Mount, "New Materials on Claude Monet: The Discovery of a Heroine," *Art Quarterly* 25, no. 4 (1962): 393–428. Ruth Butler (*Hidden in the Shadow of the Masters* [New Haven, CT, 2008], pp. 147, 162, and n. 4 for chap.15, p. 328) states that one of the witnesses at the wedding was Gustave *Manet* (Edouard's brother), not Monet as previously reported.

16. w I, p. 46 and n. 356, reports that on the day of his marriage Monet cited both his previous military service and his marriage as grounds for exemption. However, he was unable to provide any proof of his past service. It would not have protected him from serving again in any case,

because a law passed in August 1870 made former army men subject to the draft in preference to those who had never served.

17. W I, p. 51 and n. 358. See also WL 61, dated December 21, 1871, in which Monet asked his friend to send the paintings to him at Argenteuil.

18. Marianne Alphant (*Claude Monet, une vie dans le paysage* [Paris, 1993], p. 196), suggests that Monet may have chosen Trouville because he hoped that Aunt Lecadre's funeral would reunite the family and lead to acceptance for Camille. Whatever hopeful fantasies he may have entertained, no reconciliation occurred and Aunt Lecadre remembered neither Claude nor Léon in her will, which left her entire estate to members of her late husband's family.

19. For his classic, succinct account of the war and its enduring effects, see D. W. Brogan, *The French Nation, from Napoleon to Pétain* (New York, 1957), esp. pp. 145–64. Emile Zola wove his carefully researched novel *Le débâcle* (1892), arguably his greatest achievement, around the disastrous Franco-Prussian War. For details about his extensive research, see Frederick Brown, *Zola: A Life* (Baltimore, 1995), pp. 633–45. An English version, *The Debacle*, translated by Leonard Tancock, appeared in 1972 (Harmondsworth, UK). Tancock's introduction, pp. 7–19, provides an excellent description of Zola's handling of the conflict in the novel.

20. Monet *père* undoubtedly helped his son financially at this time. W I, p. 51, reports that his father was moved by his son's eternal financial troubles. Alphant (1993, p. 198) suggests that Adolphe Monet helped to subsidize his son's flight to England to be rid of him, noting that, soon after Claude's departure, Monet *père* married his mistress and acknowledged the legitimacy of their daughter.

21. David Bomford et al., *Art in the Making: Impressionism* (New Haven, CT, 1991), cat. no. 3, *The Beach at Trouville*, pp. 126–31; comment on p. 313: "The brilliantly conceived flag is simply an unpainted area in the surrounding sky, with cream and red horizontals dashed over it to give a vivid impression of the wind tugging at the striped fabric."

22. Ibid., pp. 127–31.

23. Boudin's letter was penned on July 14, 1897, the year before his death. For the original text, see Aubry, 1987, p. 157.

24. Hansen, in Hansen et. al., 2005, cat. no. 11, pp. 80–81 in the German version, p. 27 in English.

25. J.-P. Hoschedé (*Claude Monet, ce mal connu*, 2 vols. [Geneva, 1960], vol. 1, p. 83) reports that decades after her demise Monet continued to speak of Aunt Lecadre with affection.

26. The catalogue raisonné (W 162) rejects the original identification, a revision now generally accepted. No evidence has surfaced indicating that Geneviève visited the Monets at Trouville that summer; however, Camille had reconciled with her family at the time of her marriage, so such a visit may have been a possibility. Brettell (2000, cat. nos. 72–73, pp. 118–20) suggests that in both *Camille on the Beach at Trouville* (W 160) and *On the Beach at Trouville* (figure 7.8) "the proximity of other figures gives them a social intimacy that is correctly interpreted as familial, yet although the figures must surely include Camille and her relatives, the aim of Monet's transcription was clearly not particular. Rather, he captured the summary effects of light and wind on the clothing and hair of variously clad female figures and their companions in ways that actually deny us access to their individuality. Even when Camille faces us . . . she acts almost as a staffage figure, against which we measure the livelier scenes of figures behind her."

27. W I, pp. 52–55, reports that Monet rented an apartment in an elegant establishment a stone's throw from Kensington Palace. This choice demonstrates that the artist had considerable funds at his disposal at the time.

28. In Dürer's engraving of that title from 1514, the angel also holds a book in his lap; his melancholy relates to the sands of the hourglass running out, like the brief span of human life.

29. Since Bazille was not yet a well-known public figure, news of his death presumably would not have spread beyond Montpellier.

30. J.-P. Hoschedé, 1960, vol. 1, p. 120, notes that Monet frequently spoke of Bazille with real affection, and even made a detour to visit Frédéric's tomb during a brief trip to the Mediterranean coast in December of 1883.

31. The fact that they included w 157, 158a, and possibly w 156, purchased in June 1871, proves that Monet had the Trouville pictures with him in London. He also had the reduced version of *Camille*, and possibly other pictures, with him there. How their transport had been arranged remains a mystery. Various sources have suggested that Camille arranged for their shipment, but no documentation that might clarify the details has come to light.

32. Durand-Ruel included works Monet had executed in 1870 and 1871 in four of the six exhibitions of the Society of French Artists he staged in London between 1870 and 1873. For additional information on Monet's London stay, see John House, "New Material on Monet and Pissarro in London in 1870–71," *Burlington Magazine*, October 1978, pp. 638–42.

33. See w 1, pp. 56–57, and wL 56–60.

34. w 1, p. 56, reports that Pissarro knew the area, as did Daubigny. No doubt Johan Jongkind, a favorite mentor of Monet's, had also mentioned the town to him. Rewald (1973, p. 263) suggests that Monet may have gone there "on the advice of Daubigny, if not actually invited by him, for the latter did work in Holland during the years 1871 and 1872; he even purchased one of Monet's views of the canal of Zaandam."

35. For a detailed discussion of Monet's stay in Holland, the works he produced there, and photos of a number of sites he painted, consult Pickvance et al., 1986. For Pickvance's discussion of the disputed painting of Camille and the related sketch that Wildenstein assigns to 1869 (w 138 and 138a) but that Pickvance convincingly attributes to the Zaandam period, see cat. nos. 7–8, pp. 116–18.

36. For details, consult w 1, p. 58 and nn. 406–7.

37. Ibid., pp. 57, 58, and wL 60–61.

CHAPTER EIGHT

1. The family lived in their first house until October 1874, when they moved to a newly constructed dwelling, where they remained until January 1878. For details, consult Rodolphe Walter, "Les maisons de Claude Monet à Argenteuil," *Gazette des Beaux Arts* 68 (December 1966): 333–42. See also w 1, pp. 58–61.

2. Monet seems to have used this studio primarily for business and storage purposes. The excellent railroad service to Paris would also lead to undesirable changes in Argenteuil, as the town played host to crowds of weekend visitors from the city, including prosperous Parisians who purchased second homes there. This ever-increasing influx, plus the changes brought about by the rapid industrialization of France following the Franco-Prussian War, soon transformed Argenteuil from a bucolic retreat into an ugly "modern" town, robbed of the idyllic sites the artist once had found there. These changes, considered in later chapters, are extensively documented by Paul Hayes Tucker in *Monet at Argenteuil* (New Haven, CT, 1982).

3. For details of Monet's income during 1872 and 1873, see w 1, pp. 62–64 and relevant notes; consult also Charles F. Stuckey, *Claude Monet, 1840–1926* (Chicago, 1995), pp. 196–98. Durand-Ruel paid

his top price, two thousand francs, for the version of *La Grenouillère* (w 136) that was presumably destroyed during World War II. See also Charles Stuckey, "Love, Money, and Monet's Débâcle Paintings of 1880," in Annette Dixon, Carole McNamara, and Charles Stuckey, *Monet at Vétheuil: The Turning Point* (Ann Arbor, MI, 1998), pp. 46–50, who raises many fascinating—but to date unanswerable—questions about Monet's financial arrangements with Durand-Ruel. Stuckey raises similar queries about whether Ernest Hoschedé and Monet had been "silent partners in a badly failed art market venture" beginning in 1876, leading to their joint financial collapse and eventually to their joining forces to share one habitation in Vétheuil (see ibid., pp. 50–55).

4. Durand-Ruel published the four-volume *Recueil d'estampes* in 1873, illustrating pictures by artists in his gallery. In his preface to the volumes, Armand Sylvestre singled out Monet as "the most daring artist of his generation."

5. For details see Stuckey, 1995, p. 196.

6. See w 1, pp. 62–64 and notes.

7. As Richard Brettell (*Impression: Painting Quickly in France* [New Haven, CT, 2000], p. 116) points out, "[Monet's] experience as a master of open-air painting was so great by 1870 that he left few areas of visual experience untouched by his methods. . . . The number of works that appear to have been painted in short sessions increased dramatically in the early 1870s, just as his own confidence reached a peak. . . . Monet produced more than four hundred paintings during the 1870s, an average of forty per year."

8. Léon encouraged Claude to participate in the Twenty-third Municipal Fine Arts Exhibition held in Rouen, where he showed *Meditation* (as *Interior*) and a *Canal at Zaandam* owned by Léon. For details, consult w 1, 62 and n. 421, and wL 63, in which Monet discussed the upcoming exhibition with Pissarro.

9. See w 1, pp. 65–66 and notes. Very few pictures from 1872–73 are dated, and the similar subject matter and treatment of certain compositions make dating them precisely somewhat problematic. As Brettell (2000, pp. 115–16) points out, establishing definitive dates for many of Monet's works is problematic, both because he often did not date pictures until he sold them and because he also returned to works later, as may have been the case with *On the Bank of the Seine, Bennecourt*, discussed in chapter 5.

10. See Brettell, 2000, cat. no. 31, pp. 118–21, who suggests that this portrait and Monet's other early depictions of Jean may all have been birthday mementos. He emphasizes the frequency with which Monet painted his son, interprets the earlier portraits as dealing with "issues of family loyalty and paternity," and cites *Jean Monet on His Horse Tricycle* as "a significant step in the father's pictorial analysis of his paternity and his son's growth." The fact that the artist retained several of his depictions of Jean in his private collection provides additional evidence that they may indeed have commemorated birthdays or other special occasions.

11. If the approximately twenty-year time difference between the execution of the prince's portrait and that of *Las meninas* (ca. 1656, Prado, Madrid) did not make the substitution unlikely, one might nominate the attractive childlike midget shown at the far right of the later composition, with his foot resting on the huge canine, as the logical candidate to have served as the prince's double.

12. Blanche died in 1947; the picture was sold the following year.

13. The catalogue raisonné entry for *Springtime (The Reader)* (w 205) notes, "According to Blanche Hoschedé-Monet, the painting depicts Camille, but this is debatable." For an example of the identification of the model as Mme. Monet, see Paul Hayes Tucker, "Of Sites and Subjects and

Meaning in Monet's Art," in *Monet: A Retrospective* (Tokyo, 1994), pp. 63–64, who describes Camille in this portrait as "the ultimate embodiment of feminine beauty and suburban leisure set in an enchanting locale far from the pressures and rapid pace of modern life."

14. See Tucker, 1982, p. 130.

15. By no means a horticultural expert, the author was unfamiliar either with the pink variety of lilacs or with bushes as tall as those depicted in these pictures and wondered whether they involved poetic license on Monet's part, rather than reality. A knowledgeable informant at the Chicago Botanic Garden reported to me that not only do numerous varieties of pink lilacs exist but several of them can grow as high as fifteen feet, which fits with the appearance of the treelike bushes Monet depicts.

16. See Paul Hayes Tucker, *The Impressionists at Argenteuil* (New Haven, CT, 2000), cat. no. 17, pp. 84–87, who points out that the painting functions both as modern references to the *Fêtes Galantes* of Watteau and his followers and as the modern *Hortus Conclusus*, or "Virgin Mary in the enclosed garden." Monet returned to the latter theme in 1875; see figure 10.1 below.

17. It is impossible to discern in this picture whether Jean wears a dress or short trousers; since wild poppies bloom in June or early July, before he would have turned six, he is presumably still clad in a unisex costume. Two other compositions painted during the same period (w 275–76), both now in private collections, also depict small-scale figures roaming through the prairies around Argenteuil, but the models are too tiny and sketchily rendered to permit precise identifications.

18. The child's hand—indeed his entire body—is so loosely painted that reading this feature remains problematic. Tucker (1995, p. 84) emphasizes the fragile organization of the entire composition, commenting that only Camille's central position keeps the unbalanced construction from falling apart.

19. Tucker, 2000, provides a thoughtful comparison of these two works in cat. nos. 19 and 20, pp. 90–95.

20. See Jean Aubry, *Eugène Boudin* (orig. 1922; Paris, 1987) for this quote, which comes from a letter Boudin sent M. Martin on December 12, 1872. Virginia Spate (*Claude Monet: Life and Work* [New York, 1992], p. 108) also disputes theories of their estrangement, pointing out that Monet's paintings show that Camille "was constantly with [her husband] when he worked, not only as a model but, as can be seen in Manet's painting of the two of them together in the studio boat, as a companion."

21. As previously noted, the catalogue raisonné assigns this work to 1873 (w 257), although it must have been executed in the winter of 1868–69.

22. Spate, 1992, p. 77.

23. We know from photographs made during the artist's final years that he proudly displayed *The Red Cape* among his figurative works. None of these photographs include reproductions of *Camille Monet at the Window*; neither do they provide complete views of the disused studio in which they were customarily displayed, or of the varied arrangements of his collection of Monet's Monets that the artist made from time to time. Michel Monet, who inherited all his father's unsold paintings following the artist's death, sold *The Red Cape* around 1939, but not *Camille Monet at the Window*, which Wildenstein acquired in 1968, presumably as part of the dealer's inventory of the artist's studios conducted after Michel's demise. Today both pictures are in American museums.

24. Spate (1992, pp. 106–12) argues that depictions of figures seemingly alienated—or at least affectively uninvolved—with one another "were characteristic of avant-garde Realism's reification

of the external world, including the human figure." She cites Degas, Manet, and Monet as all representing people as objects. For views more congruent with that presented here, see Joel Isaacson, *Observation and Reflection: Claude Monet* (Oxford, 1978), pp. 205–6, and Tucker, 1995, pp. 83–89, who emphasize the enigmatic and disturbing character of several of Monet's mother-child paintings. Marianne Alphant (*Claude Monet, une vie dans le paysage* [Paris, 1993], pp. 37–39) cites *Camille and Jean in the Garden at Argenteuil*, among other works, favoring her hypothesis that the artist had never known a tender mother—a theory, as previously noted, completely at variance with the view presented here.

25. For a concise summary of the symbolism of the hoop and hoop-rolling, see Milly Heyd, "De Chirico: *The Girl with the Hoop*," in *Psychoanalytic Perspectives on Art*, vol. 3, ed. Mary Mathews Gedo (Hillsdale, NJ, 1988), pp. 85–106, esp. 97–101.

26. Alphant (1993, p. 247) believes that *père* Doncieux was already demonstrably ill by 1870, when his signature as a witness to his daughter's marriage was tremulous.

27. See WL 70, 72, and W I, 64, n. 447. In May 1873, Théodore Duret (who would become a major supporter of the Impressionists) had purchased Monet's 1867 painting *Cabin at Sainte-Adresse* (W 94), for the considerable sum of twelve hundred francs, to be paid in installments. His slow rate of payment irked Monet, who twice wrote him requesting payment of the remainder (WL 66, 68). On November 8 Monet sent Duret a terse, impersonal note (WL 72), acknowledging the receipt of two hundred francs in full payment of the amount due, with Pissarro acting as go-between. It is interesting that Monet, who was so cavalier about settling his own debts, should be so draconian in demanding prompt payment of sums due him.

28. For details, see W I, p. 64 and esp. nn. 446–47.

29. Rose-Marie Hagen and Rainer Hagen ("Geranienbeete leuchten, Gesichter sind verschlossen," *Art* [Hamburg], no. 8, August 2001, pp. 72–77) also note this relationship but interpret it differently. "That tall, arched bed of geraniums—if it actually existed—represented not so much the reality as Monet's longings. The same geranium bed appears in his painting of the garden layout of his aunt Lecadre, as well as in a Caillebotte painting of his manorial country house. It must have been something like a status symbol. The fact that Monet allowed it so much space in [*The Bench*] indicates that it was important to him" (p. 74). Although Monet frequently modified elements of the settings he depicted, the geranium bed was certainly quite real and—as the Hagens note—important to the artist, but not primarily because it constituted a status symbol.

30. See Colin Bailey, in C. Bailey, Joseph J. Rishel, and Mark Rosenthal, *Masterpieces of Impressionism and Post-Impressionism: The Annenberg Collection* (Philadelphia, 1989), pp. 46–49, 154–55, especially p. 46, where he summarizes the numerous symmetries linking the two pictures.

31. Monet's letter (WL 2440), dated June 7, 1921, was addressed to Georges Durand-Ruel. *Camille in the Garden* (W 280) was never publicly exhibited during Monet's lifetime; according to the recent edition of the catalogue raisonné, *The Bench* (W 281) was not shown until 1907. Bailey (1989, p. 155, n. 32) states that, contrary to the Wildenstein catalog, the painting was first exhibited in the seventh Berliner Sezession exhibition of 1903. "A stamp on the back of the painting, 'Bruno and Paul Cassirer, Berlin,' indicates that *The Bench* was sold by the Cassirer brothers before 1902, as the brothers separated around this time. It has not been possible to determine from whom they acquired *The Bench*."

32. According to Bailey, 1989, p. 48, "Nineteenth-century mourning dress was not a specific costume, for which one could locate designated prototypes. Rather, it was a reordering of the wardrobe

to stress certain elements and to display as much black as possible. In a suburban town, such as Argenteuil, the wearing of elaborate mourning dress would communicate not only bereavement but status, and servants would be expected to wear attire of a similar nature. If Monet did indeed paint Camille in mourning dress in *The Bench*, this would be consistent with the other elements of bourgeois existence that are emphasized here: the well-tended, walled garden, the black frock coat and top hat [of the visitor], the fashionable crinolines."

33. Bailey (ibid.) argues that Camille appears clad entirely in black in *Poppies at Argenteuil*, which suggests to him that it was painted after her father's death. However, as noted above, Monet either depicts her in two different costumes in the work or arbitrarily alters the color and trim of her dress (and hat) as she appears at the bottom of the hill. Moreover, wild poppies typically bloom in France in June and sometimes July, a time preceding M. Doncieux's death by several months.

34. Bailey (ibid., pp. 49, 155 and n. 21) reports that Camille's outfit can be dated to circa March 1873, when a very similar dress was shown—and carefully described—in a spring issue of *La Mode Illustrée*.

35. Robert Gordon and Andrew Forge (*Monet* [New York, 1983], p. 87) describe Camille's expression as "melancholy" but do not explore the reasons for her sorrowful expression. Instead they describe Camille's relationship with the garden as intimate, creating "an extraordinary sense of the garden gathered into her, as though she is its representative." They point out that details of her costume, the "broken, scalloped, ruffled, petaled" edges of her dress, and the "flowerlike" profile of her chapeau, help to develop the interaction between her figure and the garden.

36. Bailey, 1989, p. 46.

37. *The Bench* depicts the garden enclosed by a solid wall covered with vegetation. However, in *Monet's Garden at Argenteuil* (*The Dahlias*) (fig. 8.7) the artist shows that area of the garden separated from his neighbor's by a more mundane picket fence. Either the property was enclosed by two different materials or Monet, exercising artistic license, substituted the romantic vine-covered wall for the more prosaic picket fence.

38. See Gordon and Forge, 1983, pp. 85, 88; Tucker, 1995, p. 86; and Spate, 1992, p. 108.

39. See Isaacson, 1978, p. 20, and n. 50, p. 208.

40. See Bailey, 1989, p. 48, and p. 154 for related notes.

41. Hagen and Hagen (2001, p. 76) note that the arrangement of the figures leads one "to suspect a hidden story" and mention that the visitor has been interpreted "as Death personified, or at the very least as a messenger of Death." Rather than attempting to penetrate this enigma, they turn to a discussion of the real-life identity of the caller, whom they believe to have been Eugène Manet. Although members of the Manet family owned a summer home near Argenteuil and Manet conceivably *could* have posed as the visitor, Monet would certainly have recalled that Manet, who married Monet's close friend Berthe Morisot, had served as his model.

42. See Isaacson, 1978, p. 20 and p. 205, no. 42. It should be noted that he does not identify either woman.

43. Whether Mme. Doncieux was a frequent visitor to Argenteuil during the family crisis is open to question, but she must have been in close contact with her daughter and son-in-law during the months following her husband's death. Documentary evidence shows that a legal agreement between Camille and her mother was not reached until November 24, 1873, which postdates the execution of *The Luncheon* by several weeks. Walter, 1966, p. 342, n. 11, quotes the document, preserved in the Archives Nationales, revealing that on November 24 Mme. Doncieux paid Camille four thousand francs of the sum due her. Since the funds in M. Doncieux's estate were

not sufficient to pay in full the remaining six thousand francs owed Camille, a liquidation settlement was reached, granting her only 2,130 francs of the total. Geneviève's surrogate guardian (assigned by the will of M. Pritelly, who either was the girl's biological father or believed himself to be) sued to break this settlement. However, a definitive verdict rendered on October 28, 1874, ruled in favor of the Monets and Mme. Doncieux. For additional details, consult w 1, p. 61 and nn. 450–59. Alphant (1993, pp. 246–47) suspects that the shortage of assets in M. Doncieux's estate resulted from illegal transactions perpetrated by his widow; she may be correct, but no definitive proof of such wrongdoing on Mme. Doncieux's part has come to light.

44. When Monet showed it in 1876, in the second exhibition organized by the Impressionists and their associates, he listed it simply as a "panneau décoratif."

45. The picture has occasionally been identified as a *petit-déjeuner* or breakfast, but the French do not serve wine at breakfast.

46. Bailey, 1989, p. 49.

47. Spate (1992, p. 12) remarks: "Monet's search for an ideal state of being in painting was so intense, so obsessive, so driven, that it suggests not only a desire to escape the fragmentation of modern life, but a more fundamental desire for what all have lost, the infant's integration with the undifferentiated body of the mother." Although Spate does not mention the source of her idea, this usage derives directly from Melanie Klein, the celebrated British psychoanalyst.

CHAPTER NINE

1. In his letter to Camille Pissarro written from the Hôtel de l'Amirauté and dated January 27 (WL 76), Monet indicated that he planned to remain in Le Havre for several more days.

2. Such a sojourn would have required his absence from home during most of February and March, when arrangements for the impending Impressionists' exhibition would have been at their height. An aura of mystery surrounds these pictures, which were signed but neither dated, listed in his sales ledger, nor exhibited during his lifetime. No letters exist (or survive) that might resolve these questions. Wildenstein (w 1, pp. 70–71) contends that Monet, discouraged about hitches in arrangements for the upcoming exhibition, undertook this lengthy project abroad, but other scholars question this conclusion. Charles F. Stuckey (*Claude Monet, 1840–1926* [Chicago, 1995], p. 198), for example, suggests that Monet may have exhibited or sold these pictures outside Paris. He also questions whether they might have been painted in 1873. Reassigning them to that year would augment the unusually low number of works the catalogue raisonné assigns to 1873. Roland Pickvance ("Amsterdam," in *Monet in Holland* [Amsterdam, 1986], pp. 145–46) points out that the twelve compositions seemingly depict varied times of year; he suggests that they were probably executed during several brief trips, each lasting a week or ten days at most. For the tentative dates Pickvance assigns to these paintings, see nos. 26–37, pp. 147–65.

3. For complete texts of all extant reviews, see Ruth Berson, ed., *The New Painting: Impressionism, 1874–1886; Documentation*, 2 vols. (San Francisco, 1996), vol. 1, 9–43, and for lists and illustrations of his known pictures, vol. 2, pp. 9–10 and 24 respectively. See also Paul Hayes Tucker, "The First Impressionist Exhibition in Context," in *The New Painting: Impressionism, 1874–1886*, ed. Charles S. Moffett et al. (Geneva, 1986), pp. 93–142.

4. See Rodolphe Walter, "Les maisons de Claude Monet à Argenteuil," *Gazette des Beaux-Arts* 68 (December 1966): 336. For details about the Manet loan, consult w 1, p. 71 and nn. 509, 511, and WL 77–78. This was the first of several times when Manet would aid Monet financially.

5. John Rewald, *The History of Impressionism*, 4th rev. ed. (Boston, 1973), p. 346.

6. On the devolution of Argenteuil's environment during Monet's residence, and his resistance to depicting these changes in his art, see Paul Hayes Tucker, *Monet at Argenteuil* (New Haven, CT, 1982), esp. pp. 149–53, for his discussion of the far-from-pristine condition of the river and its banks by 1874. Virginia Spate (*Claude Monet: Life and Work* [New York, 1992], pp. 99–106, esp. p. 102) views *By the Bridge at Argenteuil* as a representation of "the interaction of natural and machine time," in which only "the wandering Camille and Jean" give some continuity to the landscape, a judgment that seems more apt for *Poppies at Argenteuil* (1873; figure 8.5), showing mother and son moving through the wild poppy field, than for the work in question.

7. For reprints of the extant 1876 reviews see Berson, 1996, vol. 1, pp. 53–113. Zola's article is reproduced on pp. 111–13.

8. Manet had begun to experiment with *plein air* painting the previous summer, during a vacation spent at Berck-sur-Mer, where he executed *On the Beach* (Musée d'Orsay) at least in part outdoors, as sand in the paint attests.

9. Reported by Marc Elder (Marcel Tendron) in *A Giverny, chez Claude Monet* (Paris, 1924), p. 70.

10. Cited by Ambroise Vollard, *La vie et oeuvre de Pierre-August Renoir* (Paris, 1918), vol. 1, p. 68.

11. Charles S. Moffett, in *Manet, 1832–1883*, ed. Françoise Cachin and Charles S. Moffett with Michel Melot (New York, 1983), no. 141, p. 362, suggests that Camille's pose consciously echoes that of the seated figure in Monet's *Women in the Garden*, for which Camille had also posed.

12. See Paul Hayes Tucker, *The Impressionists at Argenteuil* (New Haven, CT, 2000), cat. no. 21, p. 96. He identifies the fowl as rooster, duck, and duckling.

13. See *Correspondance de Emile Zola*, ed. by B. H. Bakker et al., 10 vols. (Montreal, 1973–93), vol. 2, p. 19, and Moffett, 1983, cat. no. 141, p. 362.

14. On September 12, 1873, Monet wrote Pissarro (WL 69) inviting him to visit, adding that he could spend the night if he liked because Renoir "is not here [at the moment]." Rewald (1973, p. 342) comments on the intimate friendship that existed among Renoir and Claude and Camille Monet during this period.

15. Monet, inspired by Daubigny's earlier example, had the rowboat equipped with a primitive cabin. The studio boat not only permitted him to work right at water level, and move quickly from motif to motif, but also to take overnight journeys to more distant sites.

16. This is the theory proposed by Étienne Moreau-Nélaton, *Manet raconté par lui même*, 2 vols. (Paris, 1926), pp. 22–23.

17. Two india-ink drawings by Manet, depicting Monet in the same straw hat, presumably date from that summer. They are illustrated in Cachin and Moffett 1983, cat. no. 142.

18. In 1876, Manet traded the smaller version for Monet's *Women in the Garden*. Manet had acquired this work when, at the request of the bereaved parents of Frédéric Bazille, he exchanged Renoir's 1867 portrait of their dead son, which he had owned, for the Monet painting. Monet retained *Claude and Camille Monet in His Studio Boat* in his private collection until his death.

19. For concurring identifications, see Dennis Rouart and Daniel Wildenstein, *Edouard Manet: Catalogue raisonné*, 2 vols. (Lausanne, 1975), cat. no. 220, pp. 184–85, as well as Marcello Venturi and Sandra Orienti, *L'opera pittorica di Edouard Manet* (Milan, 1967), no. 195A, p. 104. The Courtauld Gallery of Art, where the picture is on extended loan, concurs in proposing Mme. Monet and Jean as the models.

20. I am indebted to Barbara Mirecki for this suggestion (personal communication).

21. Robert Herbert comments that the model is "dressed in the showy clothing of lower-middle-class women, rather than in the more elegant and restrained dress of the woman in *Boating*." See Robert L. Herbert, *Impressionism: Art, Leisure, and Parisian Society* (New Haven, CT, 1988), p. 236.

22. For his comments about the possibility that Manet worked on both pictures in his studio, as well as outdoors, see Moffett, 1983, cat. nos. 139–40, pp. 353–59.

23. Tucker, 2000, cat. 40, p. 142.

24. As Melissa McQuillan (*Impressionist Portraits* [Boston, 1986], p. 98) observes, the fact that Morisot joined in representing this motif demonstrates that this subject interested a leading female avant-garde artist as well as her masculine counterparts; presumably in her case the discourse about male imaging of female sexuality does not apply.

25. During this same period, Renoir also executed a bust-length portrait of Mme. Monet, now in a private collection, wearing the same robe and, judging from the inclined angle of her head, once again reading.

26. Tucker, 2000, p. 138, cat. no. 38.

CHAPTER TEN

1. On January 30, 1875, the National Assembly declared that France would remain a republic, although a vocal minority continued to push for the return of the monarchy. For details, consult D. W. Brogan, *The French Nation, from Napoleon to Pétain* (New York, 1963), pp. 157–66.

2. See Merete Bodelsen, "Monet's Early Impressionist Sales, 1874–94," *Burlington Magazine*, June 1968, pp. 331–49, and w I, 73–74 and nn. 530–34.

3. See WL 79–83 and, for Manet's letter to the critic Albert Wolff, w I, p. 74 and n. 538. Beguin Billecocq bought several drawings and a painting in November 1872 for two hundred francs. See James A. Ganz and Richard Kendall, *Monet: Pastels and Drawings* (New Haven, CT, 2007), p. 146. Ruth Butler (*Hidden in the Shadow of the Masters* [New Haven, CT, 2008], p. 186) cites a passage from the count's journal relating a visit he made to Argenteuil in July 1876, accompanied by Monet's brother. In order to raise Claude Monet's spirits, "Léon gave him 500 francs. I did the same."

4. Both compositions have evoked literary associations from critics: *Train Engine in the Snow* to Zola's *La bête humaine* (1890) and *The Coal Dockers* to a Dantesque vision of the unending labors of the damned.

5. w I, p. 73. Relations between Renoir and Monet perhaps gradually cooled until 1880, when both artists submitted to the Salon rather than participating in the Fifth Impressionist Exhibition.

6. Renoir's painting *Woman with a Parasol* (ca. 1874–76; Museum of Fine Arts, Boston) depicts a pretty brunette dressed in white lolling in the grass near a toddler (seen only from the rear) who appears to be running away from her inattentive caretaker. In both size and coloring the child closely resembles the toddler in Monet's painting, a fact that lends additional credence to speculations that Camille may have posed for the Renoir work. If so, he must have paid a brief visit to the Monets again in 1875, although no records document his presence that summer. For details and an illustration, see John House, Anne Distel, and Lawrence Gowing, *Renoir* (New York, 1985), cat. no. 31, pp. 71, 206.

7. For an analysis of this picture and its artistic and personal implications, see Mary Mathews Gedo, "Retreat from an Artistic Breakthrough: Gauguin's *Nude Study (Suzanne Sewing)*," *Zeitschrift für Kunstgeschichte*, no. 3 (1995).

8. Marianne Alphant, *Claude Monet, une vie dans le paysage* (Paris, 1993), pp. 252–53.

9. For details, see w II, pp. 44–46, and WL 645–56, 658–60.

10. For his discussion of the circumstances surrounding Monet's return to figuration, see Paul Hayes Tucker, *Claude Monet: Life and Art* (New Haven, CT, 1995), pp. 122–27. See also Martha Ward, "The Eighth Exhibition, 1886: The Rhetoric of Independence and Innovation," *The New Painting: Impressionism, 1874–1886*, ed. Charles S. Moffett et al. (Geneva, 1986), pp. 421–71. Consult also Robert L. Herbert, "*La Grande Jatte* in the Eighth Impressionist Exhibition," in *Seurat and the Making of "La Grande Jatte"* (Chicago, 2004), pp. 118–31.

11. For Wildenstein's analysis of such similarities, see w II, pp. 46–48 and nn. 488–93.

12. See WL 664 and John Rewald, *The History of Impressionism*, 4th rev. ed. (New York, 1973), p. 534.

13. For details, see w III, pp. 82–83, and WL 1397, 1399, and 1402.

14. For this quotation, see W. G. C. Byvanck, *Un Hollandais à Paris en 1891*, reprinted in Charles F. Stuckey, ed., *Monet: A Retrospective* (New York, 1985), pp. 165–66. For an interpretation of the compositions featuring Suzanne at variance with that presented here, see Tucker, 1995, pp. 122–24. See also Virginia Spate, *Claude Monet: Life and Work* (New York, 1992), pp. 175–76, who compares the dual treatments of Suzanne to "less a solid, finite form than a concentration of light, a concentration which fluctuates and dissolves, particularly when viewed side-by-side with the figure in the other painting." She compares this effect to "the intense but ambiguous sensuousness conjured up by Stéphane Mallarmé's *L'après-midi d'un faune* of 1875." The latter comparison seems especially apt in view of the fact that Monet was not only familiar with contemporary French poetry but a close friend of Octave Mirbeau. On April 2, 1886, Monet became a member of Mirbeau's Les Bons Cosaques, a literary group to which Mallarmé also belonged. For details, see w III, p. 1, n. 603, and related letters.

15. J.-P. Hoschedé, *Claude Monet, ce mal connu*, 2 vols. (Geneva, 1960), vol. 2, p. 113.

16. According to Lila Cabot Perry ("Reminiscences of Claude Monet from 1889 to 1900," *American Magazine of Art* 18, no. 3 [March 11, 1927], p. 120), the artist claimed (in a manner that impresses one as rather boastful) that he had put his sabot-clad foot through the canvas one day in a fit of pique. He showed her the repaired tear, which she described as "a tremendous criss-cross rent right through the center of the canvas, but so skillfully mended that nothing showed on the right side."

17. See w II, p. 50, and w 1076–77; and, for conclusions about the damage to the figure facing left, Anne Distel, *Hommage à Claude Monet* (Paris, 1980), cat. nos. 92–93, pp. 267–78. This description conflicts with Perry's account, written many years after the incident. Monet typically "murdered" the children of his fantasy by cutting the canvases to shreds with a knife; perhaps he started to destroy the painting of Suzanne in this manner, but soon thought better of it.

CHAPTER ELEVEN

1. For these quotes, consult René Gimpel, August 19, 1918, in *Diary of an Art Dealer*, trans. Joseph Rosenberg (New York, 1963), p. 59.

2. See w I, p. 74, for this figure as well as for details about the disappointing results of the sale the Impressionists held at the Hôtel Drouot on March 24, 1875.

3. The depictions of Camille that Monet selected for the exhibition might be viewed as a miniretrospective of his representations of her during their first years at Argenteuil, beginning with the idyllic portrait of her in *Springtime* from spring 1872 and ending with that large-scale bizarrerie *La Japonaise*, created during the fall and winter of 1875–76.

4. Most of the reviews appeared in the popular Parisian press, although several French cultural journals and foreign publications also covered the show. For the complete texts of all surviving reviews, see Ruth Berson, "The Second Exhibition 1876," in *The New Painting, Impressionism, 1874–1886; Documentation*, ed. Berson, 2 vols. (San Francisco, 1996), vol. 1, pp. 53–113. For her discussion of the public and critical reaction to the exhibition, consult also Hollis Clayson, "A Failed Attempt," in *The New Painting: Impressionism, 1874–1886*, ed. Charles S. Moffett et al. (Geneva, 1986), pp. 144–86.

5. See Louis Enault, "Mouvement artistique: L'Exposition des intransigeants dans la galerie de Durand-Ruelle [sic]," *Le Constitutionnel*, April 10, 1876, p. 2; reprinted in Berson, 1996, vol. 1, pp. 81–83. Two surviving fragments of nineteenth-century kabuki costumes in the collection of the National Museum of Tokyo, both heavily encrusted with embroideries, are fashioned from tightly woven woolen fabrics of the same shade of red as the kimono depicted in *La Japonaise*. The larger piece, once part of a *jinbaori*, depicts a dragon amid waves; the second, originally a section of an *obi*, shows a carp, also in the sea. Both fragments are gifts of Tagaki Kyo.

6. For one of the more positive—but puzzled—reactions to *La Japonaise*, see the brief, unsigned review in *Le Petit Moniteur Universel*, "Courrier de Paris: L'Ecole des Batignolles," April 1, 1876, p. 3. For their positive comments about other works Monet showed, see P. Dax, "Chronique," *L'Artiste*, May 1, 1876, pp. 347–49. Dax allied himself with those mystified by *La Japonaise*, which he confessed that he observed "without comprehending it." See also Emile Zola, "Deux expositions d'art du mois de mai," *Le Messager de l'Europe* (St. Petersburg, in Russian), June 1878, a variant of *Le Sémaphore de Marseille*, April 30–May 1, 1876; Zola singled out Monet's landscapes for praise while labeling *La Japonaise* "striking in its color and strangeness." Reprinted in Berson, 1996, vol. 1, pp. 101, 70–81, and 111–13, respectively.

7. Charles F. Stuckey (*Claude Monet, 1840–1926* [Chicago, 1995], p. 261, entries for April 14, 1876) persuasively links this letter (WL 88) to the (evidently fictive) sale of the painting, which had occurred only three weeks earlier. Stuckey also notes: "The 12,300 francs of art income recorded in Monet's account book for that year includes this questionable sale, as well as some advances on paintings not yet realized. The total might therefore be exaggerated by as much as twenty per cent." For the auction, consult also Hélène Adhémar, "Ernest Hoschedé," in *Aspects of Monet*, ed. John Rewald and F. Weitzenhoffer (New York, 1984), pp. 60–61 and n. 18.

8. W 1, p. 80 and n. 550. For the painting's provenance, see also W 387.

9. Armand Sylvestre also commented on the similarities between the two works: "M. Monet has sent a Japonerie of grand dimensions in which one finds again all the qualities of *Camille*." See "Exposition de la rue Le Peletier," *L'Opinion Nationale*, April 2, 1876, p. 3; reprinted in Berson, 1996, vol. 1, p. 109.

10. Elisa Evett ("The Critical Reception of Japanese Art in Late Nineteenth Century Europe," PhD diss., Ann Arbor, Mich., ca. 1982, pp. 9–10) also notes that the sketchy rendition of the fans precludes their use as documents of specific works of art. Several critics have suggested that Monet's decision to include the *uchiwa* in the background of *La Japonaise* may constitute a homage to Edouard Manet, whose recent painting *Lady with Fans: Portrait of Nina de Callias* (1874; Musée D'Orsay, Paris) features a similar display. However, the lower halves of three *uchiwa* are shown in the background of Renoir's *Mme. Monet Reading "Le Figaro"* (fig. 9.11), suggesting that such fans formed a regular part of the decor *chez* Monet at the time.

 According to Jill Liddell (*The Story of the Kimono* [New York, 1989], p. 194), Monet would

have purchased these fans from a Parisian shop specializing in Japanese arts and crafts. The first venues of this type opened in the early 1850s, but they proliferated in the wake of the International Exposition of 1867, in which Japan was invited to participate and for which the French officials helped to select the items shown. Mitsukini Yoshida et al. (*The Hybrid Culture: What Happened When East and West Met* [Hiroshima, 1984]) state that the myriad objects featured in the Japanese pavilion included 5,600 ukiyoe prints and 250 round and 450 folding fans.

11. Several critics who reviewed the exhibition commented on the peculiar characteristics of the *uchiwa*. G. d'Olby ("Salon de 1876: Avant l'ouverture—Exposition des intransigeants chez M. Durand-Ruel, rue le Peletier, 11," *Le Pays*, April 10, 1876, p. 3) compared them to butterflies fluttering around the model's head, while Marius Chaumelin ("Actualités: L'Exposition des Intransigeants," *La Gazette des Étrangers*, April 8, 1876, pp. 1–2) noted: "On a blue background, other fans, filled with bizarre designs, move around the principal motif." Punch (Gaston Vassy) ("La journée à Paris: L'exposition des impressionistes," *L'Événement*, April 1, 1876, p. 2) described the fans as keeping themselves suspended in the void "by an incomprehensible miracle of equilibrium." For reprints, see Berson, 1996, vol. 1, pp. 99–101, 67–68, and 105, respectively.

12. In 1988 the Museum of Fine Arts, Boston, organized a miniexhibition around *La Japonaise*, which interpreted the protagonist as dancing with a fan; the picture was shown with other depictions of dancing women in Japanese and Western art. No catalog was published in connection with the exhibition; this information comes from a personal communication of January 18, 1996, from Sydney Resendez, then a research assistant in European paintings at the museum.

 Klaus Berger (*Japanese in Western Painting from Whistler to Matisse*, trans. David Britt [Cambridge, 1992], p. 69) also identifies the painting as depicting Camille as "a Japanese fan dancer." However, as Sachiko Tanaka-Levin has pointed out, dance fans have wider panels and fewer bamboo struts than the *sensu* Camille holds in *La Japonaise* and are designed so that the dancer can insert her fingers between the struts.

 The inspiration for including the *sensu* may have been Camille's. The fan may have been a favorite accessory of hers at the time; she is also represented holding it in Renoir's *Mme. Monet and Her Son in the Garden at Argenteuil* (1874).

13. For illustrations of other works by Whistler showing women in kimono or featuring Oriental *objets d'art* as props, see A. M. Young et al., *The Paintings of James McNeill Whistler*, 2 vols. (New Haven, CT, 1980). During his first years in Europe, Whistler resided in Paris, entering the atelier of Charles Gleyre (with whom Monet would later study) in 1856. Although Whistler moved to London in 1859, he visited Paris frequently thereafter and was friendly with such leading artistic figures as Manet, Courbet, and Henri Fantin-Latour. His first meeting with Monet has not been documented, but the two artists probably met soon after 1862, when Monet returned to Paris and entered Gleyre's atelier.

14. Christopher Wood (*Tissot: The Life and Work of Jacques Joseph Tissot, 1836–1902* [Boston, 1986], p. 37) describes *Japanese Girl Bathing* as "an uneasy, vaguely pornographic image, which cannot be accounted one of Tissot's most successful works, although it is his only large female nude." Michael Westworth (*James Tissot* [Oxford, 1984], pp. 67–71) calls the work "doggedly western." He notes that despite the negative criticism Tissot's Orientalizing paintings generated, his preeminence as a *japoniste* appeared unassailable after he was appointed drawing master to Prince Akitake (younger brother of the last Tokugawa shogun), who was in Paris as the titular head of the Japanese Imperial Commission to the Universal Exposition.

15. Both John House (*Nature into Art* [New Haven, CT, 1986]) and Paul Hayes Tucker ("Of Sites and Subjects and Meaning in Monet's Art," in *Monet: A Retrospective* [Tokyo, 1994]) cite numerous examples of the influence of woodblock prints in Monet's work after 1875–76. In contrast to fellow artists also fascinated by Japonisme, Monet represented Oriental objects in his paintings on only two occasions: in *Meditation* (1871) and—of course—in *La Japonaise*.

16. For reproductions of numerous examples of such prints from Monet's collection, see G. Aitken and M. Delaford, *La collection d'estampes japonaises de Claude Monet à Giverny* (Paris, 1983).

17. Berger (1992, pp. 69–70) also suggests that Monet had Tissot in mind:

 Some whimsical impulse led the painter to show his wife Camille both as a blonde and as a Japanese fan dancer [sic]. The painting is unique, not only among Monet's rare figure compositions, but in his whole oeuvre. Apart from the costume, and the fans that bob like balls across the background, this painting is about as un-Japanese as it could possibly be, even though Monet frequently demonstrated his attachment to Japanese formal principles in the works that preceded and followed it. Was this a joke at the public's expense? Or was it a tour de force to show that he could do anything that a fashionable painter—a Tissot, say—could do? The unusual, rather loud coloring of Monet's painting is more reminiscent of Tissot than of anybody.

18. Yoshida, in Yoshida et al., 1984, p. 90, states that the kimono "was one used for theatrical dramas and was brought to Paris in 1867 for [the] International Exposition." As Monet's letter (WL 84) quoted above reveals, he was aware that the robe had belonged to an actor.

19. W I, p. 73 and n. 527. The fact that Monet sold both robes, two picture frames, and three (Japanese?) plates for the modest total sum of two hundred francs indicates how desperate his financial situation must have been at the time.

20. Hugo Muensterberg (*The Japanese Kimono* [New York, 1996]) points out that, in contrast to the dearth of surviving kabuki robes, numerous noh costumes have come down to us. (Kabuki costumes were frequently remade; even embroidered motifs were unstitched and redone.) Ken Kirihata (*Kabuki Isho* [Kabuki Costumes] [Kyoto, 1994]) describes the difficulties he encountered in unearthing enough nineteenth-century costumes to illustrate his volume.

21. For beautiful color photographs of such costumes, consult Kirihata, 1994. Only three of the illustrations depict mythical or "actual" personages who show some similarity to the manikin pictured on the robe in *La Japonaise*.

22. Samuel Leiter (*New Kabuki Encyclopedia* [Westport, CT, 1997], p. 158) characterizes *The Tale of the Heike* as "an anonymous medieval war chronicle narrating the [real-life] conflict between the defeated Taira (or Heike) and victorious Genji (or Minamoto) clans during the years 1132–1191. Its characters and events became an abundant source of materials for noh, puppet, and kabuki plays. Despite their tragedy, many of the Taira came to be sympathetic characters in Japanese legend, which often favors the underdog."

23. Samuel Leiter and other sources contacted by Tanaka-Levin all agreed that they could not specifically identify the samurai.

24. For numerous illustrations of garments representing such large-scale creatures and landscapes, see Kirihata, 1994.

25. Over the centuries, innovative costumes designed by female impersonators played key roles in the evolution of the *obi*, the creation of new patterns and colors in kimono, and the popularization of outsize, garish embroideries such as that depicted in *La Japonaise*. Middle-class women

flocked to the theaters to study (and copy) the latest styles and hairdos affected by the *onnagata*. For a concise summary of their contributions to the evolution of feminine clothing, see Muensterberg, 1996, pp. 37–43, 64. See also Liza Dolby, *Fashioning Culture* (New Haven, CT), pp. 44–48, 275.

26. Around June 10, 1867, Monet left Paris for Sainte-Adresse, where he remained throughout the summer except for brief trips to Paris. By mid-June the Universal Exposition had been open for more than two weeks, allowing ample time for him to have seen any kabuki performances staged before he left the capital. His surviving letters from that summer make no mention of having attended a kabuki drama. For details, consult w 1, pp. 35–37, and WL 32–38.

27. For their reviews, see S. Boubée, "Beaux-Arts: Exposition des impressionistes chez Durand-Ruel," *Gazette de France*, April 5, 1876, p. 2, and E. Poncheron, "Promenades d'un flâneur: Les impressionistes," *Le Soleil*, April 4, 1876, p. 4. For reprints, see Berson, 1996, vol. 1, pp. 64 and 102–3, respectively.

28. Virginia Spate (*Claude Monet: Life and Work* [New York, 1992], p. 115) also suggests that Monet may have been playing on the European idea of the geisha as prostitute.

29. For Tucker's analysis of this atypical, puzzling painting, see Paul Hayes Tucker, *Claude Monet: Life and Art* (New Haven, CT, 1995), pp. 84–86. See also Marianne Alphant, *Claude Monet, une vie dans le paysage* (Paris, 1993), pp. 37–38. Michel Monet sold this painting in 1940. For its provenance, consult w 282.

30. For his complete review, see M. Chaumelin, "Actualités: L'Exposition des intransigeants," *La Gazette des Étrangers*, April 8, 1876, pp. 1–2; for the reprint, see Berson, 1996, vol. 1, pp. 67–68.

31. Clare Joyes (1985, p. 50) describes Monet as "equally prone to absolute passivity and extreme violence, flying into a temper if some premature blossom had altered the subject of a painting." As he grew older, richer, and more self-critical (as well as more self-indulgent), he impulsively destroyed many paintings that displeased him. He recounted several examples of this sort to Lila Cabot Perry ("Reminiscences of Claude Monet from 1889 to 1900," *American Magazine of Art* 18, no. 3 [March 11, 1927], pp. 119–20), including an incident when he became so furious at what he perceived to be his inadequacy while painting in his studio boat that he tossed all his equipment overboard. By the next day he had, of course, recovered his enthusiasm—but had to replace everything he had "drowned." Such tempestuous behavior echoes childish temper tantrums, which he had never been helped to overcome at the appropriate stage in his early development.

32. Alphant (1993, p. 263) notes:

> In this strange work that provokes malaise, the *other* Monet breaks through—not the painter of pleasant scenes and harmonies, but [the creator of] dissonances that strike one in certain *London Parliaments*, or in the terrible vegetative entanglements of the *Japanese Bridges*. Beneath this grotesque warrior, beneath this blond wig that so strangely disfigures Camille, one cannot but perceive the symptoms of intimate tensions—something menacing, parodying, and unarticulated.

CHAPTER TWELVE

1. See w 1, pp. 79–80, and, for Monet's correspondence, WL 85–99.

2. For the most extensive exploration of the interconnection between Monet's art and the rapidly accelerating deterioration in Argenteuil's environment, see Paul Hayes Tucker, *Monet at*

Argenteuil (New Haven, CT, 1982), especially pp. 155–85. For Marianne Alphant's theory about tensions in the Monet marriage, consult Alphant, *Claude Monet, une vie dans le paysage* (Paris, 1993), p. 263. Richard Brettell, in his 1995 Art Institute of Chicago lecture "Portrait of a Marriage," concurred in identifying this period as a troubled one in the couple's domestic life.

3. Only w 401, now in the Musée Marmottan, includes a fragmentary view of the Pavillon, the only portion of the palace still standing.

4. Tucker (1982, p. 163) points out how carefully—and characteristically—Monet limited the perimeters of his painted universe in both series.

5. See w 1, p. 101, for a photograph taken on January 1, 1878, showing Mme. Hoschedé holding her son Jean-Pierre, then four months of age. She looks equally plump—but more attractive—in another photo from the same year reproduced in Claire Joyes, *Claude Monet: Life at Giverny* (New York, 1985), p. 21.

6. Whether she posed for *Woman in the Garden* (w 407), which seems to have been left in a sketch-like state, is unclear. Most likely she did model for *Resting in the Garden, Argenteuil* (w 408), in which the model appears seated on the grass beside an unidentified male companion.

7. Virginia Spate, *Claude Monet: Life and Work* (New York, 1992), p. 119.

8. Dr. John Lurain, personal communication.

9. See Tucker, 1982, p. 158.

10. Charles F. Stuckey, *Claude Monet, 1840–1926* (Chicago, 1995), p. 201, entry for August; Paul Hayes Tucker (*Claude Monet: Life and Art* [New Haven, CT, 1995], p. 91) proposes that Monet worked at Montgeron "for approximately six months, from July to December." w 1, p. 83, describes Monet's stay as extending from the summer to the fall but does not assign precise dates.

11. On the contrast between the unspoiled character of the Hoschedé estate and the accelerating deterioration of Argenteuil and its river, see Tucker, 1982, pp. 163–69.

12. For details, see w 1, p. 81 and n. 561, and pp. 83, 91; see also Alphant, 1993, pp. 279–80. See Hélène Adhémar, "Ernest Hoschedé," in *Aspects of Monet*, ed. John Rewald and Frances Weitzenhoffer, pp. 57–62 (New York, 1984). For additional details regarding Hoschedé's business arrangements, see Hélène Adhémar, ed., *Hommage à Monet* (Paris, 1980), pp. 169–74 and notes.

13. For the studies, see w 417, 419, 431–32; Hoschedé also owned *Arriving at Montgeron* (w 421). Whether he briefly took possession of the full-scale version of *The Pond at Montgeron* remains unclear.

14. Although he showed *The Turkeys* (w 416; Musée d'Orsay, Paris), the earliest of the four paintings, in the 1877 Impressionist Exhibition and again in the Monet-Rodin exhibition of 1889, both catalogs describe the picture as unfinished.

15. Monet provided additional glimpses of the lower right area of the pond in *Corner of the Garden at Montgeron* (w 418, present whereabouts unknown), in which Spate (1992, p. 120) discerns a second, still more covert image of Mme. Hoschedé, visible "only through the broken colors which hint at her reflection."

16. Joel Isaacson (*Observation and Reflection: Claude Monet* [Oxford, 1978], no. 58, p. 210) contrasts *The Pond*, "slow, contemplative, receptive, under a maternal sway," with the more active, masculine world of *The Hunt* (w 431; private collection). "[In these two pictures] Monet offers two worlds, more surely separated in feeling and function than by the obvious differences of season."

17. See Alphant, 1993, pp. 259–81; the excerpt from October 8 appears on p. 277. Wildenstein also seems to subscribe to this theory; see w 1, p. 83 and n. 595, in which he points out—as have other

accounts—that Jean-Pierre Hoschedé let it be understood that *he* believed Monet was his father, although, as Wildenstein concedes, the artist did not treat him in any special manner, as he might have a "love child." I do not believe that Monet was Jean-Pierre's biological father, but he was certainly the only father figure Jean-Pierre would ever know, for Ernest Hoschedé effectively abandoned his wife while their youngest child was still an infant, and in his later annual visits to the Hoschedé-Monet ménage he scarcely demonstrated any real paternal interest in his flock.

18. Alice Hoschedé's favorite sister, who had suffered a postpartum depression, died in 1868, the same year she lost her mother; her father passed away in 1870, a brother in 1871. For a "diagnosis" of Mme. Hoschedé and further excerpts from her diary, see Alphant, 1993, pp. 265–66. This is not to say that Mme. Hoschedé should not have mourned these significant deaths but rather that it was abnormal for them to have preoccupied her so exclusively five and six years later. Many years later, she would mourn the passing of Suzanne Hoschedé-Butler (1868–99) in even more pathological fashion, and she never fully recovered from that loss.

19. See Tucker, 1995, pp. 105–6 and n. 34, p. 228.

20. According to the oncologist I consulted about Camille's illness, cancer of the cervix typically begins around age thirty and has a three-year duration if left untreated. Camille was probably experiencing severe hemorrhaging when the Monets consulted the physicians, who would have treated the acute problem by packing her to stem the flow of blood. Evidently this measure proved effective—at least for the moment—for by Monday, December 4, 1876, Monet was back at Montgeron, as his letter of that date (WL 99) to Gustave Manet indicates.

Joseph Baillio and Cora Michea, in "Chronology and Pictorial Survey of the Life and Career of Claude Monet," in *Claude Monet (1840–1926): A Tribute to Daniel Wildenstein and Katia Granoff* (New York, 2007), on p. 160, under the heading "1879," posited that Camille Monet died of tuberculosis. How they arrived at this conclusion is puzzling, because according to medical consultants she never showed any symptoms of this condition. Rather, the description of her symptoms in 1879 (as reported in Monet's letters, here quoted in chapters 13–15) are quite consistent with a cancer that spread from her cervix to her uterus, her ovaries, and ultimately her entire body.

21. B. H. Monet, "Notes Posthumes de Blanche Hoschedé Monet," in J.-P. Hoschedé, *Claude Monet, ce mal connu*, 2 vols. (Geneva, 1960), vol. 1, 158.

22. Wildenstein suggests that two pastels (W V, P 57–58) depicting Mme. Monet crocheting while reclining on a chaise lounge may have been executed as late as 1878, during her second pregnancy, although P 57 is signed and dated 1868. Moreover, as Wildenstein himself points out, Camille's hairdo in these pictures most closely resembles the style she affected around 1868–71.

23. Blanche Hoschedé (1960, p. 158) specifically states that Monet painted Germaine's portrait while staying at Montgeron but does not allude to the other two portraits.

24. Blanche Hoschedé (ibid., pp. 158–59) emphasizes Monet's love of children, describing him as "très taquin"—quite a tease with them.

25. Germaine's portrait was briefly jointly owned by both parents, but when Ernest Hoschedé effectively deserted his family, he left the portrait of her and that of her unidentified sibling behind. Both remained in the Hoschedé-Monet collection for many years; eventually Germaine's portrait passed to the sitter and her husband, Albert Salerou; it was not sold until after her death. The other portrait remained at Giverny until after Michel Monet's demise. For provenance information about their subsequent ownership, consult the entries for W 434–35.

26. For his identifications and comments, see Isaacson, 1978, no. 58, p. 208. To his list I would add the poignant *Red Cape* (1868) and perhaps *The Stroll*. As this text emphasizes, Monet's more typical representations of Camille focus not on her personality but on her symbolic role as Nature and Nature's ornament.

27. As previously noted, he repeated this pattern in 1868 and 1870. For Monet's description of their financial situation in the latter half of 1876 and the first months of 1877, see letters WL 93–100, 102–3, and 107–8.

28. For details, see W 436.

<center>CHAPTER THIRTEEN</center>

1. As Wildenstein himself points out, the hairstyle she wears in these two pastels is strikingly similar to her coiffure as shown in pictures from circa 1868–70, such as W 110, 1868, and 163 (1870–71). For illustrations and Wildenstein's argument for the 1878 date, consult W V, p. 165.

2. After several fruitless attempts to obtain official permission to work there, Monet finally succeeded, as he triumphantly informed a friend in a letter dated January 7, 1877. For details, consult W I, pp. 83–84, and WL 100–101. See also Jean Renoir, *Renoir, My Father* (London, 1962), pp. 174–75, for the (possibly apocryphal) account, no doubt related to him by Monet, about his interview with the station director.

3. In addition to paying the rent, Caillebotte advanced Monet another 1,660 francs during 1877. See chronology in Anne Distel et al., *Gustave Caillebotte, Urban Impressionist*, exh. cat. (Paris, 1995), p. 313. Wildenstein, evidently convinced that Monet had initiated his romantic relationship with Mme. Hoschedé at Montgeron, suggests in W I, p. 83, n. 599, that the flat also would have provided a convenient spot for discreet meetings with her.

4. See Charles F. Stuckey, *Claude Monet, 1840–1926* (Chicago, 1995), entry for January, p. 202.

5. Organized, financed, and publicized almost entirely by Caillebotte, it featured 241 works by eighteen artists. For details, consult Richard Brettell, "The 'First' Impressionist Exhibition," in *The New Painting: Impressionism, 1874–1886*, ed. Charles S. Moffett et al. (Geneva, 1986), pp. 189–240.

6. For current titles of all the *identified* works Monet showed, see Ruth Berson, ed., *The New Painting, Impressionism, 1874–1886; Documentation*, 2 vols. (San Francisco, 1996), vol. 2, pp. 75–78.

7. For his article "Les Impressionistes," see *La Petite Presse*, April 9, 1877, p. 3, in Berson, 1996, vol. 1, pp. 174–75.

8. For his positive comments about the Gare Saint-Lazare series, see Jaques (pseud.), "Menus propos: Salon impressioniste," *L'Homme Libre*, April 11, 1877, p. 2, quoted in Berson, 1996, vol. 1, pp. 155–56. For reprints of *all* extant 1877 reviews, including related caricatures, see Berson, 1996, vol. 1, pp. 123–200.

9. On August 18, 1877, Hoschedé temporarily fled to Brussels, abandoning his beleaguered wife (on the verge of delivering their sixth child!) to face their creditors alone. The bailiffs seized the Hoschedés' Parisian apartment and its contents, then the chateau and all its furnishings, except for the silver and jewelry, which Mme. Hoschedé managed to save. Assisted by relatives, she boarded a train to Biarritz, where, on August 21, she gave birth to her youngest child, Jean-Pierre. For details, see W I, pp. 81, 83, 91. Consult also Marianne Alphant, *Claude Monet, une vie dans le paysage* (Paris, 1993), pp. 279–80, and Hélène Adhémar, in *Hommage à Monet*, ed. Adhémar (Paris, 1980), pp. 169–74, esp. p. 169, n. 1, and p. 172, n. 6.

10. For details, consult w i, pp. 87–89 and n. 612. Stuckey, 1995, entry of June-July, p. 202, notes: "When possible, [Monet] barters art to settle debts, for example trading sixteen works to his art supplier, Voisinot."

11. w i, p. 88.

12. For these letters, see WL 102–3, 106–10. The missive he sent de Bellio that June (WL 107) was especially dramatic. Beginning "I could not be more unhappy," Monet claimed that the family was threatened with imminent eviction and seizure of all possessions. However, with five hundred francs he could save the situation, and he offered de Bellio twenty-five canvases for that sum! De Bellio selected ten paintings, for a total of one thousand francs, and agreed to advance Monet the five hundred francs that would "save" him.

13. Desperate for money, Monet offered paintings for as little as fifty francs. His patron Eugène Murer snapped up four canvases at this price—surely one of the best bargains in the history of art! For details, see WL 110–11.

14. Manet lent him 1,200 francs, de Bellio 200, and Caillebotte 160. For details, consult w i, p. 89, and WPJ 30.

15. See w i, pp. 116–21, 127–29, and WL 116, 117, 119–22.

16. Monet acknowledged receipt of the money in a letter to Manet dated March 10. For details, see w i, p. 89, and WL 124. Wildenstein believes that this sum was apparently separate from the twelve hundred francs Manet had lent Monet in January, although the entries in both artists' account books are unclear on this point. Caillebotte also continued to advance sums to Monet throughout 1878. In March he purchased five paintings from the artist. However, Monet owed Caillebotte so much money that he got little or no profit from the transaction. For details, consult Anne Distel et al., *Gustave Caillebotte, Urban Impressionist*, exh. cat. (Paris, 1995), pp. 310–11, and Stuckey, 1995, p. 203, entry for March.

17. For the letter to Zola, see WL 129, dated April 7; and to Murer, w 130, dated April 11.

18. Ernest Hoschedé purchased Monet's view of the rue St. Denis but kept it only a few days before reselling it for two hundred francs—he had paid only one hundred. That Hoschedé had the audacity to continue buying—if not retaining—works of art seems little short of incredible. His bankruptcy, initially declared in 1877, had been confirmed by the Court of Appeals on April 8, 1878, and on June 5–6 he had been forced to auction his art collection; the sixteen works by Monet included in the sale brought modest prices, ranging from 35 to 505 francs, averaging 155—an indication that the market for his work continued to be depressed, despite the fact that Théodore Duret had just issued a pamphlet, *Les peintres impressionistes*, in which he singled out Monet as the "Impressionist par excellence." The dealer Georges Petit purchased three of Monet's pictures, buying back at least one for the artist himself, as documented by WL 135. Before too long Petit would become Durand-Ruel's chief rival as the leading dealer in Impressionist pictures. For details of the sale, consult w i, pp. 90–92, and Adhémar, 1982, pp. 172–73 and nn. 11, 12. See also Stuckey, 1995, p. 203, entry for June 5–6.

19. According to Paul Hayes Tucker ("Of Sites and Subjects and Meaning in Monet's Art," in *Monet: A Retrospective* [Tokyo, 1994], pp. 105–6), the invitation to share households and expenses originated with Monet. Alphant (1993, p. 300) believes it most likely originated with Hoschedé. Wildenstein (I, p. 92) skirts the issue altogether.

20. See WL 140. Poor Camille's "bad milk" certainly did not affect Michel's future physical health or longevity; he was killed in an auto accident on February 9, 1966, shortly before he would have

celebrated his eighty-eighth birthday. Hardly surprisingly, he fared far less well psychologically; unable to apply himself seriously to any line of study or work, he lived off the proceeds of selling his father's pictures, including paintings from Monet's private collection. He did not marry until five years after his father's death.

21. Following his bankruptcy, he received five hundred francs a month, plus free use of a Parisian apartment (no doubt nicely furnished) from his doting mamma. For details, consult w 1, pp. 93–94; and for a more sympathetic view of Hoschedé's later life, see Hèléne Adhémar, "Ernest Hoschedé," in *Aspects of Monet*, ed. John Rewald and Frances Weitzenhoffer (New York, 1984), pp. 66–67.

22. Stuckey (1995, pp. 204–5), in his entry for October, reports that Monet's income from art sales amounted to only 4,000 francs, while Tucker (1995, p. 103) puts the figure at 11,500 francs.

23. For Caillebotte's advances, consult Distel et al., 1995, entries for 1878, pp. 313–14.

24. For an example from Picasso's oeuvre, see Mary Mathews Gedo, *Picasso: Art as Autobiography* (Chicago, 1980), p. 130.

25. See, for example, his letters to de Bellio (wL 154, dated March 10) and Murer (wL 156, March 25). But not all Monet's letters from this period sound such a despairing note. On February 8 he wrote Duret, announcing that he had become "a country squire" and asking his friend to send him a little barrel of cognac, for which he would settle later (wL 154)!

26. Via a combination of financial aid, encouraging words, and concrete help in collecting the pictures Monet wished to show, Caillebotte persuaded his friend to participate in the exposition, which he again assumed primary responsibility for organizing, publicizing, and funding; it ran from April 10 to May 11. Between January and April, Caillebotte advanced Monet three thousand francs, paying an additional two hundred for a Vétheuil snow scene. For details about these payments, consult Distel et al., 1995, pp. 314–15, and for his encouraging letter to Monet, see the entry for February 19. See also Stuckey, 1995, p. 204, entries for mid-March and April 10–May 11; w 1, pp. 95–96; and wL 155–57.

27. As had been the case in 1877, reviews were generally more favorable in tone. Although Monet did not receive kudos from everyone, most critics praised his two versions of the fête of June 30. Ph. B. (Philippe Burty), for example, hailed *La Rue Montorgueil, 30th of June, 1878*, as the work of a master. See Burty, "L'Exposition des artistes indépendants," *La République Française*, April 16, 1879, p. 3, reproduced in Berson, 1996, vol. 1, pp. 209–10. Even Louis Leroy, that relentless disparager of the Impressionists, confessed to responding positively to the two fête pictures but couldn't resist adding that if you stared at them long enough you would have to visit an oculist. He also reluctantly admitted to unreserved—if puzzled—admiration for the elegiac *Entrance to the Port of Trouville* (1870): "This study is very refined tonally, very accurate, very successful. What are all these fine qualities doing in an Impressionist work?" See Leroy, "Beaux-arts," *Le Charivari*, April 17, 1879, p. 2, and Berson, 1996, vol. 1, pp. 227–28. See Arsène Houssaye, the unidentified author of "Lettres, sciences, beaux-arts," *La Petite République Française*, April 13, 1879, pp. 2–3, translated in Berson, 1996, vol. 1, pp. 236–37. He hailed *The Garden at Sainte-Adresse* as a "chef-d'oeuvre of frankness, light, and vigor. And note that the picture has a very finished facture. *Honi soit qui mal y pense!*" Ph. D. (Philippe Burty) admired *La Rue Montorgueil* as "the composition and painting of a master." See Burty, "L'Exposition des artistes indépendants," *La République Française*, April 16, 1879, p. 3, and Berson, 1996, vol. 1, pp. 209–10.

28. See w 1, p. 97 and n. 372.

29. Monet's identification with his father would permit him to initiate the affair with Mme. Hoschedé, which, I believe, did not begin until well after Camille's passing.

30. Caillebotte purchased an unidentified "Vétheuil" for 100 francs (paying cash rather than deducting the sum from the sizable amount Monet owed him), and Duret bought *Vétheuil Seen from Lavacourt* (w 528) for 150 francs, a sale brokered by Hoschedé.

31. See w 1, pp. 96–97 and nn. 721, 723–24.

32. For details of Caillebotte's disbursals to Monet during 1879, see Distel et al. 1995, p. 315; the 700 francs Caillebotte advanced in October were presumably earmarked to pay the annual rent for Monet's Paris studio. That August, Ernest Rouart also loaned Monet 100 francs; Tucker (1995, p. 107) puts Monet's income for 1879 at 12,285 francs!

33. He wrote his mother from Vétheuil on August 13, noting "the terrible condition of Mme. Monet, who has not been able to keep any food down for the last three days." On August 19, he again wrote his mother, urgently requesting the "150 francs that remain to be paid on September 1" (presumably for the rent). For these quotations, see w 1, p. 98, n. 734, and p. 96, n. 720, respectively.

34. Ibid., p. 97 and n. 725.

35. Monet's neighbor and friend, the wealthy painter Léon Peltier, also criticized the artist's treatment of the dying Camille, evidently basing his judgment on scenes he had witnessed while posing for Monet, who painted Peltier's portrait that summer (w 542). Unfortunately, no details concerning his observations have come down to us (ibid.).

36. Ibid., pp. 97–98 and n. 738.

37. These quotations all come from the letter Mme. Hoschedé wrote her mother-in-law on September 12, 1879, cited in w 1, p. 98 and n. 741.

38. Typically a Catholic burial would have been preceded by a requiem mass, but such services were not then available on Sundays, when the morning was devoted to offering multiple masses for the congregation.

39. w 1, p. 99 and n. 748. James A. Ganz and Richard Kendall (*Monet: Pastels and Drawings* [New Haven, CT, 2007], p. 150 and n. 88, p. 286) report that Beguin Billecocq's journal may contain further information about Camille's terminal illness. Ruth Butler (*Hidden in the Shadow of the Masters* [New Haven, CT, 2008], p. 193) cites unpublished portions of the journal to the effect that on the day of Michel's birth Monet told Beguin Billecocq that Camille's illness was incurable and her suffering was great.

CHAPTER FOURTEEN

1. For details, consult w 1, pp. 99–100, nn. 757–58 and 765, and wL 165–67. For Monet's letter to Hoschedé, see Hèléne Adhémar, "Ernest Hoschedé," in *Aspects of Monet*, ed. John Rewald and F. Weitzenhoffer (New York, 1984), pp. 65–66, and, for Caillebotte's advances, Anne Distel et al., *Gustave Caillebotte, Urban Impressionist*, exh. cat. (Paris, 1995), p. 315.

2. w 1, p. 105.

3. For this quote and de Bellio's response to Monet's letter, see w 1, p. 105, n. 798.

4. See w 1, pp. 107–8 and nn. 799–811, and wL 172.

5. See w 1, pp. 109, 119, and nn. 803, 804, 806, 808, 909, and wPJ 43–44. Monet's share of the joint household expenses amounted to three-tenths of the total for himself and his two sons, while Hoschedé was charged with contributing seven-tenths of the total amount, to cover Mme. Hoschedé and their six offspring.

6. See W I, pp. 109–10.

7. Renoir's delightful *Portrait of Mme. Charpentier and Her Children* (1879; The Metropolitan Museum of Art) found favor not only with its subject and her husband but also with the jury of the 1879 Salon, where it was displayed advantageously. For details, consult John House, Anne Distel, and Lawrence Gowing, *Renoir* (London, 1985), cat. no. 44, p. 214.

8. It was true that Monet had no proper studio in the crowded dwelling at Vétheuil; when he needed to work indoors, it was either in his bedroom or in the attic. Throughout his career, he not only often retouched or completed works in his studio but also, more rarely, executed entire compositions indoors, based on studies created outdoors.

9. For the catalog, see Théodore Duret, *Le peintre Claude Monet, notice sur son oeuvre* (Paris, 1880). The pamphlet-sized catalog lists all of the eighteen paintings Monet showed, but not all have been positively identified. For Wildenstein's comments and identifications, see W I, pp. 110–12 and n. 848. See also Virginia Spate, *Claude Monet: Life and Work* (New York, 1992), pp. 141–43 and n. 32, p. 325. Taboureux's interview appeared in the June 12 edition of *La Vie Moderne*, accompanied by a portrait of Monet by Edouard Manet (also used for the catalog). A second story, published a week later, reproduced Monet's drawing of the 1867 marine (W 94), presumably executed specifically for the journal.

10. Zola's essay appeared on June 18, 19, and 21 in *Le Voltaire*, also published by Charpentier. His snide reference to "personal considerations" in Monet's life was recognized as a thinly veiled allusion to his relationship with Mme. Hoschedé.

11. See W I, pp. 111–12 and n. 839, and Anne Distel, "Chronology," in Distel et al., *Gustave Caillebotte: Urban Impressionist*, exh. cat., The Art Institute of Chicago (Chicago, 1995), see p. 315.

12. For details about the rift, consult Joel Isaacson, *The Crisis of Impressionism, 1878–1882* (Ann Arbor, MI, 1980), esp. pp. 3–7. See also Charles S. Moffett, "The Fifth Exhibition, 1880: Disarray and Disappointment," pp. 293–369, and Joel Isaacson, "The Seventh Exhibition, 1882: The Painters Called Impressionists," pp. 375–418, in *The New Painting: Impressionism, 1874–1886*, ed. Charles S. Moffett et al. (Geneva, 1986). The 1882 exhibition was the last in which Monet participated; he had abstained in 1881.

13. See W I, pp. 115–16, and, for letters to de Bellio, WL 195, 201; to Duret, WL 197, 200. He also repeatedly wrote to Charpentier (WL 192, 194, 198) urging him to send (in advance) all—or part of—the next payment for *Floating Ice*.

14. For a list of the pictures and critical responses, see W 115 and nn. 863, 865.

15. See W I, p. 116 and nn. 876, 878–79, and WL 202–4.

16. See Georges Clemenceau, *Claude Monet, Les Nymphéas* (Paris, 1928), reprint ed. *Claude Monet: Cinquante ans d'amitié* (Paris, 1965), pp. 21–22. As has frequently been recognized, the scene in Zola's *L'Oeuvre* in which Claude Lantier impulsively paints the portrait of his dead child was probably based on Monet's experience. It provides yet another instance of Zola's callous exploitation of incidents from Monet's private life.

17. Joel Isaacson (*Observation and Reflection: Claude Monet* [Oxford, 1978], p. 210) makes the same observation.

18. For example, Steven Z. Levine ("Monet, Madness, and Melancholy," in *Psychoanalytic Perspectives on Art*, ed. Mary Mathews Gedo [Hillsdale, NJ, 1987], vol. 2, pp. 124–25) states, "The brushstrokes that beat out a rhythm of distress over the dead Camille deform her features after the manner of caricature." Paul Hayes Tucker (*Claude Monet: Life and Art* [New Haven, CT,

1995], p. 102) emphasizes "the contrast between Camille's mandorla-shaped head and the wind-swept surface of the rest of the canvas; the former is sweet, angelic, and passive; the latter force-ful, energized, and brimming with impasto." For Isaacson (1978) the portrait seems "haunting, almost spectral," and "does not betray an automatic fascination with the tonal nuances." Spate (1992, p. 137) perceives the work as "an astonishing image of dissolution in which insubstantial, drifting, thread-like strokes . . . suggest something of the mystery of a body from which life had departed."

19. Isaacson, 1978; J.-P. Hoschedé (*Claude Monet, ce mal connu*, 2 vols. [Geneva, 1960], p. 83) notes that Monet repeatedly spoke affectionately of Aunt Lecadre.

20. See Steven Z. Levine, *Monet, Narcissus, and Self-Reflection* (Chicago, 1994), pp. 252 and 24, respectively.

21. See Spate, 1992, pp. 311–12.

22. Between summer 1887 and December 1892, Robinson spent a great deal of time in France, much of it at Giverny. Monet and he soon became close friends. The four diaries Robinson kept during his Giverny years provide valuable insights into Monet's attitudes about his art. Later accounts of visitors to Monet's bedroom, describing the myriad paintings he kept there, do not mention *Camille on Her Deathbed*. Did Monet remove it—whether spontaneously or at Alice's insistence—following his marriage to Alice, always so jealous of her predecessor?

23. Proposed by Spate, 1992, p. 138.

24. Isaacson (1978, p. 211, no. 62) emphasizes the daring character of Monet's viewpoint, suggesting that he adapted the angled perspective of Degas to the still life.

25. The composition also evokes associations to water from Isaacson (ibid.), who suggests that Monet views the table "almost as he was to view the cliffs against the sea in his paintings of Normandy in the next two to three years."

26. Psychoanalyst J. E. Gedo dismisses this threat as "moral blackmail."

27. See Spate, 1992, p. 138. John House (*Nature into Art* [New Haven, CT, 1986], p. 40) denies that any of the still lifes of 1879–80, or the ice floe paintings that followed, have an "autobiographi-cal" significance; he attributes them instead to a change in the artist's commercial strategy.

28. For the weather conditions during January and February 1880, consult w 1, pp. 106–7 and nn. 790–94. See also Isaacson, 1980, cat. no. 30, p. 132. Although w 556–58 also depict ice floes and w 556 is even titled *Ice Floes at Lavacourt*, neither Wildenstein nor Isaacson includes them in the Débâcle series.

29. The catalog listing for W. 557, which preceded the Débâcle series, notes: "Two small figures center left were visible in 1905, but were subsequently covered over." Whether they were covered over by Monet's hand or that of another is not clear.

30. *Lavacourt* (w 578), Monet's successful Salon entry, was also a studio creation, based on an amal-gam of w 475 and 538–40, all dated 1879. As Isaacson (1980, nos. 30 and 31, pp. 132–35) and others have observed, Monet no doubt retouched and refined other pictures from the series, initiated before the motif, in his studio.

31. Monet executed two similar works in the summer of 1881 (w 680–81), showing Mme. Hoschedé seated in the garden at Vétheuil, again with her features only vaguely delineated. He neither presented any of these three pictures to his model nor retained them for his private collection; Paul Durand-Ruel bought all three shortly after their completion.

32. Recent neurophysiological studies have demonstrated that traumatic events such as the prema-

ture loss of a parent can physically alter the brains of youthful victims, forever imprinting their thought patterns, emotional responses, and behavioral modes.

EPILOGUE

1. For the period immediately preceding the move to Giverny and the first three years there, consult w II, pp. 1–58; for the years 1887–93, see w III, pp. 1–56, and relevant notes and letters from both volumes. By 1890 Monet, whose paintings now commanded much higher prices, was fairly prosperous. Nonetheless, he required—or at least requested—an advance of three to four thousand francs from the dealer Paul Durand-Ruel to help finance the Giverny purchase.

2. His return to Rouen is documented by WL 1175, written on February 16, informing Alice of his arrival. For details about the 1893 Débâcle series and the cathedral paintings executed between 1892 and 1893, see w III, pp. 44–55 and the relevant catalog entries. There were ice floes on the Seine for three weeks before it froze solid on January 18; the *débâcle* began five days later, causing Monet to complain in a letter to Durand-Ruel (WL 1174) that the thaw had occurred before he was ready. For details, consult w III, pp. 48–50. Many—perhaps all—of the ice floe pictures were later finished, or at least retouched, in his studio, which accounts for the fact that some bear an 1894 date even though they had been initiated the previous year.

3. w III, pp. 48–50. Bennecourt undoubtedly did remind Monet of Zola, who had originally recommended the area to the artist and had utilized observations of Monet at work there in 1868 as the basis for an incident in *L'Oeuvre*. In view of the artist's distress over Zola's free adaptation of events from his personal history for the novelist's roman à clef, it seems highly unlikely that he would have been drawn to return to Bennecourt in imitation of Lantier.

4. Wildenstein (w III, p. 50) suggests that an exhibition of Japanese prints by Hiroshige and Utamaro that Monet and Pissarro had visited on February 1, 1893, with their "images of still waters, exotic plants, miniature bamboo forests and Japanese bridges," may have helped to shape the decidedly Oriental flavor the Giverny water gardens would assume. It seems more likely that the artist, an avid collector of Japanese prints, had such a plan in mind well before visiting the exhibition. As early as 1891 a Japanese gardener had responded to an invitation to visit Giverny (as attested by WL 1111b). For Monet's extensive print collection, see G. Aitken and M. Delaford, *La collection d'estampes japonaises de Claude Monet à Giverny* (Paris, 1983).

5. For Monet's professional and personal relationships with leading French poets, see Steven Z. Levine, *Monet, Narcissus, and Self-Reflection* (Chicago, 1994), 132–33.

6. See Paul Hayes Tucker, *Claude Monet: Life and Art* (New Haven, CT, 1995), pp. 175–235, for his sensitive—and moving—discussion of the Giverny gardens.

7. Monet kept his word to the Sisley children, arranging a benefit auction of the artist's unsold works at the Georges Petit Gallery in Paris on May 1, contributing a recent work of his own, purchasing one of Sisley's, and keeping the bidding lively. For details about these deaths and their sequelae, consult w IV, pp. 2–3 and relevant notes, plus WL 1434–37, 1442, 1445–49, and 1451–62.

8. For details, see w IV, pp. 3–4, and WL 1440–41.

9. Although the London trip was ostensibly to visit Michel Monet, who was studying English there, the artist soon began to paint views of the Thames from his window in the Savoy Hotel. Fascinated, he returned to the city for two long working trips in 1900 and 1901. Cumulatively, he would initiate (but not complete in situ) perhaps as many as a hundred views of London, including a number left incomplete at his death, as well as others probably destroyed by the

artist, who had become increasingly ruthless and hypercritical about his output. Like the Rouen series, the London pictures were all executed indoors from various viewpoints overlooking the Thames, primarily from the Savoy Hotel, where he also lodged on the two later visits. For a good overview of these campaigns and their results, consult Grace Seiberling, *Monet in London*, High Museum of Art (Atlanta, 1988). See also w IV, pp. 10–16; w 1521–1617; and relevant letters from the second and third journeys.

10. See w IV, pp. 25–26; consult also George Shackelford and MaryAnne Stevens, "The Garden at Giverny, 1900–1902," in Paul H. Tucker with Shackelford and Stevens, *Monet in the Twentieth Century* (New Haven, CT, 1998), pp. 118–27.

11. See w IV, pp. 29–31, and wL 1641, written to the prefect, and 1644, dated October 19 and addressed to Durand-Ruel.

12. In January 25, 1882, Monet returned to Vétheuil to arrange a fifteen-year lease on "the part of the cemetery" that contained Camille's tomb. Neither he nor later Michel ever renewed this lease. For details, see w I, p. 99, n. 749.

13. For details about the expansion, consult Robert Gordon, "The Lily Pond at Giverny: The Changing Inspiration of Monet," *The Connoisseur* 184, no. 741 (November 1973): 154–65. See also w IV, pp. 29–32 and relevant notes and letters. By this time Monet's paintings were in such demand and fetched such high prices that he could—and did—play one dealer off against another. But he usually contacted his original dealer, Durand-Ruel, whenever he needed money, as he did on August 13, 1901, to request an advance of twenty thousand francs—no doubt to finance the upcoming water-garden construction (wL 1640). In February 1902 Durand-Ruel exhibited thirty-eight of Monet's paintings at his New York Gallery while, virtually simultaneously, the Bernheim-Jeune Gallery, which had acquired first right to exhibit them, showed about a dozen of his recent Vétheuil works. By this time Monet exhibitions were regularly reviewed by numerous critics, usually quite favorably.

14. For my discussion of this material, consult chapter 1. See Levine, 1994, p. 201, and Virginia Spate, *Claude Monet: Life and Work* (New York, 1992), pp. 310–12, for their statements about the photograph.

15. w IV, pp. 60–62, and w 1736–72.

16. w IV, p. 72, nn. 647–48, and relevant letters, claims that the chronic depression Alice suffered from the time of Suzanne's death until her own, as well as the troubles her elder son Jacques (who seems to have been something of a psychopath) caused the family, played critical roles in the course of her illness. These factors may have hastened Mme. Monet's decline, but nothing could have made any difference in the final outcome.

17. For Monet's comments about the problem and the results of medical consultations, see wL 1904b, 1906, and 1908, all written in the fall of 1909. Whether the vertigo, which he also experienced in 1909, was related to a virus Alice and he may have contracted while abroad remains unclear. The headaches themselves were more likely due to eye strain resulting from his struggle to overcome the effects of developing cataracts on his visual acuity.

18. See w IV, pp. 62–68 and related notes and references.

19. Monet's fame and wealth continued to grow during his fallow period. Paintings already extant were featured in numerous exhibitions, both in Paris and abroad. Twenty-nine of the Venetian paintings, exhibited in 1912, elicited rave reviews and fetched high prices. For a concise account of exhibitions staged between 1910 and early 1914, consult Charles F. Stuckey, *Claude Monet, 1840–1926* (Chicago, 1995), pp. 242–45.

20. See W IV, pp. 72–78. Early symptoms of Jean's illness—and loss of judgment—probably began to manifest themselves around 1910, when Monet's brother Léon was finally forced to fire his nephew—never a very satisfactory employee—whom he had kept on at the chemical factory he managed out of family feeling. The fact that Jean then purchased a trout farm (which his father later had to sell) was symptomatic of his impaired judgment. Although Wildenstein delicately states that Jean suffered from an illness that "neither medicine nor hydrotherapy could cure," in an accompanying note (W IV, p. 72, n. 651) he cites an oral communication from J.-P. Hoschedé that Jean had contracted a venereal disease while in Switzerland on a working trip for his uncle. Wildenstein does not date this incident, but third-stage syphilitic symptoms of general paresis typically take fifteen to twenty years to develop, and it is more probable that Jean had contracted the disease during his year of compulsory military service in 1890. As Tucker points out (1995, p. 235, n. 42), "Jean's biography remains cryptic, like that of the rest of Monet's children and stepchildren." Monet unfairly blamed his brother for Jean's illness and death and subsequently broke off all contact with him, proving that no good deed goes unpunished—particularly when the do-gooder is the object of unresolved childhood sibling rivalry!

21. Quoted in Jean Martet, *Georges Clemenceau* (1929), trans. M. Waldman (London, 1930). See also Georges Clemenceau, *Claude Monet, Les Nymphéas* (Paris, 1928), reprint ed. *Claude Monet: Cinquante ans d'amitié* (Paris, 1965). As previously noted, the fantasy of creating an environment that would symbolically immerse the viewer in the watery world of Monet's creation had originated with the artist himself several years earlier.

22. W IV, 78–88 and WL 2116; consult also François Thiébault-Sisson, "Les Nymphéas de Claude Monet," *La Revue de l'Art Ancien et Moderne*, June 1927, especially p. 46, for Monet's eloquent description of his visual problems and how he worked around them.

23. Jean-Pierre Hoschedé, Michel Monet, and Germaine Hoschedé Salerou's husband all served in the army. See W IV, pp. 80–83, and related letters.

24. On this issue, consult the catalogue raisonné, which assigns all the late paintings to loose, often overlapping, chronological periods.

25. These photos are widely reproduced and discussed; see, for example, Tucker, 1995, pp. 208–9.

26. That same year, he painted four self-portraits. Only the one now in the Musée d'Orsay survives; the artist himself destroyed the other three.

27. For a detailed discussion of these years and their difficulties, see Andrew Gordon and Charles F. Stuckey, "Blossoms and Blunders: Monet and the State," pt. 1, *Art in America* 67, no. 1 (January–February 1979): 102–17; and Stuckey, pt. 2, *Art in America* 67, no. 5 (September 1979): 109–25.

28. Consult W IV, pp. 93–105, and related letters and paintings.